Into the Light of Things

Into the Light of Things

The Art of the Commonplace from Wordsworth to John Cage

George J. Leonard

University of Chicago Press

Chicago and London

George J. Leonard, professor of interdisciplinary humanities at San Francisco State University, is the author of the novels *Beyond Control* and *The Ice Cathedral.*

The University of Chicago Press, Chicago 60637
The University of Chicago Press, Ltd., London
© 1994 by The University of Chicago
All rights reserved. Published 1994
Printed in the United States of America

03 02 01 00 99 98 97 96 95 94 1 2 3 4 5

ISBN 0–226–47252–3 (cloth)

Library of Congress Cataloging-in-Publication Data
Leonard, George J. (1946–)
 Into the light of things: The art of the commonplace from Wordsworth to John Cage / George J. Leonard.
 p. cm.
 Includes bibliographical references and index.
 1. Arts, Modern—19th century. 2. Arts, Modern—20th century.
I. Title.
NX454.L46 1994 93-24555
700′.1—dc20 CIP

♾ The paper used in this publication meets the minimum requirements of the American National Standard for Information Sciences—Permanence of Paper for Printed Library Materials, ANSI Z39.48-1984.

For my parents, my wife, my son Andrew
and
for Richard Kuhns

There is no science but tells a different tale, when viewed as a portion of a whole, from what it is likely to suggest when taken by itself, without the safeguard, as I may call it, of others. . . . The drift and meaning of a branch of knowledge varies with the company in which it is introduced. . . .

John Henry Cardinal Newman, "The Idea of a University"

Contents

Preface

An extensive critical literature now raises many methodological cautions about comparing art and literature. First, I'm indebted to Arthur Danto and to Richard Kuhns for advice about periodization.[1] See Danto's 1965 *Analytical Philosophy of History,* the integral text of which Danto revised and augmented into *Narration and Knowledge,* particularly the added chapter entitled "Historical Understanding: The Problem of Other Periods." *History* was written in "the spirit of" Thomas Kuhn's *The Structure of Scientific Revolutions* and N. R. Hanson's *Patterns of Discovery.* "Hanson's point was that observation is (if I may borrow a locution from Derrida) 'always already' permeated by theory to the point that observors with different theories will interpret even retinally indiscriminable observations differently." Danto's "general point" throughout *History* was that "narrative structures penetrate our consciousness of events in ways parallel to those in which, in Hanson's view, theories penetrate observations in science." The figures I write about, and even their critics, routinely periodize—indeed, they routinely deal in "ages" of mankind (please see footnote 2, below). My thesis, on the contrary, requires no periodization. One may write, as M. H. Abrams does in *Natural Supernaturalism,* about one "intellectual tendency" (or in my case, "religious orientation") without making it into the only one; one may write, as I do, about the tactics some artists used some of the time without implying all artists used them; or even that any used them all of the time.

My thesis also runs counter to any efforts to declare "modernity," or "Western art," or "art" itself over. I only describe the recurring tactics by the artists of one recurring religious orientation; and how they arrived at a point at which they felt able to jettison the art object. In sum, I do

1. Although creating an annotated bibliography is not the point of this book, in fields less familiar to the general scholarly community I've referenced, in my notes, some arguments I've found particularly useful or suggestive.

An older, but still valuable book is Frank Kermode's *The Sense of an Ending* (New York: Oxford University Press, 1966, 1967), which cautioned that "our interest" in "epochs" and ends of epochs "reflects our deep need for intelligible Ends." See also Hayden White's *Metahistory: The Historical Imagination in Nineteenth-Century Europe* (Baltimore: Johns Hopkins University Press, 1973), particularly the lengthy "Introduction: The Poetics of History," on pp. 1–42. In a 1987 seminar at San Francisco State, Professor White frequently rebutted arguments taken from Danto, and I've considered his objections.

not write to reduce either "periods" or individual artists to a single theme, but to discuss a particular religious orientation and its tactics when it appears in an artist's work.

I reviewed Umberto Eco's 1991 *The Limits of Interpretation* warmly and seconded his worries about the "cancer of unlimited semiosis." While I personally enjoy Roland Barthes' own playful "writerly interpretations," I agree with Arthur Danto and Joseph Margolis that writerly interpretation implies "readerly" interpretation first—"historical explanations of salient features of the work," explanations which can err.[2]

With those cautions in mind I have deliberately avoided what Jean Hagstrum calls "iconic" or "ecphrastic" descriptions of visual artworks, as tending to manufacture the evidence I am required to supply. The reader will find artists respected as thinkers, and taken as authorities (though not the *sole* authorities) on their intentions. "I am anxious that the world should be inclined to look to painters for information on painting," Constable once wrote—a moderate hope indeed.[3]

Such intentionalism is not out of place here. For one thing, the book relates to Arthur Danto's work and he has done much recently to redeem "intention." More important, my topic is precisely a change in what certain artists intended to accomplish. Whether they accomplished it is another story, and I will often, in fact, argue that they did not. One should be particularly aware that theorists, like other human beings, often fail to live their ideals. When Ruskin, acknowledging where his theories lead, piously announces he would trade even his Turners for windows overlooking the Alps, we may fairly point out that he could have and didn't. Arthur Danto announced the end of art and became an art critic, Emerson and Whitman reviled sculpture and hobnobbed with

2. *San Francisco Review of Books* (Winter 1991). Personal communication, Arthur Danto, 10 July 1991.

3. For a comprehensive overview of research on literature's relations with other arts, sciences, and scholarly disciplines, see the MLA's *Interrelations of Literature,* edited by Jean-Pierre Barricelli and Joseph Gibaldi (New York: Modern Language Association, 1982). Particularly relevant to our topic are Giles Gunn's "Literature and Religion" (pp. 47–67); Ulrich Weisstein's "Literature and the Visual Arts" (pp. 251–78); and Thomas McFarland's "Literature and Philosophy" (pp. 25–47). Each chapter includes a well-organized bibliography, though Weisstein doesn't seem to think English and American sources as authoritative as continental ones. For methodological cautions particularly pertinent to our topic, see Wendy Steiner's *The Colors of Rhetoric: Problems in the Relation between Modern Literature and Painting* (Chicago: University of Chicago Press, 1982). Older, but essential, is René Wellek's "The Parallelism between Literature and the Arts" (New York: AMS Press, 1965 [*English Institute Annual,* 1941]). See also the Modern Language Association's recent introduction, *Teaching Literature and the Other Arts,* particularly the article by my colleague Marcia Green.

sculptors. Only those two pure spirits, Carlyle and Thoreau, seem to have been untempted by the things of art.

"There will be found in these volumes," Wordsworth wrote, "little of what is called poetic diction; as much pains has been taken to avoid it as is ordinarily taken to produce it," in order to "bring my language near to the language of men." Stern advice for any critic writing about him, or who was ever moved by Harold Bloom's hope that an act of criticism could itself be a "severe poem." Semiological jargon has all but become American literary criticism's poetic diction but aesthetics still resists. I come from Kuhns's and Danto's tradition, a philosophic tradition that tries to write, like Wordsworth, as "a man speaking to men." (In the generic sense, of course!)

Yet this is a work of criticism, not poetry, and I will sometimes sacrifice grace for accuracy. Criticism should not be, but mean. "Artwork," for instance, is simple English but less precise than "art object" when we try to discuss a piece the artist deliberately did no work on (see pp. 163–68). Unusual art requires unusual words. The reader will find that phrases from aesthetics like "real things interpreted as art objects" do help us deal with recent developments. Though I borrow words like "artworld" from Danto's philosophic vocabulary for precision, it would be self-defeating to address a work to several fields of scholars and use words in a sense only understood in one. Aside from a few aesthetic terms like those just mentioned, my words should be understood in their ordinary English uses, not their specialized philosophic uses, which are often different. (Danto's vocabulary is, of course, indebted to Heidegger.) I realize that substituting "art object" for "artwork" seems to narrow my meaning down to art one can see and touch. I'll ask the reader to understand "art object" in the extended sense contemporary aestheticians often give it, to include poems and musical pieces. I would prefer to avoid recent neologisms like "artproducts," "artpieces," "artifacts," and "artefacts," and even the (to me) graceless "art things."

I've tried to avoid gender-biased language. When speaking in my own voice, I write "humankind," not "mankind"; "people" not "men." When paraphrasing, however, I found that helping Carlyle, Ruskin, or even Marinetti learn to say "humankind" cosmeticized their very real sexism. I've opted not to modernize them.

Finally, interdisciplinary work is at heart the urge to break artificial bounds, reconnect the arbitrarily divided. The modern university's division of knowledge into departments and specialties walled like Siena in a Lorenzetti fresco can be understood economically but not epistemologically. It is the division of labor, capitalism applied to knowledge. "We have much studied and much perfected of late," John Ruskin wrote, "the

great civilized invention of the division of labor, only we give it a false name." It was not the "labor" that was divided, "but the men:—Divided into mere segments of men—broken into small fragments and crumbs of life; so that all the little piece of intelligence that is left in a man," Ruskin grieved, "is not enough to make a pin, or a nail, but exhausts itself in making the point of a pin or the head of a nail" ("The Nature of Gothic").

For these reasons, interdisciplinary work like mine consciously re-connects what has been artifically divided—and consciously ignores the very prudent advice not to fight in other people's backyards. Certain sections, parenthetic to the whole, are meant to be suggestive, evoca-tive—not definitive. Need I acknowledge that any of the figures here given a chapter merits a library, and a lifetime's study? And yet, there is also a time to try to see them and their works intertextually. Cardinal Newman reminded us, long before Umberto Eco did, that "there is no science but tells a different tale," when we see it as "a portion of the whole, from what it is likely to suggest when taken by itself. . . . The drift and meaning of a branch of knowledge varies with the company in which it is introduced. . . ." Like Pierre Menard's celebrated *Don Quixote,* even the familiar changes when we recontextualize it. To read Carlyle and Ruskin next to John Cage alters all three.

I've written in the belief that the reader who simply has no faith in interdisciplinary work—in *anyone's* ability to do "professional" work in more than one discipline—has easily recognized this book for what it is and passed it by. Each writer constructs a Model Reader and I have had another in mind. Knowing my Reader's tastes, when I had the chance to suggest a fruitful line of argument, I have done so, even if I couldn't follow up on it within the boundaries of this one volume. To do other-wise would be counter to the cross-pollinating, polyphiloprogenitive spirit of interdisciplinary work.

Acknowledgments

Not the least important part of my personal methodology was to ask the contemporary thinkers the book discusses to read either the whole manuscript or the sections relating to their work, and then to offer me advice on how the book could most accurately represent their thought.

I above all thank Richard Kuhns for giving so unselfishly of his time, attention, and encouragement during the years it took to write this book. Whatever I may know of aesthetics comes from Dick Kuhns, and his faith in the manuscript sustained me.

By the same token, my ideas about the nineteenth century all stem from a decade of John D. Rosenberg's classes and critiques. John's readings of Ruskin and Carlyle entered my thought so early they became premises for the rest.

Arthur Danto very kindly read drafts of this entire work as I wrote. He has for years provided inspiration and encouragement. As I finished the book, I met with Arthur several times a week during a five-week NEH summer institute on aesthetics organized by Anita Silvers.

I owe a great debt to David and Eleanor Antin, who read the work and gave me insights into the American artworld from the 1960s to the present. David read several drafts and suggested improvements.

I delivered the entire section on John Cage entitled "The Two Cages" in a performance with him at Hofstra University in October, 1990, at Gail Gelburd's "An Evening with John Cage," during the conference, "Bamboo and Oak: The Impact of East Asia on American Society and Culture." Mr. Cage privately read and commented on much of the chapter, graciously let me tape-record his answers to every question I could think of about him, aleatory art, Daisetz Suzuki, even Marcel Duchamp. Since fully a quarter of this book concerns Cage in one way or another, it's immodest but highly relevant to note that Mr. Cage pronounced himself so pleased with my unusual interpretation of his career since 1957 that he upgraded my paper, which was to have been an introductory lecture on him, into a kind of performance. He sat with his back to the audience while I delivered it at him, like a trial attorney's summation. For the videotape, Cage said, "I've never felt compelled to reply to an introduction before but this time I must. Thank you. For what you said."

My critique of John Cage's debt to the East was immeasurably im-

proved by discussions of Taoism and *feng-shui* with my colleagues at Beijing Advanced Teacher's College, particularly Dean Zhu. Mr. Shi Xianrong, Deputy Director of the People's Republic of China's Institute for American Studies, invited me to speak on my work to a panel of scholars. My brother-in-law, Associate Professor Y. F. Du of Beijing Commercial College, helped me translate difficult concepts.

To improve my understanding of Daisetz Suzuki's relationship to Cage, Mr. Blouke Carus of Open Court Publishing generously let me read Suzuki's unpublished letters, which changed my whole theory about Suzuki's Western Zen.

Allan Kaprow read the entire manuscript and, with David Antin also contributing memories, gave me line by line advice. During the 1950s, Allan Kaprow devised the first of his famous "Happenings" in John Cage's legendary class at the New School. He joined Cage very early in Zen, and now sits several times a week. Arguably Cage's best student, a father of American conceptual art, he was an invaluable eyewitness source.

Jeff Kelley, editing Allan Kaprow's works for the University of California Press (*Essays on the Blurring of Art and Life*), gave me advance copies of strategic manuscripts and his good advice.

Harold Bloom read an earlier version of certain chapters and was encouraging, though (as the book will show) we later disagreed on the question of "influence." While I was assistant professor at Yale he graciously allowed me, though a colleague, to attend his graduate seminar for a year. Where I differ with him it is with respect.

Murray Krieger graciously read the sections which applied to his work. Jacques Barzun, my former professor, read the entire manuscript.

Jack Miles read several drafts, diplomatically proposed a major structural change, and, above all, forced me to realize that the book's real topic was religion. While he edited the *Los Angeles Times Book Section,* the books he selected for me to review unfailingly had an impact on this work.

Dean Nancy McDermid's grants of release time, and her personal encouragement, have furthered the work in all ways. By appointing me co-editor of the School of Humanities faculty *MAGAZINE* she brought me together with Jonathan Middlebrook, the poet William Dickey, and our best writers.

Alan G. Thomas, my editor at Chicago, ably guided this book through the Press.

An earlier version of pages 11–19 appeared in *Philosophy and Literature* (Fall 1989): 297–306.

I thank Jay Martin and the Huntington Library for providing a fellow-

ship to research Reynolds and Wordsworth in residence for two months at their incomparable collections and Martin Ridge for arranging other support. Virginia Renner, the Huntington librarian, was invaluable.

Leon Golub sharpened my ideas about the nature of recent art. Artists Helen Mayer Harrison and Newton Harrison clarified my understanding of contemporary ecological art. I thank Louis Cornell, Barbara Novak, and Alice Fredman for reading an early version of several chapters. Martha Vogeler, Al Vogeler, Geoffrey Green, Peter Mellini, James Kohn, Lois Lyles, Manfred Wolf, Robert and Katherine Morsberger educated me about the writing of criticism. Mary Scott scrutinized the section on Zen. George Stade, novelist and critic, encouraged the work and found me agreeable assignments at Scribner's. Stephen Wyman and Michael Hahn provided support. The late Walter Oakeshott, sorely missed, was an inspiration. Robert A. Leonard gave me a Diver-ian linguist's point of view. Neville Wakefield critiqued several drafts from a British art historian's point of view and helped me try to reach an international perspective on my topic. The artist Tonia Aminoff often shared her library, her knowledge of the art world, of ecology, and of Zen.

San Francisco offers an unparalleled chance to study contemporary trends in religion and the growing union of East and West. In a school thirty-five percent Asian-American, one lives that union. Perhaps, too, only San Francisco State University could field the legions of humanists necessary to support Interdisciplinary Humanities, an entire department devoted exclusively to interdisciplinary courses. Colleagues Marvin Nathan and Rodger Birt have shared ideas and methodologies for years. Arthur Chandler, Howard Isham, and others at the weekly Nineteenth Century Luncheon listened to and critiqued my ideas every Monday for three years. San Francisco State University President Robert Corrigan and Vice-President Marilyn Boxer have accelerated my career.

Over the years students at Yale, Scripps, and San Francisco State University who reflected my insights back to me with improvements included Sally Radell, H. J. P. Harding III, Vivian Craig Shaver, Barbara Johnson, Paula Keener, Carolyn Gerardo, Adrienne Stout, Brenda Wallace, Esther Allen, Jillian Kendall, David Kahn, David G. Helder, Diane Rosenblum, Diane Shappy, Kevin Gallagher, Frank D. Fiore.

I must thank the staff of the various Columbia, Yale, University of California, Irvine, Scripps, and San Francisco State University libraries where I worked for years. Signora Graham of the Museo Vaticano gave me access to rooms closed for restoration. Sir Joseph Cheyne at the Keats-Shelley Memorial in Rome also extended privileges.

I thank my gifted librarian computer researcher Rhona Klein. Katy Cartledge checked many of the notes. Kathryn Kraynik labored valiantly

on the proofs. For many years Lynda Schenet has been a rapid, gifted word processing professional and an invaluable help.

My beloved wife Simei is my rock of support; our son Andrew daily gives me lessons in life—and the same lessons that Wordsworth, Carlyle, Ruskin, and Cage once gave me.

The End of Art?

*We / open our eyes and ears seeing life / each day excellent as it is / This realiza-
tion no longer needs art.*—John Cage

*Away with your nonsense of oil and easels, of marble and chisels; except to open
your eyes to the masteries of eternal art . . . the eternal picture which nature
paints in the street . . . they are hypocritical rubbish.*—Ralph Waldo Emerson

Arthur Danto and the "End of Art"

Some thirty years ago, 1964, the American philosopher Arthur Danto walked into the ultravanguard Stable Gallery and saw what seemed to be stacks of Brillo cartons piled everywhere, as if the Stable had been "pressed into service as a warehouse for surplus scouring pads." Danto had happened upon the new Andy Warhol exhibition—Warhol still sufficiently unknown for the *Artnews* critic, in his review, to have to explain who he was. Seventeen years later, 1981, in *The Transfiguration of the Commonplace*, Danto still remembered how his "aesthetic repugnance" was gradually overwhelmed by "philosophical intoxication," as he realized the implications of what he was seeing.

Wandering through the exhibition, foreseeing the triviality and predictability of the variations—including Warhol's—that would follow the Brillo boxes, Danto decided that "the history of art had come, in a way, to an end." The art didn't fascinate Danto. The sophisticated audience at the Stable Gallery did. He saw that they had discovered they could enjoy the Brillo boxes just the way they enjoyed sculptures. What difference was now left between art and what Danto came to call, in elaboration of Heidegger's language, "mere real things"? Warhol would soon submit to the public his Campbell Soup cans, some of which were just taken from the shelves "where the rest of us buy our soups."[1] Danto's idea, looking at the audience's reaction to such work in 1964, was that art was, in some important sense, "over": "It has not *stopped* but ended, in the sense that it has passed over into a kind of consciousness of itself and become . . . its own philosophy. . . ."[2]

Once we had the power to "transfigure the commonplace," as Danto has phrased it in thirty years of books and articles, what need of art's stuff? Leave the piano unstruck; away with art. If you had gained the eyes to see even a Brillo box as a glowing cube of color, then you could get, every second of your life, the experience you once had to go to the museum for. Why walk to the museum if your walk was as good as the museum? Or better? Compared with the world's immensity and variety, what were artworks?

In 1990, Danto—by then a National Book Critics' Circle Award-winning art critic, whose influence a *New York Sunday Times Magazine*

profile had compared to Clement Greenberg's or Harold Rosenberg's in their prime—again distinguished carefully between art "coming to an end" and art "coming to a stop." Danto never doubted there would continue to be artwork. It was the "history" of art which Warhol had brought to an end. Art would now enter its "posthistorical phase."[3]

Novelty was no longer possible. Since Pop, the whole world was art. Surely, objects might still be produced and marketed, but now the whole ritual was "posthistorical": at best, pluralism, at worst, an endless garage sale of past styles. No more avant-garde—just styles drifting in and out of fashion like miniskirts. Artists could spend eternity picking through the artworld's Salvation Army bins, or choose a more serious attitude: dump art's stuff as passé, get on with the final job of proving to the audience, as Warhol had, that the audience too had outgrown its dependence on art.

After the Brillo boxes only one last artwork was possible: a work of conceptual art which would hold a mirror up to the art process, show it its method, and bring its development to an end in a climax of Hegelian self-awareness. The paper Danto then wrote, in 1964, "The Artworld,"[4] from which the philosophers George Dickie and Richard Sclafani later developed influential theories of art, was meant to be that last artwork. "Perhaps the final creation in the period it treats of. Perhaps the final artwork in the history of art!"

By 1980, most of the artworld shared a conviction that something important was over. But what? Nestor, of course, would have said there were no more real men as well as no more real artists; and we know from such works as Renato Poggioli's *The Idea of the Avant-Garde,* that, in this century, particular movements have routinely declared themselves to be art's climax.[5]

Yet by 1980 "art is over" was no-one's boast but a general fear and the sense of an ending seemed—like the events it followed—something without clear precedent. The College Art Association devoted the Fall/Winter 1980 issue of *Art Journal* to the topic. Irving Sandler, who edited, reported that leading "artists, architects, historians and critics" were proclaiming that modernism either "never . . . existed" or was "dead." We could "shrug off" such claims if they were "made in only one discipline—but several? And by respected authorities in each?"[6]

The sixties, Sandler sums up, saw the final triumph of the styles called "modernist, avant-garde, or mainstream, the terms more or less interchangeable," by painters like Ad Reinhardt and Frank Stella, critics like Clement Greenberg and Michael Fried. After 1970, attacks on "modernism" grew, as "the notion of avant-garde ceased to be believable." Sandler

even whimsically dared to name the "very moment" art ended: "the evening of July 1, 1969," when New York's Museum of Modern Art opened the Information Show, and "Conceptual Art" was, so to speak, formally received at court.[7] Periodization is always problematic. Danto, we know, would set the date as early as 1964, when he wrote to declare that art had become its own philosophy, and the philosopher (indeed, a certain philosopher) was now the last artist. And Sandler agrees that, even before the Information Show, "critics had questioned whether an avant-garde still existed."[8]

Critics like Jacques Barzun, artists like Amédée Ozenfant, had, of course, been saying for years that the avant-garde was exhausted. Barzun in fact had long believed that after 1920 art merely "amplified and multiplied" what had been achieved by the late nineties and certainly by the end of the Cubist Decade. "Western civilization has not had a new idea in fifty years."[9] Most critics would think that date premature. Sandler thought the "limit" came when the works began pushing toward the final "boundary," coming "as close as possible to being non-art."[10]

The "Obliteration" of Art

That swelling inclusiveness, leading to a collapse of any ability to define (set some limit to) art, is the problem Danto's narrator faces in *The Transfiguration of the Commonplace* (1981)—Danto's book summing up five articles written during seventeen years on this subject. Four collections of essays have followed, elaborating *Transfiguration's* arguments— including 1990s *Encounters and Reflections: Art in the Historical Present,* which won the NBCC Award. Be that as it may, the lesser-known *Transfiguration* is the philosophic work the essays rest on, and by far the better book. *Transfiguration's* style and wit owe something to Kierkegaard, but even more to Borges. Every time Danto's narrator tries to set up an exhibition which will include some objects as "artworks," and exclude others as "mere real things," a horde of Borgesian characters attacks him; most memorably, "a sullen young artist with egalitarian attitudes, whom I shall call J."[11]

J's attacks bear out Danto's (and Sandler's) contention that this time something ("art"? "modernism"?) really has reached some final boundary. For instance, J, like Robert Rauschenberg, exhibits his bed as a work of art. Rauschenberg had splashed paint over his bed first, but J goes the "full distance": he merely displays his ordinary bed, without bothering to add "that bit of vestigial paint Rauschenberg superstitiously dripped over *his* bed, perhaps to make it plain that it was still an artwork. J says his bed is not an imitation of anything: it is a bed."[12] Looking at it,

Danto's narrator, and we, realize that J's bed would be accepted as art in the modern artworld, as easily as Warhol's chosen soup cans were. In this serious jest Danto is alluding to Plato's discussion of the painter as imitator in Book 10 of the *Republic*. Plato had discussed a painter who painted a bed and his bed's relation to real beds. J's bed manages to be art, yet escapes Plato's definitions. If art could once be defined as an "imitation," it can be no longer. Even expanded mimetic theories of art (like Erwin Panofsky's)[13] as mimesis of process fail: J didn't create the bed. He isn't imitating anyone. He just points at the bed.

Yet objects like J's familiar brand of found sculpture were not what led critics to conclude that something ultimate had happened, but the movement called "conceptual art," which grew logically out of objects like J's bed.

Critics found conceptualism alarming. Conceptualism "demolished," Sandler complained, "every notion of what art should be—to the extent that [artists] have eliminated what may be irreducible conventions in art—the requirements that it be an object and visible."[14] Murray Krieger stormed that conceptualism had completed the "obliteration of the realm of art, its objects, its museums." All "elite objects" drowned, "immersed within the indivisible flood of experience."[15]

Yet how large a leap beyond Pop *was* conceptual art? Did it not merely champion the cause of very large objects? Terry Atkinson, for example, in 1967, accepting that Duchamp's ready-made *Bottle Rack*, like J's bed, "took on art object status" through the artist's "act," asked, logically, that if that bottle rack was now an art object,

then why not the department store that the bottle rack was displayed in, and if the department store then why not the town in which the department store is situated, and if the town then why not the country. . . . and so on up to universe scale (and further if you like!).[16]

Should size, after all, define art? Small objects—yes; large objects— no? Brillo boxes—yes; Brillo box factories—no? Therefore, Atkinson solemnly reported, the object he had chosen to confer status on was "Oxfordshire." Oxfordshire, he reasoned, was large enough compared to the Bottle Rack to afford "sufficient contrast." Atkinson and his partner Baldwin proceeded to erect, for their audience, a temporary mental ("conceptual") museum over Oxfordshire.[17] If the object cannot come to the museum, then the museum must go to the object. Nothing stopped them, as Atkinson said, from erecting their tent over the entire universe.

Indeed, concept artists invite us to do so: for concept artists are trying to persuade us we no longer need artists any more than we need art

objects. Objects, concept artist Joseph Kosuth was asserting by 1969, are "irrelevant to art." Though an artist might choose, as in the past, to "employ" objects, "all art is finally conceptual." In fact it is now time that the object, nothing more than the "physical residue" of the artists' mental "activity," was dispensed with.[18] "We / open our eyes and ears seeing life / each day excellent as it is," John Cage chanted. "This / realization no longer needs art. . . ."[19] "I do not mind objects," Lawrence Weiner told Ursula Meyer, "but I do not care to make them. The object—by virtue of being a unique commodity—becomes something that might make it impossible for people to see the art for the forest."

We have arrived, by logical steps, at a strange reversal. This special class of elite objects, unique commodities, has become a potentially dangerous "forest" distracting us from the real "art"—that is, the world. What we've always called "art" is now an outmoded fetish. What we've called the ordinary world is now, somehow, a higher value than the little art object. "During the last 40 years," John Berger wrote in a special *Soho News Art Supplement* (29 September 1981) "transatlantic painting has demonstrated how there is no longer anything left to paint."[20] Pictorial art has "nothing of consequence" left to do and concept art is "merely a discussion of this fact." Robert Hughes quotes Barbara Rose: "There is an inescapable sense among artists and critics that we are at the end of our rope. . . ."[21]

And Barzun argues that concept art and performance art are at least seventy years old. As the child of one of the first Cubists, Barzun grew up with Futurists, Dadaists, Surrealists, watching their manifestations and theater pieces.[22] Today, "the lessons" of those pieces Barzun saw in his boyhood "have grown dull by overuse." The old "tricks" are exhausted and "nothing" is left but "variations" increasingly "dreary." Once one man has "earned a large fee in New York by digging a hole and calling it a sculpture, little advance can be seen in Munich, where a confrere fills part of an exhibition room with dirt."[23]

What would Barzun say of Joseph Beuys, who was still filling rooms "with dirt" in 1983, nine years after that passage used it as the very symbol of staleness? That by now artists fall back "automatically" on the same "old twists" threatens to degrade them into "commercial hacks" grinding out a "formula, knowing what is wanted."[24]

These sentiments had long been current in the French post-Cubist circles Barzun came from. Old combatants like Ozenfant, who, with Le Corbusier, had founded Purism in the teens, waited fifty years for modern art to run through the variations they foresaw, and end. In 1928 Ozenfant was writing impatiently that since recent "masters" had been "revolutionaries," people had begun to assume that "every artist" had to

play "Lenin"—but what was left to revolt against? Artists, Ozenfant felt, had already won "the full right to do anything they please in music, literature, painting." What was the point of leaping over a wall when "the door is open"? Ozenfant deplored these "traditionalists of the artistic revolution" ("What ridiculous figures they cut")[25] and in the "tyranny" of the avant-garde "tic" Ozenfant saw the makings of a new orthodoxy, even a new academy, imposing new obligations on each little Robespierre-artist to "storm non-existent Bastilles. . . ." Summoning up his audience's memories of trench warfare in World War I, Ozenfant declared that since "innumerable brave men" had died cutting paths through "the barbed wire," we now must rush through, "else why the wasted lives?" Yet that hadn't happened. "In art, we stand before that open breach, cutters in hand, languidly or nervously looking for wire that does not exist."[26]

"Great periods of art and thought," Barzun admonishes us, "have to come to an end." It happens through a mixture of "exhaustion" and "self-destruction." First comes the "full positive exploitation" of the new ideas and techniques. Then a second type of artist puts them through "the subtle art of allusion, parody and inversion" until even that wears out. At this point, there's nothing left to do but "declare bankruptcy. That is the meaning of anti-art."[27]

Such was Barzun's conclusion in his Mellon Lectures, by 1974. It is no exaggeration to say that every year since, as the artworld realized that recovery was not just around the corner, the situation grew sadder and colder.[28]

Even those who (like Danto and Sandler) think Ozenfant premature; who find in Barzun's work an anger at this sort of art we can't really share, are yet sadly, though not angrily, aware that something seems to have come to completion. "Art is and remains for us a thing of the past,'" Danto quotes Hegel in his 1984 sequel to *Transfiguration*. "On the other hand, it has been an immense privilege to have lived in history."[29]

When Ozenfant in 1928 proclaimed the artists' new right to do "anything they please" he accurately predicted the artworld we now live in. In the 1990s, critics disagree over whether the free-for-all after "modernism's" collapse has been in some way a good thing ("pluralism") or whether, as art drowned, its entire life flashed before its eyes. "In lieu of the historical sequence," Hal Foster complained, we find only a "static array: a bazaar of the indiscriminate replaces the showroom of the new."[30] Everyone agrees that something has gone wrong with the steady tide of "movements" the artworld had long known. Since "anything goes," Foster said, "nothing changes." Back in 1980 Kim Levin wrote a damning summary of the seventies artworld. Over a decade later, there's been so little change, it's still worth quoting at length:

Robert Smithson's earthwork in Great Salt Lake—the Spiral Jetty—is submerged under five feet of water like some relic of the prehistoric past, Photo-Realism looks dead as a dinosaur, Minimalism is the establishment, Conceptualism is the old order, and Conceptualist Douglas Heubler's statement about the world being full of objects—"I do not wish to add any more"—has the ring of history. And nobody seems to know what's happening.—The seventies came and went, and most of the art world pretended they never existed at all, grumbling that there was no new art, no superstars, no new movements, no isms that lasted longer than fifteen minutes.

As the artworld floundered to regain a sense of purpose and direction,

The work went to extremes. . . . There was post-literate story art and mute pattern painting. Gigantic land projects and miniaturized villages. Aggressive feminist art and passive political art. Cold-blooded virtuosity and intractable ineptness. Painstaking simulations appeared and so did awkward images. There was art you could hear instead of see and art that was nothing but light.[31]

Barzun had yawned at the artist who "fills part of the exhibition room with dirt," and Kim Levin, in a short "glossary" of nine seventies art movements, duly mentions

Scatter Works: an extreme type of early process art, reduced art to a random scatter of raw materials on the gallery floor. It emphasized the physical properties of substance and opposed formalism with formlessness.[32]

He has been watching, Levin concludes, the "death throes of modernism"; what Sandler called, in a 1979 symposium, "the death of the avant-garde as a believable concept."[33] Today, the mood is still as bleak. Danto summed up the artworld's "uneasy consensus" in a recent essay titled (he quotes Elizabeth Frank) "Bad Aesthetic Times." "The engines of the art world turn furiously"—more magazines, more artists, more art schools, more everything—but for over two decades now, "the output has been aesthetically stalled." Danto had already seen it back in 1964. "The possibilities (are) effectively closed" he had argued, "and the history of art has come, in a way, to an end." But, Danto realistically continued, though art had "ended," "it has not *stopped*."[34]

Nineteenth-Century Attacks on the Art Object

What Has "Ended"?

Yet, what has "ended" is not clear. "Modernism"? The "avant-garde"? These terms are neither identical nor easily defined. Are we actually "witnessing in all the arts and in all that the arts refer to"—Barzun writes—"the liquidation of five hundred years of civilization—the entire modern age dating from the Renaissance"?[35]

Danto says "art" ended, and four years after *Transfiguration,* he hazarded an explanation partly inspired by E. H. Gombrich's work. With a few modifications, it continues to satisfy him. Danto pictures art undergoing two broad phases before the end. Art's first "task" was to make "progress . . . largely in terms of optical duplication"[36] of mere real things—or at least, of the way they look to us. Its first job was to "produce equivalences to perceptual experience."

About 1905 a rival, cinematography, takes over this first task from art. Danto chooses 1905 because by then "almost every cinematic strategy that ever would be developed had been developed."

And it was just about then painters and sculptors began asking, if only through their actions, the question of what could be left for them to do, now that the torch had, as it were, been taken up by other technologies. . . . About 1905 it appeared that painters and sculptors could only justify their activity by redefining art. . . .[37]

Aestheticians like Croce, to their "credit . . . responded" to the situation with theories which explained that painters "were not so much representing as expressing." This (for the moment) justified a new sort of painting and sculpture (like the Fauves') but soon set off a *second* progression toward an end. "As expression seemed more and more" to be what defined art, "objects became less and less recognizable and finally disappeared altogether in Abstract Expressionism."[38] At this point the possibilities of progress were once again exhausted, and art, though it would not and will not stop, "sunders into a sequence of individual acts. . . ." I have simplified Danto's argument but not falsified it. The 1986 version of "Art, Evolution and History" named names, cited the Impressionist "discoveries about the color of shadows," elaborated and buttressed the argument, as did the 1989 essay, "Narratives of the End of Art."[39]

Berel Lang solicited Danto's 1986 essay; then assembled eight responses from scholars in a broad variety of disciplines. Despite all their differences, Lang records, the scholars "move almost with a single voice" to protest the reasons Danto gives for art's "end."[40] Christopher Butler writes that the "optical illusion" which Danto sees as art's first goal had been "the last thing" artists wanted to do.[41] Butler and Norman Miller wonder why, according to Danto's logic, the flight from art's first purpose, the shift to expressive theory, didn't come about with "the advent of *still* photography" in the 1830s? Why say painting was mortally affected by cinematography other than to help the dates fit? How can Danto cite Hegel for support? Hegel said art was "*already* dead" decades before even the invention of photography, let alone cinematography.

Above all, though something has ended can it really be "art" itself?

Richard Kuhns, the author of *Psychoanalytic Theory of Art,* argued that humans need art as a kind of "spiritual metabolism" for experience, and we can no more give it up "than we can give up physical metabolism." (Danto agreed in 1989, that "there will always be art in the sense that there will always be metabolism. . . .") Though Richard Kuhns accepts Danto's contention that we are, in important ways, in a "post-historical" artworld, he points out that many world cultures feel no need for a historical, "developmental" kind of art; and yet art is still "centrally functional" in their lives. Our culture may now have joined those cultures.

Kuhns, to whom Danto dedicated *Transfiguration,* has in recent years created the strongest post-end-of-art, post-Danto defense of the art object. He and Danto have worked side by side at Columbia for almost forty years, and, though very different thinkers, inevitably their works have begun to conduct a dialog. In such books as *Psychoanalytic Theory* and *Tragedy: Contradiction and Repression* Kuhns salvages posthistorical art by regrounding art's worth on new clinical data about the ways humans use objects.

Clinicians now expand the concept of "transference" beyond Freud's sense, to describe the way people relate to certain objects which have been "of crucial importance to their psychological development." Kuhns describes the vital psychological worth to children of "transitional objects"—"toys, dolls, blankets, fetishistic-like things"—which they use in primitive play-acting vital to their maturation. He relates it to the way cultures make similarly vital use of art objects. Kuhns's main point, which even Danto now apparently accepts, is that humans use certain objects to "metabolize" experience—get hold of it, relive it, chew it over, digest it, take the value from it. "Art history," Kuhns warns, usually dwells on "the evolutionary trajectory of forms" and it has a tendency to "slight the object in its other relationships: to the artist and to the perceiver." Kuhns steers the debate away from the "historical" justifications of some particular object, forcing us to remember the object's "maturational" and "developmental" worth to us. Whether art "history" is over or not, we can no more give up art and its objects than we can give up physical metabolism.

Kuhns agrees with Danto that something has definitely ended. That something, however, cannot be "art" itself. Art must go on and well it should. Precisely what did end, Richard Kuhns doesn't venture to say.[42]

Emerson, Whitman, and Concept Art

This book will argue that both Danto and his critics are right. Something reached a climax—not an end—but it was not art and it was not in reaction to the advent of cinematography. I will be arguing that neither "art"

nor "modernity" ended. What completed itself had more to do with Western religion than with Western art.[43]

As we've now seen, the widespread abandoning of the art object at the end of the 1960s was taken as something radically, even frighteningly new, by critics and artists alike. My first point is a straightforward matter of literary and art history: attacks on the art object strikingly similar to those made at the so-called "end of art" can be found in the works of Wordsworth, Ruskin, Carlyle, Emerson, and Whitman. Many of these attacks are as scathing as any the sixties concept artists ever made. If they are unfamiliar to the modern reader, that is because they were indeed *so* scathing, that criticism has avoided them as anomalies. Until the late sixties, it was hard to believe artists, cultivated people, could seriously have meant such attacks on art. "Away with your nonsense of oil and easels," Emerson writes in "Art" (1841); "except to open your eyes to the masteries of eternal art"—the life around us—"they are hypocritical rubbish." Rather, such seemingly philistine positions seemed, as even a fine critic like Tony Tanner wrote of Emerson, "against his own intentions. . . ."[44] Barbara Novak, also a perceptive critic, in her deservedly praised *Nature and Culture,* first suggests Emerson "can now be seen as the unofficial spokesman for the American landscapists" then in a footnote admits sadly he "seems hardly to have been much interested" in them. On the contrary: he was interested enough to call paintings "hypocritical rubbish" (and much else) in an essay with a perfectly clear title: "Art." Novak, like Tanner, resists dealing with it.

Second, I hope to show that these attacks on the art object were not anomalies (and certainly not philistine or puritanical outbursts we must pass with averted eyes) but the necessary outcome of what M. H. Abrams cautiously termed "a new intellectual tendency" in Western culture around 1800, "Natural Supernaturalism."

It has long been a scholarly commonplace that after 1800 an "intellectual tendency" extolling the possibilities of this world emerged in all parts of Western culture, producing in the social sciences, for instance, such work as Comte's or Frederick Harrison's. One term now in use for this tendency when it surfaces in literature is Abrams's "Natural Supernaturalism" (adapted, of course, from Thomas Carlyle). Many similar terms are in use, none very satisfactory (we'll consider some in the section after next). Harold Bloom called many of the same artists the "visionary company." "Man," Wordsworth decreed, can and must learn to see "Paradise" in the "simple produce of a common day."[45]

That new attitude to mere real things necessarily meant a new attitude to what had been their presumed superior, the work of art. Therefore it is surprising that so little attention has been paid to what happened when Wordsworth, Emerson, et al. confronted the art object. Emerson

and Whitman shall be the first of many we'll discuss who were necessarily ill-at-ease with the idea of art objects as "elite objects" superior to the common things it was their mission to extol. I do not propose to study either Emerson or Whitman at length. Studies of Wordsworth, Carlyle, Ruskin, and John Cage will repay us more. For the moment I will also postpone addressing Harold Bloom's theories of the complex ways "influence" spreads ideas through a culture. Thomas Carlyle's influential work furnishes the best exhibits for that discussion. I will treat Carlyle in detail. But since Emerson writes expository prose, not poetry, and avoids Carlyle's and Ruskin's fanciful terminology, he makes a good place to enter this dark wood. Let us begin with some straightforward, overdue interdisciplinary history, reading Emerson on the art object, noticing similar passages in Whitman, and comparing what they say with what the supposedly novel 1960s concept artists said.

Emerson: "The Office of Art"

Emerson's philosophy, the progressive theologian Catherine Albanese recently summed up, suffers from an unresolved "confusion." On the one hand Emerson holds "a view of matter as 'really real,' the embodiment of spirit and the garment of God." On the other hand he holds a quite contrary, more platonic view of matter as "illusion and unreality, ultimately a trap from which one needed to escape." (She cites critics from James Elliot Cabot to Ralph L. Rusk in support.)[46] Both views turn up in Emerson's thoughts on the art object. That inconsistency may matter more to Cabot or Rusk or myself, however, than to the man who wrote in "Self Reliance," "A foolish consistency is the hobgoblin of little minds"—a remark to remember when beginning *any* discussion of Emerson.[47]

In his essay, "Circles," Emerson scorns objects as but thoughts's "inert effect," as for the concept artist Joseph Kosuth they would be but the "physical residue of the artist's activity." Emerson and Kosuth, opposite Shakespeare, do not applaud the art process as the giving to an airy nothing a local habitation and a name; rather they disdain the stuff as petrifactions, as dead mud footprints left by living thoughts that have raced away.[48] In "Circles," Emerson derides our admiration for an imposing building, directing us to admire instead the "little waving hand" that built it, for "that which builds is better than that which is built." By extending that logic, the "invisible thoughts" which truly wrought the object, were even better than the hand and "nimbler."[49]

When such passages are discussed at all, they are usually termed "Platonic." In his essay, "Art," however, Emerson envisions a use for art objects Plato would have blinked at. For the *time being*, art objects have a

particular "office" to fill. That office, Emerson was writing in 1841, was to "educate us to the perception of beauty."[50] Art is not an end, but an education. "What we have loved, others will love, and we will teach them how," Wordsworth—whom Emerson shares more with than with Plato—had concluded his life-work.[51]

Man, Emerson argues, is "immersed in beauty"[52] which he lacks the eyes to see. Habit, sheer familiarity has closed his eyes to the world's perfection; art exists to open them. If the stars only shone once in a thousand years, awe-struck man would "believe and adore," Emerson exclaims in "Nature," (using an image reminiscent of his friend, Thomas Carlyle). But since these "envoys of beauty"[53] bless us every night, we, illogically, take them as *less* of a miracle than if they were a once-a-millennium apocalypse. That too, we'll see at length later, had been Wordsworth's theme and Carlyle's. According to Emerson, art's "virtue" lies in its ability to cut loose and "sequester" one object from the embarrassment of riches with which the world bombards us. Even when Emerson praises the object, then, it seems a kind of pabulum: a small, easy thing to "assist and lead the dormant taste." Thus, protected by art from real life's numbing sensual overload, beginners contemplate certain "excellent" objects until they gain the strength to "learn at last the immensity of the world. . . ."[54]

Since art's office is to educate, it follows that this office is, for man, "merely an initial" step. Emerson writes scornfully that even "the best pictures can easily tell us their last secret." What could even the best be but "rude draughts" of a few of the "miraculous dots and lines and dyes which make up the ever-changing 'landscape with figures'" we live in. Painting, Emerson proposes, is "to the eye what dancing is to the limbs."[55] This is an enigmatic remark unless we know that in Emerson's aesthetics, even dancing exists only to educate the body to "self-possession, to nimbleness, to grace," and when dancing has done that, the "steps of the dancing master are better forgotten"! In a parallel way, Emerson continues, painting exists merely to teach us the "splendor of color and the expression of form."[56]

But once that lesson too has been learned?

Emerson: "Away with your nonsense . . ."

As soon as man's eye is "opened" by art to "the eternal picture which nature paints in the street, with moving men and children, beggars and fine ladies, draped in red and green and blue and gray," the painter is best forgotten with the dancing master, for if the artist "can draw everything, why draw anything?"

Painting only teaches us coloring; sculpture teaches us "the anatomy of form." Emerson will concede that after contemplating some noble statues, and passing to a place where people are assembled, the people look like "giants" to him. Lest that sound like praise of art, Emerson insists immediately that the experience only reinforces his conviction that painting and sculpture are but "gymnastics of the eye," for "there is no statue like this living man." Even the most ordinary man has the "infinite advantage over all ideal sculpture, of perpetual variety. What a gallery of art have I here!" Awakened, observant, Emerson in the midst of the gallery of life now triumphantly sweeps art away: "Away with your nonsense of oil and easels, of marble and chisels; except to open your eyes to the masteries of eternal art," except to open your eyes to life, "they are hypocritical rubbish."[57]

Once our eyes are open, away with art. Emerson is quite explicit. Hegel's thought prompted Emerson, and as Arthur Danto has observed, until the end of the 1960s, no one quite believed Hegel fully meant his end-of-art philosophy.[58] Hegel, in general, had argued that art, "considered in its highest vocation, is and remains for us a thing of the past."[59] Emerson always respected Plato, but Hegel is probably the stimulus for these particular ideas on art. "Thought and reflection have spread their wings above fine art," Hegel had proclaimed, and art objects have given way to "the philosophy of art."[60] Since "the Concept is the universal which maintains itself in its particularizations," art objects were but particulars being generated by a universal: thus even the work of art belongs to the humbler "sphere of conceptual thinking."[61]

Hegel is more complicated than this but Emerson took only what he needed. Hegel, for instance, pictures art's progress as an attempt to free itself from the object "until, finally, in poetry the external material is altogether degraded as worthless."[62] And Hegel had said—in passing—that no work of art can compete with a work of nature, and, if one foolishly tries, it will look like "a worm trying to crawl after an elephant."[63] But Emerson makes that more central to his contempt for the object than Hegel did. Just as Hegel could not be credited till recently, so it was hard to believe Emerson meant what he wrote: as anti-art object a philosophy as the 1960s would ever produce.[64]

Emerson, Whitman: "I cannot go back to toys"

Except to open your eyes to Life, then, the arts "are hypocritical rubbish." Once the eyes are opened, "Away with your nonsense of oil and easels, of marble and chisels. . . ."

In fact, one art has already, Emerson tells us joyfully, "perished." Mankind, Emerson informs us (reworking Hegel for his own ends) has outgrown the need for sculpture, "childish carving": "Already History is old enough to witness the old age and disappearance of particular arts. The art of sculpture is long ago perished to any real effect."[65] We didn't need that particular dancing-master anymore, so he's been dismissed. Much later, 1969, Joseph Kosuth would say the same when he explained why he had stopped making objects. He had observed that friends who had lived through the recent New York artworld with him now had such intense visual "experiences" of the ordinary world that "perhaps mankind was beginning to outgrow the need for art on that level."[66]

The supposedly radical artists like Kosuth who consequently abandoned the art object, never attacked it more violently than did Emerson, who could grant that though sculpture had once had its uses (as "a mode of writing, a savage's record of gratitude or devotion") mankind had now outgrown this primitive practice. In the 1840s no one, not even Emerson, could brush aside the prestige Greek sculpture had among his readers, but he gives it what must be the most grudging endorsement of the nineteenth century: "Among a people possessed of a wonderful perception of form," Emerson allows, "this childish carving was refined to the utmost splendor of effect."

Not that Emerson thinks Praxiteles was a child (though he well might); but all art is "childish" by nature since, once man's powers have grown to see form around him, he has no further need for sculpture. Sculpting stones is only a game played by a "rude and youthful people," not the "manly labor" of a "wise and spiritual nation," like the United States: we have the wisdom to know that the "real sculpture" is in the "assembly room," in the "street," even under the "oak-tree loaded with leaves and nuts." Emerson vents his disdain for the other stuff at length:

In the works of our plastic arts and especially of sculpture . . . I cannot hide from myself that there is a certain . . . paltriness, as of toys and the trumpery of a theatre. . . . I do not wonder that Newton, with an attention habitually engaged on the paths of planets and suns, should have wondered what the Earl of Pembroke found to admire in "stone dolls."[67]

Sculpture's only un-"hypocritical" use is to "teach us" to see the wonder in life's forms. Through sculpture, man, the "pupil," will learn the "secret of form," will learn (here the language becomes so Hegelian it's hard not to see Hegel as an inspiration) "how purely the spirit can translate its meanings" into the "eloquent dialect" of sculpture. Nonetheless, Emerson quickly admonishes us, "A great man is a new statue in every attitude and action."

The "sweetest music," Emerson proclaims, is not in "the oratorio," but in the ordinary human voice "when it speaks" in no gilded and perfected harmonies, but "from its life tones of tenderness, truth, or courage." The perfected sound has "lost its relation to the morning, to the sun, and earth," while the human voice is still "in tune" with them. In sum, life is the better art: "Life may be lyric or epic, as well as a poem or a romance."[68]

Emerson was always saying much the same—and saying it in his central works. Some years later in "Nature," (1844) he is still deriding art objects as "toys." During that great hymn to the natural world—"these sunset clouds, these delicately emerging stars"—he remembers "art," and says that this day in nature has left him "over-instructed" for any return to art. "Henceforth I shall be hard to please. I cannot go back to toys."[69]

"And the cow crunching with depress'd head surpasses any statue," is how, from the 1850s on, Whitman would phrase his agreement with Emerson's anti-art object aesthetic.[70] Whitman's mission, throughout *Leaves of Grass,* of which the poem later known as "Song of Myself" occupied more than half the first edition, was as radically anti-art as that of his then "Master," Emerson. To appreciate how radical, let us return for a moment to the 1960s.

The Art Object as Impediment to Vision: "You shall no longer take things at second or third hand . . ."

Having read Emerson, we too are perhaps overinstructed for our return. "Art today," Susan Sontag would announce in an essay representative of the New York artworld's thinking in that decade, is now nothing but a "new kind of instrument" for "modifying consciousness" and teaching us "new modes of sensibility." Once art has fulfilled its office to educate, once the steps of the dancing-master are learned, art becomes—Sontag quotes not Emerson, but a French surrealist—a "'stupidity.'"

For now, this "new" attitude (the "truly serious attitude") takes art only as a "'means'" to an end which, she tells us, might best be reached "only by abandoning art." She describes how these "new" artists working today have "unmasked" art as "gratuitous"; the "very concreteness of the artist's tools" they have now revealed to be "a trap."[71] A few years earlier she had styled this attitude the "New Sensibility." In a youthful essay titled "One Culture and the New Sensibility" she adduced, in a kind of honor roll, "the music of Milton Babbit and Morton Feldman, the painting of Mark Rothko and Frank Stella, the dance of Merce Cunningham. . . ."[72]

"I do not mind objects," Lawrence Weiner was telling Ursula Meyer about that time, "but I do not care to make them." The art object, Weiner explained, too easily becomes something that makes it "impossible for people to see the art for the forest."[73] Art objects, once elite, had become by logical steps a potentially dangerous "forest" distracting us from the real "art"—that is, from the world. "So art," Sontag was concluding, "must tend toward anti-art. . . ."[74]

Long before Sontag's "New Sensibility," Whitman and Emerson had followed their own logic through to this position. Whitman in particular realized the contradiction in praising cows over statues, praising real things over artworks—while simultaneously distracting mankind with a new artwork. Whitman spends his life refining *Leaves of Grass* partly because it is not only to be the greatest poem, but the *last* poem the reader ever needs to read.

Indeed, Whitman's poem fearlessly tells you that you no longer need Whitman and his poems. "Have you practis'd so long to learn to read?" Whitman taunts the reader. "Have you felt so proud to get at the meaning of poems?" Just "stop this day and night with me," Whitman chants, "and you shall possess the origin of all poems / You shall possess the good of the earth and sun. . . . You shall no longer take things at second or third hand," but possess them directly. Ruskin had recently defended the art object by saying it gave us a chance to see nature through Turner's eyes. Borrowing a dead artist's eyes, fitting them on like a pair of spectacles through which to see your living world struck Whitman as a ghoulish exercise. After *Leaves* you will no longer need to "look through the eyes of the dead, nor feed on the spectres in books, / You shall not look through my eyes either, nor take things from me."[75]

This passage, in what Tony Tanner called Whitman's "very first poem in that irresistibly familiar tone which was so new in American literature," would have made a much better epigraph for the 1960s American conceptual artists than the tags from Wittgenstein and Merleau-Ponty they used to cite. Their ideas had a long American pedigree.[76] Emerson, long before the concept artists, had, like Whitman, begun to consider the art object not only no longer a necessary training aid but now something negative, dangerous, seductive. The problem these days, Emerson argued, is that men still fail to recognize nature as "beautiful" and so run off "to make a statue which shall be. They abhor men as tasteless, dull, and inconvertible, and console themselves with color-bags and blocks of marble."[77] The whole business starts to seem corrupt, at best a confession of weakness.

In the 1840s Emerson already longs for the day when man can put all

this distracting stuff behind him—a day when everyone's eyes have finally "opened" to the "eternal picture which nature paints in the street."

The Argument of This Book

One of this book's central contentions will be that the turn against the art object we have just seen Emerson and Whitman make was inevitable, given their credo that paradise, perfection can be found in the "simple produce of the common day," the commonplace, the "eternal picture which nature paints in the street," in "mere real things." Does not the very existence of the separate term "art object" imply a class of things which aren't identical to mere real "objects"? Moreover—if they are not to be senseless duplications or inferior imitations—things which are at least slight improvements over simple "objects"?

Emerson, in "The Divinity School Address" (the "greatest document" of American religion, Harold Bloom calls it) wrote that "the word Miracle" as conceived by "Christian churches, gives a false impression; it is Monster." Their misuse of the concept for what is merely *unusual* distracts us from noticing that "man's life [is] a miracle, and all that man doth. . . ." Their kind of miracle is "not one with the blowing clover and the fallen rain." Emerson naturally had to fear something else as a Monster: the elite object encased in its little shrine for worship, distracting us from that miraculous clover it was Emerson's very mission to reveal.

Emerson (and those who share his values, I mean to suggest) must therefore at best tolerate art's objects—"hypocritical rubbish," "toys"—as temporary training aids, a child's "gymnastics of the eyes." Emerson quite logically yearns for the day when the arts can "die,"—when man, strengthened, matured, abandons "stone dolls" and other nonsense with relief. "Away with your nonsense of oil and easels!" Once mankind has awakened to the beauty of the entire world, once the artist can choose anything for a subject (Constable's humble *Water Meadows near Salisbury,* Marinetti's motorcar, a Warhol Brillo box, a Goings pickup truck) then Emerson, like the conceptual artists one hundred and twenty-five years later, next asks, "If he can draw everything, why draw anything?"[78]

How did people who mistrust, despise, even fear the art object come to be involved with the arts? Answering that will tell us something important about "natural supernaturalism."

Long before M. H. Abrams wrote *Natural Supernaturalism,* of course, the idea that a general religious crisis in the West had deeply affected what happened inside the nineteenth-century artworld was an estab-

lished, indeed, a time-honored observation.[79] I'll quote a little more fully than usual, in this next section, to bring out that point.

The crisis was well underway by 1760, when Rousseau, in the "Confession of a Savoyard Vicar" section of *Emile,* has the vicar beg the narrator to "shun" the new skeptical philosophers, who, "under the pretense of explaining nature," really, with their "far-reaching decisions," destroy faith.

"They overthrow, destroy, and trample underfoot all that men reverence; they rob the afflicted of their last consolation in their misery; they deprive the rich and powerful of the sole bridle of their passions; they tear from the very depths of man's heart all remorse for crime, and all hope of virtue. . . ."[80]

J. Hillis Miller makes a fine distinction between the "nihilism" which is "covert" in nineteenth-century literature and not "explicit"[81] until Nietzsche; others, like Abrams, Bloom, or Barzun, find nothing covert about Rousseau's statement that "a haughty philosophy leads to atheism"[82] or about Carlyle's Everlasting No. Barzun remarked that though

the "death of God" was not proclaimed until the mid-nineteenth century, it was implied, felt, and acted on fully a hundred years earlier, during the century of Reason, the Enlightenment. Its deism and atheism, its skepticism and materialism left many earnest souls seeking an outlet for piety, a surrogate for the *infâme* church that had been discredited.[83]

No-one has said this more plainly than Danto himself. "The nineteenth century, in its way," he wrote in *Nietzsche as Philosopher,*

was as much an age of faith as was the twelfth century. Almost any European thinker of this epoch appears to us today as a kind of visionary, committed to one or another program of salvation, and to one or another simple way of achieving it. It was as though the needs and hopes which had found satisfaction in religion still perdured in an era when religion itself no longer could be credited, and something else—science, education, revolution, evolution, socialism, business enterprise, or, latterly, sex—must be seized upon to fill the place left empty and to discharge the office vacated by religious beliefs which could not now sustain.[84]

Danto, surprisingly, does not put art in his list, but connections between thwarted religious feeling and post-1800 art have long been proposed. Art, as we know from reading Clive Bell (among many others) has usually been included as a new "channel" for minds that could no longer find "satisfaction in dogmatic religion."[85] As Bell wrote in 1912, when "spiritual ferment [that] used to express itself through the Christian Church" welled up during the nineteenth century, it found its old channel "silted up." Diverted, it found an outlet in a new place: art. "There is no more important point to be made about English Romantic

poetry than this one," Harold Bloom similarly contended in *The Vision-ary Company*. "Though it is a displaced Protestantism, or a Protestantism astonishingly transformed by different kinds of humanism or natural-ism, the poetry of the English Romantics is a kind of religious poetry, and the religion is in the Protestant line. . . ."[86]

Like Bloom, M. H. Abrams has chronicled, in the romantics and after, "the assimilation and reinterpretation of religious ideas, as constitutive elements in a world view founded on secular premises."[87] Barbara Novak has described the religious upheaval's effect (and *lack* of effect) on nine-teenth-century American painting;[88] and Tony Tanner, in *The Reign of Wonder*, its effect on American literature. "You don't believe in Heaven, so you begin to believe in a heaven on earth. In other words, you get romanticism," T. E. Hulme long ago sneered. "Romanticism then, and this is the best definition I can give of it, is spilt religion."[89]

Hulme's 1912 comment reminds us afresh how time-honored the ob-servation is. Hulme was, in fact, inverting a symbolist boast from twenty years before.

During the twentieth century, the term "romanticism," comprehend-ing both Wordsworth and Byron, both Constable and Delacroix, proved unworkable. Arthur O. Lovejoy, in his classic essay "On the Discrimina-tion of Romanticisms," notes that he writes near the centenary of the "twelve years of suffering" spent by M. M. Dupis and Cotonet in trying to discover, by collecting definitions, the essence of "Romanticism." All in vain. Lovejoy, writing after another century of attempts has swelled the pile, finds it traced, by Russell, to Rousseau, and by Santayana to Kant; to Fenelon and Guyon and Francis Bacon; to Joseph Warton, to the "Anglo-Norman Renaissance," and to Plato. The Romantic move-ment is claimed "to have begotten the French Revolution and the Ox-ford Movement; the Return to Rome and the Return to the State of Nature; the philosophy of Hegel, the philosophy of Schopenhauer, and the philosophy of Nietzsche—than which few other three philosophies more nearly exhaust the rich possibilities of philosophic disagreement."

Lovejoy decides first that the word is presently meaningless, that if we must use it we should use it in the plural, and say "romanticisms," not "romanticism,"[90] and that, pertinent to what we have been discussing, "any attempt at a *general* appraisal even of a single chronologically deter-minant 'Romanticism' as a whole—is a fatuity."[91]

Abrams avoids fatuity by avoiding certain Romantics, like Byron, and electing to write only of those he can group under the enormously broad outlines of "Natural Supernaturalism." Abrams put Wordsworth forward as Natural Supernaturalism's great English poet.

As has been so often discussed, Wordsworth's poems celebrate not

nature, so much as the everyday, the common: in the late 1790s, when Wordsworth and Coleridge were refining *Lyrical Ballads,* man's everyday *was* nature. "Mr. Wordsworth," Coleridge wrote of those poems, "was to propose to himself as his object, to give the charm of novelty to things of every day, and to excite a feeling analogous to the supernatural, by awakening the mind's attention from the lethargy of custom . . . the film of familiarity and selfish solicitude [whereby] we have eyes, yet see not, ears that hear not . . ."[92] Wordsworth had the gift, his friend said, of making "fresh" again things "which, for the common view, custom had bedimmed all the lustre."[93] "Paradise . . . " Wordsworth chants in the lines he always called the "key" to his works, "the discerning intellect of Man . . . shall find . . . a simple produce of the common day."[94]

"The vision of Wordsworth," Bloom wrote of that passage, "finds its highest honorific words in 'simple' and 'common,' and human felicity in the moving line, 'a simple produce of the common day,' in which we are told our lives are perpetually renewed by that ordinary process of hallowing the commonplace"—in Danto's vocabulary, transfiguring the commonplace—"that Wordsworth had first described in poetry."[95] Abrams writes of the same passage: "Here, in short, is Wordsworth's conception of his poetic role and his great design. . . . To create out of the world of all of us, in a quotidian and recurrent miracle, a new world which is the equivalent of paradise."[96] "Nor need the Christian Paradise be a paradise lost," Abrams paraphrases Wordsworth. "For such realms are available on this earth, to each of us, as an ordinary possibility of every day."[97] (It's extraordinary that Danto's "transfiguration of the commonplace" has never been discussed in this context.)

That, then, was the core of Abrams's "Natural Supernaturalism," which he called a "new intellectual tendency."

I hope to refine that definition, but notice, for now: Professor Abrams calls it an "intellectual tendency." Harold Bloom always put it more frankly. As far back as *The Visionary Company,* Bloom was arguing that it was a kind of *religion.* In 1982's *Agon* Bloom was calling a variant of it "the American religion" and he has persisted, summing up in 1991's *The American Religion.*

Natural Supernaturalism, then, is, for Abrams and Bloom, a kind of philosophy or religion—*not* some kind of art. Abrams and Bloom simply *assume* that because we first encountered variants of Natural Supernaturalism in the artworld it must have something intrinsically to do with the artworld. They even seem to assume it has some special fondness for the arts. They never become aware of these assumptions, which certainly don't follow from their premises. Nor are these small assumptions. Yet

it isn't hard to slip into them if your work doesn't customarily involve you with statements about the physical objects the visual arts create.

If, however, one does start investigating such statements, one runs into—as we just have, reading Emerson—such stunning hostility to the art object that one gradually becomes aware of Abrams's and Bloom's assumptions. Neither Abrams nor Bloom ever notice, or at least never try to deal with, frequent assertions, paralleling Emerson's, that the arts are merely to be tolerated as a kind of childish gymnastics. Not a few figures long openly, like Emerson, for the day when mankind can leave the arts forever; and they do so in central documents, like Wordsworth's "Prospectus." Connect such statements with the "end of art" in the sixties, and there comes a disorienting "Ah-ha!" experience, like those pictures psychologists use in which everything reverses: the crone becomes the lady in the feathered boa, the silhouette of the goblet becomes the lovers' kiss.

Let's go back to the premises, and remember that Natural Supernaturalism was never claimed to be a kind of art, but a kind of intellectual or religious phenomenon. True, we find it in the arts. But, if you'll forgive a personification, what if it *never liked being there?* After all, the argument usually went that the artworld only had attracted people of this orientation because their natural home, the religious institutions, were in the grip of anthropomorphic religion. What if people of this orientation were trying to get out of this foster home from the first, and finally succeeded, and *that* was what Danto and Sandler and Krieger saw in the 1960s? Not the "end of art," but the end of dependence on the arts, the day the dancing master could be dismissed because his lessons had at last been learned? So many have explained that it was "displaced" into the arts (Bloom), that it surged up through the artworld, like magma from below, looking for a "channel" (Bell) through which to vent itself— since, in the West, its natural outlet was dammed. The Western churches were still committed to a supernatural monotheism which often literally demonized this world. Marjorie Hope Nicholson, in her great *Mountain Gloom and Mountain Glory,* long ago showed us Wordsworth and Coleridge copying out passages of Thomas Burnet's still-popular *Sacred Theory of the Earth,* which looked at the mountains ("great Heaps of Earth") and rivers ("without any Order") and saw only "a World lying in its Rubbish," storm-blasted by sin.

With that image in mind let us sharpen, cautiously, M. H. Abrams's definition of "Natural Supernaturalism" into something more faithful to his source, Carlyle. Abrams wisely defined the term broadly and used it infrequently. One fears making up reductionist new -isms to enroll -ists

into. (In a wonderful New Yorker cartoon, "Morning at the Hudson River School," Thomas Cole calls the roll while the artists, painting shoulder to shoulder, sing out "Here!" "Present!" "Yo!") I think, however, that although we may agree with Lao Tsu that the "tao that can be named is not the eternal tao," nonetheless, as T. S. Eliot retorted, "I've gotta use words when I talk to you." Abrams's definition, "recurrent intellectual tendency," is so prudently chosen as to be uncommunicative. What *kind* of intellectual tendency? I will use "Natural Supernaturalism" to describe a *religious orientation.* "Orientation" suggests getting one's bearings, re-directing oneself, suggests a change in where one looks for something. Wordsworth and Emerson would re-orient humanity's devotion from the next world to this one. As Coleridge said, they find an experience "analogous to the supernatural" through the contemplation of this world here. People who do not share a religion may share this *orientation.* The unbe-lieving Carlyle and the Christian Ruskin both look to the natural world for their spiritual experience, while Joshua Reynolds—otherwise as Christian as Ruskin—sees nothing there not flawed by sin. I say "spiritual experience," not "spiritual evidence," to distinguish "natural supernatu-ralism" from eighteenth-century "natural theology." Though certainly a precursor, though certainly a break from Augustinian *contemptus mundi,* natural theology (Leslie Stephen and Basil Willey long ago explained) used this world as evidence of a spiritual experience to come in the next. Wordsworth and Emerson sought their spiritual experience here, in the blowing clover and the fallen rain.[98]

Many have explained that the people of this religious orientation wound up in the Western artworld through historical accident. We have too easily assumed it was a *happy* accident. When we reflect on what these people believe, we doubt that. When we think of the joy with which they finally abandoned art objects, we realize having this religious orientation actually made people necessarily anti-art, or at least anti-art *object.* Those who would teach people to find paradise in the "simple produce of the common day" had to have been necessarily ill at ease with the very con-cept of an art object, of an elite object superior to the commonplace whose exaltation was their very goal. Like Emerson, they tolerated art's objects as unavoidable, but temporary, training aids, "a child's gymnas-tics of the eyes," while yearning for the hour when the arts could "die"— Emerson's word. Once these people were able to teach their lessons without art's dangerous, competing objects, they did so, with loud self-congratulation. That, at least, will be our High Argument, which it will take the rest of this book to support.

Thomas S. Kuhn, in *The Structure of Scientific Revolutions,* described the way such a "paradigm" shift has happened in the individual sciences

through attention to what he calls "anomalous" phenomena. The early researchers into electricity, for instance, all must have noticed that "chaff, attracted to a rubbed glass rod, bounces off again," but few bothered to record it. What they were looking at was the "mutual repulsion of two negatively charged bodies" but their paradigms of what electricity was (a new kind of fluid, for instance, that ran through certain substances but not others) had no place for the observation. It was an anomaly. So the repulsive chaff was ignored or written off as a mere mechanical effect. Paying attention to that anomalous chaff, however, eventually created the new paradigm.[99]

By the same token, Thomas Carlyle is that central nineteenth-century figure from whom M. H. Abrams rightly took his term for the entire Natural Supernatural "intellectual tendency." Yet Carlyle denounced all art objects except portraits of national heroes as "chaff" that "ought to be severely purged away." "May the Devil fly away with the Fine Arts!" Contemporary critical theorists ignore Carlyle's repulsive word "chaff" as successfully as electrical theorists ignored the repulsive chaff which didn't fit their paradigm. What makes both pieces of chaff minor is simply that they don't fit the paradigm. Whatever doesn't fit a paradigm is minor; until, by studying precisely what doesn't fit, we create a new paradigm.

This book reframes the discourse of conceptual art against passages, principally in Wordsworth, Carlyle, and Ruskin, heretofore considered anomalous. We will try taking seriously the disturbing passages criticism now refuses to deal with: Emerson's "hypocritical rubbish," Carlyle's calling for the Devil to "fly away" with art, Ruskin's repeated insistence that "any sensible person would change his pictures, however good, for windows," Wordsworth's opening poems in *Lyrical Ballads* telling us, close your books, enough of art.

The art Natural Supernatural beliefs produced was—much more than is now realized—from the first an anxious, self-contradictory kind of art, divided about its right to exist at all. We will discover Wordsworth and Ruskin to have been, from the start, painfully aware of the self-contradiction involved in directing men and women to the admiration of mere real things by putting forward yet another distracting special object. As Fernand Leger later complained, the very notion of the special object, "objet d'art," was "a blindfold" preventing people from seeing that "the Beautiful is everywhere; perhaps more in the arrangement of your saucepans on the white walls of your kitchen than . . . in the official museums."[100] When Wordsworth declared art to be "but a handmaid," he already had in mind what he called "the blissful hour"[101] when the handmaid's work would be done, all commonplace life trans-

figured, and the audience lifted to a plane from which it could see all mere real things as miracles.

In that hour, the handmaid would be dismissed. From the start of the nineteenth century, the new orientation involved the novel idea that "art"—or at least the art object—was something which the awakened human mind would eventually dispense with. John Cage's famous "silent piece," 4'33", signaled the "blissful hour's" arrival. This new paradigm, Natural Supernaturalism as anti-art, is the only one that prepares us for the years in which those who shared this orientation at last joyfully overcame their dependence on the art object—the glorious climax we experienced, but misunderstood. John Cage emerges as the great fulfiller of aims 170 years old. Studying Cage's journey out of the arts into ecology will illustrate for us that Earth Day starts with Wordsworth.

New aims required new tactics. My last point will be that some not only longed for the blissful hour, but developed unusual strategies to hasten its coming. In particular, this book will notice a systematic expansion of terms like "artwork," "painting," "sculpture," until the words included all mere real things. Wordsworth and others like him were forced to such radical techniques, for the timing of their entry into the artworld could not have been worse. Entering Sir Joshua Reynolds's artworld they encountered a ruling aesthetic they considered sheer blasphemy, funded by powerful government institutions to brainwash, in organized schools, the most sensitive spirits in each country—spirits who might otherwise have been those most easily recruited to the new cause. This blasphemous philosophy still held sway when Emerson, in 1841, issued those denunciations of the object we have been reading, and its continuing reign fuels his indignation.

The aesthetic theories of the artworld in which Wordsworth and Constable grew to maturity did not merely *imply* the inferiority of mere real things. Since Plato's time, the point of making art objects—those shadows of shadows—had continually been challenged. Art's supporters had long defended the art object's right to exist by taking the offensive; they derogated the mere real things that this world, without trained artistic assistance, could supply. "Upon the whole . . . the object and the intention of all the Arts is to supply the natural imperfections of things," Reynolds had decreed in his *Discourses* during Wordsworth's school days. "The most beautiful forms have something about them like weakness, minuteness, or imperfection. But it is not every eye that perceives these blemishes . . ."[102] With his help, every eye would: the whole force of Reynolds's *Discourses*, and his new Academy, was to educate England's eye to appreciate ideal artworks by becoming aware of the blemishes in even the "most beautiful" real things. As for the sort of everyday scenes Words-

worth and Constable would set themselves to transfigure, this, specifically, was Reynolds's opinion: "Whatever is familiar, or in any way reminds us of what we see and hear every day, perhaps does not belong to the higher provinces of art, either in poetry or painting."[103]

The next section examines how great an improvement over mere real things art objects had long been claimed to be; and how Wordsworth, Ruskin, and others could not ignore the older aesthetic's systematized (in England, newly institutionalized) contempt for the commonplace. Ruskin saw the best minds of his generation being twisted in the Academic schools. He sat down to write thirty-plus volumes of countertraining, teaching England to find the beauty in each leaf, each branch, each stone.

We shall also become aware of the older aesthetic as a network of *defenses*—defenses of the art object's very right to exist. When the younger artists attacked that aesthetic for their largely theological reasons, they were stripping the art object of some of its historic defenses—defenses perhaps necessary for the separate class "art object" to exist at all.

The Status of the Art Object Relative to Mere Real Things Before 1800

All the objects which are exhibited to our view by nature, upon close examination will be found to have their blemishes and defects. The most beautiful forms have something about them like weakness, minuteness, or imperfection. . . . The Moderns are not less convinced than the Ancients . . . that all the arts receive their perfection from an ideal beauty, superior to what is to be found in individual nature. . . .—Sir Joshua Reynolds

Zeuxis . . . from the choice he made of five virgins drew that wonderful picture of Helena, which Cicero, in his Orator . . . sets before us. . . . [Zeuxis] thought it impossible to find in any one body all those perfections . . . because nature . . . makes nothing that is perfect in all its parts.—John Dryden's translation of Bellori's "The Idea of the Painter, Sculptor, and Architect, Superior to Nature by Selection from Natural Beauties"

Some Recurring Defenses

The Natural Supernaturalists were not the first to feel distaste for that strange cultural product, the art object. At the beginning of the West's long aesthetic argument, Plato and his followers had asked: If the art object is at best "an exact imitation" *[mimesis eikastike]* of "such forms" as nature already provides—what is, after all, the point of it? By nature the object had to be a flawed imitation, a shadow of a shadow, a *triton ti apo tes aletheias* (third remove from the truth)."[1] At best it would be a senseless duplication.

Art and its objects have constantly needed defense—and not only from Platonists. Every political or religious upheaval soon calls art before the bar and asks what it's still good for, other than propaganda, and whether it distracts people from living correct lives.

Examining the myriad defenses of Western art prior to Wordsworth's time, I will cautiously distinguish two recurring arguments, two broad "families" as it were, of defenses.

But first we should notice a popular, less philosophically sophisticated tradition: epigrams and anecdotes praising various artists who have succeeded in imitating nature "to the point of deception"—all those birds pecking at painted fruit. "Like Homer," Jean Hagstrum writes, this tradition (which lasts even to our day) "celebrates the artist, who, in the contest with Nature has outwitted and shamed her."[2] The speaker admires the *"difficulté vaincue,"* and enjoys the feeling of *"multum in parvo"*—Hephaestus capturing all of life on Achilles' shield, creating fields that really "looked like earth that had been ploughed though it was gold." "Such was the wonder of the shield's forging."[3]

Hephaestus' shield is a far cry from J's bed. The objects this old defense praises are neither commonplace nor celebrations of the commonplace, but triumphs over it. Like the gold worked so cleverly it seems ploughed earth, they're miracles of skill; of *human* skill. When Myron makes a bronze cow so lifelike that calves die vainly sucking its udder we are meant to see man not only equaling nature but putting one over on her. An epigram in the tenth century *Greek Anthology*[4] gloats over a similar statue, "It's a sure thing that in time men will end up by making stone itself live,"[5] and we realize this simple-seeming tradition is, underneath,

part of the Promethean spirit: A mortal has equaled the gods. That's why it's so peculiarly exciting that the crows come down to peck at the grapes Zeuxis created—nature itself (the crows) can no longer tell man's grapes from the gods'.

Such Promethean glorying in man's technological skill, much in the same spirit that we relish live television pictures from outer space, produced objects still susceptible to challenges (like those of the Christian era's Isadore of Seville's) that they were inferior to the nature they merely "counterfeited." As a result, where this tradition moves beyond simple expressions of awe at human *techne,* as it does in Philostratus, we find it associated with what I'll call an *istoria* defense, a contention that "poets and painters make equal contribution to our knowledge."[6]

The *istoria:* Alberti

The large family of defenses I'm grouping as the "*istoria* defense" praises art objects as superior to mere real things because, like the theater, they can embody a humanistic content.

Not only (it is argued) are art objects showpieces of human prowess, but the artist, like the poet, presents for our contemplation the actions of the gods and heroes. The objects are, like Hephaestus' shield, enactments (to borrow a word from Kuhns) made eternal and therefore superior to unedifying, transitory mere real things.

I take the term *"istoria"* from Leon Battista Alberti: his *Della Pittura* (1435) was, in modern times, the seminal version of this defense, cited and imitated for 350 years. Arthur Danto, you will remember, incurred critical wrath by suggesting "technological progress" in illusionism as the reason art had ended. The *istoria* art defenders certainly had no interest in such "progress." They warned, like Reynolds, "it is not the eye, it is the mind, which the painter of genius desires to address."[7]

Della pittura was, as Alberti claims, the first treatise of its kind on painting since the ancients.[8] "We are . . . building anew an art of painting about which nothing, as I see it, has been written in this age."[9] Alberti's moderate approach to the *istoria* (and to idealism, which we shall discuss next) conditioned by his familiarity with the problems of working artists, was codified, then ossified by the scholar-writers who came after him.[10] Alberti, with an artist's pride, had insisted his words "be interpreted solely as those of a painter."[11] The Reynolds *Discourses* Wordsworth and Constable read as students are closer to Alberti, often, than to any of the treatises in between, for Reynolds shares both Alberti's practical concerns and consequent theoretic moderation as well as Alberti's interest in the raw material Nature affords.

Writing contemporaneously with the Florentine Academy (whose scholars tried to see their ideas in his popular book),[12] Alberti shares their new fervor for antiquity but none of the Academic fascination with system. Artists, not philosophers, excite Alberti. Son of an exiled Florentine family, he had been allowed into Florence on a papal commission in 1434 in the revolutionary days of Ghiberti's Baptistry doors, Donatello's sculpture, Masaccio's and Masolino's new art.

Alberti systematically elevates the object's dramatic interest above its visual interest, claiming that a painter's "greatest" work was "not a colossus, but an *istoria. Istoria* gives greater renown to the intellect than any colossus."[13] The visual is the merest come-on for the dramatic, like an eye-catching robe on King Lear. The painting should be "pleasantly attractive," but only enough to "capture the eye" of anyone looking at it, "learned or unlearned"; the goal, however, is to "move his soul."

Alberti so deeply regards painting as mute theater that he scarcely separates painted from acted *istorie:* "I strongly approve in an *istoria* that which I see observed by tragic and comic poets. They tell a story with as few characters as possible."[14] The painted figures are thought of as actors: "No picture will be filled with so great a variety of things that nine or ten men are not able to act with dignity."[15] Nine or ten "men"? Notice how "landscape," which will be Natural Supernaturalism's preoccupation, is for Alberti but part of the "copious" background for the drama, in which "are mixed old, young, maidens, women, youths, young boys, fowls, small dogs, birds, horses, sheep, buildings, landscapes and all similar things."

Alberti borrows dramatic laws from the classical critics and recasts them as pictorial laws; a version of *"si vis me flaere,"* for instance:

The *istoria* will move the soul of the beholder when each man painted there clearly shows the movement of his own soul. . . . we weep with the weeping, laugh with the laughing, and grieve with the grieving.[16]

Alberti, consequently, even addresses himself to the method of acting in this silent, permanent theater, to the way a static art may achieve the effect of live drama. Since "the movements of the soul are made known by movements of the body," he teaches would-be painter/dramatists that "a sad person stands with his forces and feelings as if dulled, holding himself feebly and tiredly"—and if one of your painted actors should be not only sad but "melancholy," remember that his forehead is to be "wrinkled," his head "drooping," and all his "members" should "fall as if tired and neglected."[17]

Later aestheticians who defended the art object's merit as drama, tended, like Alberti, to praise pictures in so far as they triumph over the

dramatic limitations of the medium. Alberti singles out a painter named "Demon" for praise since the "ancients" report he had accomplished the feat of creating a Paris whom "you would easily see to be angry, unjust, inconstant, and at the same time placable, given to clemency and mercy, proud, humble and ferocious. . . ."[18] This is to be a great director indeed! French academicians would later advise painters to get directorial ideas from studying the ingenious gestures of mutes[19] and Reynolds, elaborating on this, disposes of most of the surface of the painting—everything Monet would go to it to admire—as "subordinate parts," stage props. "Figures"—Reynolds too talks of them as if they were actors in a play he is directing—"must have a ground whereon to stand; they must be cloathed; there must be a back-ground; there must be light and shadow: but none of these ought to appear to have taken up any part of the artist's attention. They should be so managed as not even to catch that of the spectator."[20]

Contrary to Danto, for these artists and critics, "great" painting was emphatically not a drive toward illusionism. Great painting was not even a question of creating visual beauty. The "genius" will not "waste a moment," Reynolds contends, on the "smaller objects" which merely appeal to the senses, "divide" the audience's "attention" and "counteract" the genius's "great design" of speaking not to the eye but "to the heart."

That "great design"—dramatizing an *istoria*—is what, Reynolds contends, raises great art above a "mechanic" trade, like *chinoiserie* furniture painting. Speaking to the heart, not the eye, is what gives painting its "true dignity," is what "entitles it to the name of a Liberal Art," not a mere craft, is what "ranks it as a sister of poetry."[21]

Both the *istoria* and idealist theorists occasionally defend art as a mirror, but in this context you can see they mean a mirror of man's *acts*, or of man's life or of his morals; not of his retinal appearance. Certainly not the retinal appearance of mere real things, which are only the humble stage against which the all-important human drama is played. "Painting," Reynolds warns sternly, "ought to be . . . strictly speaking, no imitation at all of external nature."[22] "The majority of mankind" know so little about "the arts" they may be said to be in "a state of nature." The "Painter" is to no more look to them as guides on art than he would look, as guides on "morals and manner . . . to the opinions of people taken from . . . New Holland"—that is, from New York.[23]

After almost two centuries of Natural Supernaturalism, even distinguished critics have trouble accepting that many in the pre-1800 artworld in no way regarded "great" art as whichever painting was most beautiful. (Ruskin started a critical tradition which still pointedly ad-

mires Reynolds's paintings for everything Reynolds valued least.) "Paint-ing, [Reynolds] believed, is never merely an art of the eye," Rensselaer Lee reminds us, "but it is the mind, whose servant the eye is, that the painter of genius, like the poet, chiefly desires to address."[24] Great art affected the mind, *through* the eye: ideal drama made eternal. Though Reynolds grudgingly "allowed" that color "harmony" might play the same role, for the eye, that "an harmonious concert of musick does to the ear, it must be remembered, that painting is not merely a gratifica-tion of the sight."[25] Writers like Reynolds and Bellori scorned those paintings (principally by Venetians) in which the visuals had gotten out of hand, as the work of facile technicians, anti-intellectuals—mere Tech-nicolor productions, in effect.

Art objects, then, were defensible as mute theater—and, thereby at least theater's equal. Such theater, after all, is not only permanent, it transcends language barriers. For these thinkers, optical values, positive or neutral in theory, in practice become dangerous, since they compete for attention with the *istoria* and its moral. Hence Reynolds' practical advice on how to keep a painting's action "unembarrassed with whatever may any way serve to divide the attention of the spectator." Like theater, art objects can lead men to "Virtue." They start by "disentangling the mind from appetite," much as Hegel later claimed they did. Forced by them to "contemplation," our thoughts are conducted upward through "successive stages of excellence" till the journey that "began by Taste" for mere visual pleasures "may, as it is exalted and refined, conclude in Virtue."[26] Great art objects are no more an affair of "mere" optical val-ues—of mere beauty—than great theater is an exhibition of pretty cos-tumes and backdrops. Any theater which forgets that, declines. Any painting which forgets that, declines.

The Ideal

"The Works of Nature Are Full of Disproportion"

A second large family of sophisticated defenses may be grouped as "The Ideal." The Ancients were "not less convinced" than the Moderns, Reyn-olds justly says, "that all the arts receive their perfection from an ideal beauty, superior to what is to be found in individual nature."[27] In sup-port, Reynolds then quotes Plato's Proclus,[28] an "Ancient":

"He who takes for his model such forms as nature produces, and confines him-self to an exact imitation of them, will never attain to what is perfectly beautiful. For the works of nature are full of disproportion, and fall very short of the true standard of beauty."[29]

Even Plato showed some respect for this second antique defense of art. That the artist furnished men with objects that were in some way improvements over mere real things seems to have been a common assumption long before it was a self-conscious aesthetic. Here, obviously, the Natural Supernaturalists found a cultural assumption they could not let stand unchallenged.

In Book 6 of the *Republic* Plato alludes to it for his own purposes. To describe the way his philosopher-king will create a new state, Plato makes an extended simile with the methods of an idealist painter. "How will this artist [the philosopher-king] set to work?" Adeimantus asks, and Socrates, picking up the metaphor, responds that the king, "will take society and human character as his canvas, and begin by scraping it clean"—in context, a purge—"until he is given a clean surface to work on. . . ." The king will then "sketch in the outline of the constitution."

Then—this is no mere copyist—the king, "guided" as Homer was by what of the "godlike" he found among men, "will rub out and paint in again this or that feature" until he has created an ideal "type" of "human character. . . ."

Plato's reason for selecting this metaphor becomes clear when Adeimantus conveniently exclaims, "No picture could be more beautiful than that." The philosopher-king is the better artist. Plato's point-by-point comparison of philosopher-king and painter ultimately conveys his disdain even for the idealist painter. The painter makes two-dimensional men on canvas out of colored earth. The better artist, the philosopher-king, shapes living men in the real world, working "to mould other characters besides his own . . . into conformity with his vision of the ideal. . . ."[30]

When Aristotle too speaks of great men, he uses an image which assures us that the theory of the ideal art object has become so familiar, he's certain his listeners will immediately get his point. "Great men," he explains, are distinguished from the ordinary, "in the same way as beautiful people from plain ones, or as an artfully painted object from a real one, namely in that that which is dispersed,"—the world's scattered excellences, in later terminology—"has been gathered into one."[31]

Succeeding ages were no less familiar with the argument that the artist's special things were improvements over mere real things. Each philosophy colored its own version of the ideal. Plotinus decides real beauty is found not here but in the absolute, and that the artist at best transfers his inner vision of perfect beauty (which is also a vision of perfect goodness) from his mind to the resisting "block of stone."[32] Later, the Christian philosophers found Plotinus' idea of art so easy to Christianize they

took it over, Panofsky tells us, "almost without alteration." St. Augustine had only "to replace the impersonal world soul of Neoplatonism with the personal God of Christianity" to yield an aesthetic "acceptable to a Christian" which became "in fact authoritative for the entire Middle Ages."[33]

Only in the early Renaissance do we find the "extraordinarily new" idea that the work of art should be in some way "a faithful reproduction of reality." Faithful—*not* slavish. Though Leonardo says, "that painting is most praiseworthy that has the most similarity to the thing reproduced," he indeed means "similarity," not identity.[34] The memory of any of his paintings will assure us he has not set up commonplace things as the standard by which to judge artworks. Panofsky points out that the era's art writings urge artists to be "faithful to nature" but also to "choose the most beautiful" objects from nature, for "by selecting and . . . improving," the painter "can, and accordingly should, make visible a beauty" which earth never completely provides.[35] For this reason, Alberti, like many before and after him, lambasts the poor painter Demetrius (as if anyone had seen his work for better than a thousand years) who "failed to gain the highest praise because he strove to make things similar to nature rather than lovely."[36]

Zeuxis and Phidias: Idealism's Two Principal Parables about Art Objects

The Zeuxis Parable

At this point, let us risk one generalization about the Western artworld before people like Wordsworth entered it. Art's defenders assumed there was a class of things different from mere real things and in some way an improvement on them. That isn't much to ask the reader to accept, but it is the only generalization we need entertain to realize how novel, even antithetic, the coming attack on the art object would be.

Further consider just *how* great an improvement over mere real things Wordsworth and Constable were taught art objects were. (Indeed, even the Impressionists were largely raised in this artworld.) The last section surveyed some of the most important representations of the countless varieties of the idealist defense the Western world produced. All the defenses were, in part, excuses for the existence of the separate class "art object"; they were more than that but they were also that.

This section examines two principal ideal defenses, of those many previously touched upon. Before 1800 a great number of artists and theorists tended to cite either the Zeuxis or the Phidias parable (so I'll call them) to explain why art objects were superior to mere real things. The

parables reflected two schools of thought within idealism, which had divided over whether mere real things were worth examining at all, in the course of creating something superior, the art object.

Aestheticians know that we can now no longer avoid a story repeated, M. H. Abrams complains, "with a unanimity which makes indifference to boredom the *sine qua non* of research . . . the old story of the painter Zeuxis. . . ."

Zeuxis reappeared in the Renaissance in Alberti's succinct work, and there again we shall start. This fallen Earth cannot offer perfect beauty. Complete human beauty is not found in any one body, Alberti warns, "but *disperse e rare in piu corpe.*"[37] By what method, then, shall the artist construct his more perfect objects? How to paint what no one has ever seen?

Alberti argues for the method of Zeuxis, "the most excellent and skilled painter of all [*prestantissimo*]. . . ." Unlike those students who ignore real life (and try to sketch personal fantasies) Zeuxis "did not rely rashly on [*suo ingenio*] as every painter does today." Zeuxis, knowing beauty to be *disperse e rare,* "chose, therefore, the five most beautiful young girls from the youth of that land in order to draw from them whatever beauty is praised in a woman. He was a wise painter." To create his ideal object Zeuxis selected the best feature from each mere real woman, so to speak. "Always take from nature that which you wish to paint, and always choose the most beautiful."[38] Ideal beauty is, for this idealist school of thought, something not to be imagined but "discovered" and "learned" by comparing flawed natural examples.

In another treatise, *De Statua,* Alberti claims he actually used Zeuxis' method when he himself created a statue: "I too chose a number of bodies considered very beautiful by knowledgeable judges. . . . I then compared these with each other . . . imitating in this the painter who, when he was to make an image of a goddess at Croton, [etc.]"[39]

The version of the Zeuxis parable Sir Joshua Reynolds favored—and which Wordsworth and his generation studied in Reynolds's collected *Works*—appeared in Dryden's "Preface" to the translation (by William Mason) of Du Fresnoy's *De Arte Graphica,* a Latin poem composed in Rome in 1637. Rensselaer Lee calls that poem, "the best single text for the entire doctrine based on *ut pictura poesis.* . . ."[40] *De Arte Graphica* was so popular, after its Paris appearance in 1667, that it was regularly translated into English: by Dryden (1695), Defoe (1720), Wright (1728), Wells (1765), William Mason (1783); Mason's translation appeared, together with some fifty pages of notes on it by Reynolds, in Reynolds own *Works.* Malone, the editor, also saw fit to include Dryden's long preface, the "Parallel of Poetry and Painting."[41]

This last will reward our examination, for it contains a long translation from Bellori which includes both the Zeuxis and Phidias parables. Reading Dryden's text we read the version Reynolds approved, and Wordsworth and Constable studied in their youth. (Both often quote Reynolds.) Finally, the text itself is a symbol of the artworld's long consensus about the art object's status: one author cited inside another like a nest of Russian dolls.[42] Reynolds reprints Dryden quoting Bellori quoting Cicero quoting Plato quoting Proclus; the quotations stretching back through time, until all sing the object's superiority to real things in one agreeing chorus. Dryden even translates[43] the title of this section of Bellori's essay, "The Idea of the Painter, Sculptor, and Architect, Superior to Nature by Selection from Natural Beauties."[44]

We may, then, legitimately consider the agreement on this single point (that the art object was an improvement on mere real things) without being thought to collapse an entire epoch into a single statement. I quote at length from what Hagstrum calls "Dryden's excessively free translation,"[45] (so we can read exactly what Reynolds, Wordsworth and Constable read) correcting it in brackets where necessary from Bellori's original Italian:

If, says he [Proclus, in Plato's "Timaeus"] you take a man as he is made by Art [sculptural art], the work of Nature will always appear the less beautiful because Art is more accurate than "Nature." . . . Zeuxis . . . from the choice he made of five virgins drew that wonderful picture of Helena, which Cicero, in his Orator before mentioned, sets before us . . . [Cicero] admonishes a Painter [and sculptor] to contemplate the ideas of the [best] natural forms; and to make a judicious choice of several bodies, all of them the most elegant which we can find: by which we may plainly understand, that he thought it impossible to find in any one body all those perfections which he sought for the accomplishment of a Helena, because nature . . . makes nothing that is perfect in all its parts.

Here Bellori again quoted Cicero to that effect. Dryden continues:

For this reason Maximus Tyrius also says, that the image which is taken by a Painter from several bodies produces a beauty, which it is impossible to find in any single natural body, approaching to the perfection of the fairest statues.

Dryden omits a similar quotation from Socrates.

Thus Nature, on this account, is so much inferior to Art, [*tanto inferiore all' arte*] that those Artists who propose to themselves only the imitation or likeness of such or such a particular person without election of those ideas before mentioned, have often been reproached for that omission. Demetrius was taxed for being too natural; Dionysius was also blamed for drawing men like us, and was commonly called, Anthropografos, [by Pliny] that is, a Painter of Men. . . .

Notice how the Dutch school (then generally considered the lowest) paints the closest likeness to ordinary objects, therefore the "worst":

In our times, Michel Angelo da Caravaggio was esteemed too natural: he drew persons as they were and Bamboccio, and most of the Dutch Painters, have drawn the worst likeness. Lysippus, of old, upbraided the common sort of Sculptors for making men such as they were found in Nature, and boasted of himself, that he made them as they ought to be; [Panofsky: Bellori exaggerated about Lysippus.] which is a precept of Aristotle, given as well to Poets as to Painters.

The Phidias Parable

Alberti, you will remember, praised Zeuxis for selecting and composing his object's higher beauty from nature's flawed excellences instead of relying entirely on some image created in his imagination. There Alberti was attacking a harder line idealism which allowed mere real things no excellences at all. This competing position advanced the painter Phidias above Zeuxis. Phidias, in another parable, had disdained completely to look at everyday objects (about this the authors are adamant) even to select beauties from them. Phidias worked entirely from an interior image. Continuing from the Dryden text which Reynolds, Wordsworth, and Constable knew: Cicero claimed

Phidias . . . when he produced his Zeus or his Athena, [*Jovis formam aut Minervae*] did not look at a [*scil.* real] human being whom he could imitate, but in his own mind there lived a sublime notion of beauty; this he beheld, on this he fixed his attention, and according to its likeness he directed his art and hand.[46]

Plotinus:

Artists do not simply reproduce the visible, but they go back to principles [*logoi*] in which nature itself had found its origin. . . . for they are in possession of beauty. Phidias produced his Zeus according to nothing visible. . . .[47]

Bellori, in a similar vein, praises Raphael, who, in the famous answer to Castiglione, wrote cautiously that he wasn't sure where his idea of beauty came from. "In order to paint a beautiful woman I should have to see many beautiful women," Raphael allowed. In the end, however, "I make use of a certain idea that comes into my head."[48]

As we are seeing, during most of Western history aestheticians had defended art objects by derogating mere real things. Many defenders seem to have further concluded that "the best defense is a good offense": they can muster an extraordinary hostility to real life. Bellori, for one, argues that when "the noblest Poets and the best Orators" wanted to "celebrate any extraordinary [human] beauty"

they were forced to have recourse to statues and pictures, and to draw their persons and faces into comparison: Ovid, endeavouring to express the beauty of

Cyllarus, the fairest of the Centaurs, celebrates him as next in perfection to the most admirable statues:

> A pleasing vigour his fair face expressed;
> His neck, his hands, his shoulders, and his breasts,
> Did next in gracefulness and beauty stand,
> To breathing figures of the Sculptor's hand.

How far from this will Emerson be, when he boasts that sculpture— "stone dolls"—has died because it is no longer needed to educate our eyes to living men's *perfection.*

Bellori alone seems to have awakened to a flaw in the Zeuxis parable: by selecting from the Crotonian maidens to paint his Helen, Zeuxis created an art object more beautiful than any of them.

But what of the original Helen? Was not that one living person still more beautiful than her portrait? Not at all, Bellori writes. *"Helena con la sua bellezza naturale* did not equal the forms of Zeuxis and Homer; nor was there ever a woman who had so much extraordinary beauty as the Venus of Cnidos or the Athenian Minerva. . . ."[49] Bellori is, after all, writing a work entitled "The Idea of the Painter, Sculptor and Architect, Superior to Nature by Selection from Natural Beauties." But having denied Helen's beauty, Bellori is left to come up with a motive for the Trojan War—which he does, in a moment of inspiration:

Helen was not as beautiful as they pretended, for she was found to have defects and shortcomings, so that it is believed that she never did sail for Troy but that her statue was taken there in her stead, for whose beauty the Greeks and the Trojans made war for ten years.[50]

That an important scholar could write that, and that it could be taken seriously, tells a lot about the climate of the artworld before 1800 (and also, perhaps, about important scholars). Homer, Bellori suggests, changed it from a statue to a woman, "in order to satisfy the Greeks and to make his subject of the Trojan War more celebrated. . . ."

Sir Joshua Reynolds: The Artworld in which Wordsworth and Constable Grew to Maturity

The Discourses

Art's claim to be a sister to drama or the creator of ideal beauty met the platonic challenge (a challenge, Panofsky contends, made more by Plato's disciples than by the philosopher himself) and endured in differing versions through many eras and cultures, to Sir Joshua's day. He himself cites "The *gusto grande* of the Italians, the *beau ideal* of the French, and the *great style, genius,* and *taste* among the English," as but different names for the "same thing," that ideal which gives the "intellec-

tual dignity" to what the painter does, "ennobles" his art, and—not least—firmly separates him from the "mere mechanick" who covers walls or furniture with paint. The painter produces the "great effects" that the poet or orator must struggle slowly to create—and all in "an instant," unlike their arts' "slow and repeated efforts . . . such is the warmth with which both the Ancients and the Moderns speak of this divine principle of the art. . . ."[51]

Reynolds does not exaggerate: Wordsworth, Constable, and even Claude Monet would have to fly in the face of all that.

To repeat, I only wish to advance one generalization: before 1800 art's defenders defended art objects as superior to mere real things. By now, I hope, we have refreshed our memory of just how superior the art objects were asserted to be. That claim, so strongly argued by so many Western philosophers for so long, was an obstacle that could scarcely be ignored. The very existence of a class of objects proclaimed superior to the things of everyday life was a standing challenge to the new values. During Wordsworth and Ruskin and Emerson's lifetimes entire Royal Academies were teaching scorn for everyday life.[52]

In retaliation, they took up arms and began their systematic redefinitions of art and most of its attendant terms in conscious inversions of what had been gospel. The "ideal," that most widespread assertion of the art object's superiority was their first object of attack. Discrediting the Academies—dismantling first the idealist defense and later the *istoria* defense—would take over a century.

But by divesting art of idealism, one of art's historic *defenses* (against challenges like the Platonic one) was removed. Once *istoria*—the premise that art objects could be defended as a form of theater—had also been dispensed with, the art object was on the road to its crisis in the 1960s, in a burst of assertions from the concept artists that "Mere real things are enough." Some form of the "ideal" or of the "*istoria*," the art object's historic defenses, may be necessary simply for art objects to have any excuse to exist. Completely remove both from an object and is it not just another "mere real thing" like J's bed? The constant presence of those two families of defenses throughout Western history was not accident but necessity.

The theoretician closest to Wordsworth's generation is Joshua Reynolds, founder of the English Academy and author of the enormously prestigious *Discourses,* which will repay our study for several reasons, one of them being their unoriginality. I mean no disrespect. Reynolds's work belongs, many have observed, to a genre characteristic of his time: the summing-up statement, the "fixing" (in the sense of making permanent)

of a truth—what oft was thought but ne'er so well expressed. Reynolds himself frequently insists, with justice, "The principle now laid down is far from being new or singular. . . ." Instead he worked to produce what Robert Wark rightly calls a "magnificent summary" of the past three hundred years of European art. Though there is "nothing particularly original" in his thought, Wark says, though "nearly all" of it can be found in the earlier works, Reynolds gives the ideas their most "elegant and persuasive presentation."[53] And that had been Reynolds's goal.

Reynolds simply tells the truth, then, when he claims his *Discourses* are the "general opinion" of "enlightened . . . mankind"; and had long been. Wordsworth and Constable do not come out of nowhere; we shall speak of Shaftesbury, Alison, the sublime; yet we must also point out that when Wordsworth and Constable were born the aesthetic grown out of the idealist and *istoria* defenses was not at all in "decline." In fact, the reverse. In their country it'had recently won royal sanction and an institutional apparatus with which to enforce itself; had just been given its most persuasive statement ever by England's first internationally admired painter. Blake's savage, funny marginalia on the *Discourses* ("Villainy! a Lie!" "This Man was Hired to Depress Art.") have become so famous they mislead us. Blake was, as usual, both brilliant and a crank. Wordsworth, Constable, and Ruskin shared in the general awe of Reynolds that most English felt.[54]

Moreover, the *Discourses* do not define, but do help us understand, not only painting, but also poetry in Wordsworth's youth. Neoclassicism tried to unify the principles of the arts, and one of Reynolds' special goals had been to establish that painting's principles were "parallel" with the "other arts." In the *Discourses* the learned painter left no doubt he was legislating for poetry as well.

The *Discourses* were one of the central efforts of Reynolds's life.[55] Fifteen were eventually delivered at the newly founded English Royal Academy, of which Reynolds was the first president, between 1769 and 1790. The lectures were printed and reprinted, published in collected editions, with Reynolds using each new printing as a chance to polish and revise.[56]

Ironically, Reynolds thereby cost himself the literary eminence he passionately desired: the polished texts are so good it was assumed his many literary friends had collaborated with him. The *Discourses* legislate for literature as well as painting, which strengthened that mistaken notion.[57] This misapprehension (textual evidence alone indicates Johnson and Burke did less than a modern copy editor would)[58] concerns us. However such a mistake may have irked Reynolds, it gave great prestige to the *Discourses*. Wordsworth, Constable, and the others almost certainly

considered the *Discourses* the way the rest of the country did: a joint state-
ment on the arts by the greatest English painter; by Johnson, the "one
man Academy"; and also by Burke, author of the enormously influential
aesthetic treatise, *On the Sublime*. In truth, Reynolds (to whom Boswell
dedicated his life of Johnson) was indeed always writing, as Ruskin puts
it, "under the immediate sanction of Johnson."[59]

"The Vulgarism of Ordinary Life": The Reaction to Reynolds

It has been the fashion for years to moderate an earlier, more Romantic
account of Wordsworth's poetics by pointing to the similarities he bears
to Reynolds and other eighteenth-century figures. For instance, W. J.
Bate:

Following Reynolds—whose *Discourses* he greatly admired—Wordsworth dis-
missed any argument for taste which presupposes the validity of untutored senti-
ment: taste, he said, 'can only be produced by severe thought and a long contin-
ued intercourse with the best models of composition . . . '[60]

Be that as it may, Wordsworth's poetics, and his poetic practice, break
sharply with Reynolds. Here, for instance, Bate cites Wordsworth's canny
adoption of part of a Reynolds argument in order to glide over Words-
worth's total disagreement on what "taste" is. Certainly Wordsworth ad-
mired the *Discourses;* but the "taste" Wordsworth would cultivate is oppo-
site Reynolds's. Wordsworthian taste would find heaven in the common
day; Sir Joshua contended that "Greek and Roman fable and history"
made the best subjects because they were "familiar and interesting to all
Europe, without being degraded by the vulgarism of ordinary life in any
country."[61] A note in a Reynolds manuscript is characteristically blunt
about art's relation to nature: "Sculpture represents nature without the
infirmities."[62]

As the Romantics' critical reputation ascended during the fifties,
there was an understandable tendency among eighteenth-century schol-
ars to put forward, in some anger, the Romantic virtues already well de-
veloped among eighteenth-century artists and writers. Paradoxically,
that tactic can imperil the writers being defended. As Stanley Cavell has
noted, a new style doesn't merely "replace" an old one, in subtle ways it
changes the "significance" of the old style, almost changes "what the past
is." It would be ironic and awful to reduce the eighteenth-century hu-
manistic artists to a group of early Romantics just when the postmodern
artworld has a renewed interest in *istoria* and humanistic content, which
I take to be the eighteenth century's proper concerns.[63]

Wordsworth, Coleridge, Ruskin rebelled against an entire aesthetic,

not just against Reynolds; and when they did rebel against Reynolds it was not against Reynolds the painter. Whatever the relation between his theory and his art, his art they easily assimilated: Ruskin blithely says that Reynolds proves

how completely an artist may be unconscious of the principles of his own work, and how he may be led by instinct to *do* all that is right, while he is misled by false logic to *say* all that is wrong. For nearly every word that Reynolds wrote was contrary to his own practice; he seems to have been born to teach all error by his precept, and all excellence by his example. . . .[64]

That perverse argument has to have been close to Constable's opinion, judging by Constable's respect for Reynolds's paintings, despite his often-stated antagonism to the principles Reynolds held most dear.

Wordsworth in particular often seems to address Reynolds because they both try to answer the same question. To what degree is real life— are mere real things—excellent, and how does that excellence compare with the excellence an art object can achieve? Wordsworth's novel answer is that the everyday world "surpass[es] the most Ideal Forms / Which craft of delicate Spirits," like Sir Joshua, "has composed. . . ."[65] Wordsworth's "Lines, Left upon a Seat in a Yew-Tree" contains what seems a specific rebuke to neoclassical idealists—proud, established, and boasting of their developed faculties:

Stranger! henceforth be warned; and know that pride,
Howe'er disguised in its own majesty,
Is littleness; that he who feels contempt
For any living thing, hath faculties
Which he has never used.[66]

The Disfiguration of the Commonplace: Acquiring the "Power of Discerning What Each Wants in Particular"

Wordsworth and Ruskin considered the older aesthetic's training not merely wrong but actively harmful. It ended with the idealist artist and all who had acquired that artist's idealist taste, in a "desert of ugliness," Ruskin wrote. Idealism led to contempt for real life, a contempt he thought almost literally diabolic. To understand the *moral* fury with which these figures attack the Ideal we must see the idealist defense through their *Weltanschauung* rather than through our own.[67]

Reynolds, like Alberti, favored in his teaching the Zeuxis parable, as opposed to the Phidias parable. The Phidias parable utterly disdained life in this world. Plotinus cited Phidias respectfully, and St. Augustine had found Plotinus adaptable to Christian aesthetics.

The Zeuxis parable, while it has greater respect for this world, still

encourages, in another way, our contempt. Reynolds had followed a continental tradition of rationalizing a course of study out of the Zeuxis parable. As Zeuxis assembled the Crotonian maidens and compared them, selecting and combining to form his ideal artwork, so Reynolds trained the Academy's art students (and his work's wide audience) to compare all the things of this world and find them wanting.

Wordsworth and Ruskin could read, in Reynolds's own pages, the effects of such a program on Reynolds himself. Reynolds ends convinced that "All the objects which are exhibited to our view by nature, upon close examination will be found to have their blemishes and defects. The most beautiful forms have something about them like weakness, minuteness, or imperfection."[68]

In England's new Royal Academy, then, the "defects" of mere real things were being sought out, taught, learned. Imagine Wordsworth's emotions as he read how the young were being *instructed* in the world's "blemishes" until all faded for them into the light of common day! For Reynolds readily admitted that "not every eye" perceives those "blemishes" which offend him but only an eye trained in the habit of "comparison of forms," the good against the less-good. The painter long studies "what a set of objects of the same kind have in common," to gain a new power: the "power" of noticing "what each wants in particular." This "long laborious comparison should be the first study of the painter. . . ."

At the risk of getting ahead of the story, anyone who knows Wordsworth and Ruskin knows how often they speak of conferring "power" on the audience, knows their famous training for the eye. It was, in fact, a *counter*-training: the Zeuxis parable (all those Crotonian maidens compared) had become, in the eighteenth-century academies, a training for the eye.

But *what* a training. Wordsworth and Ruskin would later send you out into the world with the new power to transfigure the commonplace; idealist art training would disfigure even the "most beautiful forms" you previously admired, train you in their "weakness" and "imperfection." I use the word "disfigure," to emphasize that ideal art did not merely leave the commonplace alone. Young people were being carefully trained to look at life and find it ugly— *"tanto inferiore all' arte"* as Bellori claimed. Wordsworth and Ruskin could not let that go unchallenged. They did not.

"The power of discovering what is deformed in nature," Sir Joshua taught, "or in other words, what is particular and uncommon, can be acquired only by experience. . . ."[69] His training gave England's youth that experience.

Ruskin, in reaction, can only rage that "the lovers of ideal beauty" will

only look at a mere real thing "to see how best it may be altered into something for which they have themselves laid down the laws. Nature never unveils her beauty to such a gaze."[70] Ruskin does not hesitate to call the result "evil" or lament how it spreads from artist to viewer: "Nor is the effect less for evil on the mind of the general observer. The lover of ideal beauty, with all his conceptions narrowed by rule, never looks carefully enough" on quotidian things "to discern the inner beauty in them"—which Ruskin, using his unique powers, immediately begins transfiguring for us, arguing better by example than he ever does by logic:

The strange intricacies about the lines of the lips, and marvellous shadows and watch-fires of the eye, and wavering traceries of the eyelash, and infinite modulations of the brow, wherein high humanity is embodied, are all invisible to him.

In a famous passage, Ruskin contended that "All the Renaissance principles of art," which had valued "Beauty above Truth" and had sent men seeking Beauty "at the expense of truth," ended with the "inevitable" punishment: "that, those who thus pursued beauty should wholly lose sight of beauty." Indeed, that was the assumption behind idealist teaching: beauty did *not* naturally exist, it was *created* by artists like Zeuxis from imperfect materials. Ruskin rises in wrath to contemn that method's results. By training themselves to seek out and learn the "Ugliness" in every real thing, the idealists ended, through Dantesque justice, in a self-willed hell: "One desert of Ugliness was extended before the eyes of mankind. . . ." Recoiling, they tried to replace the natural beauty they had lost the eyes to see, with an artificial one, and so "their pursuit of the beautiful, so recklessly continued" reached its "unexpected consummation in highheeled shoes and periwigs. . . ."

Ruskin's attack makes us aware of a circularity in Reynolds's argument. Reynolds argues that "art makes up for the deficiency of things"—while at the same time carefully training the artist to find them deficient:

By [this long laborious comparison] . . . his eye being enabled to distinguish the accidental deficiencies, excrescences, and deformities of things . . . he makes out an abstract idea of their forms more perfect than any one original; . . . this idea of the perfect state of nature, which the Artist calls the Ideal Beauty, is the great leading principle, by which works of genius are conducted.[71]

Having purposefully destroyed his own wonder at mere real things, the idealist turns to admire "works of genius." After all, what is left?

To speed up the student's power to discover "deformity" in the common day, Reynolds says he knows of only "one method" that will "shorten the road": judge nature by art. Compare flawed nature with the ideal creations, in this line, of previous thinkers, who themselves reached the

heights by a "careful study" of classical sculpture. The "ancient sculptors" left "models" of "perfect form" by being "indefagitable in the school of nature"—that is, indefagitable in finding fault with nature. Comparing flawed nature with such "supremely beautiful" works can, alone, shorten the student's path.[72]

Reynolds means the opposite of what Wordsworth and Ruskin will mean when he says "nature denies her instruction to none, who desire to become her pupils." He only sends us to nature to learn to perceive her "deformities," so that we may create (as the great artists did) superior. When Wordsworth entered the artworld, this then, was the status of the art object relative to mere real things: "Upon the whole, it seems to me that the object and intention of all the Arts is to supply the natural imperfections of things. . . ."[73]

Behind Reynolds's disdain for everyday life lay a religious idea obnoxious, indeed sacriligious, to Natural Supernaturalism. For Reynolds as for Marsilio Ficino, nature is fallen and heaven remains with God, elsewhere. Trapped inside our flesh is a "spark" of "divinity" which, divine, must yearn toward other divine things not of this earth; is indeed, "impatient of being circumscribed and pent up by the world which is about us. . . ." As much as "our Art" yearns in this way for something better than this life, "just so much" does it have of "dignity, I had almost said of divinity; and those of our Artists" whose work possessed this quality "in the highest degree" were therefore called "DIVINE."

The forms this divine artist produces, his "idea of the perfect state of nature," only another word for "the Ideal Beauty," these forms have also "acquired . . . the epithet divine." These perfected forms are no less than what we can deduce of the "will and intention of the Creator, as far as they regard the external form of living beings."[74] Divine art makes up for a "defective world."

Not surprisingly, "divine" becomes one of the first words Wordsworth wanted to wrest control of and redefine. Wordsworth's "divine" means the opposite of Reynolds's "divine." Through "the vision and the faculty divine," "the poet will lend his divine spirit to aid the transfiguration" of the commonplace. Similarly, Ruskin twice praises the painter of an ordinary strawberry plant, whose unidealized picture was "patiently and innocently painted from the *real thing*, and *therefore most divine.*"

In Reynolds' universally admired pages, Wordsworth and Ruskin saw the commonplace not merely ignored, but actively despised. "The thoroughly great men," Ruskin would counter, "are those who have done everything thoroughly, and who have never despised anything, however small, of God's making." He cites Wordsworth's "daisy casting its shadow on a stone," and asks painting to follow him: "Our painters must come to this before they have done their duty."[75]

Wordsworth and Ruskin watched Reynolds carry his disdain for mere real life to amazing lengths. Since the great "Artist" may sometimes have to "deviate from vulgar and strict historical truth, if it conflicts with the grandeur of his design," Sir Joshua decrees we must even improve the Apostles. He praises Raphael for having made them look noble, although "we are expressly told in scripture they had no such respectable appearance," and though we are even told by "St. Paul . . . himself, that his *bodily* presence was *mean*."[76] Reynolds's painter is not interested in the eye but in the *istoria*, and since he has no other way of showing "the dignity" of Paul's mind, except by his "external appearance," it is a "poetical license" to make Paul Pauline, so to speak. "He cannot make his hero talk like a great man; he must make him look like one."[77]

In the notes Reynolds made on his journey to Flanders and Holland, he disapproves of Rubens's Ghent St. Francis, "a figure without dignity, and more like a beggar. . . ." "Like" a beggar? When one reflects for a moment on St. Francis's philosophy, and his strictures about worldly goods and worldly pride! In the same church Rubens's "Mary Magdalen expiring," is condemned, for Rubens has made her look "old and disagreeable." The aesthetic that would censure an "expiring" woman for looking "old and disagreeable," had to be reexamined.[78]

In sum, during the first Natural Supernaturalists' youth, the artist, and everyone who aspired to the vision of the "divine" idea, was taught to embark upon a "laborious investigation," a systematic dis-figuration for himself of everything he had previously thought wonderful in real life: "The most beautiful forms have something about them like weakness, minuteness, or imperfection. But it is not every eye that perceives these blemishes. . . ."

In reply, Wordsworth and Ruskin trained one to develop an opposite "power" to find the miracle in the everyday; a conscious inversion of the way the idealist artist and audience were trained to grow in the "power of discovering what is deformed in nature . . ."[79]

And this, specifically, was Reynolds's opinion about the sort of everyday scenes Wordsworth would soon set himself to transfigure:

Whatever is familiar, or in any way reminds us of what we see and hear every day, perhaps does not belong to the higher provinces of art, either in poetry or painting.[80]

In this climate Wordsworth began his work. The artworld of 1800, far from being Natural Supernaturalism's natural home, could not have been more hostile to it.

III

Confronting the Art Object: The Simple Produce of the Common Day

Alas! Ages must pass away before men will have their eyes open to the beauty and majesty of Truth, and will be taught to venerate Poetry no further than as she is a handmaid. . . .

Up! up! my Friend, and quit your books. . . .—William Wordsworth

I believe any sensible person would change his pictures, however good, for windows.—John Ruskin

Certainly the man is grateful to his fine raft, but does it make sense for him to carry it on his back now that he's reached the other side?—Buddha

51

A. *William Wordsworth: The Simple Produce of the Common Day*

The Paradise in the Everyday

PARADISE

Wordsworth says;

> Groves Elysian, Fortunate Fields

—why should these words mean only departed things, or fictions of what never was? Having studied Reynolds, we can feel how revolutionary it was for Wordsworth to claim that

> Beauty—a living presence of the earth

waits upon his steps, and pitches her tents before him as he moves—a Beauty, moreover, "surpassing" any the Royal Academic painter could create:

> Surpassing the most fair Ideal Forms
> Which craft of delicate Spirits has composed
> from earth's materials

—a specific refutation of the Zeuxis method Reynolds had promoted in the *Discourses*. Since poets do not compose from "earth's materials," the "delicate Spirits" in this draft are painters and the "Ideal Forms" are their paintings, so long promoted at the expense of mere real things. Instead, Wordsworth contends, Paradise, the Groves Elysian, the Fortunate Fields

> the discerning intellect of man . . .
> shall find these
> A simple produce of the common day.

This passage, which Wordsworth himself called the "Prospectus" and the "key"[1] to his great work, is, M. H. Abrams writes, our "indispensable guide to understanding the design informing Wordsworth's poetry." "A crucial passage . . . long meditated . . . often rewritten, and so emphati-

cally stated."[2] The passage proposes a revolution in what we are to get from art. Whitman, who agreed, must still say defensively, fifty-five years later:

The land and sea, the animals fishes and birds, the sky of heaven and the orbs, the forests mountains and rivers, are not small themes . . . but folks expect of the poet to indicate more than the beauty and dignity which always attach to dumb real objects . . .[3]

These dumb real objects, till now *tanto inferiore all' arte*, sculpted from the despised *materia*, will be elevated through the new artist's power.

Critics approach the Wordsworth passage as if the "Spirits" he would contend with and prescribe for were poets, but they have little ground to stand on. One should never underestimate Wordsworth's ambitions. Wordsworth's revisions of this passage make it clear he aspired, like Reynolds, to legislate for more arts than his own. Critics know that the earliest manuscript draft has, not "Spirits" but "Poets," capital "P," presumably in the wider, Greek-root sense, "maker," since these Poets already compose from "earth's materials" and the "Beauty" being discussed is *visual*, not audible. In any event, Wordsworth cut "Poets." Since he goes through the trouble of changing "Poets" to "Spirits," spirits who use the doubly physical "earth's materials" to create visual beauty, we have to take the Spirits as painters or sculptors. The *ut pictura poesis* tradition legislated for both arts and Wordsworth never aimed lower than a predecessor. This "crucial passage," this "key" to his work is interdisciplinary. Understanding that, we realize it fires the first shot in the Natural Supernatural battle against the art object.

It would be Wordsworth's task, Coleridge wrote, to produce a feeling "analogous to the supernatural by awakening the mind's attention from the lethargy of custom," or habit, and redirecting its attention to the "wonders of the world before us." So Coleridge wrote in an endlessly quoted passage from *Biographia Literaria*[4] to call attention to "the two cardinal points of poetry" that he and Wordsworth had set out to illustrate in *Lyrical Ballads*.[5] We would find the "world before us" (probably an allusion to "the world was all before them"—Adam and Eve, fortunately fallen, turned out of Milton's Paradise to find a better home in this world) to be an "inexhaustible treasure, but for . . . the film of familiarity and selfish solicitude [whereby] we have eyes, yet see not, ears that hear not, and hearts that neither feel nor understand."[6]

The idealist and *istoria* families of defenses had long been compatible, and by Wordsworth's time they had fused into what, speaking broadly, I will call for convenience, "the older aesthetic." (In Danto's revised usage, the older "artworld.") We will see how Wordsworth in his poems and

prefaces, in his subject matter and technique alike, inverted almost everything that older aesthetic called poetry, to claim that *this* was poetry: waking up to the excellence of mere real things, "the wonders of the world before us." The *Prelude* ends, "what we have loved, others will love, and we will teach them how."[7] For Wordsworth, we might say, *poetry* is consciousness of the "wonders" of mere real things, *genius* is the extension of that awareness to others.

Wordsworth and Ruskin offered you the very opposite of the older aesthetic's "ideal." Zeuxis had given you rarer and more beautiful than you expected; Wordsworth and Ruskin gave you more common than you expected. Reynolds's ideal led you away from daily life, they purposefully led you back to it. The older aesthetic offered you elite objects; the new aesthetic guided you away from them. Wordsworth and Coleridge began by seizing art's old words and tools and using them to lead the audience away from art objects to mere real things, using the conventions of art object contemplation to force the audience to contemplate what the idealists so long had taught it to despise: real life.

"Long before the Blissful Hour"

Wordsworth's desires have sometimes been interpreted as, not a new role for poetry, but a new theory of psychology. It is customary to note that Wordsworth wrote he would proclaim

> How exquisitely the individual Mind . . .
> To the external World
> Is fitted:—and how exquisitely too . . .
> The external World is fitted to the Mind;
> And the creation (by no lower name
> Can it be called) which they with blended might
> Accomplish.[8]

"All this at first glance may seem very remote from twentieth-century concerns," Jack Stillinger tells us. "In Wordsworth's chief meaning of the word, we are all of us these days 'poets'—creating as we perceive, combining past impressions with new ones, experiencing an 'interchange of action from without and from within.'" Although Stillinger, in this youthful essay, will admit that Wordsworth's ideas are "for him a tremendous discovery," they "are now commonplace (though the extent to which the mind modifies perception is a subject of increasing interest in modern psychology.)"[9]

Abrams, at least during *The Mirror and the Lamp*, had said much the same. "What we now call the psychology of art," Abrams writes, "had its origin when theorists in general began to think of the mind of the artist

as interposed between the world of sense and the work of art" and began to "attempt to describe what goes on in the mind in the process of composing a poem. Most frequently . . . the mind is imaged by romantic poets as projecting life, physiognomy and passion into the universe."[10]

With all respect to these fine critics, if Wordsworth had thought we were all poets, he would not have had to write poetry. He did subscribe to an idea of what the mind does that led him to believe men might become poets, someday—with his help, and the help of certain poets like him, and above all with the help of a radical redefinition of the term "poet." For all his debts to Hartley and the late eighteenth-century philosophers of mind, both Wordsworth's critical work and poetic practice show real skepticism that the average mind could as yet long or dependably project "life, physiognomy and passion into the universe." If it could we wouldn't need Wordsworth's poet, or later, Carlyle's prophet, Ruskin's "modern" painters, Joyce's heroic novelist. "What we have loved, others *will* love, and we *will* teach them how," Wordsworth concluded his life-work (emphasis mine).

"Poetry" for Wordsworth isn't something the mind does. Indeed, it is something the average mind as yet *can't* do—without the heroic leader-poet, who (Wordsworth and Arthur Danto choose the same metaphor) "will lend his divine spirit to aid the transfiguration" of the commonplace.[11] Far from this being a common ability of the mind, even that "divine" leader-poet does not himself have the power equally at all times of his life ("Immortality Ode"). In fact, as we know from Coleridge's "Dejection," he can lose the power altogether.

Wordsworth in the "Prospectus" calls himself "the transitory Being that beheld / This Vision" and what he offers is a new mission for poetry, not a theory of mind. The new religious tendency demanded a new aesthetic. Which raises a second point: the "poetry" described above is only what became "poetry" after Wordsworth's violent redefinitions. What he offers, then, is not a theory of mind, not even a theory of what "poetry" *is,* but a daring Vision of what poetry must become. One day, far in the future, through this new poetry, even average minds finally will be able to transfigure the commonplace, all will be poets (at least, according to his startlingly expanded definition), and then we will live in Paradise regained. Wordsworth, at Natural Supernaturalism's very start, has a "Vision" of the climax. Neither Stillinger nor Bloom, in their discussions of the "World fitted to the Mind" passages, cite some anomalous lines which come just after the prediction of Paradise and just before the fitting of the mind to the world, and which link the two passages together:

> I, long before the blissful hour arrives,
> Would chant, in lonely peace, the spousal verse
> Of this great consummation . . .

I cannot overstate the importance of bringing those anomalous lines forward. Criticism hasn't known what to make of that Wordsworthian loneliness, that statement that some hour he longs for lies far in the future. *What* hour? What is the nature of this "great consummation?" Here, at the "lonely" beginning, we already find Wordsworth speaking of some kind of climax. He has begun by derogating even the "most fair" art object. Now he prays for strength while waiting for the "blissful hour" of full transfiguration: the very event which Danto, Sandler, and the others observed in the 1960s, the hour when the art object could at last be put aside and all mere real things were finally, and reverentially, appreciated in its stead. The "Prospectus" is Wordsworth's prayer for the "end of art" and the "great consummation" of a true Earth Day, when the "progressive powers" of the species, educated by the "divine" leader-poet, have developed into a "discerning intellect" that can transfigure the world on its own. Wordsworth already knows what those divine spirits are going to endure on their way to that consummation. He prays for strength. Carlyle constantly warned us, when we write about religious personalities, not to be condescending toward beliefs we don't share by treating them as if their authors too thought them merely fanciful myths or poetic tropes. In this grim moment Wordsworth isn't spinning out some metaphor. He believes in that "blissful hour." That "great consummation" is as real to him as the second coming was to Paul. He's writing to tell us that he has pledged his life to bringing it about. There is no indication he thinks he will live to see it. He prays for strength, "long before" the blissful hour, in "lonely peace," surrounded not by natural poets but—as he himself characterizes them—by the "sensual," the "vacant," and the "vain." Whitman later put it more bluntly, telling unenlightened human kind:

> Long enough have you dream'd contemptible dreams,
> Now I wash the gum from your eyes,
> You must habit yourself to the dazzle of the light and of
> every moment of your life.[12]

The Existing Groundwork: Archibald Alison

Any great edifice must stand on a strong foundation and Wordsworth's was no different. What was that groundwork?

As we said earlier, Wordsworth's theory of poetry is superficially so

reminiscent of Kant's theory of mind that many have assumed Wordsworth was inspired by Kant. The later Wordsworth was indebted to him, but René Wellek, in a book more useful than widely read, *Kant in England,*[13] long ago showed that the youthful Wordsworth, the author of *Lyrical Ballads* and the *Prelude,* couldn't have been.

Wordsworth had traveled to Germany in 1799 but his "less intellectual temperament, his aversion to technicalities" and above all "his ignorance of German, never led him to a study of German idealism." Coleridge could read German; what Wordsworth knew of Kant eventually came through him. There was no complete translation even of the *Critique of Pure Reason* until 1838. Judging by Coleridge's letters, even Coleridge's first real interest in Kant, certainly his first belief in him, did not begin until 1801.[14] By that time—after the preface to the second edition of *Lyrical Ballads*—Wordsworth's main beliefs had already formed; indeed, he had published them. The most "Kantian" lines in Wordsworth, how the mind can be fitted to the world, in "The Recluse," and how it half-creates and half-perceives, in "Tintern Abbey," were written in 1797 and 1798 respectively, before even Coleridge had learned German. Wordsworth performed his revolution—in poetry, not psychology—on his own.

We may fairly seek to understand, however, the intellectual climate in which Wordsworth's thought grew (to use an appropriately organic metaphor). James Engell has explored English Romantic debts to the Germans, particularly Coleridge's to Tetens, as I noted. When we seek more specifically to understand Wordsworth (who was, after all, as Coleridge said, the one who was writing the poems of the "every day"), the first writer I would look at, only partly because he has been largely overlooked, is Archibald Alison.

Alison's book is now surprisingly little known, though greatly influential in its day. Samuel Holt Monk long ago tried to call our attention to him, insisting that "the importance of his influence is not to be lightly estimated."[15]

When Wordsworth opened Alison's 1790 *Essays on the Nature and Principles of Taste,* this is what he had learned by page 7: "Sublimity" and even "beauty" are not properties of objects but "emotions" we have about objects.[16] (By implication, no object is more elite than any other. Beauty is up to us.) There is a difference between ordinary sight and awakened sight, for the "simple perception" of an object isn't enough to "excite" those desirable emotions (that is, beauty, sublimity) unless sight is "accompanied with" an "operation of mind."[17] (This is Alison's early version of the looking/seeing distinction so many would later make. Compare Ruskin on our page 100.)

As proof that unless we "exercise" our "imagination," we don't feel the "emotions of beauty and sublimity," think how much "difference" there is in the feelings we have at different times about "the same objects."[18] In the course of making that point, Alison quite casually assumes the beauty in the simple produce of the common day and makes it our fault that we don't find it: "In the scenery of external nature," the beautiful and sublime are "almost constantly before us; and not a day passes, without presenting us with appearances, fitted both to charm and to elevate our minds; yet it is in general with a heedless eye that we regard them, and only in particular moments that we are sensible of their power."[19]

The beautiful and sublime "almost constantly before us?" Imagine the youthful Wordsworth or Constable reading that after Sir Joshua's dictum that "whatever . . . in any way reminds us of what we see and hear every day" has no place in the "higher poetry or painting." We understand why Constable later said Alison had meant so much to him. Alison expressed what the younger men already felt, and found themselves at odds with the whole academic world in feeling: that "not a day" passed without nature offering them sights which not only charmed but in some way seemed to "elevate" their minds.

And he had already identified the great problem. There was no way to deny that few found this quotidian beauty. Even those who did couldn't find it all the time.

Alison's explanation was that the world is so much with us we lay waste our powers: Our cares, or the preoccupations "of business . . . destroy, for the time at least, our sensibility to the beautiful or the sublime. . . ."[20] Though every man has felt "the beauty of the sunset," all have known times when they "beheld all the magnificence with which nature generally distinguishes the close of day, without one sentiment of admiration or delight."[21]

Here, as throughout the book, Alison's conclusion is that "matter," therefore, cannot be "beautiful in itself," or it would always be so; our inability to always find it so, our moments of visual deadness prove that matter only "derives its Beauty from the Expression of mind."[22] His method, to demonstrate that beauty is not something *in* an object, but something we do *with* an object, is to constantly remind us how indifferent we grow (for many reasons) to daily "magnificence." The 413 pages of his book become, as he hunts for examples, an anatomy of the numbing effects of habit, aging, listlessness, mad endeavor, and all that is at enmity with joy.

Even today, reading Alison's countless accounts of the reasons our "sensibility" must eventually fail makes one self-conscious, almost ner-

vous. Alison is emphatically *not* Wordsworthian in his conclusions: "habit" and "familiarity" must eventually conquer, neither travel nor adventure nor expense can long stave off our sensibility's decay. Studying Alison no doubt contributed to that more than conventional anxiety which Wordsworth, even in his youth, always shows over the state of his powers.

Alison, I submit, is often Wordsworth's inspiration (if one is needed) where we have suspected Rousseau; as where we previously suspected Kant. Tony Tanner reminds us that Wordsworth had not inherited his child-seer from Rousseau. On the contrary, Rousseau's message had been that "childish modes of perception must give way to more complex and sophisticated modes." Rousseau doubts a child could feel anything looking at nature. The Romantics, by contrast, Tanner writes, "elevate into positive virtues" the child's "passivity to detail" and its "inability" to criticize or judge; make childhood a higher state we fall off from.[23] Rousseau had no truck with mystic visions and deplored those who, at the sight of the "'treasures of nature, feel nothing more than a stupid and monotonous admiration,'" while he was tracing the "chain of connection" between things. Rousseau, in fact, is probably the "philosopher" Alison satirizes as looking at nature and feeling no more than a "man of business" because preoccupied with "causes."

One finds endless parallels in Alison with Wordsworth's later values, even opinions one thought rather idiosyncratic. Alison's very first targets are "critics," those who by attending to "minute and solitary parts" destroy "the fancy of youth." Alison's first objects of praise are "young people" who, if not quite seers blest, have "greater sensibility" than their elders, "because every thing, in that period of life, is able to excite their imaginations . . . it is their own imagination, which has the charm, which they attribute to the work. . . ." "The business of life" generally destroys our "sensibility," which we have in its "fullest" only in "youth" when "the imagination is warm."

But once young people fall into the hands of critics and pedants, Alison tells us with Wordsworthian passion, "all this, however, all this flow of imagination, in which youth, and men of sensibility, are so apt to indulge, and which so often brings them pleasure at the expense of their taste, the labour of criticism destroys." Neither the "philosopher" nor the "man of business" can respond as well to a "beautiful scene in nature" as the "young mind" possessed of "sensibility" in whom nature can produce a "delight, which not only would be little comprehended" by the first two, but which "seems also to be very little dependent upon the object which excites it," and actually seems to come from their "exercise of mind itself."[24]

Alison, then, building on Reid, Priestly, Hartley, had organized most completely, just at the start of Wordsworth's career, the idea that beauty is not something inherent in certain objects, but an attitude to certain objects we sometimes have; that beauty is not something out there, but something we do. Thus all hierarchies are undermined. Alison—against his will it seems—freed the artists to incite the audience to create beauty wherever they chose. It was left to the youthful Wordsworth and Coleridge to draw a moral and consequently a strategy: "If nothing's inherently beautiful, then classical statues are no more inherently beautiful than the simple produce of the common day. If beauty's inside us, then it's in our control. If it is something we do, let us do it more." Almost surreptitiously, Alison's work contained a Magna Carta for everyday objects; Wordsworth and Coleridge wrote their Declaration of Independence. Alison never went so far because he was no practicing artist, nothing of a revolutionary, and above all entirely pessimistic about our powers past our youth. In their youth, Wordsworth and Coleridge disregarded that part of his lesson.[25]

For them, beauty had become a choice we make; in fact, an act of will, which they were sure, could be strengthened. Alison had virtually made beauty our responsibility. "In the common hours of life," he wrote, when we are "busy," the things we would otherwise admire "make but a feeble impression on us." Even people who have the power to be sensitive to the daily beauty surrounding them (here one can almost picture Wordsworth's face as he read) are so caught up in their affairs they've lost their powers:

The husband-man who goes out to observe the state of his grounds, the man of business who walks forth to ruminate about his affairs, or the philosopher, to reason or reflect, whatever their natural sensibilities may be, are at such times insensible to every beauty that the scenery of nature may exhibit. . . .

Alison had even written (in an oddly Wordsworthian meter and rhyme) of those "moments of listlessness and languor, in which no objects of Taste whatever, can excite their usual delight," moments when "our favourite books, our favourite landscapes, our favourite airs, cease altogether to affect us." Not that the "objects" have "changed, . . . not even that we have not the wish to enjoy them, for this we frequently attempt, and attempt in vain. . . ." But we have come to them with "minds fatigued," or under the "influence of other feelings," like the "busy" men described above.

Alison, like all the reign-of-wonder writers who would follow him, names "habit" as the opponent, "habit . . . which in this, as in every other case, is supposed to diminish the strength of our emotions." But habit

(at least in our youth) is not insuperable, Alison teaches: "Such indifference is never permanent . . . there are times when the most familiar objects awaken us to the fullest sense of their beauty." Alison almost predicts Wordsworth's mission when he implies that beauty could return to the preoccupied souls mentioned above if they were inspired to redirect their attention:

> nor do they begin to feel them, until they withdraw their attention from the particular objects of their thought, and abandon themselves to the emotions which such scenes may happen to inspire.[26]

It is debatable, but I believe, with Samuel Holt Monk, that Wordsworth also had available, in Alison, "the first clearly expressed realization" that there is a "purely aesthetic experience" long before Kant's version reached England.[27]

Alison's book is very long and, everyone admits, very complicated. The complications (indeed, contradictions) come about because he didn't entirely like where his logic led him. Alison's conclusions, if accepted, predicted an art which was beyond his powers to enjoy and which he was certainly not prepared to defend. He was, in the end, a man of the last century, who saw nothing contradictory in praising nature by quoting latinate rhymes about swains and milkmaids. His system owes its complexity to the doubleness of his effort: he would bring his incendiary brand of associationism fully into aesthetics while fashioning codicils to protect Ideal Beauty, rhyme, meter, poetic diction, and everything else the eighteenth century approved. This did not lessen his charms for Wordsworth, who (like all aestheticians) enjoyed a book which showed one exactly what should be said, but didn't say it. Alison's work owed its turn-of-the-century popularity to his ability to compromise, though it is too harsh to disdain him as a compromiser. As Lipking remarks, Reynolds's age dealt with opponents by inviting them to tea, and had Reynolds read Wordsworth, a later *Discourse* might have attempted to politely integrate even those ideas into the system. Alison is very interesting because the ideas which worry him are his own.

We must not make Alison into Wordsworth. Alison seems to have thought Claude and Thomson as much of "Nature" as human beings wanted. Wordsworth, reading those pages I've quoted above, would have also found Alison saying close by that objects make their greatest impression on "the vacant and the unemployed,"[28] and would have heard him later praise "the superiority" of paintings over "the scenery of Nature," since, unlike "the usual tameness of common scenery" paintings lead to pleasing "trains of thought."[29]

The reader can already sense that, taken as a whole, Alison's politic

book is less like a synthesis than an English coalition government, filled with backbenchers from minor and rival parties. Within its pages the young Wordsworth could find him destroying any possibility of hierarchies of beauty or subject. Yet, he would also find Alison tranquilly explaining how the artist creates Ideal Beauty, "more beautiful than any [forms] that were to be found in Nature itself."[30] "The most beautiful Forms in real Life," he writes, are "still in some respects deficient"—forgetful that elsewhere he had insisted that whatever beauty a form had depended primarily on us, not on the form. "Matter is not beautiful in itself, but derives its Beauty from the Expression of mind."[31]

All this made Wordsworth enjoy his reading all the better, for if ever there was a man who felt he must create his own system or be the slave of another man's, it was he, and Alison's system not only spurred Wordsworth's thoughts (even ground some personal axes) but was endearingly contradictory and imperfect. One could go right seeing where Alison went wrong; he inspired one without possessing one. He was a gold mine of fatalistic discussions of the ways habit, custom, business, wealth, age, city-living, pedantry crippled our powers to find joy—without his ever quite realizing that by placing beauty within our minds he had placed it to some extent within our power. It was a lament, not a manifesto. He was content to describe the situation; Wordsworth and Coleridge were ready to change it.

The Audible Produce of a Common Day

"Quam nihil ad genium, Papiniane, tuum!"

"This is not for your taste, follower of Pope!"—on the title page of the second volume of *Lyrical Ballads* (1800)

Critics have offered many explanations for Wordsworth's revolutionary poetic practice, which stands Pope's and Johnson's hierarchy on its head. Wordsworth's poetic is the logical result of his Natural Supernaturalist beliefs: he would not only exert his readers to see the paradise in the common day, but the poetry in prose. "The language of Prose may yet be well adapted to Poetry. . . ." He had enormous hopes. If Wordsworth could make us find poetry in poems written "as far as was possible in a selection of language really used by men," we would eventually gain the power to hear as poetry the everyday language around us, the audible "simple produce of the common day."[32]

Wordsworth and Coleridge (like any serious English aestheticians of their time) knew Reynolds's *Discourses* well. Reynolds is, in fact, the first critic cited in the very first foreword (1798) to the first version of *Lyrical*

Ballads. "The very existence of poetry," Sir Joshua had written, "depends on the license it assumes of deviating from actual nature," a passage Wordsworth echoes as he castigates poetry "distinguished" only "by various degrees of wanton deviation from good sense and nature." Poetry, Reynolds taught, "sets out with a language in the highest degree artificial, such as never is, nor ever was used by man," against which Wordsworth argues that the "language of the earliest Poets . . . was really spoken by men," though now humanity's taste has been "gradually perverted." One admires Wordsworth's *faccia di bronzo* when, a few pages earlier, in the middle of overturning Reynolds's taste, he calmly says, "an *accurate* taste in poetry . . . as Sir Joshua Reynolds has observed, is an *acquired* talent. . . ." Sir Joshua's philosophy rests poetry's "very existence" on its difference from the common day's experience of words:

Let this measure be what it may, whether hexameter or any other meter used in Latin or Greek,—or Rhyme, or blank Verse varied with pauses and accents, in modern languages,—they are all equally removed from nature, and equally a violation of common speech.

Wordsworth could not let this idea stand unchallenged; could not, logically, propose a poetry that would reveal the paradise in the "common" day, while accepting that the poem itself gained its interest by being "a violation of common speech."

Reynolds went so far as to claim that a human mental "principle" made poetry still "more artificial, carries it still further from common nature, and deviates only to render it more perfect." That principle is "congruity, coherence, and consistency." Elevated language had to go with "sentiments" and actions "elevated above common nature," for "one uniform whole" to be produced.[33] If Wordsworth began by wishing to celebrate common scenes, this passage would have admonished him (had he not thought so already) that for "coherence's" sake alone, he must also try to find the poetry in common language.

"Many persons . . . accustomed to the gaudiness and inane phraseology of many modern writers," Wordsworth wrote in the first preface to *Lyrical Ballads* "will look round for poetry, and will be induced to inquire by what species of courtesy these attempts can be permitted to assume that title."[34] And, in truth, Wordsworthian lines like

> Now here, now there, an acorn, from its cup
> Dislodged, through sere leaves rustled, or at once
> To the bare earth dropped, with a startling sound . . .[35]

sound scarcely like poetry, to ears accustomed to

In vain to me the smiling mornings shine,
And reddening Phoebus lifts his golden fire;
The birds in vain their amorous descant join
Or cheerful fields resume their green attire . . .[36]

"In our time, every vanguard," Harold Rosenberg wrote in 1969, "in widening the horizons of art, introduces the threat of an ultimate dilution that will do away with art entirely. . . ." But what Rosenberg says characterizes the sixties begins with Wordsworth's effort to widen the word "poetry" over prose and mere real speech—and that threat of dilution was felt.[37] Byron, in his 1808 *English Bards and Scotch Reviewers* castigated Wordsworth on this point: "the dull disciple of thy school, / That mild apostate from poetic rule . . . / Who, both by precept and example shows / That prose is verse, and verse is merely prose . . . / . . . All who view [in Wordsworth's "Idiot Boy"] the 'idiot in his glory' / Conceive the bard the hero of the story" (lines 235–55, passim). Wordsworth accurately says that "a practical faith in the opinions" which he advocates "is almost unknown."

Almost unknown. Here, yet again, the Rev. Archibald Alison precedes Wordsworth in a fascinating way. In 1790 Alison was theorizing that all the arts, when they began, were preoccupied, at first, with alerting men that something new was going on, that the art objects or enactments being presented were not mere real things or acts. When men "first began to take pleasure in the exertion of their agility" and wanted "praise for their skill" they made the first "motions and gestures" those "farthest removed from the natural or easy motions of the body."[38]

The "same principle," Alison next reasoned, gave rise to "the invention of Rhyme and Meter in Poetry" which explains the "very remarkable fact" that poetry precedes prose in Western literatures. To show off their new "Skill" and set their artworks apart from that which happens naturally, poets tried to differentiate what they did "as much as possible from common language." So rhyme and meter, obvious choices, came to be considered the mark of poetry or art.

Reynolds had seen in artificiality the civilized pursuit of the ideal; suddenly Alison makes artificiality a primitive holdover, a relic of "a rude Age," of barbarity! "The greater and more important characteristics of the Art, a rude people must necessarily be unacquainted with. . . ."

Until the invention of writing, Alison hypothesizes, the form of the poems, of the laws, of everything composed had to be noticeably artificial to alert the listeners' attention that it had been done by design at all. After writing was invented, "what was written, was of itself expressive of Design," and "artificial Composition" was no longer needed. Of course, in 1790 rhyme and meter still persisted, but, as Alison calmly

said, persisted without any reason (notice how many of Wordsworth's ideas he forecasts in a single paragraph):

The discovery of writing, seems therefore naturally to have led to Composition in Prose.... the same cause should have freed Poetry from the restraints with which the ignorance or the necessities of a rude Age had thus shackled it; and that the great distinctions of Imagery, of Enthusiasm, of being directed to the Imagination, instead of the Understanding, etc. should have been sufficient distinction of it from prosaic Composition, without preserving those rude inventions, which were founded solely upon the Expression of Art.

Alison comes within an inch of creating Wordsworth's poetic only to stop, conciliatory as ever, and begin inventing the reasons which will everywhere continue to "prevent this natural effect" (of an unrhymed unartificial poetry coming to the fore). Foremost is "the permanence of poetical Models," and our "irresistible prejudice" for them, "even from no other cause than their antiquity."

Once again, Alison had seen where his reasoning led, had seen how large the consequences must be, and recoiled. (In distaste? Disbelief?) Wordsworth had no fear. He knew that if ideas like his were accepted, and carried to their logical conclusion, "carried as far as they must be carried, if admitted at all," then all our judgments, Wordsworth says boldly, "concerning the works of the greatest Poets both ancient and modern will be far different from what they are at present, both when we praise, and when we censure." The Rev. Archibald Alison had *no* taste for that sort of thing; but it was Wordsworth, after all, who had run off to join the revolutionaries in France.

Wordsworth as Natural Supernaturalist "Sage": The "Revolution of De-definition"

We can trace the shock that reversing the older aesthetic's goals dealt art by glancing at the Orwellian redefinitions of familiar words Wordsworth and Coleridge immediately embarked on: words as familiar as "poetry" (some of their new "poets" not only never write a line, but are illiterate!), "genius," "imagination." Whole libraries have been written about their fluctuating uses of each of these terms.[39]

In Victorian studies, John Holloway long ago studied the argumentative techniques of a genre he called the "Victorian Sage." Holloway's 1953 book was well known once, but so far ahead of its time it needs rediscovering. Holloway had nothing to learn from Foucault about the way intellectuals rig a discourse. The people Holloway politely calls "sages" are actually great tricksters: that is what Holloway would reveal. Carlyle's arguments, for instance, are not "factual" but "verbal," de-

signed to "justify the use of words in new, surprising, paradoxical or un-expectedly pregnant senses." To say what he "wished to say, Carlyle had to remould and modify a quite appreciable part of the language. On a scale not fully recognized, he created language."[40]

But Wordsworth and Coleridge did first. Though Romantic studies are much more reverent to the main figures' critical theories, Holloway's insights apply to them too. Criticism tends to speak of Wordsworth and Coleridge as if they had set out to discover new truths about poetry; Holloway examines the way Carlyle sets out to capture old words and make them mean new things. Holloway, for instance, identifies five clear "stages" in the way Carlyle "creates and exploits new senses" of a word or expression. Since Holloway, a Victorianist's interest perks up when-ever he finds an aesthetician using words like "true," "real," "highest," or even "essentially," coupled with familiar aesthetic terms, for example, "all *real* 'Art' is definable as Fact. . . ." "All poetry is *essentially* 'song'. . . ." Holloway even produces a two-page "Table" analyzing the "expansion of the sense" of the words "poetry" and "song" in the course of one Carly-lean essay. Carlyle's "sage" tactics, let us follow Holloway in calling them—if only so we can avoid French terminology—are often general Natural Supernaturalist ones. The Natural Supernaturalists needed to entirely invert an older aesthetic's values, but wanted to preserve its cen-tral terms, perhaps to make the revolution seem less revolutionary.

In any event, the battle against the old aesthetic involved, from the first, gaining control of the definitions. As a result, since 1800 life has been hard for aestheticians, particularly those trying to define art, which means, set some limit to it. The whole recently vexed question of the definition of art is bogus. For 2,300 years "art" was so easy for the West to define no one bothered, but pressed on to battle over which art was best.

"Art" only became hard to define after 1800 when it made people of a certain new religious orientation so nervous or envious they deliberately began changing the definitions. "For at least half a century, advanced painting and sculpture in Europe and then in America have been under-going a revolution of de-definition," Harold Rosenberg claimed. "Step by step, every attribute by which paintings have been identifiable as paintings . . . has been stripped off."[41] We shall find, however, that—just as Emerson anticipated concept art's attacks on the object—so Words-worth began Harold Rosenberg's "revolution of de-definition." Since Wordsworth's time the aestheticians have had competition: the Natural Supernaturalist artists themselves. They commonly expand terms like "art," "poetry," "sculpture" to cover more and more commonplace items. All along the battle has been largely, as David Antin has written of Du-champ's works, linguistic in nature; during the middle of the twentieth

century it becomes *primarily* linguistic in nature. Thinking back to Danto's prototypical transfigurationist, J, and his artwork "Bed," we realize that J did no *physical* work on his bed to convert it to an art object. He expanded the word "sculpture" to cover it. Like J's bed, often the objects aren't touched at all, only toted in to illustrate a kind of unwritten lecture on aesthetics. Is J an anti-artist or an aesthetician who uses some props? Sometimes at a show like J's, a written lecture even *is* provided, and one glances up from the very interesting catalog essay to the less-interesting objects offered as illustration then back to the true work—the catalog.

From 1950 to 1970, the artists'/aestheticians' accelerating expansion of art's definition outward made havoc in aesthetics. Rosalind Krauss calls attention to the linguistic nature of late transfigurationist art in her 1979 article "Sculpture in the Expanded Field": "In the hands of [postwar American art criticism] categories like sculpture and painting have been kneaded and stretched and twisted in an extraordinary demonstration of elasticity, a display of the way a cultural term can be extended to include just about anything."[42] When Abrams published *The Mirror and the Lamp* in 1953, he could still talk of the change from mimetic definitions to expressive definitions of what art does as a correction which had stood the test of time; but within a few years aestheticians were hunting replacements for the expressive definitions, which could no longer include the deliberately inexpressive "aleatory" work—deliberately "inexpressive" of anyone's personality—which Cage had successfully defined as art.

Definitions of what art "is" changed rapidly during the twentieth century as theorists, watching the circle spread to include more and more that had not been art, ventured that art's limit must be artwork with "significant form"; then any artwork that expressed a feeling; then not an artwork but an art object, dignified by an artist's election; then any random object at all; then, not even an object. The theorist/aesthetician had become engaged in a losing game *against* the artist/aesthetician, a game which began when Wordsworth started expanding the word "poetry" over what had been prose. Aestheticians should stop arguing over what art "is" and start studying what Natural Supernaturalism has done to it; stop doing philosophy and start doing history. The theorists of the 1950s are people trying to mark how far the artistic tide comes up the beach of mere real things. They then "de-fine" it, draw a line in the sand. But every five years this tide came half a mile further up the beach and swept away all their lines. Kennick's proposal, that you could not define "art" but if you sent a child into a warehouse it would come out with the works of art, was plausible in 1961 and preposterous five years later.

The very attempt to "define" art ("only those things which are expres-

sive," "only those things which have significant form") was futile, applied
to an intellectual tendency whose point was erasing definitions: "I have
the desire to just erase the difference between art and life," John Cage
frankly said.[43]

During the final triumphant years Natural Supernaturalists, led by
Cage or at least by his example, embark on an accelerating quest to show
every mere real thing the equal of any art object, transfiguring simple
colors, random blotches, Brillo boxes. Or—more accurately—the
artists/aestheticians expand the *definition* of art to include simple colors,
random blotches, Brillo boxes. Holloway frequently calls this tactic,
when Carlyle uses it, the "expansion" of a word. To expand art, the Natu-
ral Supernaturalists expanded language.[44] We will watch that start with
Wordsworth. Since 1800, the primary aestheticians have not been the
philosophers trying to define art but the artists/aestheticians relentlessly
expanding (to the philosophers' continued confusion) every proposed
definition.

In art and literature, at least, the need for such widespread word
battles in the nineteenth century were also created by the early Natural
Supernaturalist contradictions. By the 1960s, concept artists could be
quite simple and direct about valuing real things above art objects; they
could even frankly discard the art objects. But the first generations felt
great anxiety about such impulses: though Wordsworth writes "Close up
your books," though Ruskin says over and over of artworks, "The best in
this kind are but shadows," they were in no way ready to jettison the art
object. They remained in the anxious position of creating art objects
promoting the idea that the world was more worthy of one's attention
than the art objects they were creating.

For our purposes it will suffice to glance at a sample of the terms
to notice how Wordsworth and Coleridge systematically capture, invert,
expand the older aesthetic's words. Here the spirit of Harold Bloom's
sort of work can be genuinely helpful, for it asks us always to remember
we're dealing with English poets, who have a different approach to ex-
perience than German philosophers do. The English poets, for diverse
reasons, have favored presentations, "performances" of experience, in
Richard Kuhns's terminology, as opposed to "arguments," analyses of
experience. Trying to turn Coleridge, for instance, from a major English
poet into a minor German philosopher (though he himself might have
wished it) only opens him to such telling attacks as Norman Fruman's.
We miss the point of Coleridge's "sage" techniques, which Holloway,
looking at the Victorians, saw were not deceptions but a different sort of
artwork: in fact, the kind of aggressive aesthetics which Danto's charac-
ter J put forth.

As late as *Biographia Literaria* Coleridge can still praise what he calls

Wordsworth's "imaginative faculty" and tie it to "his original gift of spreading the tone, the *atmosphere,* and with it the depth and height of the ideal world around forms, incidents, and situations, of which, for the common view, custom had bedimmed all the lustre. . . ."[45]

In passages like this, Wordsworth and Coleridge seize an old term and qualify it, divide it into parts, link impressionistic adjectives to it (like the famous "esemplastic"); but modifying "imagination," for instance, into little more than ability to transfigure the commonplace leaves over so many normal uses of "imagination," inferior categories had to be devised for them. "Fancy," (originally a contraction of "fantasy") had been, as the *Oxford English Dictionary* tells us, "in early use synonymous with Imagination"; the OED quotes Milton's approval of Shakespeare as "Sweetest Shakespeare, Fancy's child."[46] Addison had announced he would use the two words "promiscuously" and did, in sentences like "the imagination can fancy to itself things more great. . . ."[47] Wordsworth and Coleridge capitalized on a trend John Trusler (1766) and James Beattie wrote of (1783) to consider "imagination" a more solemn word than "fancy." But they still had to fly square in the face of Johnson's *Dictionary* which, while obstinately defining "Imagination: 1. Fancy" and "Fancy: Imagination," furthermore sewed the ideal right into Imagination: "the power of forming ideal pictures." James Engell sums up, "the distinction between fancy and imagination" as Coleridge and his contemporaries made it, "is almost the reverse of that found in classical and mediaeval thought, which, in fact, persisted into the eighteenth century." In fact, "in this older distinction, the Greek *phantasia*, with its suggestion of a free play of mind, was the higher or more creative power."[48] After the redefinition, Wordsworth and Coleridge could, when they wished, dismiss traditional poetry, no matter how imaginative, as "fancy"—little better than wit. In Coleridge's lines quoted above, high art's attention has been turned 180 degrees from what Ficino termed *ardor divinarum rerum* to the adulation of what had been *malum.*

Wordsworth and Coleridge are even bolder with the highest English honorific word: "genius" had to be captured for their new aims. To accept artists with opposite aims as "geniuses" would certainly have jeopardized the new program. Ficino, Panofsky tells us, began the modern concept of "genius" in the Renaissance. The neoclassical genius wrote "what oft was thought, but ne'er so well expressed." Reynolds and the eighteenth century, Lee and Monk write, began using "genius" as a category to excuse and protect great artists who had not followed neoclassical rules—a tactic which not only protects the artists from the rules, but the rules from the artists. If Michelangelo reached greatness without following the Academy's rules, that is no judgment on the rules, if "genius" lies outside all rules.

That opened the door for a strategist to step in, fit "genius" with a definition, and capture a category the eighteenth century had already placed above "talents" who follow rules—or mere rules, by implication. The word "genius" had never meant, particularly in English, what Coleridge (and Wordsworth, elsewhere) now make it mean. With doctrinaire relentlessness, Coleridge redefines "genius" as the power of spreading their redefined "Imagination," claiming that it is "the prime merit of genius" and the most "unequivocal" proof of its existence, that it can show "familiar objects" in such a way as to "awaken" in others a "kindred feeling" about them, spread to others the genius's own "freshness of sensation"; a freshness, Coleridge remarks, which is also the "constant accompaniment of mental" and "bodily convalescence."

Had Bellori ever dreamed of acclaiming a person recovering from an illness as "imaginative," let alone a "genius"? The convalescent as "genius" became an even stronger theme in French poetry than English. Abrams shows it tied to the child-seer theme, citing Baudelaire's comment that the genius was *"un éternel convalescent . . . un homme-enfant,"* to whom "no aspect of life has become stale." The child, the convalescent, and the genius are but different manifestations of the same principle for Baudelaire: convalescence is "like a return to childhood," and "the genius is 'an eternal convalescent.'"[49]

But before that, Coleridge's genius was already an eternal child, one who could "carry on the feelings of childhood into the powers of manhood." This was the very "character and privilege of genius," this was a mark that "distinguished" genius from mere "talents." The genius could look at the scenes of "everyday" which had been "familiar" for "forty years" and still see them with a "child's sense of wonder and novelty."[50] As an instance, Coleridge exclaims,

Who has not a thousand times seen snow fall on water? Who has not watched it with a new feeling, from the time that he has read Burns' comparison of sensual pleasure, "To snow that falls upon a river / A moment white—then gone for ever!"[51]

But Coleridge misquotes. What Burns actually wrote was, "But pleasures are like poppies spread, / You seize the flow'r, its bloom is shed: / Or like the snow falls in the river— / A moment white, then melts for ever."[52] Burns, with the older aesthetic's humanistic values, wished to teach us the vanity of sensual pleasure, not awaken us to the beauty of the snow; Coleridge has revised Burns into Wordsworth.

He and Wordsworth also dealt as roughly with the eighteenth-century aesthetic category, "the sublime." A taste for it was implicitly at odds with the taste they wanted to create. Characteristically, they upend the term.

Samuel Holt Monk's summation of the sublime's career in the eight-

eenth century shows aesthetics hard put to keep up with a disquieting taste: people had "felt certain emotions" that were "incompatible" with their values. The early eighteenth century knew a lot about art, but it didn't know what it liked. We have read its sacred texts, and there is nothing in either Zeuxis or Phidias to explain to a rational Augustan gentleman his irrational joy in tree-smashing waterfalls, giddy precipices, raging seas. Such scenes were scarcely Ideal, nor would their *istorie* conduct your thoughts to Virtue.

Monk described how the eighteenth-century British explained to themselves that their perverse preferences for this material were in fact a noble taste for the "sublime." In 1756 the statesman-philosopher Edmund Burke (who would later attempt to explain away the French Revolution) conclusively stretched the old rhetorical category of the "sublime" to encompass all sights that "rob the mind of all its powers of acting and reasoning . . ." Whatever astonishes or terrifies is "therefore . . . sublime, too."[53] He was memorably rebuked by Richard Payne Knight, who wrote that if Burke had "walked up St. James's street without his breeches, it would have occasioned great and universal astonishment; and if he had, at the same time, carried a loaded blunderbuss in his hands, the astonishment would have been mixed with no small portion of terror: but I do not believe . . . any sentiment or sensation approaching to sublime. . . ."

Gradually, not only frightening experiences, but whatever experiences could not be covered by the normal explanation of "the beautiful" were tossed into "the sublime." Listening to later eighteenth-century accounts of the experience of the sublime, we find that people of taste have encountered pleasing objects neither useful nor traditionally beautiful, objects that seemingly took an act of will to enjoy. This act of will, further, seemed to be willing *not* to will, that is, ignoring one's self-interest.[54] Their "sublime" then, also included the class of objects not naturally beautiful, but, by an act of will, transfigured.

From the sublime to the aesthetic was but a step. The "sublime" acknowledged we enjoyed certain sights (like raging seas and towering cliffs) though they ran contrary to our self-interest or were useless to it. The size of a peak was enough to stun our human desires into a "powerless state of reverie," in Archibald Alison's phrase, similar, Monk points out, to Wordsworth's "doctrine of a 'wise passiveness.'"

Alison then drew the conclusion that Kant, looking at similar evidence, would draw: the contemplation of something apart from our self-interest produced "delight" (Wordsworth's word for it is "joy") while the contemplation of something for practical ends produces only "pleasure." Thus it was, I think, that Alison fashioned "a new creation" from

Hartley, Priestly, and Reid that is "strikingly similar to the ideas on which *Lyrical Ballads* is based."

It remained for Wordsworth to expand the sublime into harmlessness by stretching a concept fashioned for Alps and tigers to cover experiences of the common day. The "central paradox" of Wordsworth's "major period," M. H. Abrams contended, is the "oxymoron of the humble-grand, the lofty-mean, the trivial-sublime."[55] Paradox is far too charitable a word for Wordsworth's crafty maneuver against the sublime. A taste for the sublime was, like a taste for the Ideal, a threat to that taste for the commonplace Wordsworth had pledged himself to create. Wordsworth, dismayed by the sublime's implicit challenge to the commonplace's preeminence, put together a "sage" argument in which the *true* sublime is the mind powerful enough to find great emotions in little, ordinary objects and subjects. Byron was less charitable, but closer to the truth than Abrams, when Byron jeered that "the simple Wordsworth, framer of a lay / As soft as evening in his favorite May," was arguing ("in prose insane") that "Christmas stories tortured into rhyme / Contain the essence of the true sublime."[56] Shades of Rosalind Krauss's complaint that postwar aestheticians had "kneaded and stretched and twisted" aesthetic categories "to include just about anything."

After a childhood love of the conventionally sublime subjects, Wordsworth's obviously autobiographical Boy, in the *Excursion,* graduates and himself becomes "sublime and comprehensive":

> There littleness was not; the least of things
> Seemed infinite; and there his spirit shaped
> Her prospects, nor did he believe,—he *saw,*
> What wonder if his being thus became
> Sublime and comprehensive![57]

As Albert O. Wlecke explains, in the Wordsworthian sublime, one looks inward, and, in an act of "radical apperception," experiences sublimely one's *own* sublimity, one's "being . . . sublime and comprehensive!"

The egotism of it would have taken Addison's and Burke's breath away; though Wordsworth hastens to add

> Yet was his heart
> Lowly; for he was meek in gratitude
> Oft as he called those ecstasies to mind

Wordsworth's egotistical sublime did, in other poems, alienate Constable as a possible comrade when Sir George Beaumont first brought Wordsworth and Constable together. Even Geoffrey Hartman admitted

of the *Excursion* "that to read carefully its nine books is a massively depressing experience. . . ."[58]

For a final example, their new values required the most astonishing of the two friends' redefinitions: "poet."

> Oh! many are the Poets that are sown
> By Nature; men endowed with highest gifts,
> The vision and the faculty divine

At the end of the 1815 Essay Supplementary Wordsworth will repeat those lines, "the vision and the faculty divine," and rest the merit of all his poems on them. In these lines the narrator is, however, describing men

> wanting the accomplishment of verse

yet still, "poets," and not just any poets: the "highest" sort. An astounding redefinition: to be a "poet," one need no longer even write poetry—just have the "vision," be able to transfigure the common day.

What would Dante or Vergil make of this? "Poets" who can't write poetry?

> Yet wanting the accomplishment of verse
> (Which, in the docile season of their youth
> It was denied them to acquire, through lack
> Of culture and the inspiring aid of books,
> Or haply by a temper too severe.
> Or a nice backwardness afraid of shame.)[59]

If you bother to write your "vision" down, if you pick up the trick of making music with words, all well and good—but secondary, in fact unnecessary. "There is that indescribable freshness and unconsciousness about an illiterate person," Whitman will later say, "that humbles and mocks the power of the noblest expressive genius. The poet sees for a certainty how one not a great artist may be just as sacred and perfect as the greatest artist."[60] What could Reynolds have said to that?

Here again we find the new aesthetic's goals inverting the older aesthetic's (not to mention English's) old words: convalescents and children become the "highest" geniuses, "true" poets don't have to write poetry (or anything), and the "best" sublime is little, ordinary things.

Wordsworth: "Quit your books"

Such beliefs, born of disdain for art objects as but means to an end (an end which those "men endowed" have reached without needing to read poetry) is not adventitious to Natural Supernaturalism, but central to it.

What does the art object matter if you have already reached the goal? We have already read Emerson and Whitman's impatience with the art object. Reynolds had sent the student to learn the world's poverty by comparing it to ancient sculpture; Emerson congratulates the race on having outgrown "stone dolls." Wordsworth in his "Prospectus" had declared that an hour's walk would turn up beauty "surpassing" anything the artist could create. Emerson and Whitman long candidly for the day when the general eye is opened to the daily miracle and they can say, away with your nonsense of oils and easels; the day when humanity will no longer need to see the world through a dead poet's eyes. The 1814 "Prospectus" spoke of Wordsworth's lonely longing for that "blissful hour." In Natural Supernaturalism's very first moments, the first two poems of the 1800 *Lyrical Ballads*, Wordsworth calls for the end of art. It's only what we should expect. He had already adopted an aesthetic in which the simple produce of the common day "surpasses" anything art offers—even poetry.

Lyrical Ballads begins with two complementary poems, "Expostulation and Reply" and "The Tables Turned—an evening scene on the same subject." That subject? The relative worth of real things and an artwork—specifically this book of poems the reader has just started. Whitman was not the first to tell us we no longer needed to look through his eyes. Wordsworth opens his book by telling the reader to close it.

Like Emerson and Whitman, Wordsworth is resigned to the existence of.artworks in his time. Although in 1810 he will be equating "arts" with unnecessary "ornaments" that "break in upon the sanctity and truth of [the artist's] pictures,"[61] he acknowledges that for now "the adversary of Nature (call that adversary Art or by what name you will) is *comparatively* strong."[62] "Alas!" he cries, "ages must pass away before men will have their eyes open to the beauty and majesty of Truth, and will be taught to venerate Poetry no further than as she is a handmaid."[63]

Wordsworth's two opening poems agree: they are so radical that, despite their prominent—indeed, primary—position in the book, critics have, again, refused to deal with what the poems clearly say. It was as unthinkable—as anomalous—as what Hegel's philosophy or Emerson's "Art," similarly slighted, proposed.[64] Jack Stillinger speculates that the Wordsworth poems are "playful," and other critics don't even go that far.[65] "When Wordsworth attacks book-philosophy he is nearly always," Geoffrey Hartman conjectures about these two poems, "attacking 'moral philosophy': those who emphasize the role of self-interest or seek to counter this emphasis by process of reasoning."[66] That's true in general, but these texts specifically attack *"books"*—and even "Art."

> "Why, William, on that old grey stone,
> Thus for the length of half a day,
> Why, William, sit you thus alone,
> And dream your time away?
>
> "Where are your books?—that light bequeathed
> To Beings else forlorn and blind!
> Up! up! and drink the spirit breathed
> From dead men to their kind.

We can't miss the double entendre in those last two lines: books—like the one the reader holds—are "the spirit breathed" by "dead men" to others as dead as they. Nor can we miss the obnoxiousness of:

> "You look round on your Mother Earth,
> As if she for no purpose bore you;
> As if you were her first-born birth,
> and none had lived before you!"

The narrator, we soon learn, castigates a man in the state Wordsworth and Coleridge redefined as "genius," contemplating the earth with "feelings as fresh," as if it all had just "sprung forth," the divine (and bookless) state of those highest poets.[67]

> One morning thus, by Esthwaite lake,
> When life was sweet, I knew not why,
> To me my good friend Matthew spake
> And thus I made reply.
>
> "The eye—it cannot choose but see;
> We cannot bid the ear be still;
> Our bodies feel, where'er they be,
> Against or with our will.
>
> "Nor less I deem that there are Powers
> Which of themselves our minds impress;
> That we can feed this mind of ours
> In a wise passiveness.[68]

Wordsworth, then, is experiencing the natural "Powers" directly when Matthew tells him he must go learn from books or else be "blind"—tells Wordsworth that at a moment he is seeing and a Seer.

Wordsworth makes the companion poem even more explicit: "The Tables Turned: an evening scene upon the same subject." The "turning" is *not* the offering of an antithesis to the argument the first poem presented. In the first poem a friend called Wordsworth from real things to art objects and Wordsworth refused; in the second Wordsworth calls a friend from art objects to real things. These are two poems with a single message, which Wordsworth doubly reinforces by buttressing it from two

sides. The two poems treat the "same subject," the relative worth of art objects and mere real things.

"Up! Up!" Wordsworth begins, echoing Matthew's words to him,

> Up! up! my Friend, and quit your books
> Or surely you'll grow double:
> Up! up! my Friend, and clear your looks;
> Why all this toil and trouble?
>
> The sun, above the mountain's head,
> A freshening lustre mellow
> Through all the long green fields has spread,
> His first sweet evening yellow.
>
> Books! 'tis a dull and endless strife:
> Come, hear the woodland linnet,
> How sweet his music! on my life,
> There's more of wisdom in it.

We must give Wordsworth credit for daring. The first pages the reader reads attack reading: quit *this* book or you'll grow double, the sun is shining, go and see it. Not until John Cage's 1952 4'33" of silence could it have been credited that a serious artist—no prankish Dadaist—could say that and mean it. It's no trope, but in fact an act of conscience, the only way Wordsworth can create a book of poetry yet stay consistent with his principles.

Wordsworth, as self-conscious an aesthetician as any poet ever was, realized the contradiction in calling people to mere real things by giving them yet another special object with which to distract themselves. For now, however, people require artworks to "enlarge" their "sensibility." So Wordsworth creates his artwork, but puts these admonitory poems—not one poem, but two "upon the same subject"—in the most prominent position he can: first.

> And hark! how blithe the throstle sings!
> He, too, is no mean preacher:
> Come forth into the light of things,
> Let Nature be your Teacher.

Not Wordsworth; not the book you've opened.

> She has a world of ready wealth
> Our minds and hearts to bless—
> Spontaneous wisdom breathed by health
> Truth breathed by cheerfulness.
>
> One impulse from a vernal wood
> May teach you more of man,

> Of moral evil and of good,
> Than all the sages can.
>
> Sweet is the lore which Nature brings;
> Our meddling intellect
> Mis-shapes the beauteous forms of things:—
> We murder to dissect.

One often reads that last line patched together with the famous slash at scholarly 'reason' as "that false secondary power which multiplies distinctions." Read in context, however, the line is Wordsworth's opening blow at the Ideal, particularly the Zeuxis wisdom he had read in Reynolds's *Works* (and which he attacked later in the "Prospectus") of dissecting the "beauteous forms of things" to recombine them into special art objects. That academic dissection (a wonderfully grisly word to describe Reynolds's "laborious comparison") will murder, as Ruskin later said, all possible delight in them: "we murder to dissect." "He who feels contempt for any living thing," Wordsworth will himself later say, betrays that he has "faculties / Which he has never used."

Mere real things, "beauteous forms of things," are better than any ideal object. The "Science" dismissed in the next line must therefore be the meticulous training we encountered in Reynolds, Bellori, DuFresnoy, et al. (That line has bewildered critics, since Wordsworth is normally respectful of science. The "Science" he's had enough of here is the "meddling" academic method mis-shaping "the beauteous forms.") But even more important is Wordsworth's repudiation of the last word in the next line:

> Enough of Science and of Art;
> Close up those barren leaves;
> Come forth, and bring with you a heart
> That watches and receives.[69]

Wordsworth says "Enough . . . of Art." Like Emerson, he knows what he means and he has made no mistake. Enough of Art. Until recently, however, it was very difficult to believe that a serious artist could write that and mean it.

In his manifestolike "Prospectus" he would pray for the moment described in these first two poems, when humankind could say "enough of art" and "come forth into the light of things." From the first, Natural Supernaturalism was planned to end with the books closed; with the artist's audience abandoning the gallery and the stone dolls; with Matthew rising from his books to join Wordsworth in the contemplation of the world; with John Cage and David Tudor sitting silently before an untouched piano, listening to the rain strike the leaves outside the Wood-

stock concert hall. That, however, would take one hundred and fifty-two years to achieve.

B. *Thomas Carlyle: Natural Supernaturalism*

Harold Bloom and the Question of "Influence"

Thomas Carlyle, a generation younger than Wordsworth, a generation older than Ruskin, is M. H. Abrams's paradigmatic Natural Supernaturalist. In deference to his influence and cultural centrality Abrams took his term for the "intellectual tendency" not from Wordsworth but from Carlyle. Abrams saw that Carlyle made explicit what others had left implicit. Abrams cites Carlyle's decree, in *Sartor Resartus,* that since the modern world could no longer believe in the "Mythus" of the Christian religion, the great need now was "to embody the divine Spirit of that Religion in a new Mythus." In saying that, in the 1830s, Carlyle "precisely defines a cardinal endeavor of the preceding Romantic generation: to its results we can apply another phrase from *Sartor Resartus*—'Natural Supernaturalism'. . . ."[70]

Studying Carlyle, we will not only see Natural Supernaturalism most clearly, we will learn what Abrams's specimen Natural Supernaturalist considers the role of the arts and the worth of the art object. That will be illuminating.

Above all, now that we've come to Carlyle we can (indeed, we must) face the question of "influence." We have already encountered artists who seem to echo earlier ones, even seem to rewrite or revise them. We shall meet more. What do we imply when we say a Joseph Kosuth passage or a Susan Sontag argument "sounds like" Emerson? What do we imply when we remark how John Cage sounds like Wordsworth or John Muir? Are we implying what Harold Bloom calls "misprision," a creative misreading of an earlier text? Did Cage read "The Tables Turned"? How does an "intellectual tendency" like Natural Supernaturalism percolate through a culture? F. R. Leavis tried to make us realize that there lay Carlyle's significance.

In his 1950 "Introduction" to Mill's essays on "Bentham" and "Coleridge" Leavis asks us to include Carlyle beside those two, saying that though Mill himself might not be conscious of "any particular view or change of view that he owes to Carlyle," yet that had already happened. Carlyle was one of those who changed the "total sense of things—of human experience and the problems implicit in it—upon which analysis operates, and which conditions the analytic process. . . ."

There, Leavis concluded, lay Carlyle's great importance. Leavis says

he is aware that by the time he writes, 1950, it has become "hard" to remember why Carlyle "in his own time" was felt to be "so great and profound an influence. . . ."

The kind of "influence" Carlyle exerted was akin (I will argue) to the influence Mill ascribes to Bentham and Coleridge. "Coleridge," Mill wrote, "used to say that everyone is born either a Platonist or an Aristotelian," and now contemporary Englishmen were "by implication either a Benthamite or a Coleridgean."[71] Mill, writing in the 1830s of Bentham and Coleridge, put the situation perfectly, saying that though "the multitude" has only read their "slightest" works, and even then their readers had been "few," they had been "the teachers of the teachers." Mill wants to "renew" a lesson which each age learns the hard way but which each new age disregards: "speculative philosophy," which the "superficial" think the thing most "remote" from men and from the "business of life" is in fact "the thing on earth which most influences them. . . ."

Mill's point and Leavis's point is exactly that the Benthamite need not have read Bentham; certainly need not have "misread" him. If this kind of author is successful, there is no need to read him. On the contrary, the truly successful teachers—"the teachers of the teachers"—need not be read at all. They have become incorporated in the *Weltanschauung* and their influences "diffuse themselves through the intermediate channels over society at large."[72] George Eliot made that point about Carlyle. Why ask if Carlyle's books would actually be read "a hundred years hence"? It was, she wrote, by 1858, already an "idle question." Carlyle's influence would be there whether his books were read or not. If all of them were to be "burnt on the grandest of Suttees on his funeral pile, it would be only like cutting down an oak after its acorns have sown a forest. For there is hardly a superior or active mind of this generation that has not been modified by Carlyle's writings; there has hardly been an English book written for the last ten or twelve years that would not have been different if Carlyle had not lived."

This idea of influence is at odds with one current way of interpreting "influence" situations; and, more important, at odds with the way in which many of this era's writers specifically have been interpreted, by Harold Bloom. Despite some later cautions about his beliefs, they remain substantially as he expressed them in the "Manifesto" of *The Anxiety of Influence*:

Summary—Every poem is a misinterpretation of a parent poem. A poem is not an overcoming of anxiety, but is that anxiety. Poets' misinterpretations or poems are more drastic than critics' misinterpretations or criticism, but this is only a difference in degree and not at all in kind. There are no interpretations but only misinterpretations, and so all criticism is prose poetry.[73]

Bloom's theory, an elegant version of the simplest idea of causal rela-
tionship—*post hoc ergo propter hoc*—simultaneously demoted poetry and
promoted criticism. Many critics found Bloom's temptation irresistible.
In that book he is appropriately fascinated with Milton's Satan, calling
him the "archetype of the modern poet at his strongest";[74] but Milton's
Satan, capable of originating nothing, is only a critic: and reading
Bloom's book one remembers "Lifted up so high / I sdein'd subjection,
and thought one step higher / Would set me highest, and in a moment
quit / The debt immense of endless gratitude. . . ."[75]

Poetry becomes, for Bloom, "the anxiety of influence," becomes "mis-
prision." "Poetry (romance) is Family Romance," in which son poets
grapple with "precursor" father poets.[76]

Bloom's is a (let us give him credit) poetic but simple way of dealing
with one of the recurrent, broad philosophic questions. Indeed a ques-
tion so enormous that after these few pages I will firmly shut the door
on it, for it would pull us right out of this book. What gave rise to much
of Hegel's philosophy, and eventually the concept of the *Weltanschauung*,
was the attempt to deal with what Richard Kuhns has called "the difficult
problem" of "describing the unity we feel" in an epoch's manifesta-
tions.[77] As Karl Mannheim puts it in "On the Interpretation of *Wel-
tanschauungen*," "Interpretation serves for the deeper understanding of
meanings; causal explanation shows the condition for the actualization
or realization of a given meaning."[78] Bloom tries to handle this enor-
mous topic as if he were observing something that only happens in litera-
ture, particularly late Romantic literature, which puts him at a terrible
disadvantage: he is trying to seize the hydra by one head.

As soon as we recall the familiar idea of the *Weltanschauung*, we realize
Bloom's theory pointedly ignores it. Theories such as Bloom's require
direct contacts, require the later poet to be consciously aware of the
"precursor's" work in a detail which is often quite unlikely. In this book
we would be about to start fitting Carlyle inside of Wordsworth (or Kant
or Fichte), then Ruskin and Emerson inside of Carlyle, like that old car-
toon in which each fish is eaten by a bigger fish.

It is too simple an idea of cultural causal relationships to stand by
itself: it needs a great complication of flying buttresses. When we com-
plain we find in a later passage insufficient resemblance to the suppos-
edly influencing passage, Bloom's too-efficient theory then explains that
the later poet has altered or misinterpreted the earlier passage ("clina-
men," "tessera," "kenosis," etc.) The pseudo-Freudian explanations ex-
plain why the later poet also disguised the evidence of his knowing and
misreading the influencing passages. "Do strong poets gain or lose
more, *as poets*, in their wrestling with their ghostly fathers? Do clinamen,

tessera, kenosis, and all other revisionary ratios that misinterpret or metamorphose precursors help poets to individuate themselves, truly to be themselves, or do they distort the poetic sons quite as much as they do the fathers?"[79]

Clinamen, kenosis, and the rest too easily decline into examples (even in their nomenclature) of what David Antin, a scientifically educated poet, once described: the famous "finagle variable" in recent physics. To preserve a certain paradigm, yet explain why a lower number of electrons flowed out of a substance than flowed in, a new physical entity had once been seriously proposed, "the electron hole." The electron hole had a kind of naked beauty: it was an entity which would be "capable of absorbing electrons" so that whatever results you unfortunately had, "could be made equivalent to the answer that you wanted." The electron hole was but one example of the "finagle variable"—"any magnitude any constant any number any equation anything that you can associate by any means whatsoever, to the number that you have in hand that will give you the number that you want, provided only that it is proposed with the right manners or in the right dialect. . . ." Kenosis, askesis, and the rest are so sweeping, they can explain *any* lack of resemblance or lack of evidence as some intricate kind of influence. They become finagle variables, "influence holes."

The finagle variable, then, complements Kuhn's discussion of "anomalous facts." To preserve a paradigm, whatever exists but doesn't fit becomes unimportant and soon, invisible. Whatever should exist (phlogiston, ether, electron holes) soon will.

Antin, writing before Bloom's theory was published, was making an important point about culture as a "sacred discourse." Even something like the "electron hole" can be proposed, as long as it is proposed "with an apparatus of appropriate discourse . . . a kind of oligarchic conversation. . . ."[80] The simpler the theory, the more hieratic the terms must be. Explaining why a son poet doesn't look enough like a father, one can't say "influence hole" but "*Clinamen* . . . I take the word from Lucretius, where it means a 'swerve' of the atoms so as to make change possible in the universe. A poet swerves away from his precursor, by so reading his precursor's poem as to execute a *clinamen* in relation to it."[81] Choosing (from Lucretius!) a term like *clinamen* (which one must "execute") is both comical and wonderful. Bloom, that old Kabbalist, knows that criticism, like science, is a "sacred talking."[82]

Surely, what Bloom says always happens sometimes happens. Human experience is infinitely varied and why should not direct causal relationships sometimes happen too?[83] Staying with the subject at hand, Carlyle did creatively misinterpret the German philosophers. Since 1948, how-

ever, we have had John Holloway's analyses of the Victorian sage's techniques, so this was no revelation. Could it ever have been? Did we need anyone to tell us that—from time to time—poets have engaged in wrestling matches with their great precursors? It was the central critical problem for Roman art and literature (culminating, in literature, with Vergil's use of Homer). Bloom has, to this ancient discussion, contributed interesting insights and a specialized terminology. He can be said (and I mean this as real praise, not faint praise) to have extended Holloway's work.

Bloom's work produces such interesting results when used on certain scholarly, not to say bookish, poets; the unfortunate thing about his work is that, when widely applied, those too-efficient categories of his become finagle variables and create not insights but a giant reduction.

I am at pains to separate myself from this theory of causality because it itself has almost become part of the *Weltanschauung* when critics look at the figures I deal with. In this book, as we pursue that elusive sense of unity, making comparisons between writers and artists, the reader, familiar with Bloom's work, may assume that Bloom's sort of simple influence is the conclusion I am leading up to. Worse, for many of these figures, even the best studies have often routinely drawn such conclusions. One can hardly speak of Wordsworth's and Constable's affinities without recalling that whole tradition of criticism (Kenneth Clark, Herbert Read, Morse Peckham) in which Constable becomes Wordsworth's disciple. Leger becomes a Futurist, the Futurists become Walt Whitmanites, Whitman is influenced by Emerson, Emerson is in thrall to Wordsworth who himself, in Bloom's version, is Milton's ephebe. (Since—worse luck!—John Cage's full name is John Milton Cage, I want to divorce myself from this line of thinking immediately.)

By contrast, my research supports another sort of "influence."

Ironically, Bloom's theory doesn't give the powerful founding figures credit *enough*. Any really successful writer no longer has to be read. Someone like Carlyle, the writer to whom we now turn, comes to so thoroughly pervade a culture that he enters the collective *Weltanschauung*. Not all of him. A small distinctive abstract of him becomes part of what any "cultured" person assumes. This abstract is part of one's premises. One does not think *of* him, one thinks *with* him, uses him to think. After a while, Leavis is saying (and it is no more than the truth) it was not necessary to read Carlyle—one thought with Carlyle. To the extent that later writers were "cultured" men, they can seem to be Carlylean, for the culture they saw had been colored by the tint he gave their lenses.[84]

The nineteenth century knew Thomas Carlyle's Natural Supernaturalism much better than it did Wordsworth's. Carlyle's emphatic prose

versions—not buried in prefaces, implied in poems, or obscured by a foreign language—had the greatest influence on Anglo-American culture. Partly, Carlyle was lucky in his disciples. Carlyle's admirer and sometime literary agent, Emerson, assimilated Carlyle's ideas to America, where they fused with transcendentalism's core. Emerson's admirer, Whitman, became so popular in translation he spread augmented versions all over the world.[85] As Betsy Erkkila has described in *Walt Whitman Among the French,* Whitman's translation there during the Cubist decade created a mania for him among Continental writers and artists: it's startling to hear the Futurist sculptor Boccioni promoting his own work as "physical transcendentalism." But much earlier we find a copy of Carlyle's *Sartor Resartus* prominent in Gauguin's portrait of his roommate de Haan. Van Gogh writes warmly of *Sartor.*[86] Carlyle's main English disciples were no less than Dickens, who dedicated *Hard Times* to him, and Ruskin, who, after his father's death, wrote Carlyle almost daily letters, starting, "Dear Papa Carlyle."

Fortuitously, an extraordinary incident which happened to John Ruskin led him to make my very point—and Eliot's and Leavis's—about the subterranean way Carlyle's influence had spread. Ruskin even did so to refute a student who had proposed to him a Bloomian idea of influence, picturing Ruskin as a deceitful son wrestling with a poetic father—Emerson—and concealing the influence. This happened in the 1850s, a decade before Carlyle had even reached the "zenith" of his influence (as criticism calls it). One of Ruskin's students at the Working Men's College, in that helpful spirit which animates certain students, had come forward with a copy of Emerson's poems and implied Ruskin had been doing some misprision, so to speak. Ruskin, to his horror, found some of the poems "so like" parts of *Modern Painters'* end, "even in turns of expression" that he was certain the student was not alone in his suspicions. Ruskin felt the need to publically "justify" himself of the "charge of plagiarism." In an unprecedented appendix, frankly titled "Plagiarism," Ruskin explains that he doesn't have to read Emerson's poems to sound like them because he always reads Carlyle. He knows his mentor to have been one of Emerson's, and says he has read Carlyle "so constantly," that without consciously meaning to imitate him "I find myself perpetually falling into his modes of expression. . . ." So does Emerson, Ruskin means, and that's why he and I share a sibling resemblance.[87]

This incident bears out both Leavis and Mill. Carlyle, Ruskin is testifying, had been the teacher of the teachers. We want to further notice that Ruskin's working-class student was thereby becoming Carlylean without having to read Carlyle. The unwitting student even recognized the root similarity in the education he got from Ruskin and Emerson.

Ruskin explains it was the Carlylean element they share. The student, like Bloom, confronted by the similarity, ascribed it to plagiarism (and without Ruskin's account, might not Bloom too? And how could we have refuted him?). Ruskin was forced to instruct the student in the subtler ways that influence can also spread.

In the manner Ruskin describes, a small part of Carlyle's thirty-volume oeuvre became important to the West: the Natural Supernaturalist part which entered the general Western *Weltanschauung,* our culture's "total sense of things—of human experience and the problems implicit on it." Through their acculturation, later writers acquired it as part of their own *Weltanschauungen,* a Natural Supernatural tint in the lenses of those mental spectacles we can never remove; a tint coloring their perception of the "total sense of things."

Carlyle: Natural Supernaturalism

Carlyle's *Sartor Resartus* gives us the core statement of the new religious intellectual tendency. Though there were earlier models, *Sartor* became the nineteenth century's paradigm account of the fall to unbelief, journey through a dark night of the soul, and reawakening into Natural Supernaturalism.[88] "The loss of his religious Belief," *Sartor's* narrator writes of the hero, Diogenes Teufelsdrock, is "the loss of everything." The world becomes a "grim desert," as he encounters "The Everlasting No." Since the Enlightenment, that is the "common lot" for anyone who isn't "purely a Loghead. . . . The whole world is, like thee, sold to Unbelief. . . ."[89] The popularity of these passages tells us a lot about the nineteenth century's spiritual state. As late as 1927, D. T. Suzuki, beginning his central work on Zen Buddhism, the *Essays, First Series,* would confidently begin by discussing The Everlasting No—never even bothering to mention Carlyle's name. One could assume everyone knew.

Diogenes, like Carlyle, saves himself, reaches the Everlasting Yea, by realizing that spiritual experience doesn't change, only the words and forms men had wrapped around it: the "Mythus." They were little better than clothes the experience wore, and gradually they turned into rags. Christianity had been but such a Mythus; Christianity at last wore to rags. There remained, however, the vital body beneath, and in *Sartor* Carlyle already knew what its very heart was: the enraptured contemplation of our earthly existence. Carlyle, Diogenes, and later, Stephen Dedalus[90] realize that finding a new way to talk about spiritual experience, translating the eternal spiritual impulse into terms, a "dialect," this age can live with, is to be their calling. (How great an improvement is the term, "discourse?") "For it is man's nature to change his Dialect from century to

century; he cannot help it though he would." In the 1940s, Suzuki and Cage actually changed that "dialect" from a Western to an Eastern one, without ceasing to speak of these same "spiritual truths." Fashioning that new dialect, stripping off the rotted dialect-mythus-discourse-"clothing" that hides the world's wonder from our eyes, is the work of one whom Carlyle calls "poet."

Like Wordsworth's poet—and Whitman's, later—Carlyle's differs in degree, not in kind, from other men. "A vein of Poetry exists in the hearts of all men," but "a man that has so much more of the poetic element developed in him as to have become noticeable, will be called Poet by his neighbors." Again: no mention of whether the "Poet" writes poetry. In fact, this Poet might be above writing poetry, unless in the mood; what counts is his "poetic nature." What is called the "poetic" element is here, more explicitly than in Wordsworth, simply the religious element, and the "poetic" nature is the religious nature—or, some would say, its replacement. Carlyle claims in "The Hero as Divinity," that by raising us to wonder, the poet-prophet raises us to worship: "worship is transcendent wonder." "Through every star, through every blade of grass, is not a God made visible, if we will open our minds and eyes?"[91]

The careful reader will notice that Carlyle says "a God." He rarely says "God," unless he has provided a specific antecedent, as in the sentence "the name of the Infinite is GOOD, is GOD." He prefers to use words like "the godhead" or his favorite, "the godlike." That's the quest of the poet—who, as for Wordsworth—is no longer someone who writes poetry. The "poet" is now anyone who finds a God or the godlike in the simple produce of a common day. "Proof of what we call a 'poetic nature' [is] that we recognize how every object has a divine beauty in it; how every subject still verily is a window through which we may look into Infinitude itself. He that can discern the loveliness of things, we call him Poet, Painter, Man of Genius. . . ."[92] Whether he bothers to scribble any of his visions down, or daub any canvases with it, is secondary. "Whether he write at all" will depend on "extremely trivial accidents—perhaps . . . on his being taught to sing in boyhood!" Lacking such an accident, he may become "perhaps still better, a Poet in act."[93]

In *On Heroes, Hero-Worship and the Heroic in History* Carlyle, trying to get back to the living flesh beneath the rotting clothes of theism, replaces "worship" with "wonder," heaven with earth, and—his boldest move— Jesus and God with the Hero. "All religion hitherto known," he claims, "stands" on Hero-worship.

Hero-worship . . . is not that the germ of Christianity itself? The greatest of all Heroes is One—whom we do not name here! Let sacred silence meditate that

sacred matter; you will find it the ultimate perfection of a principle extant throughout man's whole history on earth.

The hero, dropped into a superstitious period, becomes a God; as superstition declines, the hero is treated consecutively as a prophet, priest, poet—but always "to this hour . . . the vivifying influence in man's life."[94]

Had we not suspected that the ex-minister Carlyle was trying to mitigate, for his era, the loss of someone in particular, he gives us pretty obvious clues. He presents Luther born in a little "hut" and comments "there was born here, once more, a Mighty Man; whose light was to flame as the beacon over long centuries. . . . It leads us back to another Birth-Hour, in a still meaner environment, Eighteen Hundred years ago,—of which it is fit that we *say* nothing, that we think only in silence. . . ."[95] You haven't lost Jesus, Carlyle tacitly reassured the sorrowing English. All Jesus ever was, was a hero—and hero he remains, "vivifying" our lives.

What was implicit in early Wordsworth is explicit in Carlyle: a new Hero Poet must arise to convert literature into the new religion. Or, more accurately, reduce it to the new religion, cast out every role for himself as poet but the *vates* role. Literature is pictured as a huge, generally contemptible "froth-ocean" which nevertheless has scattered in it "fragments of a genuine Church-Homiletic . . . even of a Liturgy. . . ." Years before in "Characteristics," Carlyle had tried to annex literature for religion: "Literature is but a branch of Religion, and always participates in its character: however, in our time, it is the only branch that still shows any greenness; and, as some think, must one day become the main stem."

"It is in his stupendous Section, headed *Natural Supernaturalism,* that the Professor first becomes a seer."[96] "There are those," Carlyle wrote just before writing *Sartor,* "who have to realize a Worship for themselves, or live unworshipping. The Godlike has vanished from the world; and they, by the strong cry of their soul's agony, like true wonder-workers, must again evoke its presence. This miracle is their appointed task. . . ." In *Sartor Resartus,* his task.

The most sinister of the many Weavers hiding the shining world from Man is habit, "custom." Custom makes "dotards" of all of us, plays on us innumerable "illusions and legerdemaintricks." Her cleverest trick is the way she can persuade us "that the Miraculous, by simple repetition, ceases to be Miraculous." In *On Heroes, Hero-Worship,* pressing this theme, Carlyle would go on to remind us of "that fancy of Plato's," of a man raised in some "dark distance" taken out to see his first sunrise. "What would his wonder be, his rapt astonishment at the sight we daily witness

with indifference!" He would recognize it as "Godlike, his soul would fall down in worship before it."

Custom weaves four principle garments to hide Life's wonder from us: Names and their offspring Science; Space and Time. So surprisingly potent are names that a man who never saw a sunrise would respond to it partly because it as yet "had no name to him; he had not yet united under a name the infinite variety of sights, sounds . . . we now collectively name Universe, Nature . . . and so with a name dismiss from us." Names subtly, inevitably stereotype experience and thereby hide its infinite variety from us: we say *a* sunrise, *a* cloud, *a* meadow. To the person who manages to *see* the earth "not veiled under names," it stands "naked, flashing in on him there." Science supplies new names to things in its efforts to explain them. It weaves yet another shroud between us and reality. Carlyle is no technophobe, but he fears the way that in our efforts to control the world we can lose our most valuable experience of it:

We call that fire of the black thunder-cloud "electricity" and lecture learnedly about it and grind the like of it out of glass and silk: but *what* is it? What made it? Whence comes it? Whither goes it?. . . . This world, after all our science and sciences, is still a miracle . . . on which all science swims as a mere superficial film . . . wonderful, inscrutable, *magical...* to whosoever will *think* of it.

Revising Kant's terms, for Natural Supernaturalist ends, Carlyle adds Space and Time to his list of "custom-woven, wonder-hiding garments." Space and Time are mere "illusory appearances, for hiding Wonder." They are only "Forms of Thought," whose "thin disguises hide from us" the greatest miracles. We would think it miraculous if Carlyle stretched forth his hand and clutched the Sun, but, deceived by Space, we see no miracle when he stretches forth his hand to clutch the things around him. "Art thou a grown baby, then, to fancy that the Miracle lies in miles . . . and not to see that the true, inexplicable God-revealing Miracle lies in this, that I can stretch forth my hand at all . . . ? Innumerable other . . . are the deceptions, and wonder-hiding stupefactions which Space practises on us."[97] Time plays similar tricks. If the universe had been created two hours ago, we would marvel at it. Because it was created two trillion hours ago, we cease to wonder. Is that logical, Carlyle asks? Through these and countless similar arguments he reasons us into wonder for all mere real things.

Carlyle and the Art Object
"One of the Deadliest Cants"

Carlyle, then, is rightly Abrams's specimen Natural Supernaturalist, from whom Abrams justly takes his term for the entire "intellectual ten-

dency." Of great interest, then, will be this archetypal figure's opinion of the art object. What have Carlyle's deep Natural Supernatural convictions led him to say about painting, sculpture, or even novels and artworks in general?

Very little—and almost all hostile. Carlyle on art is painful reading, but not at all the simple philistinism even a fine critic like John D. Rosenberg has—with regret—assumed it to be. Apart from the characteristically violent tone which disfigures much of his work after 1850, his disdain for art is on principle, like Emerson's. Where he approves he accords with the Natural Supernatural beliefs expressed in his other writings; as where he disapproves. My goal, as before, is to untangle Natural Supernaturalism from any necessary connection with art, to bring out full the significance of what Abrams and Bloom have already admitted, that it is not a form of art but a form of religion. That done, we can again consider whether this particular "intellectual tendency" might not be intrinsically *anti*-art, and only temporarily using the artworld's tools. Reading Carlyle, Abram's paradigmatic Natural Supernaturalist, we grasp most firmly that this tendency is logically, inherently anti-art. Apart from the small portion that he can bend into Natural Supernaturalism's service, Carlyle thinks artworks but "chaff" that were better "severely purged away."

In a word, the specimen Natural Supernaturalist detests art. He values almost anything but art objects, values almost everything above them. His lifelong fear, abundantly recorded, is that he will fail, and people will consider his works "art." As far back as 1834, frightened that England would not heed the warning in his epic *The French Revolution,* Carlyle wrote in his journal, "Alas! . . . If this should be a *work of art.* Poor me!"

His exhaustively researched histories and biographies, particularly the *French Revolution,* were standard history works in their time and have only gravitated to the English department as better documented works became available to historians. He himself feared that might happen. "I am wearied and near heartbroken," he confides to his journal after finishing *Cromwell.* "Nobody on the whole '*believes my report,*'" he writes, echoing the prophet. Instead even the "friendliest reviewers" have dwelt on the work's artistry—"The Blockheads!" They read him, he laments, the way they'd watch a "wonderful athlete . . . a ropedancer whose perilous somersets are worth sixpence to see." He damns their "eulogies" on his art—"I do not believe in 'Art'—nay, I do believe it to be one of the deadliest *cants;* swallowing . . . its hecatombs of souls."[98]

We only connect Carlyle with literature and the "arts" because most of us encounter him not in divinity school (he himself trained for the ministry) but in the English department and its anthologies. The transi-

tion to "art" that he feared for his jeremiads is complete. For instance, in the collection Oxford University Press calls its anthology of English *literature* we find Carlyle next to that other poet, Cardinal Newman (secularized and aestheticized into one of "the great prose writers of the Victorian Age.")[99] Newman's devout worries about Anglo-Catholicism are now so exotic to editors Harold Bloom and Lionel Trilling that the arguments can be savoured for their cadences, exactly the way Carlyle feared his prophecies would be admired as "perilous somersets" by a linguistic acrobat. One remembers, in fact, the way Roger Fry or Clive Bell could reduce a Benin god to enjoyable "significant form." *The Oxford Anthology* is not unrelated to the New York Museum of Modern Art: both filled with "primitive" religious symbols now fallen to "art," posed and lighted to bring out their aesthetic possibilities.

You have to do much posing and lighting to get Carlyle and Newman next to the other aestheticized fetishes and reduce their religious tracts to "significant form" ("great prose"). Carlyle's ties to the arts are no stronger than Cardinal Newman's, certainly a greater prose stylist than Carlyle. Newman now stands in the canon-cabinet next to him. The editors—otherwise so different—share some unstated belief that writing excellent prose connects one in some significant way with the artworld, no matter what one's field. By that standard St. Paul, whose brilliant onomatopoeia in the famous passage on love can't even be reproduced in English, also becomes literature; and indeed there is a lively demand for courses in "The Bible as Literature."

Jesuitism: "May the Devil Fly Away with the Fine Arts"

Carlyle, in his contempt for art, has left us only a few works that include what we might call an aesthetics of the object, but they are consonant with remarks concerning art in his letters and diaries. The section in *Jesuitism* begins, "May the Devil fly away with the Fine Arts!" This sentiment "often recurs" to him, and he claims, not to him alone. He first heard it on the lips of "one of our most distinguished public men" and only now realizes "too well how true it is."

The passage on art comes in an essay on the general hypocrisy and falsehood of modern life. Critics avoid it, or shrug it off as philistinism. Though the prose is intemperate, nothing Carlyle says against the arts goes beyond what we've read Emerson, no philistine, saying about the arts. No one *can* go beyond that.

Carlyle, already the patronizing friend of Ruskin when he wrote, though not yet the recipient of the sometimes-daily Ruskin letter entitled "My Dearest Papa" is well aware of contemporary aesthetic move-

ments. "The Fine Arts," he allows, are thought "by some . . . to be a kind
of religion, the chief religion this poor Europe is to have" for some time
to come. He brings up one of his familiar themes, that what Fichte calls
the "Scholar" or "Literary Man" will be the "Priest of these Modern Ep-
ochs,—all the Priest they have." He has written much about the hero-as-
writer before, and here adds again, in this angry synopsis of old themes,
that "all arts, industries and pursuits" are now tainted by the usual Carly-
lean demons, elsewhere called Mammonism, here called "Pig Philoso-
phy," "Mumbo-jumboism," "the paradise of quacks and flunkeys"—and
that's only in one paragraph. Carlyle astonishes us by abruptly announc-
ing that Jesuitism, "the consummate flower of Consecrated Unveracity,
reigns supreme" in the Fine Arted "Pig Philosophy," "Mumbo-jumbos"
where it "presides over an enormous Life-in-Death!"

 Jesuitism is one of the notorious *Latter Day Pamphlets*, the 1850 publica-
tion in which Carlyle's patience snaps, and bitterness, instead of energiz-
ing him, first controls him. Sickened and disappointed both by the pub-
lic's failure to take *Cromwell* as more than a work of art, and the failure
of the 1849 revolutions to awaken Europe to the plight of the poor, Car-
lyle lashed out. The stunned and incredulous reader soon discovers that
Carlyle is spinning out one of his characteristic metaphors, and we are
not to interpret his word "Jesuitism" literally. Carlyle himself smugly reas-
sures us that "the English People" long ago "rightly understood" that
actual Catholic Jesuits are the "servants of the Prince of Darkness." As a
result, England has been "tolerably cleared" of them. Possibly they went
along with the Jews whose medieval expulsion he gloated over in *Past
and Present*. ("There were many dry eyes at their departure."[100])

 Most of Carlyle's admirers drew the line at these *Latter Day Pamphlets*,
particularly the infamous "Nigger Question," which seems specifically
designed to outrage his New England transcendental disciples, aboli-
tionists all. As even his worshipful biographer Froude apologetically
phrased it, the *Pamphlets* "discharged" the "fierce acid" which periodi-
cally accumulated in him, the "Nigger Question" giving "universal of-
fence."[101] After the *Pamphlets*, Emerson's letters chill, drop off to barely
one a year. Carlyle, in a letter to Emerson written the day after finishing
Jesuitism acknowledges the "great deep cleft" that "divides" him from Em-
erson politically, yet begs him not to let it kill the friendship. "Has not
the man Emerson, from old years, been a Human Friend to me?" Can
he ever think "otherwise than lovingly" of Emerson? He begs Emerson
to look beneath the "cleft" to "where the rock-strata, miles deep, unite
again."[102]

 Carlyle's acid sermon in *Jesuitism* is that "all men" have become "Jesu-
its," by which he means a kind of radical inauthenticity he has deplored

before, "that no man speaks the truth to you or to himself," that modern man does not even "know" that he is "lying." Once we strip the argument of its offensive bigotry, this serious topic is one of Carlyle's enduring concerns. Whether we *should* endlessly be stripping his arguments of their offensive bigotry is another question.

It is significant that the longest discourse on art objects as such we can find in Carlyle only comes about because he needs an illustration of hypocrisy. "For they [the "Fine Arts"] are become the Throne of Hypocrisy, I think the highest of her many thrones, these said Arts. . . ." Long ago, they were "divorced entirely from Truth" and wedded to "Falsehood, Fiction and such like," so that now, from roaming wild, they do insane "tricks" equal to any in "Bedlam." "Too truly these poor Fine Arts have fallen mad!"

Carlyle, in these few pages when he considers them, has a Savonarolic contempt for the arts. The "public man," Carlyle tells us, finds the arts "rather imaginary," and the "practical man, in his moments of sincerity, feels them to be a pretentious nothingness; a confused superfluity and nuisance, purchased with cost,—what he in brief language denominates a *bore.*" And Carlyle, in brief language, chimes in. "It is truly so, in these degraded days."

We hear so often of Dickens's reverence for Carlyle that we have almost come to think of Carlyle as a fictionalist himself. In *Carlyle and Dickens* Michael Goldberg recounts a witticism that Wordsworth was Coleridge's finest poem, then suggests that "*Hard Times* was Carlyle's finest novel. . . . Dickens himself thought the book a Carlylean novel."[103] But Carlyle had emphatically not written a *novel* about the French Revolution. He wrote, John D. Rosenberg has demonstrated, a laboriously researched *history.*[104] The difference mattered to him. His written opinion of fiction, only four years before Dickens was writing his most Carlylean novel, *Hard Times,* was that "fiction . . . or idle falsity of any kind, was never tolerable" except in a world of lies and "shams" which had gradually made "its inhabitants tolerant of that kind of ware."

But a serious soul, can it wish, even in hours of relaxation, that you should fiddle empty nonsense to it? A serious soul would desire to be entertained, either with absolute silence, or with what was truth, and had fruit in it, and was made by the Maker of us all. With the idle soul I can fancy it far otherwise; but only with the idle.

Statements uncannily reminiscent of *Hard Times*'s tragically misguided villain four years later, the schoolmaster Gradgrind. Gradgrind opens the book saying, "Now what I want is, Facts. Teach these boys and

girls nothing but Facts. Facts alone are wanted in life . . . You can only form the minds of reasoning animals upon Facts."

"Truth, fact, is the life of all things," Carlyle had himself declared a few years earlier. "Falsity, 'fiction,' or whatever it may call itself, is certain to be death and is already insanity," to whomever gets involved with it. "God almighty's *Facts*" are the one "nourishment" we have in the world.

Dickens was one of the few Carlyle disciples who had tried to learn from the *Latter Day Pamphlets*[105] in which these remarks appeared. Michael Goldberg finds him trying to accept such un-Dickensian thoughts as Carlyle's attacks on model prisons, disdain for philanthropists, even Carlyle's idiosyncratic disdain for philanthropy toward Africans. Dickens read the *Pamphlets* attentively and respectfully. How could he not have been shaken by this violent disdain he found expressed toward popular storytellers like himself?

Carlyle, in a passage reminiscent of another statecrafter, Plato, insists that "fiction" is "not a quite permissible thing," even as art. Fiction must be kept within "iron limits," or better, not permitted "at all!" Carlyle's dictatorship led by a Hero on behalf of the workers can often be little distinguished from the Marxian Dictatorship of the Proletariat. One and all must do their part in creating the new order, and the "Fine Arts," just like the "coarse and every art . . . are to understand that they are sent hither not to fib and dance, but to speak and work. . . ." Whatever's not part of the solution is part of the problem. Shakespeare, Homer, and the biblical poets, like all true "Vates talents," Carlyle esteems, but only as prophets or statesmen *manquè*. "Alas," Carlyle frets, poor Shakespeare worked "not in the Temple of the Nations" but in the "Bankside Playhouse," where he had to give the "sovereign public" its sixpence' worth. That Carlyle could consider Shakespeare's plays evidence of a talent *lost!* We dread to hear what he thinks of lesser works, and indeed, they're beneath his discussion.

This vitriolic essay does faithfully synopsize many of Carlyle's themes until 1850. Through the smog of hatred covering this essay, we discern a serious anti-artwork aesthetic parallel to that Emerson had expressed some years before, but without losing his composure. As yet, Emerson wrote, men do not recognize nature as "beautiful" and so run off "to make a statue which shall be. They abhor men as tasteless, dull, and inconvertible, and console themselves with color-bags and blocks of marble." For Emerson and Carlyle alike, a taste for artworks virtually confesses your inability to deal with life.

Fiction, Carlyle says, is "all falsity," and what "serious soul" could wish you to "fiddle empty nonsense to it?" Emerson, contemplating statues,

had been caustic, but Carlyle loathes the artworld. He damns the artist and his "reading publics, dilettanti, conoscenti," all of whom are the decadent minions of "Luxurious Europe"—that "monster of opulence, gluttonous bloated Nawaub, of black color or of white." The sensualist bourgeois public has not attended the outraged Carlyle's sermons. Nawaub has been far too busy listening to "prating story-tellers" paid to "amuse his half-sleepy hours of rumination." If from this monster's "deep gross stomach sinking overloaded as if sinking towards its last torpor, they can elicit any wrinkle of momentary laughter, however idle, great shall be their reward."

How could the amusing Dickens have read that with anything but shock? Carlyle ranks "story-tellers" in the toady depths: "Wits, story-tellers, ballad-singers, especially dancing-girls who understand their trade, are in much request with such gluttonous half-sleeping black or white Monster of Opulence." Give Nawaub a "bevy of supple dancing girls" to enact the "Loves of Adonis" or the "Barber of Seville,"(!) satisfy Nawaub's "hot heavy-laden eye," appease his "bottomless ennui,—then victory and gold purses to the artist; be such artist crowned with laurel or with parsley, and declared divine in presence of all men." Dickens, that divine storyteller, had received victory and gold purses beyond any previous English writer.

Michael Goldberg cites much evidence in support of Dickens's son's statement, that his father called Carlyle "the man who most influenced him." We know Dickens wrote Carlyle in the sixties, "I am always reading you faithfully and trying to go your way." The ringmaster Sleary's plea to Gradgrind—usually read as a plea to Benthamites—has more pathos and intensity once we realize it is also a plea to someone much dearer to Dickens's heart, someone he knew would read *Hard Times* carefully, if only because the work was dedicated to him. "People must be amuthed, Thquire, thomehow," Dickens replies respectfully. "They can't be alwayth a working, nor yet they can't be alwayth a learning. Make the betht of uth"—of us artists—"not the wurtht." Obviously, the passage defends Dickens's art against the utilitarian mind, with Dickens as the greater ringmaster. Less obviously, Dickens must plead for his art with his personal hero, Carlyle, and justify his art's existence against a growing body of Natural Supernaturalist opinion that art was either a tool for teaching you the wonders of mere real things, or else a trivial distraction from them. Dickens's books were neither, and he knew it. Billy Bitzer, the boy brought up on nothing but facts, and a monster because of it—incomplete, a mere bitzer of a soul—is Dickens's answer. The fictionalist is *not* on the same plane as sleepy Nawaub's "dancing-girl"; his fictions

humanize us to each other, and help us to reach fullest humanity our-
selves.

"The Opera": "Fiction and Delirium"

If that is what Carlyle thinks of fiction, we dread to read his thoughts on
the arts even Emerson derided. Happily, he is usually too busy with his
proper subjects to bother with them. A short piece on "The Opera" writ-
ten to help a friend's publication, continues, in a particularly offensive
way, the line of argument begun in *Jesuitism*.[106] I feel like apologizing to
the reader in advance: Carlyle's loathing for the artworld reaches a peak
in "The Opera" and it isn't pleasant reading. Yet to know that *the* English
Natural Supernaturalist could not talk about art without losing his tem-
per is important.

He begins by seeming to allow music some dignity, but it's actually
one of his characteristic redefinitions. Holloway presented Carlyle's
techniques as the very model for the "Victorian sage." "Serious" nations,
Carlyle argues, once used music as a "vehicle for worship, for prophecy,"
and the singer was a "*vates.*" Carlyle gradually reveals that his idea of
"music" turns out to be David's *Psalms*.

Emerson had said that the human voice was better than the oratorio,
and Carlyle is soon complaining that music today—unlike the days when
it served as background music for psalmists—no longer has anything
to do with "sense and reality" but only with "fiction and delirium. . . ."
Describing the Haymarket Opera and its ballet, Carlyle attains an ecstasy
of disgust. The ballet dancers he can only see as "mad restlessly jumping
and clipping scissors," flying about the stage in "strange mad vortexes,"
or posing in postures which "Nature abhors. . . ." He wails that the
money and energy spent on this "wearisome and dreary" spectacle could
have "taken Gibralter, written the History of England or reduced Ireland
into Industrial Regiments. . . ." Outside the mad playhouse the world is
"dying." This audience of nauseating aesthetes in their "rouge and jew-
els," ogling each other with "macassar-oil graciosity," would do better to
flee this lotus-land and return to reality, admonishing themselves, "Let
me go home in silence, to reflection, perhaps to sackcloth and ashes!"
(The Victorian reader would remember how the King of Ninevah saved
his city.) Here, in this decadent amusement park, music "burns" on its
"funeral pile." Carlyle apostrophies the soloist, Coletti, as, "Wretched
spiritual Nigger . . . born Nigger with mere appetite for pumpkins. . . ."
Since the 1960s, those eager to have Carlyle's centrality once more ac-
knowledged have edited out such passages. (Myself included. I even ded-

icated a book to him.) Though I believe Carlyle a great religious figure, this racist outburst is quite typical of him, and the reader should see it.

Holy Relics

One kind of art object did finally intrigue Carlyle, but the nature of his interest underlines his contempt for art objects as a whole. In three essays written over a span of two decades Carlyle does earnestly consider a portrait's ability to stand in for the hero portrayed, as a kind of secular relic, or—as he finally terms it—"icon." It is a measure of Carlyle's influence that entire museums were eventually founded on these slim essays and are still in operation. It is perhaps the one proper use a Natural Supernaturalist can see for the object, apart from the handmaid defense, its use as a "gymnastics of the eye."

Carlyle's idea proceeds naturally from his own attempts to replace the outmoded Christian "Mythus," in *On Heroes, Hero-Worship and the Heroic in History,* mentioned earlier. In that book, which followed *Sartor Resartus,* Carlyle moved onward from finding a God in every blade of grass to finding one in man himself. The theory behind Carlylean hero-worship is complex. Suffice to say that Carlyle would replace the saints and even the Gods with modern Heroes and recall society to order and purpose through the worship of these divinely inspired, vatic, leaders.

In an amazingly influential little essay titled, the "National Exhibition of Scottish Portraits," written for the Society of Antiquaries of Scotland, he recalls that in all his "historical investigations" one of his first efforts has always been to find a "good bodily likeness of the personage," or even a poor one, "if sincere."[107] Every historian, Carlyle declares, who "strives earnestly" to turn some mere historical name into a real "Fact and Man" will "search eagerly" for a faithful Portrait, which then becomes "a small lighted *candle*" by which one may read the old records. Carlyle never bothers voicing the opinion that a living hero is superior to his painted likeness. But at least, in this one case, he isn't literally damning artworks to Hell or accusing them of swallowing "hecatombs of souls."

He does, however, insist in "Scottish Portraits" that his desire for a good bodily likeness of the hero to be emulated is "quite apart from the *artistic* value" (emphasis his) and appeals to a far "deeper . . . principle in human nature than the love of Pictures is." We soon discover he thinks a true representation would have the inspirational power a holy relic formerly had. He has secularized yet another religious institution. If looking at a chip of bone could inspire a monk, looking at the right kind of

portrait might inspire a modern. Carlyle never saw the Lincoln Memorial but its indisputable impact is what he has in mind.

We find a less than frivolous motive here, for a Carlylean habit that's been noted, usually with amusement. Despite Carlyle's contempt for art objects, he spent a significant amount of time posing for them. He appears, prominently discoursing on the state of England with Frederic Maurice, in Ford Madox Brown's once-famous didactic painting *Work;* or scowling earnestly for Whistler; or glowering in excellent, much-reproduced photographs by Julia Cameron. Simple vanity may play a role, but Carlyle is not otherwise known to be vain. Fame came to him only in his mid-forties and he handled it well—indeed, with skepticism and irony. Rather, we see here Carlyle earnestly, even grimly accepting his role as modern *vates,* and co-operating in the production of his own icons, intended to inspire his followers. By all accounts, they did. His poses model exemplary social attitudes for us. They teach us, "Be in earnest!" "Work while it is called 'today'!" Here is Carlyle: be like him.

Carlyle's interest in a likeness's power to lionize had led him, in the 1850 series of *Latterday Pamphlets,* to his one extended essay involving statuary, *Hudson's Statue.* Art can promote the wrong heroes as well as the right ones. What Ivan Boesky was in the 1980s to junk bonds and corporate raiding, one George Hudson was to the railroad-boom of the 1840s. It horrified Carlyle that Hudson, whose bubble burst as suddenly as Boesky's, had almost had a kind of Lincoln Memorial erected to him. Twenty-five thousand pounds (no mean sum!) had already been subscribed "or offered as oblation," Carlyle laments, "by the Hero-worshippers of England to their Ideal of a Man." Had time permitted the raising of this totem, Carlyle says, England's genuine "'Religion'" might have been seen—what he called elsewhere, "The goddess of getting-on" (and what contemporary Americans might call "making it"). "Show me the man you honor; I know by that symptom, better than by any other, what kind of man you yourself are."

It is a measure of Carlyle's vast influence that even these minor essays led, worldwide, to large museums still with us to this day. Carlylean disciples were behind the opening of the National Portrait Galleries in 1895, next to the National Gallery itself. Its former director, David Piper, once admitted it has to do "with history rather than with art."

Carlyle had called for such a National Gallery in his "Scottish Portraits," but lest the reader think he had a new respect for art, he stipulated the gallery contain only portraits of heroes. Even concerning historical painting, he proposed "to make the rule absolute *not* to admit any one of these," for he had never seen one that wasn't an "infatuated

blotch of insincere ignorance," without the "least *veracity*," and therefore "entirely *useless* for earnest purposes. . . ." That is, hero-worship, in the most literal sense. He can see no "use in such things" except to those who have "turned their back on real interests and gone wool-gathering in search of the imaginary." Unless art serves the strict and narrow purposes he defines in his essays, it is nothing but "chaff" which had better be "severely purged away."

C. *John Ruskin*

"I believe any sensible person would change his pictures, however good, for windows."

Changing the Paradigm

Like the repellent chaff which bounced off the rubbed glass rod and so became unimportant, because it fit no paradigm about electricity, Carlyle's repellent opinions about art as "chaff" bounced off the critics and anthologists—unimportant, because outside any paradigm. The same fate met Wordsworth's and Emerson's vehement anti-art pronouncements. Whatever fits a ruling paradigm is important. Whatever doesn't is "unimportant."

However, as Thomas Kuhn reported, it is precisely by paying attention to what doesn't fit—instead of letting "normal science" declare it unimportant chaff surrounding the grain—that new paradigms are created. We have such a new paradigm: the Natural Supernatural religious orientation, though we encounter it in the arts, is necessarily anti-art, and *never more itself* than in those early anti-art works which were dismissed as chaff. Carlyle's hatred for the ballet, his contempt for painting and music, were small but important premonitions, foreshocks suffered by people unaware they lived in earthquake country, forecasts of the Big One that would come in John Cage's lifetime.

Let us continue with this method, taking the chaff seriously, letting it change our paradigm of another central Victorian, John Ruskin. I can imagine the reader saying, "Odd enough to see Thomas Carlyle linking arms with John Cage—but John Ruskin? Ruskin, the author of *Modern Painters,* Turner's champion, the aesthetic dictator of Victorian England? Is even he to be pictured marching with Cage?" Absolutely. We will meditate on some anomalous Ruskinian chaff.

Modern Painters I appeared when Ruskin was twenty-four and, as the father of modern Ruskin studies, John D. Rosenberg himself admitted,

"quite ignorant" of art. No matter. The book's not about art, but "modern painters." To Ruskin that's a great difference, since *his* "modern painters" are more interested in mere real things than in art. That's what makes them modern. The very "modernity" of these painters, he argues, the source of their superiority to all previous schools, is their (relative) contempt for art, compared with mere real things. Ruskin sums up his contempt for all prior landscape painters by saying they painted "nothing for the sake or love of what they [were] painting."[108] Their sin was to value the artworks they were composing above mere real things.

Ruskin's "modern" painters, on the contrary, value the mere real things more than the art object. Hence Ruskin's motto: "All great art is praise."[109] Great art knows its place. Long after *Modern Painters* was finished he could still repeat "ALL GREAT ART IS PRAISE" as the title of the first chapter of *The Laws of Fesole* (1877): "The art of man," that work begins, "is the expression of his rational and disciplined delight in the forms and laws of the creation of which he forms a part."

Delight, Ruskin said pointedly, "not in itself," the art object, "merely." "What healthy art is possible to you must be the expression of your delight in a real thing, better than the art." We may protest that we like William Holman Hunt's bird's nest better than a real one. He admits we would pay "a large sum" for Hunt's picture, but not for the mere real thing. Nevertheless, Ruskin reasonably points out, "it would be better for us that all the pictures in the world perished," than if those mere real bird's nests did. "This is the main lesson I have been teaching, so far as I have been able, through my whole life—Only that picture is noble, which is painted in love of the reality."[110]

He goes beyond that. He stipulates that art is "less beautiful than the realities" it depicts.[111] He is fond of making Shakespeare preach that moral: "'the best in this kind are but shadows.'"[112] "You will never love art well," Ruskin argues, "till you love what she mirrors better."[113] "The love of art involves the greater love of nature."[114]

This lifelong conviction is present from his very first work, *Modern Painters*. To read *Modern Painters* as if it were *Modern Artworks,* criticism has had to throw away four-fifths of it, and even then condense and apologize for the long naturalist sections which link together the snippets on art. If there were ever a situation which stood begging for a paradigm shift, this is it.

Thomas Kuhn teaches us that believing is seeing. While the Ptolemaic paradigm prevailed, Western astronomers, believers in the immutability of the heavens, simply couldn't *see* what the Chinese, with no telescopes—but also without the blinkers of that paradigm—had long observed: spots on the sun, additional planets, even "comets that wandered

at will through the space previously reserved for the immutable planets and stars."[115] It's startling to realize Ruskin himself had made that point central to his philosophy. "The first great mistake" people make is that they "must see" something just because it happens to be "before their eyes." On the contrary, some theory must precede even vision. Unless the mind is "particularly directed" to phenomena, "objects pass perpetually before the eyes without conveying any impression to the brain at all," not merely "unnoticed" but actually "unseen."[116]

Criticism has pictured *Modern Painters* as "art criticism" despite the host of unwelcome anomalies that paradigm produces. To preserve the paradigm, no less than three particular "finagle variables" are usually used. *Modern Painters* must stay art criticism, so it becomes *defective* art criticism, or *amateurish* art criticism, or simply *old-fashioned* art criticism.

Solomon Fishman can stand for many who call Ruskin's work "art criticism" only to immediately complain they find little that reminds them of art criticism in Ruskin's "prose rhapsodies on natural scenery—it is difficult to perceive their relevance to the visual arts." He can only call these passages "digressions." All they actually "digress" from is the paradigm of the work as art criticism.

Worse, once Fishman removes the digressions, leaving only what fits his paradigm, he next complains there's very little left. "The discussion of specific works of art occupies only a small fraction of the whole work." By his own admission, what looks like art criticism is only a "small fraction" of the work.[117] Yet Fishman has come to *Modern Painters* with the idea that it's art criticism, so, willy nilly, the "small fraction" which fits the paradigm *is* the work, and the rest is "digression"—though he notices it's by far the majority of the work. One remembers the Vietnam era's saying, "To save the village it was necessary to destroy it." To save the paradigm it has been necessary to throw away most of *Modern Painters*.

"Normal" or textbook science, Kuhn wrote, exists to enforce paradigms, and so does normal criticism. In their joint introduction to Ruskin in the *Oxford Anthology of English Literature,* Lionel Trilling and Harold Bloom sympathize with those delicate spirits for whom Ruskin's "evangelical anxiety" about art's "moral and spiritual effect" has had the "effect of obscuring those aspects of Ruskin's criticism that are not specifically moral." In a kind of aesthetic bowdlerism they reassure the pious reader that "if one can, so to speak, provisionally deplore Ruskin's moral impulse as it operates in his art criticism" one may find him England's "pre-eminent intellectual genius."[118]

Ruskin without the "moral impulse" is not Ruskin, is nothing. One might as well propose removing the distracting Catholicism from Hopkins's nature poems. The *Oxford Anthology* teaches us less about Ruskin

than it does about the lengths normal criticism will go to to preserve a paradigm. Kuhn describes how, following a paradigm's general acceptance, "normal" science arises, the "attempt to force nature into the preformed and relatively inflexible box that the paradigm supplies. No part of the aim of normal science" is to find new phenomena which might not match the paradigm; indeed, whatever phenomena "will not fit the box are often not seen at all."[119] In this case, we see the anthologists baldly advising the student to do just that. The student is to remove the morality from the moralist, since it has the "effect of obscuring" the paradigm, that this is "art criticism."

If we give up the paradigm, we will no longer need all the finagle variables. Let's also abandon the idea that what we're reading is in some way *old-fashioned* art criticism. Fishman had decided that the "digressive" passages were "in themselves a clue to the gulf" fixed between *Modern Painters* and "the modern consciousness of art." Ruskin a traditionalist? Having read Reynolds, Bellori, Du Fresnoy et al., we know there is nothing in pre-1800 art criticism which resembles Ruskin's works; nor could there be. Nothing in that aesthetic would forgive his paeans to mere real things.

Ruskin as Sage: "It is *not* true . . ."

Ruskin is notorious for his self-contradictions:[120] he himself joked, "The clammy hand of consistency has never rested long upon my shoulder." Like Emerson, however, Ruskin's aesthetic's self-contradictions parallel the built-in Natural Supernaturalist ones. (Carlyle's aesthetic alone has no self-contradictions. He despises art objects.) The contradictions in this anti-art tendency's involvement with art objects, contradictions which ultimately ended that involvement, were noticed from the first. In one of the first reviews (1844) of *Modern Painters*' first volume, George Darley complained that Ruskin "professes . . . a noble disdain of servile imitation in art," but despite Ruskin's protests, "he seems to think landscapes should be, throughout their details, little facsimiles of real objects."

Darley is quite right about the contradiction and though we all know the ways Ruskin answered such charges—tenets proclaiming "All great art is praise," and that "one never loves painting right till one loves what she mirrors better"—such defenses don't restore the old ideal defense against the platonic challenge. Darley quickly points that out: "If people want to see Nature let them go and look at herself; wherefore should they come to see her at second-hand on a poor little piece of plastered canvas?"[121] Darley makes the charge rhetorically. He does not expect you

to abandon the poor little "plastered" object for nature, but he has understood Ruskin and has seen where his reasoning leads. Darley brings it out to ridicule Ruskin, but Emerson had already advised us in all seriousness to abandon art objects three years before. By the 1950s Cage was ready to act on the idea.

We spoke earlier of the way Ruskin wrestled the word "divine" away from Reynolds and of his contempt for academic training's goals. Ruskin's "Great Painter," like Wordsworth's perfect poet, is he who can see the heaven in the everyday: "nothing exists in the world about him that is not beautiful in his eyes, in one degree or another."[122]

We notice the familar "sage" techniques as we watch Ruskin redefine "great" art: "All great art is either truth or praise of God." Again, the adjective "Great" alerts us that a redefinition is underway. Necessity forces Ruskin, like Wordsworth, to stand a classical term on its head: his Great Painter will paint not by the light of the classical "Ideal" but by Ruskin's extremely new "naturalist ideal." We know what the old ideal meant—Zeuxis and those Crotonian maidens, art amending the defects of life. With some surprise we discover that the "naturalist ideal" concerns "that central and highest branch of ideal art which concerns itself simply with things as they ARE."[123]

Such bald inversions horrified Darley and others of Ruskin's first reviewers. As the Rev. John Eagles wrote, in an irate but accurate review of *Modern Painters I,* "He . . . has not the slightest respect for the accumulated opinions of the best judges for these two or three hundred years—he puts them by with the wave of his hand. . . ."[124]

Ruskin is as high-handed as Eagles claims. Ruskin can laud Reynolds' *Discourses* for their "simplicity and enduring truth,"[125] can even claim his criticism is founded on Reynolds's—but what can Ruskin mean? Reynolds had arranged the final discourse so that "the last words which I should pronounce in this Academy, might be the name of—MICHAEL ANGELO."[126] Ruskin, by contrast, writes an entire essay, "The Relation between Michael Angelo and Tintoret" characterizing Michelangelo as "the chief captain in evil" behind the "deadly change" into idealist art.[127] Of the four "changes brought about by Michael Angelo" number one is "Bad workmanship" and number four is "Evil chosen rather than good."[128]

To explain such seeming disagreements with Reynolds, Ruskin informs us that Reynolds has "involved himself" in theories leading to "conclusions which he never intended." Reynolds is "utterly incapable" of explaining his "instinctive consciousness" of the truth, and so "involves" himself in "unexpected fallacy and absurdity." No matter. Ruskin shall make clear to us what Reynolds knew instinctively but lacked the

art to say: "It is *not* true that Poetry does not concern herself with minute details. It is *not* true that high art seeks only the Invariable. It is *not* true that imitative art is an easy thing. It is *not* true that the faithful rendering of nature is an employment in which [he quotes Reynolds] 'the slowest intellect is likely to succeed best.'"[129] "I had to show the mischief," Ruskin later blithely said, "which arose from obeying Sir Joshua, misunderstood."[130]

Modern Painters I

Biographers have been so intent on finding the seeds of the mature Ruskin in the adolescent they slight what that young man was: a serious, published, promising young natural scientist whose "ambition" to become President of the Royal Geological Society was perhaps, Tim Hilton writes, "not unrealizable."[131]

In his fifties, Ruskin, collecting his geological and botanical works into separate volumes, mused that the "unlucky gift" of a work with Turner sketches in it led him to the defense of Turner's accuracies which grew into *Modern Painters*. Otherwise, Ruskin complained, his "natural disposition" for the earth sciences would "certainly long ago" have made him a "leading" natural scientist, or would even have "raised me to the position which it was always the summit of my earthly ambition to attain, that of President of the Geological Society." He is proud that at twelve he began a "'Mineralogical Dictionary', intended to supersede everything done by Werner and Mohs" and that "until very lately," he has been able to "keep abreast with the rising tide of geological knowledge" and has even led it, once or twice:

> I was the first to point out, in my lecture given in the Royal Institution, the real relation of the vertical cleavages to the stratification, in the limestone ranges belonging to the chalk formation in Savoy; and my analysis of the structure of agates, ('Geological Magazine') remains, even to the present day, the only one which has the slightest claim to accuracy of distinction. . . .[132]

The Ruskin of *Modern Painters I* respected artworks the way he respected his field lens. *Modern Painters* did not begin as art criticism. The young naturalist who wrote it valued a few, carefully selected artworks as, he argued, a powerful tool with which to study nature. He selected the works—and a strange assortment they are, everyone remarks—according to their lenslike power to give us a "transcript of nature." We are to look *through* artworks, not *at* them. We use the things. Good art, he elsewhere decreed, "explains, but does not improve" on nature.[133] A certain kind of art can teach us to revere nature—and should never try to go it one better. Ruskin actually said that if a painting tried to replace

nature, it "had better be burned."[134] Even later when he had become so interested in art it often made him guilty, he still had no doubt there was "no wealth but life."

In *Modern Painters I*'s first pages, we find a young geologist (only twenty-four) feeling a call to speak up about art—about the "transcripts" of nature idealist art had offered the world. "Anyone familiar with nature," he protests, will grow "weary and sick" looking at the old school's feeble "transcripts" of her. So he conceives paintings at this time: "transcripts" of nature.

Before the painters whom Ruskin calls "modern" came on the scene, nothing "had been painted yet in true *love* of it." Even what seem to us, at first glance, faithful landscapes were but a pretext for the manufacture of art, "painted for the *picture's* sake, to show how well [painters] could imitate sunshine, arrange masses, or articulate straw." A "man accustomed" to studying nature will be disgusted with Claude's "paltry" oceans, "angered" by Salvator Rosa's fantasy mountains. "A man accustomed" to studying, as this young naturalist has done, the infinite complexity of plants, "every bough a revelation," "can scarcely but be angered" at the way Poussin "mocks him" by trying to palm off on him as tree limbs, "feathers" attached to "sticks" instead of to those revelatory boughs. Of course, the young Ruskin is correct. What we city folk take to be Gainsborough's odes to the countryside, to rocks and trees, for instance, were usually portraits of studio compositions of coal and feathers. I hate to tell students that certain picturesque tree trunks Gainsborough favors were done from broccoli stalks, for once you know, they never look like trees again. The idealist aesthetic, Ruskin claims, reduced art to the "struggle of expiring skill to discover some new direction in which to display itself. There was no love of nature in the age; only a desire for something new." As a result, the older schools "expired at last, leaving the chasm of nearly utter emptiness between them and the true moderns . . ."[135]

In sum, Ruskin's *Modern Painters* tried to prove that what is distinctly "modern" about modern painters is that they value mere real things above art objects. They only resort to art objects as "transcripts" to aid us in the study of mere real things. That was the change Ruskin thought so startling and significant that he took up his pen to write a work dedicated "to The Landscape Artists of England . . . by their sincere admirer." I am fascinated, but not surprised, to find my own book supports Ruskin's key propositions in *Modern Painters*, ideas often smiled at as youthful Ruskinian bombast. Ruskin argues that—as this book has—a change without precedent in the history of art occurred around 1800: the reversal of rank between art objects and mere real things. *Modern Painters* was

written to prove that change *the* essential fact to know about "modern" painting, its very genesis. The new aesthetic ("the infant school") was "not engrafted on that old one" but a break with it. It "differed inherently," for its "motive" was love of this world.

> However feeble its efforts might be, they were *for the sake of the nature*, not of the picture ... Robson did not paint purple hills because he wanted to show how he could lay on purple; but because he truly loved their dark peaks. Fielding did not paint downs to show how dexterously he could sponge out mists; but because he loved downs.[136]

The "modern painters" reduce art to a Wordsworthian handmaid waiting on mere real mists and downs. To support his claim, Ruskin set out to show that "modern" painters, Turner chief among them, now took great pains to make their works faithful "transcripts" for use in the rapturous study of nature. Because they are "far more just and full in their views of material things" than the pre-1800 painters, they are new and modern. Turner is the "only" painter who has ever "given an entire transcript of the whole system of nature"—water, trees, rocks, and all— therefore Turner is judged "the only perfect landscape painter whom the world has ever seen." Since providing us with a "transcript" of the natural world is the only justifiable thing an art object can do for us, the young Ruskin's firm conviction was that "we have, living with us, and painting for us, the greatest painter of *all* time."[137]

Modern Painters I concerns, as the titles of its chapters are at pains to indicate, not art but "truth"—that is, real things, not art. Tell me what you like and I'll tell you what you are, Ruskin later insisted. We should reply to him, show us what you do and we'll tell you what your aesthetic is. Ruskin's works give us unsurpassed comparisons of how things really look, compared to how we lazily think they look, with a running evaluation of which painters will either help us learn or harden us in our slovenly observational habits. Sections bear titles like "The Truth of Chiaroscuro ... the sharp separation of nature's lights from her middle tint ... the perfection of Turner's works in this respect. ..." "Of Truth of Color ... Impossible colors of Salvator, Titian. ..."

"The first great mistake that people make," Ruskin says, early in the first volume of *Modern Painters*, "is the supposition that they must *see* a thing if it be before their eyes." This is that Kuhn-like chapter entitled "That the Truth of Nature is Not to be Discerned by the Uneducated Senses," in itself a capsule statement of Ruskin's real aesthetic. "We always, as far as the bodily organ [the eye] is concerned, see something, and we always see in the same degree ..."; that is the eye's "constant habit." Therefore sight may occur, yet "awake no attention whatso-

ever. . . ." Which means that "unless the minds of men are particularly directed to the impression of sight, objects pass perpetually before the eyes without conveying any impression to the brain at all; and so pass actually unseen, not merely unnoticed, but in the full clear sense of the word unseen. . . ."[138] Ruskin, Charlotte Brontë wrote, gave her a new sense—sight. Yet it is *not* artworks Ruskin teaches us to see, but real things.

"Throughout my wanderings," John Perrault wrote in the 1970s, "the question that pops up most is one of categories. Is or isn't Conceptual Art poetry? I answer that in most instances the verbal format used is inglorious, workaday, transparent prose."[139] Now that a concept art exhibition can be a prose catalog, we can recognize *Modern Painters* as concept art's first great eruption, the most enormous exhibition catalog of earthly objects extant, challenged only by *Leaves of Grass*. Ruskin starts us off from scratch, infants in the elementary school of vision.

Draw on a piece of white paper, a square and a circle, each about a twelfth or eighth of an inch in diameter, and blacken them so that their forms may be very distinct; place your paper against the wall at the end of the room, and retire from it a greater or less distance according as you have drawn the figures larger or smaller. You will come to a point where, though you can see both the spots with perfect plainness, you cannot tell which is the square and which the circle.

Now this takes place of course with every object in a landscape, in proportion to its distance and size. The definite forms of the leaves of a tree, however sharply and separately they may appear to come against the sky, are quite indistinguishable at fifty yards off, and the form of everything becomes confused before we finally lose sight of it.[140]

Typical Ruskin—and nothing at all there about artworks. You can't even use it to see an artwork; only real things. In his essays Ruskin will typically encounter us *in* an art gallery, looking at some painting, and lead us firmly *out* of the gallery to contemplate nature—those are the supposed digressions.

He bumps into us in the National Gallery, gawping at an idealized Roman landscape (of La Riccia) by Poussin; stands with us and describes it, in a wonderful comic deadpan. "It is a town on a hill, wooded with two-and-thirty bushes, of very uniform size, and possessing about the same number of leaves each. These bushes are all painted in with one dull opaque brown. . . ." Then he spirits us out of the artworld to the place itself, to compare: "Not long ago, I was slowly descending this very bit of carriage road, the first turn after you leave Albano. . . . It had been wild weather when I left Rome, and all across Campagna the clouds were sweeping in sulphurous blue . . ." He watches the autumn sun break through and strike the wet, wooded hill Poussin had painted. "I can-

not call it color, it was conflagration. Purple, and crimson, and scarlet, like the curtain of God's tabernacle, the rejoicing trees sank into the valley in showers of light, every separate leaf quivering with buoyant and burning life; each as it turned to reflect or to transmit the sunbeam, first a torch and then an emerald." The sun plays through the soaking meadows, and "every blade of grass burned like the golden floor of heaven. . . ."

If, reading that, we think, "How is poor Poussin's painting supposed to capture 'burning life' itself?"—we've conceded Ruskin's very point. Not Poussin, not even "in his most daring and dazzling efforts could Turner himself come near it . . ." Yet, Ruskin points out, that living scene—the sun striking rain-soaked autumn foliage—is not really an "uncommon" one. There is "no climate, no place, and scarcely an hour," Ruskin assures us, in which nature doesn't create scenes beyond what "any mortal effort"—even Turner's efforts—"can imitate or approach." The painter's "artificial pigments" are "dead and lifeless" compared to nature's "living color." Place a "blade of grass and a scarlet flower" next to the "brightest canvas that ever left Turner's easel, and the picture will be extinguished."

The words "life" and "living" resound through the passage and through Ruskin's works. "There is no wealth but life." Art's things matter only when they lead us to a vision of life's everyday glories, not of art's poor mud-on-canvas self.

And so throughout the works he'll meet us standing in a gallery or sitting with our nose in a book and hurry us outdoors. The glimpse of a lawn in a painting or the mention of one in a poem will soon have us tramping across a meadow with him to pluck "a single blade of grass," and with him "examine for a minute, quietly, its narrow sword-shaped strip of fluted green." Nothing, it seems, do we find there, "of notable goodness or beauty. A very little strength, and a very little tallness, and a few delicate long lines meeting in a point,—not a perfect point neither, but blunt and unfinished, by no means a creditable or apparently much cared-for example of Nature's workmanship. . . ." And yet, "think of it well," as Ruskin says, think of it covering the "dark ground" in "companies," with "the life of sunlight upon the world, falling in emerald streaks, and failing in soft blue shadows." (Ruskin needed no Impressionists to show him the color in shadows.) Consider the variety of texture and look that even the simple grass can show in

pastures beside the pacing brooks,—soft banks and knolls of lowly hills,— thymey slopes of down overlooked by the blue line of lifted sea,—crisp lawns all dim with early dew, or smooth in evening warmth of barred sunshine, dinted by happy feet. . . . Meadows that slope from the shores of the Swiss lakes to the roofs of their lower mountains . . . paths that for ever droop and rise over the green

banks and mounds sweeping down . . . look up towards the higher hills, where the waves of everlasting green roll silently into their long inlets among the shadows of the pines. . . ."[141]

Thymey slopes, crisp lawns, waves of everlasting green: these real things are not digressions, they are the goal. Such characteristic passages, much anthologized, give the impression of Ruskin as a prose Wordsworth. His debts to Wordsworth have been fully documented. Yet such lines are few compared to the entire chapters—even more characteristic—of unpoetic but precise prose on "the Region of the Cirrus,' or "the Inferior Mountains." "Each rank" of cirrus cloud is "composed of an infinite number of transverse bars of about the same length, each bar thickest in the middle, and terminating in a traceless vaporous point at each side. . . ." By far the bulk of *Modern Painters,* supposedly about art, is unromantic, but precise, naturalism. He calls up paintings to help him lecture, exactly the way a contemporary scientist would switch slides, pausing to comment on whether this or that shot was underexposed, blurry, or falsifying the colors. "The whole field of ancient landscape art affords . . . but one instance of any effort whatever to represent the character of [cirrus clouds]. . . . Turn to [Turner's] Alps at Daybreak, page 193 . . . here we have the cirri used again, but now they have no sharp edges, they are all fleecy. . . ."[142]

Ruskin and Muir

Now that we have stopped picturing Ruskin as an "art critic" with a digressive interest in nature, reimagine Ruskin as primarily a concept artist, or even better, an environmental philosopher, more specifically an "environmental ethicist," only *using* art. (It's all so new we're still developing apt words.) Placed in that company he becomes clearer. Were he alive today, most of Ruskin's thirty-nine volumes would, after all, be more likely to appear in *Environmental Ethics* than in *Artforum.* What were the oddest parts of his work, things like speeches to children on topics like "the ethics of the dust" now look as contemporary as the kids' programs the networks show on Earth Day. Since the first Earth Day in 1970 we have been reinventing the term "natural philosopher" and the Greens now speak, like Ruskin long before them, of "the moral of landscape." In recent books like *Nature in Asian Traditions of Thought: Essays in Environmental Philosophy,*[143] a volume in the new SUNY series "Philosophy and Biology," the Victorianist encounters essays which not only remind him of Ruskin, but—at last—the great majority of Ruskin, the very parts which no one in the English or art departments ever quite knew what to do with: not only because he discussed clouds and rivers, but because he

discussed them in a strange *moral* tone. Ruskin has been wrongly mocked for his habitual mix of morality and geology, for his insistence that the way we handle nature must be judged morally; that our handling of nature is the greatest moral decision humans can make; that how we handle nature must lie at the heart of our religious life; that our moral relationship to nature will be the test of our religion. Perhaps because he expresses his moral convictions in a Christian discourse now foreign even to most Christians we have been unable (as Carlyle might say) to see beneath the frayed clothes of his language to the living body beneath. Ruskin writes with moral horror for the attitude which objectifies nature, which sees it as dead matter unrelated to humans, there for us to exploit as we please, with impunity to our souls and to our world.

To test the new paradigm, we remove Ruskin's work from the company of art critics (where everyone from Darley to Fishman has complained of the poor fit) to the company of an environmental ethicist, John Muir. The great majority of the work, those passages previously anomalous, or called, with a hapless sigh, "poetic description," immediately assume their rightful place at the work's heart.

Muir is revealing company to put Ruskin in, even better company than Emerson or Thoreau. Emerson's work is more abstract, bookish; Thoreau's prose is simply too weak to compare. Muir and Ruskin fill their work with rapturous transcripts of visual experience, acquired through endless and even dangerous travels. Both were social activists, both changed the cultures they lived in even during their lifetimes.

In John Cage's time we will watch Natural Supernaturalism end its primary dependence on the artworld. In the 1960s, as the tendency passes into being the orthodox Western *Weltanschauung*—even pulling into line behind it the disagreeing, *contemptus mundi* elements in the Christian and Jewish religions—people from the artworld flow outward into ecology, Earth Days, environmentalism. Concept art, as it evolved in the sixties, led inevitably into world ecology and "habitability."

But Natural Supernaturalism had been flowing out of the artworld from the start. A valuable study could be done of those activists who first helped Natural Supernaturalism acquire political power and even legal domain. For example, when Emerson, in old age, drew up his list headed "My Men," Thomas Carlyle was the first, but the last—thirty-five years younger than Emerson—was the naturalist John Muir, who had hiked all through the High Sierras carrying with him only some tea, dried bread, and Volume I of *The Prose Works of Ralph Waldo Emerson*. Emerson spent a week with Muir at Yosemite in 1884 which confirmed the younger man in his hero-worship.[144] Muir, a few years later, became the spearhead for the battle which saved Yosemite as a national park. He

also earned "major credit" for preserving the Grand Canyon and the Petrified Forest. In a flood of popular books and articles filled with Ruskinian hymns of praise, Muir took Americans walking with him as he discovered and named mountains, glaciers, and bays. During a three-day camping trip with Theodore Roosevelt in 1903 the then-legendary Muir made the case that led to the modern American system of national parks. He was also, significantly, first president of the Sierra Club, still the most powerful American conservation association.[145]

Muir's work parallels that of the Ruskin of *Modern Painters* so well it helps us out of our old paradigm to a truer picture of Ruskin himself. It would be too easy, in fact, to compare Ruskin on mountains with Muir on mountains. Let us challenge the new paradigm by putting next to Muir's naturalism a famous Ruskin passage supposedly art criticism. *Modern Painters'* famed chapter "Of Water, as painted by Turner," supposedly about Turner's "Upper Falls of the Tees" will serve.

Examined in this new light, we can finally notice, without condemning Ruskin for digressing, that "Of Water, as Painted by Turner" has more water than Turner, even when it seems to speak of art. He meets us in front of a painting, and swiftly leads us *out* of the gallery to see the real things he values more than the "transcript" of them. After one sentence on Turner's "Upper Falls of the Tees" (the unhelpful remark that "it is impossible to express" the great "accuracy" with which the water is painted), Ruskin hustles us out of the artworld into the real one. I can include only a short selection here, but the distance he travels from art criticism will quickly be evident:

> Now water will leap a little way, it will leap down a weir or over a stone, but it *tumbles* over a high fall like this; and it is when we have lost the parabolic line, and arrived at the catenary, when we have lost the *spring* of the fall, and arrived at the *plunge* of it, that we begin really to feel its weight and wildness. Where water takes its first leap from the top, it is cool, and collected, and uninteresting, and mathematical; but it is when it finds that it has got into a scrape, and has farther to go than it thought, that its character comes out: it is then that it begins to writhe, and twist, and sweep out, zone after zone, in wilder stretching as it falls; and to send down the rocket-like, lance-pointed, whizzing shafts at its sides, sounding for the bottom.[146]

And on, for pages. While scholars have always accepted this passage, and countless others like it, as archetypal Ruskin, no one has ever known how to justify it as art criticism. How unlike any known art criticism it is! But how similar an effort to a passage two decades later, John Muir's analysis of Yosemite Falls. Ruskin had helped us see the "rocket-like, lance-pointed, whizzing shafts," and Muir helps us see how

now and then one mighty throb sends forth a mass of solid water into the free air far beyond the others, which rushes alone to the bottom of the fall with long streaming tail. . . . The heads of these comet-like masses are composed of nearly solid water, and are dense white in color like pressed snow, from the friction they suffer in rushing through the air, the portion worn off forming the tail, between the white lustrous threads and films of which faint, grayish pencilings appear, while the outer, finer sprays of water-dust, whirling in sunny eddies, are pearly gray throughout.[147]

Less obviously than Ruskin, Muir too resorts to the language of art—"grayish pencilings"—to help us see the falls. At the falls' raging bottom, when Muir describes the "hissing, clashing, seething, upwhirling mass of scud and spray," we remember Ruskin's description of gale waves which followed closely the passage quoted above, as "rushing, writhing, tortured, undirected rage. . . ." Did Muir read Ruskin? Perhaps, but he didn't have to. By the time Muir wrote, half of Ruskin's thirty-nine volumes already existed, and his vision, his word-choices, was coloring the language. In the hundreds of pages Ruskin devoted to the sea alone he virtually exhausted the language's wordhoard for this sort of work:

The surges themselves are full of foam in their very bodies . . . and their masses, being thus half water and half air, are torn to pieces by the wind whenever they rise, and carried away in roaring smoke, which chokes and strangles like actual water. . . . whirling and flying in rags and fragments from wave to wave; and finally conceive the surges themselves in their utmost pitch of power, velocity, vastness and madness, lifting themselves in precipices and peaks. . . .[148]

So if Muir describes how the "heavier masses" of the falls "shoot out" from the "precipice" or how "occasionally the whole fall is swayed away from the front of the cliff, then suddenly dashed flat against it, or vibrated from side to side like a pendulum, giving rise to endless variety of forms and sounds"[149] he must sound to us Ruskinian because Ruskin pretty much did it all.

What matters to us is that we at last have Ruskin in the right company, company so close we even briefly wondered about direct influence; and we realize we had to leave the artworld to find this company. John Muir is no art critic, but the father of the organized American ecology movement.

With environmental ethics' growing significance for our culture, we need to reexamine Ruskin. Environmental ethics has much to learn from him; I can only begin to suggest how much in these pages. His works not only anticipate current thought, expressing it in unequaled prose, they frequently surpass it. For instance, contemporary ecology, like Muir, recognizes the rights of wilderness; but where is Muir's recognition of the human right to shelter, or an attempt to balance the two

often-opposing claims? That attempt led Ruskin to *The Stones of Venice.*
Ruskin's ethics didn't stop with nature.

In later life, Ruskin's Natural Supernaturalist principles never let him
become comfortable with his awakened affection for art's things. His
love remained a guilty love. In a late volume of *Modern Painters,* a decade
after the first, we find Ruskin insisting doggedly and dogmatically that
mere real things are always superior to art objects. He belligerently
quotes old pronunciamientos, ("I have always said he who is closest to
Nature is best") citing his own chapter and verse ("reconsider . . . the
first volume, Part I, Sec. I, Chap. v. and Part II, Sec. i, Chap. vii,") and
mumbles his old catechism once again. He nervously pictures a reader,
confused perhaps by Ruskin's new, ill-fitting enthusiasm for Tintoretto,
quizzing him afresh about the relative merits of artworks and mere real
things. The "more closely" a picture of the Alps resembles the Alps, "the
better" the picture is? (He has a reader ask.) His reply is one word: "Yes."
If Turner doesn't give "the impression of such a window, that is of Na-
ture, there must be something wrong in Turner?" "Yes."

Now the ultimate question. Does Ruskin still prefer real things, even
over Turner? Would you, Ruskin, still "change your Turners for win-
dows. . . ." Well—yes, for windows of the Alps. "I believe any sensible
person would change his pictures, however good, for windows."

So Ruskin carefully reduces painting to a means again, to a lens
through which we study the world. He knows where that leads: he anx-
iously imagines the reader "inclined to say, 'Why not give up this whole
science of Mockery at once, since its only virtue is in representing facts,
and it cannot, at best, represent them completely . . . why not keep to the
facts, to real fields, and hills, and men, and let this dangerous painting
alone?'"[150] "Dangerous" because, as the concept artists said, artworks
could distract us from real things.

Ruskin's only defense is that the time to put art away has in his day
not yet come. He inserts an all-important clause to preserve painting
for the time being, the same clause Emerson includes. Oddly enough,
examining this clause also explains why Ruskin thought Turner better
for you than Constable, or colored photographs (which he despised);
why Ruskin thought the "lowest art" was simple "mimicry" of mere real
things.

It was the belief which underlay his entire herculean effort: The truth
of nature is not to be discovered by the "uneducated" senses. Windows
are better than pictures, yes. But if we were *at this time* to trade our win-
dows for Turners, we would not yet see as much of the Alps through our
windows as we would through our Turners. We're not up to it—*yet.* At
this stage in human development, we need the great lens of a Turner

painting for the same reason we need the Ruskin essay before us: we have not entered into our full powers.

If we accept the premises, we understand why he thought a slavish imitation the lowest art. A retinally identical copy would be as little help to people with our undeveloped powers as the mere real thing. We could make as little of the duplicate as we could of the thing itself. By "true" to nature, Ruskin never meant "retinally identical" to nature. Granted, there is no point contemplating sheer error. "There was a certain foolish elegance in Claude," but his work "resembled nothing that ever existed in the world." Yet Ruskin was equally clear that Pre-Raphaelitism, as long as it "confined itself" to the "simple transcript," the "simple copying of nature," would only reach the middle ranks. Turner's gift was to stay "true" to nature without being "identical" to nature. What use to us could a mere identity be? No more than the objects themselves. Turner's performances subtract, underline, or add to mere real things, through the infinite choices available to him of vantage point, lighting, soft or sharp focus. Turner selects for display exactly, and only, the visual information we need from each scene for us to rise with him to exalted vision.

Emerson, fourteen years before, had written that art's "office" was to "educate us to the perception of beauty," and Ruskin, with infinitely more reverence, offers that, for now, it is "more desirable" to see nature "with the eyes of others." Not just any others: with the eyes of Turner. We may "wisely" say to a "great imaginative painter," a person, Ruskin tells us, "Greater a million times in every faculty of soul than we . . .

'Come between this nature and me—this nature which is too great and too wonderful for me; temper it for me, interpret it to me; let me see with your eyes, and hear with your ears, and have help and strength from your great spirit.'[151]

Yet this defense, even if we accept it, leaves us aware that we are in some important sense immature, and that these art objects are the sign of our immaturity—the training wheels on our bike. Who could accept such a condescending judgment—accurate though it may be—without silently resolving to strengthen ourselves until we have no need for this obnoxiously great spirit, "greater a million times in every faculty" than we are?

Emerson, when we mull "Art" over, has also implied that we need help for the moment. Emerson, trained minister for the pulpit, has tactfully chosen not to make us dwell on our present weakness, but to help us revel in the thought of our future power, when we cast aside stone dolls and oily canvasses and take the great world straight. When Emerson, unlike Ruskin, spoke of the artist he spoke of no Turnerian great spirits, greater a million times than we. He talked of "dancing-masters" (in his

reader's minds—pomaded, unmanly, and socially equivocal) whose steps were "best forgotten" once we had learned grace.

When Ruskin moves from art to economics he scarcely moves at all: it is no more than a change in the price of the objects. "There is no wealth but life," the message of his economics, had been the message of his aesthetics. Art objects were permitted to draw your attention to the wealth that was life, but not to distract; the same for all other objects. The manufacture of art objects was justified if they were "praise" of life; the manufacture of other objects was justified if they augmented life. In both systems life is the end, things only the means to it.

If the means ever interfere with the end, or try to replace the end—life—with their inferior selves, the system must be changed. Ruskin never loses sight that there are *two* human lives involved in every art object, the spectator's and the artist's.

Art that costs life in the artist, cancels out the life it may bring to the spectator. The artist's life is as valuable a human life as the spectator's. And when the artists, in a machine-age, are demoted to hands, who, for the sake of some indifferently pretty glass objects that fringe a window curtain, "sit at their work all day," chopping up glass rods, "their hands vibrating with a perpetual and exquisitely timed palsy, and the beads dropping beneath their vibration like hail,"[152] obviously more life is being lost than gained. In exchange for the life enhancement a glass bead gives us, we condemn those men to slavery. Simply a bad bargain—bad economics, Ruskin would say. We seem to have no word for what it costs to produce wealth, so Ruskin offered "illth."

The whole question, therefore, respecting not only the advantage, but even the quantity of national wealth, resolves itself finally into one of abstract justice. It is impossible to conclude, of any given mass of acquired wealth, merely by the facts of its existence, whether it signifies good or evil to the nation in the midst of which it exists.

We have to know how many men sat palsied to produce this wealth of glass beads; how much Gross National Pollution accompanied the Gross National Product. Ruskin, at least as innocent in these matters as Carlyle, believed that if he showed industrialists the illth they were producing, they would have to change their system: "Luxury at present can only be enjoyed by the ignorant; the cruelest man living could not sit at his feast, unless he sat blindfold."[153] But the Victorian bourgeoisie considered that a very small price to pay for the privilege of sitting at their feast; as Ruskin learned.

"THERE IS NO WEALTH BUT LIFE." Ruskin's suspicion of art objects, I mean to say, is of a piece with, and led him toward, his suspicion

of manufactured objects. Art which requires the loss of an unwilling victim's life nullifies itself. Were we to learn that the pretty little ceramic cup we have been enjoying is enameled with human blood, we could not enjoy it. The same, if we learned that it had been manufactured through the bleeding away of human lives. I don't believe Ruskin meant that the cup couldn't be pretty, for plainly it could. Blood is a brilliant red. Ruskin believed it would be unenjoyable, a totally unsatisfactory experience (and in that case, who cares if it were "pretty"?) since, as he always said, we do not, in practice, react to art just with our aesthetic sense, but with our whole being. By the same token, objects created at the cost of life were unenjoyable, as soon as we recognized the human blood on them.

This is the limit Ruskin argued we must set to art or to any other manufacture of objects; that it not, in the process of bringing us greater life, cost someone else theirs. Once we become aware, therefore, of Ruskin's mistrust of art objects, we realize his economics has an unexpected integrity and continuity with his aesthetics.

IV

Leaving the Raft Behind: John Cage

A. Recontextualizing Cage: Industrial Supernaturalism, Suzukian Zen, and the Buddha's Raft

What differentiates Zen from the arts is this: While the artists have to resort to the canvas and brush or mechanical instruments . . . Zen has no need of things external. . . .—Daisetz Suzuki, 1938

In the *Majjhima Nikaya (Mahatanhasankhaya-Sutta)* the Buddha gives his bhikkus, monks, the famous parable of the raft, likening his doctrine to it. "Suppose that a man . . . find[ing] in his way a great broad water," gathers some "reeds and twigs and leaves" and binds them into a raft. "Labouring with hands and feet," he attains safety on the other shore. Certainly the man will be grateful to the useful raft, but would it make sense for the man to carry it on his back now that he's reached the other side? The bhikkus respond scornfully: destroy the thing. The Buddha prudently suggests that the raft might be left by the water where others might find and use it. Then he calls his own teachings no more than such a raft: just for crossing over, not for carrying on your back once you've reached the other side.[1]

That had been the new religious orientation's attitude toward the art object. The ease with which Eastern religious metaphors fit Natural Supernaturalism forecasts this chapter's subject. We turn to examine the "blissful hour" that Wordsworth prayed for in the "Prospectus." "Art" does not end. Natural Supernaturalism does not end. All that ends is Natural Supernaturalism's primary reliance on art objects to teach its message. We return to "concept art," which we glanced at in our first pages. Having now studied certain anomalous passages from the nineteenth century, we have recontextualized concept art and shall see it differently.

Though Irving Sandler said concept art "demolished every notion of what art should be," though Gregory Battcock hailed it as "a new area of speculation" and a "dramatic break," and Murray Krieger spoke of his "terror over the consequences" of this "final undoing of the entire post-Kantian aesthetic. . . . All come tumbling down together,"[2] concept art's roots in the nineteenth century should be clear by now. From the start

119

of this new aesthetic, the art object was *meant* to tumble down. As the Buddha said, what use is the raft once you've reached the other shore? Natural Supernaturalism reaches the shore—and kicks away the raft.

One unique figure, John Cage, presided over so much of the liberation from the art object—and then from the artworld—that his career is a capsule history of the whole process.

Though he first became known for his work with sound, Cage influenced all the arts. When Harvard University Press called him, in a 1990 book advertisement, "without a doubt the most influential composer of the last half-century," amazingly, that was too modest. Cage influenced the visual arts even more strongly than he did music, and he also left his mark on dance, theater, and poetry. To get some idea of his prestige between 1950 and 1970 one has to think of a figure like Samuel Johnson in 1770. Cage was the single artist most responsible for convincing the artworld that every mundane object was worth our wondering contemplation.

Though Arthur Danto conceived the "end of art" hypothesis when confronted by Warhol's *Brillo Boxes* at the Stable Gallery, Cage had presided over art's release from the art object nearly thirteen years before with his much more radical 4′33″. Warhol sowed his seed in ground Cage broke. The avant-garde audience quickly understood Warhol's witty creations only because Cage had labored for years. Warhol himself later wrote he'd first dared to offer everyday things as art objects only after submitting the idea to a member of Cage's circle, Emile de Antonio. Warhol paints his younger self as a commercial artist pathetically idolizing the already-celebrated Rauschenberg and Johns, longing for acceptance by their coterie, whose spiritual leader was Cage. It was de Antonio, in fact, who arranged for the Stable Gallery to show Warhol's *Brillo Boxes*. (Cage said approvingly later that "Andy has fought" to show us that "everything we look at is worthy of our attention.")[3]

"Spiritual leader" is the best term for the mature Cage—neither "artist" nor "anti-artist." The hapless term "anti-artist" tells you only what he's against, not what he's for. Ultimately, history may decide that Cage's greatest contribution has been to American religious life. Just as *Modern Painters* becomes easier to understand when taken out of art criticism and placed next to John Muir's works, the mature Cage quickly becomes more comprehensible when he is thought of not as a musician but as a religious figure. After all, Natural Supernaturalism is not a kind of art. In the East, similar tendencies were able to come up where one would expect them—their cultures' religious institutions. In the West, however, the religious institutions were blocked, controlled by anthropomorphic

religions. Natural Supernaturalism was forced to slowly refashion the cultural institution of art into a makeshift raft. Cage, more than any other single person, realized that raft had finally crossed the Western river, and, declining to carry it on his back, got off and walked on.

Or tried to walk on: when the moment came, it wasn't that easy. Andy Warhol, with his complete moral anesthesia, could look at 1960s America, and behold, it was good. Cage, a more complex man, could not convince himself. There's the second great reason to conclude the book with him. Looking closely at Cage's career forces us to confront the crisis which people with Natural Supernaturalist orientations underwent midway through the nineteenth century and to understand its relation both to art's "end" and to the ecology movement's rise in the late sixties. Teaching people to find the beauty in the everyday scenes that the Industrial Revolution produced raised moral questions which Wordsworth's contemplation of daffodils never had.

Walter Pater defined "success in life" as the refusal ever to acquiesce in a "facile orthodoxy" of another, "or of one's own." Cage—astonishingly—even as his works at last found fame and his career, in the 1960s, became a triumph, refused to acquiesce in a facile orthodoxy, even one of his own making. I think it his greatest achievement. He became the first to publicly question the contradiction in his giving people new ears, new eyes—then sending them out to experience an ecological holocaust. Cage's work since 1965 at times almost repudiates the work before. There are two Cages, and the second is the best critic of the first. The first Cage fulfills Wordsworth's and Emerson's aims. The second, who steps outside the project and holds it, and himself, up to moral scrutiny, is even more interesting. In Cage's work, Natural Supernaturalism, in the very moment of success, confronts itself, and passes stern judgment.

Contemporary scholarship, for various reasons, still follows Calvin Tomkins's and Ihab Hassan's lead in virtually stopping the clock on Cage in 1957. For over thirty years there has been a still-unfamiliar second Cage who, when asked in the 1990 Public Broadcasting System tribute to him if he had any second thoughts about 4'33", said unexpectedly, perhaps "we have ruined the silence."[4] Asked about his comment later that year, he repeated earnestly, "Perhaps we *have*. And imagine," he laughed ironically, "then they went right on to me collecting mushrooms."[5]

When Cage broke out of art, the "great consummation" Wordsworth had prayed for, the world he saw about him had changed too much from the one the youthful Wordsworth had tried to awaken us to see. Cage spent his last three decades wrestling with the question. His resulting

journey into the fledgling ecology movement, which he then helped shape, was an example soon followed by many other artists and, more slowly, by the whole culture.

B. The Simple Produce Changes: The Industrial Revolution and the Crisis of Natural Supernaturalism

Industrial Supernaturalism

The crisis Cage underwent in the sixties had its roots deep in the nineteenth century. Cage has never been studied in that context and he must be. What follows makes no claim to be comprehensive nineteenth-century history, only an exhibit of certain moments which recontextualize Cage and help us also understand why the "blissful hour," when at last it came, was such an unexpectedly poignant and conflicted one.

In a way this chapter continues work begun by Marjorie Perloff, Cage's most perceptive publishing critic (sometimes indebted, as am I, to David Antin—Cage's most perceptive *non*publishing critic). Her 1986 *The Futurist Moment: Avant-Garde, Avant Guerre, and the Language of Rupture* recontextualized Cage's generation against that of the pre-War avant-garde. Her 1981 *Poetics of Indeterminacy: Rimbaud to Cage* and the 1990 *Poetic License: Essays on Modernist and Postmodernist Lyric* are complementary efforts, equally stimulating. My own effort is also indebted to and continues Betsy Erkkilla's work in the 1980 *Walt Whitman Among the French: Poet and Myth*. American artists, Erkkilla argued, have often borrowed back from the French what the French originally borrowed from Americans, particularly from Whitman. I will recontextualize both Cage and the futurists against the nineteenth-century English and American background. What was the nature of D. T. Suzuki's Zen, if Cage could later discover, "amazed," all its best ideas in an American transcendentalist? Understanding the nineteenth-century context will make Italian Futurism, John Cage, and even the startling growth of Western Zen much clearer.

In *Natural Supernaturalism* M. H. Abrams sometimes turns his gaze forward from the early 1800s to trace (with enviable skill) the "intellectual tendency" continuing in the work of Rimbaud, Gide, D. H. Lawrence, Stevens, Joyce, the Beats, and many others. No book can be about everything, and Professor Abrams's scope is already vast. By insisting on a strict construction, however, of what can legitimately be called *natural* supernaturalism, he leaves out the great crisis artists of that tendency fell into even in Wordsworth's time. Wordsworth tried, with little success,

to face the problem; Emerson considered it; Whitman's decision to cut the Gordian knot was admired greatly, and paid homage to, by generations of poets and painters all over Europe. Perloff's *The Futurist Moment* agrees with Renato Poggioli's idea that Italian Futurism had only been a "symptom of a broader and deeper state of mind." The Italians "had the great merit of fixing and expressing" that state of mind, Poggioli claimed, "coining that most fortunate term as its label."[6] (In deference to them, I have used "Futurism," capital F, to refer to their movement and to distinguish it from "futurism" as a permanent cultural phenomenon.) We must add to Abrams's admirable tracing of Natural Supernaturalism's lineage a sibling tendency. "Futurism" is almost *too* "fortunate" a term for it—and now the term misleads as well, for futurism is now about the past. We have emerged into a postindustrial world. Futurism was about facing facts, girding up your loins and learning to love what is now just the rustbelt—an industrial world no one ever dreamed mankind would be able to leave behind. *That* was man's "future." That was what so many artists bravely decided to help him love. We might better think of "Futurism" as "Industrial Supernaturalism," an awkward name for an often awkward concept. One early reader of this manuscript winced at the term. I laughed, myself, when years ago an undergraduate said it in class as a wisecrack. (We were looking, I think, at Charles Sheeler doing his best to transfigure Henry Ford's Rouge River smokestacks.) But I couldn't forget it. The term accurately underscores a continuity of effort between Wordsworth's transfigurations and these later ones. Replacing the word "future" with "industrial" also reminds us that Marinetti was extolling not all possible futures but the only one he thought possible: the industrial age. His "future" is now our past. We dare hope for a more ecological future. Finally, I think the term *appropriately* jarring. There are times one *should* wince; and Industrial Supernaturalist art abounds in them. Those Sheeler smokestacks are not alone.

This younger brother to Natural Supernaturalism is, by his very existence, a problem for the firstborn; and, like many younger half brothers in Western narratives (think of Edgar and Edmund in *King Lear*) this one is socially and morally questionable. Yet—also in the *Lear* tradition—the younger has long shown a vitality exceeding that of the legitimate line Abrams described. When Arthur Danto got the idea for the "transfiguration of the commonplace," he was not, after all, looking at a landscape painting but at a Warhol transfiguration of a machine-made object, a Brillo box. By the time the "blissful hour" actually arrived the commonplace world had changed so much from Wordsworth's time that it was the artists of this younger line who performed the long-awaited "transfiguration of the commonplace." Abrams, by excluding them from

his study, missed out on Wordsworth's most vigorous descendants. He writes of Sylvia Plath, but he misses John Cage.

Sir Kenneth Clark, summing up a chapter on Wordsworth and Constable, spoke of their "rapture," the rapture through which they "persuade us to enjoy such commonplace spectacles as daisies and glowworms . . . as the Willows by a Stream or the Cottage in a Cornfield."[7]

But what happens once most of us no longer live in cottages in cornfields, so that daisies and glowworms are no longer "commonplace?" Wordsworth had aspired, in the "Prospectus," to help us find Paradise in the "simple produce" of our daily lives. In 1800 he could assume that meant nature. Would it alter his plans if something were to replace natural things as the simple produce of *our* common day? If Brillo boxes were to become more common than daisies?

The Industrial Revolution accomplished that and immediately complicated an aesthetic revolution already complicated enough. Wordsworth's generation now exists in a strange isolation, separate from the long tradition they had rebelled against, yet separate from every generation after them, which grew up in an industrialized world. As Steven Marcus is fond of pointing out, the change to industrial organization was the most profound to affect human society in seven thousand years, since we gave up being nomadic hunter-gatherers and settled down to raise grain.

Abrams does not, in *Natural Supernaturalism,* consider the sad irony that Wordsworth, unluckily, had launched his project to transfigure the natural world the moment before technology began to overwhelm it. There was, as a result, a crisis among artists of the new orientation.

By midcentury, distaste for the new world the Industrial Revolution created caused the first (but not the last) mass defection to Parnassus or to a cult of the perfect object. Others, like Ruskin and Carlyle, took up political action. Still others, like Daubigny and Corot, followed nature into exile. But new recruits, like Whitman and some of the Impressionists, boldly applied the original premise to the new mere real things, fighting with increased militancy to transfigure this new common day of steam engines, working-class dance halls, modern women in their rainbow dresses colored with the new aniline dyes.

As I mentioned before, one of the most famous phrases to come out of the Vietnam War was, "In order to save the village it was necessary to destroy it." Continuing the project meant changing the project. Teaching people to transfigure the sort of daily scenes the Industrial Revolution produced (particularly in its first Dickensian decades) raised different moral questions than the contemplation of daisies and glowworms had. Sometimes, as T. J. Clark and many socially conscious critics have

charged, one had to teach people to contemplate modern city life from so great an aesthetic distance it was hard to say one wasn't teaching them to see human suffering as colors. Some of those attempting to continue the project even began, defensively, to deny that moral issues should "intrude" on art. That idea would have shocked Wordsworth, who had argued specifically that the contemplation of nature through art's lens *taught* morality.

As many have pointed out, we misinterpret Wordsworth when we call him a nature poet. Wordsworth was the poet of the everyday, of those objects on which the poet's powers "had not before been exercised" because they were too common, too "mean." The simple produce of Wordsworth's day *was* nature.

Not to imply that something like the Industrial Revolution flowers overnight. Its English roots alone reach back to Tudor times and we can find John Cleveland, in 1650, exclaiming over the first large coalfields (not exactly mines) at Newcastle, "England's a perfect World, hath Indies too; / Correct your Maps, Newcastle is Peru." (Then proverbial for mining.) Arthur Elton and F. D. Klingender, in *Art and the Industrial Revolution,* think the "first industrial landscape" may be Peter Hartover's 1680 Coal Staithes on the River Wear but it is really the industry's debut in a lesser genre, the "view." Coal pits, iron bridges, and other early industrial scenes appear among other curiosities and wonders in late eighteenth-century views by Paul Sandby, Julius Caesar Ibbetson, and Joseph Wright of Derby; sometimes commissioned by the proud industrialists, as Benedict Nicholson has shown. Nor were such sources of patriotic pride absent from any "tours" of England, such as Defoe's, published in 1724–27.

Our respects dutifully paid to the early industrial revolution, we must still say that the flower is not the bud, nor the green stem. As scholars as disparate as Gilbert Highet and Steven Marcus have long pointed out, the Western world did not even recapture the road-building technology of the ancient Romans until after 1750. The first great English canal, the Bridgewater, was not opened until 1761. "It is a symptom of the speed with which the industrial revolution transformed the life of Britain that for Dickens, writing in the 1830's and 40's," the stagecoach, a "revolution in transit" made possible by the new roads, had "already become a symbol of the good old times."[8] The mail was not carried on the new stages until 1785—when Wordsworth was fifteen.

It is hard for us to recapture how *ordinary* nature was for Wordsworth during his time (the late 1790s and the early 1800s). London, the "great Wen" as Cobbett called it later, was already swelling, but it was still possible to regard London the way Wordsworth does in Book VII of the

Prelude as (John D. Rosenberg tells us) "a kind of cosmopolitan Vanity Fair," a "gallery of grotesques."[9] Wordsworth and Constable's generation could still treat the city as a terrible curiosity, something possible to avoid.

> Forget six counties overhung with smoke,
> Forget the snorting steam and piston stroke,
> Forget the spreading of the hideous town;
> Think rather of the pack-horse on the down,
> And dream of London, small, and white, and clean,
> The clear Thames bordered by its gardens green . . .
> While nigh the throned wharf Geoffrey Chaucer's pen
> Moves over bills of lading—

So William Morris, recoiling, in his own way, from the new common day, later wrote in "The Earthly Paradise."[10]

But earlier, in Constable's and Wordsworth's artistic prime, one's world was still nature, ordinary nature; not the NATURE we make pilgrimages to on weekends, "conserved" or "preserved" on its reservation like an Eisenhower-era Indian. Paintings like Edward Dayes's Queen's Square show that London square still unclosed in 1786; the well-dressed city people still look out to the pleasant hills of Hampstead in the distance. Constable, living in those hills during summers, painted pictures (as late as the 1831 "Hampstead Heath") of a tiny London riding on a rural green sea. In 1795 Wordsworth has to wrestle the "Traveller" down onto the "seat in a Yew Tree" as if it were one of those benches placed over the subway grating in the middle of Broadway: "NAY, Traveller! rest . . .

> What if here
> No sparkling rivulet spread the verdant herb?
> What if the bee love not these barren boughs?

The jealous modern city-dweller raises his eyebrows. "All" this bench has to offer, it turns out, is a "beautiful prospect" of "curling waves / That break against the shore."[11]

By 1852—half a century of industrialization later—in Arnold's "Lines Written in Kensington Gardens" we find an experience of nature closer to the way we contemplate a "nature" carefully maintained in a national park, while car noise hums in the air:

> . . . In the huge world, which roars hard by
> Be others happy if they can!
> But in my helpless cradle I
> Was breathed on by the rural Pan.

> Here at my feet what wonders pass,
> What endless, active life is here!
> What blowing daisies, fragrant grass!
> An air-stirred forest, fresh and clear.

By 1852, "nature" is fast becoming not the common day, but a refuge from it—from "the huge world, which roars hard by." Between Wordsworth's poem and Arnold's the British population had doubled, from 10.5 million in 1801 to 20.81 million in 1851.[12] It is hard for us, who share it, to remember that Arnold's sense of man's city as "huge" and of the natural world as something comparatively vulnerable is an outlook dramatically new, something that would have startled Constable. By the same token "the rural Pan"—emblematic of a nature Constable and Wordsworth had both appealed to as the true classical permanence—suddenly seems dated and out of place "amid the city's jar."

The world of Wordsworth's first version of the *Prelude* was the reverse of that: the city, in Book Six, is still a "raree show" as John Rosenberg has noted; a strange smoky spot on the normal world of green linnets and daffodils. Industrialization progressed so rapidly that by Wordsworth's death, Nature was no longer the world, but an escape from the world, which was now the city. If Arnold's generation no longer read Wordsworth as a poet of the world, but of escape from the world, that was not Wordsworth's fault. It had been Wordsworth's intention, Coleridge has told us, "to give the charm of novelty," not to escapist exotica, but to "things of every day."[13] Nature is not even named. There was no need to name it: in 1814, by "things of every day," the green linnet is implied.

Wordsworth: "If the labors of Men of Science ever should create . . ."

Yet some members of the new generation held, amidst changed surroundings, to the original goals—transfiguration of the commonplace, whatever the commonplace—with amazing consistency. If the word "consistency" does not mislead: it is in no way a question of unbroken influence. Natural Supernaturalism reinvented itself constantly, usually with great fanfare of originality.

Wordsworth himself foresaw the possibility of a *new* common day. "If the labours of Men of Science," he writes in the 1800 Preface, should ever lead to "any material revolution," in our lives and what we "habitually" see and hear about us—if nature should ever cease to be the common day, and the products of technology ("the objects of science") become it—"the Poet will sleep then no more than at present. The poet

will be "ready to follow" right in "the steps" of the technologist, transfiguring the new world for us, "carrying sensation into the midst of the objects of the science itself."

In his time Wordsworth is the poet of nature—but "if the time should ever come" when the objects produced by even "the remotest discoveries of the Chemist, the Botanist, or Mineralogist" are a "familiar" part of our lives, then "these things . . . will be as proper objects of the Poet's art as any upon which it can be employed."

Not "when" but "if" the time comes. Wordsworth can still say "if," in this 1800 passage. *If* the time comes when technological products are as much humanity's commonplace as nature, then "the Poet will lend his divine spirit to aid the transfiguration. . . ."[14] Wordsworth's wholehearted acceptance of technology in this passage, his implicit equation of *whatever we see everyday* with *nature* runs counter to a more familiar Romantic conception of nature, "the subsistence of things on their own," as Schiller says, interesting because "we were nature just as they," so that now "they are . . . the representation of our lost childhood. . . . Our feeling for nature is like the feeling of an invalid for health."[15] Wordsworth, by contrast, contends it would be equally appropriate to transfigure plastic and formica. He doesn't know those names, but he's plainly imagined such things, and all the chemist's remote discovering.

Once they become "familiar" parts of our lives, "transfiguring" them will be the Poet's "proper" task: even down to the Brillo boxes. Fifteen years later, in his "Essay Supplementary to the Preface of 1815" he will, without mentioning the technological objects specifically, again leave the door wide open to their "transfiguration"—revealingly, he and Danto lighted on the same word. That both had to borrow religious vocabulary is also revealing. The "only proof" of "genius," Wordsworth writes, is "doing well" what's both "worthy" of doing and what was "never done before." In the fine arts, the only "infallible sign" of genius is to transfigure more and more mundane things, to widen the "sphere of human sensibility: the application of powers to objects on which they had not before been exercised." Wordsworth forecasts, and authorizes, the application of the artist's powers to objects previously untransfigured because they had not previously existed.

Before we start celebrating Wordsworth's prophetic spirit, let us reflect that his 1800 passage about the possible change, the "material revolution," was almost certainly an allusion to topics raised by poems written before Wordsworth's; poems written very much in an eighteenth-century rationalist spirit. For instance, Wordsworth could expect that any reader serious enough about poetry to be laboring through a young unknown's preface would certainly have read Erasmus Darwin's famous

Botanic Garden, published in 1789 and already, when Wordsworth wrote, appearing in revised editions prefaced by adulatory odes from important authors.

Erasmus Darwin (1731–1802), Charles's grandfather, was a patriarch of the scientific and industrial community. Despite its title, *The Botanic Garden* is a book-length hymn to the new technology of steam, eighteenth-century futurism: "Nymphs!" he begins his verses on the steam engine, "you erewhile on simmering cauldrons play'd / And call'd delighted Savery to your aid. . . ." Like John Dyer's successful 1757 didactic poem on England's new cotton industry, *The Fleece* (which Wordsworth mentions in a note to *The Excursion*) Darwin's popularizes the new industrial technologies: "Press'd by the ponderous air the Piston falls / Resistless, sliding through it's iron walls. . . ."

Darwin excited Wordsworth's contemporaries with prophecies of the brave new world they might live to see. Like space travel later, the steamboat, railroad, and even the airplane were popular topics of discussion long before they were realities:

> Soon shall thy arm, UNCONQUER'D STEAM! afar
> Drag the slow barge, or drive the rapid car;
> Or on wide-waving wings expanded bear
> The flying-chariot through the fields of air.

Darwin's scientific reputation and his scholarly notes convinced excited readers that these were no mere fantasies: "As the specific levity of air is too great for the support of great burthens by balloons . . . there seems no probable method of flying conveniently but by the power of steam, or [Darwin accurately predicts] some other explosive material; which another half century may probable [*sic*] discover."[16] Darwin's popular verses, written with the zeal of an early 1980s computing-for-poets article, made the new hi-tech world of steam user-friendly for his educated audience.

Wordsworth, as poet of the commonplace, could not avoid taking these famous predictions of its change into account. As we've read, he met them, characteristically, head-on. "If the labors of Men of Science should ever make" the steam barge, rapid car, and flying-chariot humanity's new commonplace, the Poet will "sleep no more than at present [but] . . . will lend his divine spirit to aid the transfiguration. . . ."

And yet, Wordsworth himself had small appetite for transfiguring them. In his sixties, Wordsworth wrote the conflicted, anxious "Steamboats, Viaducts, and Railways," in which his every try at praise (in willed fulfill-

ment of his youthful preface's promise?) is marred by his obvious repugnance for these things. It starts:

> Motions and Means, on land and sea at war
> With old poetic feeling, not for this,
> Shall ye, by Poets even, be judged amiss!
> Nor shall your presence, howsoe'er it mar
> The loveliness of Nature. . . .
> In spite of all that beauty may disown
> In your harsh features, Nature does embrace
> Her lawful offspring in Man's art [etc.]

If you were to praise a person while at the same time allowing that their "harsh features" did "mar" the loveliness of Nature you'd fail to please. Wordsworth's attitude toward the new industrialized world was much more complex than that late, doggedly enthusiastic poem suggests. By the eighth book of the 1814 *Excursion,* he (in the person of the Wanderer) was writing that "an inventive Age" had given birth to "most strange issues":

> I have lived to mark
> A new and unforeseen creation rise
> From out the labours of a peaceful Land

He approves that the old "foot-paths" and "horse-tracks" are gone, "swallowed up by stately roads / Easy and bold" but—shades of our present fears—do these fine roads still lead any place worth going? Wordsworth follows the stately road to

> . . . A huge town, continuous and compact
> Hiding the face of earth for leagues—and there,
> Where not a habitation stood before,
> Abodes of men irregularly massed . . .
> O'er which the smoke of unremitting fires
> Hangs permanent. . . .

He and the West are first discovering how technology gives with one hand and takes away with the other. Though Wordsworth still must "exult" over the "intellectual mastery exercised / O'er the blind elements," he sees too clearly that for now the factory is but a "temple, where is offered up / To Gain, the master-idol of the realm / Perpetual [human] sacrifice." Wordsworth, who in the great "Ode" had equated childhood with blessedness itself, stands transfixed with horror by a factory boy "whitened o'er with cotton-flakes . . . Creeping his gait and cowering, his lip pale, / His respiration quick and audible." That last comment shows Wordsworth probably aware of the respiratory diseases the "hands" developed from breathing the lint. Already Wordsworth sees that when

"the excellent and amiable Dyer" wrote his 1757 poem, *The Fleece,* "he wrote at a time when machinery was first beginning to be introduced, and his benevolent heart prompted him to augur from it nothing but good. Truth has compelled me to dwell upon the baneful effects. . . ."[17]

Emerson: "Science Learned in Love"

By Emerson's day, there was no longer a question of "if" a "material revolution" in the world humanity commonly experiences would come, only "when." Emerson goes beyond Wordsworth in facing up to the change; indeed, Emerson embraces it as one of his special claims for America. That is why Whitman springs off from him, not from Wordsworth— Whitman even more boldly accepting the "material revolution" (and, as it were, nationalizing it). This decision presages the futurists' work and that of the young John Cage.

Emerson's influential decision to continue the transfiguration of the commonplace in the face of the industrial revolution was not a foregone conclusion. Emerson wrote at a moment when the Natural Supernaturalist enterprise could have been dropped in despair, or let dwindle into ruralism and reaction. Consider Constable's attitude, and Barbizon's.

"Depend on [it]," Constable wrote his friend John Fisher, "the love of nature is strongly implanted in man, at least the pursuit of it, is almost a certain road to happiness." Though financial pressure forced Constable to live in London during the 1820s and 1830s, the new world wasn't even an issue for him, as it had been for Wordsworth decades earlier. The Barbizon painters in France, most vital between 1833 and 1848—Emerson's prime—were, by contrast, a journey into exile following the old simple produce.[18] As transportation improved in the 1840s and 1850s, the Barbizon painters' once-rural retreat suburbanized, became a weekend jaunt for Paris city people. Their canvasses become not a hymn to the rural Pan, but a lament, finally a dirge over him; the painters themselves must trek on. "Everything I wanted to paint has been destroyed," Daubigny wrote, "so . . . I'm off to see if the eternal Father hasn't upset the mountains of the Dauphine. . . ."[19] Certain of the young people who sometimes painted beside them and who identified with their love of color, turned back to the new city to declare that color could still be found there, even at the Moulin de la Galette and the Gare du Nord: the "Impressionists."[20]

Emerson's decision to embrace the new simple produce profoundly affected Whitman, who became, we shall see, an inspiration to the Futurists; and early Cage is a late Futurist. Yet the decision gave Emerson himself reservations. Emerson severely limits his advocacy. Wordsworth had

said confidently that, "if the time comes" when the objects produced by science become humanity's everyday, it will be "proper" for the poet to use his "divine spirit" for their "transfiguration." Emerson, writing in 1841, knows that day is inevitable; but Emerson tells the artist to hold back his hand until "science" (we would say, "technology") is "learned in love, and its powers wielded by love...."

Emerson includes here a stipulation later advocates of the transfiguration of the new industrial commonplace usually left out; and critics have felt its absence. Emerson was too conscious of the suffering involved in the industrial everyday to believe we could learn to regard it from an aesthetic distance without human loss to ourselves. "Is not the selfish and even cruel aspect which belongs to our great mechanical works, to mills, railways, and machinery, the effect of the mercenary impulses which these works obey?"

We can't enjoy them because we know they cause pain. Yet the new machines are not at fault; the old "mercenary impulse" is. Once we correct that (and only if we can correct that) "genius" will find its proper subjects in this new everyday:

When its errands are noble and adequate, a steamboat bridging the Atlantic between Old and New England . . . is a step of man into harmony with nature. The boat at St. Petersburg, which plies along the Lena by magnetism, needs little to make it sublime.

Emerson concludes the essay, "When science is learned in love, and its powers are wielded by love, they will appear the supplements and continuations of the material creation." A *new* nature, in other words: a "continuation" of the old one.

Wordsworth's original preface, written before the full horror of early industrial life became apparent, had included no such proviso. For Emerson, the "selfish and even cruel aspect" with which we regard "great mechanical works" is no failure of our power to transfigure those objects. Nor has the artist any business confusing our true and pitying vision of human suffering until the suffering has been erased from these objects "by love."

Emerson, once his proviso has been made, sets out to transfigure the industrial produce for us. Not only nature, but even machines are more exalted than art objects. (Since both are creations, we might ask, "why?") His work opens an important door not just to Whitman but to Marinetti, Leger, and all later efforts.

In 1841, in that anomalous, ignored essay, "Art," Emerson explicitly commands that art's face must turn from art objects to the new simple produce of this industrial century. Such bold statements as "Beauty must

come back to the useful arts, and the distinction between the fine and the useful arts be forgotten. . . . In nature, all is useful, all is beautiful," forecast Fernand Leger's argument that all "hierarchical prejudices in art" must be destroyed. "On that day," Leger predicts, people will gain "eyes to see" and "we will truly witness an extraordinary revolution. The false great men will fall from their pedestals, and values will finally be put in their proper place." Those false gods, we learn, are artists: "In the face of these artisans' achievements, what is the situation of the so-called professional artist? . . . I repeat, there is no hierarchy of art. . . ."

In 1841 we find Emerson arguing, as if he were Leger eighty years later, that in the "new facts" lies the real challenge to "genius" at this time:

It is in vain that we look for genius to reiterate its miracles in the old arts; it is its instinct to find beauty and holiness in new and necessary facts, in the field and road-side, in the shop and mill.[21]

Compare Leger in 1924 (and consider the anti-art object implications of such beliefs):

Many individuals would be unintentionally sensitive to beauty [of a mere real thing] if the preconceived idea of the objet d'art did not act as a blindfold. . . . My aim is to lay down this notion: that there are no categories or hierarchies of Beauty—this is the worst possible error. The Beautiful is everywhere; perhaps more in the arrangement of your saucepans on the white wall of your kitchen than in your eighteenth-century living room or in the official museums.

Leger and Emerson, to transfigure the work-a-day objects of our world, are knowingly revising a doctrine inherited from Hegel and Kant—that utility destroys aesthetic beauty. In truth, when Hegel and Kant separated what pleases us by being useful from what pleases us without even being useful, they did not mean something useful could never be pleasing aesthetically. Emerson, however, is careful to object to any such idea, and Leger, admitting that "in the mechanical order the dominant aim is utility, strictly utility," stipulates that "the thrust toward utility does not prevent the advent of a state of beauty."[22]

When Whitman wrote to Emerson, calling him "Master," he was able to intimate that he was the poet Emerson had called for in his 1844 essay, "The Poet." Expanding on the themes begun in "Art" three years before, Emerson complains that poetry readers still "see the factory village and the railway" as a blot on the "poetry of the landscape" for no poet has appeared to "consecrate" these new "works of art" for them. (Wordsworth and Danto use the word "transfigure" for that process. Emerson's "consecrate" is yet another theological borrowing.) In one of the earliest statements of what would become industrial supernaturalism, Emer-

son claims that the true poet will find those technological scenes no less part of the "great Order" than the beehive or "the spider's geometrical web." A bold and telling stroke! Emerson gives man's useful creations parity with the animals', equating the regular rows of factory cottages with the regular cells of a beehive, or the web of new steel tracks uniting the towns with the geometrical look of a spider web. Why study with Wordsworth to find the supernatural in those useful animal creations, and ignore man's? "Nature," Emerson assures us, "adopts them very fast into her vital circles" and she loves the railroad "as her own." Technology is second Nature.

But in 1844 Emerson admits, "I look in vain for the poet whom I describe," the "timely man," the seer of the "new religion" who will show us these and all other new American facts: "the northern trade, the southern planting, the western clearing, Oregon and Texas, are yet unsung." We need someone ready to carry a "mirror . . . through the street, ready to render an image of every created thing. O poet!"[23] Emerson didn't have long to wait.

Whitman: "A Worship New I Sing"

In a 1925 essay, Leger praises—with Cendrars and Rimbaud—Walt Whitman, for whom there had been a "mania" in France during the Cubist Decade.[24] In Whitman's work what had been *natural* supernaturalism completely embraces the new *industrial* produce; an embrace that will not loosen until the late twentieth century, when industrial damage to the world propels Cage and so many others into ecology. Whitman's enthusiasm frequently bounds past his teacher Emerson's scruples; and that was a foretaste of the future too.

Whitman's "Passage to India," written thirty years after Emerson's "Art," seems like the poem Emerson's text, with its benign steamboat marrying the two continents, had in mind. Notice the Carlylean "sage" switches of "wonder" and "worship":

> Singing my days,
> Singing the great achievements of the present,
> Singing the strong light works of engineers,
> Our modern wonders (the antique ponderous Seven outvied). . . .
> A worship new I sing.
> You captains, voyagers, explorers, yours,
> You engineers, you architects, machinists, yours,
> You, not for trade or transportation only. . . .[25]

"Thee for my recitative," he says to "A Locomotive in Winter," which may stand for many of his familiar poems. Reading, one thinks of

Charles Sheeler's precisionist painting of a locomotive's wheels half a century later (and Sheeler's wonderful photographs,[26] which he based his paintings on); or Leger's "tubist" fantasies of shining pistons, and the Cendrarian piston-men, their attendants:

> Thy black cylindric body, golden brass
> and silvery steel,
> Thy ponderous side-bars, parallel and
> connecting rods, gyrating, shuttling
> at thy sides . . .
> Thy knitted frame, thy springs and valves,
> the tremulous twinkle of thy wheels. . . .[27]

"Exact science and its practical movements are no checks on the greatest poet," Whitman had written in the 1855 Preface to *Leaves of Grass*, "but always his encouragement and support. Science underlies the structure of every perfect poem." Terms like "greatest poet" and "perfect poem" are some of Whitman's "sage" tactics. At first blush, they're offensively boastful, but they do less damage than the Wordsworthian solution of calling the transfigurationist a "real poet," as if all other poets weren't real poets at all.

Whitman has no more patience with Romantic hunger for a less prosaic life than Emerson or Constable had had. Emerson had struck out at contemporary Romantics and classicists alike in a marvelous bit of sarcasm:

They reject life as prosaic, and create a death which they call poetic. They dispatch the day's weary chores, and fly to voluptuous reveries. They eat and drink, that they may afterwards execute the ideal. Thus is art vilified. . . .[28]

Whitman's new "poets of the kosmos" must take "pleasure" in real things, which "possess the superiority of genuineness over all fiction and romance." In the hands of the greatest poet, "facts are showered over with light . . . the daylight is lit with more volatile light. . . ."

Romanticizations are not only unneeded but hurtful, if we believe that "each precise object or condition or combination or process exhibits a beauty. . . . That which distorts honest shapes or which creates unearthly beings or places or contingencies is a nuisance and revolt. . . ." Wordsworth had written that anyone who understood the dignity of real things saw no need to "trick them out with ornament" and Whitman echoes, "Most works are most beautiful without ornament. . . . Great genius and the people of these states must never be demeaned to romances. As soon as histories are properly told there is no more need of romances."[29] Another dancing-master down.

Cage and the Futurist Precedents

Even this early in our recontextualization of John Cage, we can see that the first phase of his career has roots as far back as Wordsworth, Emerson, and Whitman. He saw it himself when, late in life, he read Thoreau. Marjorie Perloff, in the introduction to *The Futurist Moment,* said she "should have liked to include some discussion of Futurist music—for example Luigi Russolo's 'art of noises.'" Cage, who became the champion of "noise," becomes much clearer in Italian Futurist context.

In the late thirties the youthful Cage is merely one of a host of people trying to transfigure a new world's new sounds; and a latecomer at that. His first manifesto, 1937's "The Future of Music: Credo" plays variations on many familiar Italian Futurist themes. He praises the industrial world's mere real sounds—his term is "noise"—above the perfected sounds that artistic instruments make. He preaches the well-known sermon that we stand in the midst of wonder, but lack the ears to hear. He sets up an auditory version of the Ruskinian looking/seeing dichotomy, to draw the conclusion that (as Ruskin might have put it) the beauty of machine noise is not to be discerned by the uneducated senses. When we futilely try to "ignore" the noise around us, "it disturbs us." But "if we listen to it," Cage tells us confidently, "we find it fascinating. The sound of a truck at fifty miles per hour. Static between the stations."[30] The aesthetic implied is an industrial supernaturalist's version of the old Wordsworthian "handmaid" defense: art is still the handmaid that will shake awake our senses to the wonder of roaring trucks and radio static.

Nothing new there, particularly if you'll take Cage's word for it. All of his life he graciously credited the influence of virtually everyone he ever admired. And overcredited: Cage was the sort of person who, when asked for an autograph by an artist, asked for an autograph in return. Most artistic lives amply illustrate Harold Bloom's darkly Freudian scenario of Oedipal son-poets throttling father-poets and hiding their bodies. Cage's career, by contrast, is filled with episodes of near-Confucian filial piety, like his irate visit to an "impresario" who had, by advertising a Stravinsky concert "Music by the World's Greatest Living Composer" inadvertently disparaged Cage's master's—Schoenberg—claim to that title. "I was indignant and marched straight into the impresario's office. . . ."[31] A youthful act, but fifty years later he still recalled the slight as angrily as if it were yesterday. His writing, like his conversation, abounds in reverential anecdotes of his inventor father, of Schoenberg, Suzuki, Duchamp, Marshall McLuhan, Buckminster Fuller. The Bloomian project of digging up the murdered Laius-poet and confronting Oe-

dipus with the reeking corpse won't help us know Cage. Nor will Bloom's cynical corollary that whomever the artist does acknowledge must be a decoy—Cage acknowledges everyone. If questioned directly, he would give an interviewer a quote in praise of almost anyone (except Samuel Beckett, and even there would only say they had "little in common").

The task here will be opposite Bloom's but no less difficult. Bad Cage criticism, like bad Ruskin criticism, is easy to write. Ruskin contradicted himself so completely, and wrote so much, the critical neophyte soon finds a dozen euphonious statements in support of his or her thesis—whatever the thesis. Cage is so generous, a fledgling critic quickly finds him admitting the intellectual parentage the critic has suspected—whomever the critic suspected. The mature Ruskin critic has also found a dozen euphonious statements *against* his thesis, the Cage critic has realized Cage can't owe everything he ever thought to everyone he ever met. One can't simultaneously be a disciple of Suzuki, Schoenberg, Duchamp, Huang Po, and Thoreau. Cage's filial demeanor—what the Chinese call *xiao*—creates a situation somewhat like *tai chi*, in which the subject, yielding gracefully to the critics' advance, lets them spin to the floor through their own force. Let us get up, dust ourselves off, and approach this agreeable man more warily, taking nothing for granted, trying to frame his work in the most appropriate contexts.

We will discover three main phases to Cage's thought, though his music has gone through many more.[32] Cage is undoctrinaire, a working artist, and once he discovers a procedure he likes, he frequently reinvestigates it. One can notice, however, when a procedure debuts, and relate it to his thought. We've begun understanding Cage's first broad phase, finding the roots of his futurism as far back as Wordsworth. We'll now frame it against the background of the *modernolatrie* that developed into Italian Futurism during the twentieth century's first decade. Whoever inspired the youthful Cage in the 1930s had themselves been inspired during that pivotal decade, and he by it through them. In 1960, invited by Wesleyan to list the ten works that most influenced his thought, Cage listed Luigi Russolo's *The Art of Noise* third, with a note indicating he encountered it in 1935. It gave a "sense of music renaissance, the possibility of invention."[33] The 1937 Cage we have just read, with his love of truck-roar and radio hum, is a late Futurist; or at least, futurist-ic. Interestingly, criticism has begun bringing out European Futurism's affinity with, and possible roots in, American transcendentalism. Since Cage seems inspired by, possibly indebted to, both Futurism and transcendentalism, let us examine the relationship between the two. Doing so will provide a better sense of how conservative and traditional Cage's

entire project was, clear up to 4′33″—and how significant, therefore, his ultimate break with this way of thought actually was. Only the later Cage is at all radical.

Whitman and Italian Futurism: Futurism and Nationalism

Whitman's hymns to the new simple produce became important in France during the cubist decade, so much so that Apollinaire could cause a scandal by printing an essay in the *Mercure de France* (on April Fool's Day, 1913) claiming that Whitman's funeral had been attended by 3,500 people who, following Whitman's instructions, got drunk and ate "great heaps of watermelons. . . . Pederasts came in crowds."[34]

"The Whitmanian craze of the pre-war years," Betsy Erkkila writes, in *Walt Whitman Among the French: Poet and Myth*[35] "corresponded to an era of good feeling between France and America.

For the *avant-garde* artist, the variety, energy, and apparent disorder of the United States was a kind of metaphor for the new spirit; and Walt Whitman, the poet of this *nouveau monde,* was a vital embodiment of this new spirit in literature.[36]

Leon Bazalgette's translation of *Feuilles d'Herbe* brought Whitman fully into the "mainstream of French poetry" in 1909. Whitman entered, it has been said, with the shock of a great contemporary. He had long been known to the poets, of course. Erkkila's appendix lists seven essays or articles written about him in 1892 alone, several by well-known symbolist poets. By the great years for cubism and futurism (1909–14), there was a veritable "Whitmania" in Paris—enough to provoke Apollinaire's hoax.

It's worth noting that Marinetti's Futurist manifesto appeared first not in Italy, but in *Le Figaro,* in Paris, on 20 February 1909. Research by Giovanni Lista and Daniel J. Robbins shows us that the "sources of Marinetti's Futurism were virtually identical to the sources for Cubists," namely, the recent French literary tradition: first, the Symbolists but then more significantly the poets of *modernolatrie* that revolted against the Symbolists' increasing "decadence."[37] It's important to remember that Futurism began as a "literary movement" and only gradually "picked up momentum among the painters, who gradually evolved an art that matched the excitement of Marinetti's own poetic exuberance."[38]

In his famous open letter to Emerson, which Whitman made into the preface to the second edition of *Leaves of Grass,* Whitman confirms at great length that his seminal version of *modernolatrie* must now become a part of the "greatest poet's" mission. The idea of transfiguring the new industrialized landscape left Constable indifferent and made Emerson

cautious. For an American with Whitman's national pride, there was an extra temptation: rejecting the new landscape meant rejecting a great chance for America to stop being eternally "number two."

How similar in tactic and tone to Marinetti is Whitman's call for poets who will praise "those splendid resistless black poems, the steam-ships of the seaboard states, and those other resistless splendid poems, the locomotives, followed through the interior states by trains of railroad cars." Whitman's heroic catalogs of facts, mixed with his chauvinism, and with his relentless conviction that his country is somehow destined for the future and the rotting past (read: Europe) must be kicked away, probably intrigued the Futurist founder, Marinetti.[39] In the first Futurist manifesto, fifty-three years later, Marinetti similarly chants that the Futurist poet

will sing of the vibrant nightly fervour of arsenals and shipyards. . . . locomotives whose wheels paw the tracks like the hooves of enormous steel horses bridled by tubing; and the sleek flight of planes whose propellers chatter in the wind like banners and seem to cheer like an enthusiastic crowd.[40]

Once again, there's no simple question of influence. Valuing the new day over the old would have tempted Marinetti no less had he never heard of Whitman. Industrial Supernaturalism exerted a deep political fascination in awakening countries that saw themselves "coming from behind," so to speak—first, the United States. That largely explains the otherwise bewildering fact that the project became a central, perhaps *the* central artistic current not in industrial England (where the new commonplace actually was abundant) but in America, Italy, and Russia. Emerson's sulking sense of our cultural inferiority sparked his demand for American cultural "self reliance." "Our houses are built with foreign taste; our shelves are garnished with foreign ornaments," Emerson protested in the 1841 "Self Reliance." "Our opinions, our tastes, our faculties, lean on and follow the Past and the Distant." Why must Americans be slaves to the "Past," Emerson protested; "why need we copy the Doric or the Gothic model?" The "American artist" should study the American "climate, the soil, the length of the day, the wants of our people, the habit and form of our government" and build anew for the new land.[41] Excellent preparation for Whitman's 1850s futurism: we're watching an artistic project get unexpected fuel from nationalist inferiority complexes, which, I think, should qualify our attitude toward it.

Marinetti, originally a free verse poet, "elevated" his fifty manifesti into art, "galvanizing slogan-texts, blasts, rallying cries, titles and subtitles," as Pellegrino d'Acierno tells us, into "violent provocations." In the famous episode in the first Manifesto, Marinetti and his friends, "like

young lions," disgusted with listening to the "old canal muttering its feeble prayers and the creaking bones of sickly palaces" jump into their motorcars and race off into the night: "We must shake the gates of life, test the bolts and hinges. Let's go!" Marinetti swerves to avoid some cyclists and rolls into a factory drain: "O maternal ditch, almost full of muddy water! Fair factory drain! I gulped down your nourishing sludge. . . ." The drain sludge rebaptizes him. He's reborn a Futurist, and comes up "torn, filthy and stinking—from under the capsized car, I felt the white-hot iron of joy deliciously pass through my heart!" We are probably meant to understand Marinetti as an industrial-age St. Theresa. From canal to factory drain, from Ruskin and Turner's Venice to industrial Italy; it's a significant passage.

But introducing into Italian visual art the Whitman spirit of praise for the new industrial produce meant facing problems totally unlike those Whitman had faced. America was raw but *new*. The Italians felt themselves suffocating inside of a mausoleum. "'I feel that I want to paint the new,' Boccioni confided to his diary in March 1907, 'the fruit of our industrial time. I am nauseated by old walls and old places, old motives, reminiscences . . . I want the new, the expressive, the formidable.'"[42]

Tourist Italy had become "the country of the dead, a vast Pompeii, white with sepulchres," the Futurist painters wrote in their manifesto. In a violent reaction to being sealed inside the "vast Pompeii," a reaction that would carry this project far from its roots in Emerson and even Whitman, the Futurists turn and gulp the liberating factory sludge with a joy that borders rage and with an undiscriminating voraciousness no later Industrial Supernaturalist painters or writers ever surpass. In a crescendo of inspiration—and fury—they overturn all hierarchies of beauty; almost all the topics any would develop later are at least forecast. (And therefore made unnecessary? So Jacques Barzun argues.) Drunk with the "inebriating modernity of contemporary life," (Boccioni, "Plastic Foundations," 1913) they carol the beauty of mere real machines. "We affirm . . . the beauty of speed . . . a roaring car that seems to ride on grapeshot is more beautiful than the Victory of Samothrace" (Marinetti, "Founding Manifesto"). "The in and out motion of a piston inside a cylinder," Boccioni writes, "the engaging and disengaging of two cogwheels, the fury of a fly-wheel or the whirling of a propeller," must be the new subjects of Futurist sculpture. "The opening and closing of a valve creates a rhythm which is just as beautiful to look at as the movements of an eyelid, and infinitely more modern."

The Futurist sculptors fling themselves at the marble masterworks which surround them, they "destroy the literary and traditional 'dignity'

of marble and bronze" and make sculpture out of "glass, wood, card-board, iron, cement, hair, leather, cloth, mirrors, electric lights, etc."
(Boccioni, "Technical Manifesto of Futurist Sculpture," 1912) Other Fu-turists are building "chromatic pianos" from "twenty-eight coloured light
bulbs, corresponding to twenty-eight keys" to play on them "colour sona-tinas—*notturni* in violet and *mattinate* in green." Then "we turned
our thoughts to cinematography" and made abstract films in which
"carmine, violet and yellow" hurl upwards like "spinning tops" (Corra,
"Abstract Cinema—Chromatic Music," 1912). The Futurist composers
proclaim that "MUSICAL EVOLUTION IS PARALLELED BY THE
MULTIPLICATION OF MACHINES" and that, since "our hearing" in
the "roaring atmosphere of major cities ... has been educated by mod-ern life," we need new instruments to play
"Rumbles
Roars
Explosions
Crashes
Splashes
Booms"
so that (just as Emerson declared the new poet would "consecrate" the
new industrialized landscape for us) "after being conquered by Futurist
eyes our multiplied sensibilities will at last hear with Futurist ears." The
awakened senses would hear "our industrial cities" as an "intoxicating
orchestra of noises" (Russolo, "The Art of Noises," 1913—Cage will
spring off there). They kick to pieces the old genres as well as the old
hierarchies: "There is neither painting nor sculpture, neither music nor
poetry: there is only creation!" (Boccioni, "Technical Manifesto of Futur-ist Sculpture," 1912).[43]

They demand Futurist theater, clothing, architecture, Futurist chil-dren's toys. They embark on the "Futurist Reconstruction of the Uni-verse," now expanding sculpture to "mechanical and electrical devices;
musical and noise-making elements, chemically luminous liquids of vari-able colours"—and everything that Constructivism or even Jean
Tinguely would later do—"Plastic complexes which decompose, talk,
produce noises and play music simultaneously"—then out into Earth-works, sculpting "Water—Fire—Rivers" and into Happenings—"PLAS-TIC-MOTOR-NOISE MUSIC IN SPACE AND THE LAUNCHING OF
AERIAL CONCERTS above the city"—and finally concept art, "any ac-tion developed in space, any emotion felt. ..." With some justice,
Jacques Barzun, citing this conceptual explosion, said art hasn't had a
new idea since them.

Yet accepting the new objects does not automatically mean making paintings retinally identical with the objects. The Futurists want also to paint the emotions these new objects raise: rather than only "depict" the object's "incidental appearance," they "live out the object in the motion of its inner forces . . ." (Boccioni, "Futurist Painting and Sculpture," 1914). Picasso, they leer, "freezes the life of the object (motion)," analyzes it into parts, then "distributes them about the picture" to create a merely visual "harmony." "He kills the emotion."

Above all, the Futurists want to give you that emotion, the emotion of the new technologized life, that bursting, driving, hammering sensation they pound into you in their jangling, antirational manifestos. "We Futurists are right inside the object. . . ." "For us the picture is no longer an exterior scene. . . ." "We shall put the spectator in the centre of the picture." The last thing the Futurists want their audience to do is pass into the stillness of aesthetic contemplation. The only way to reach that stillness before the objects of modern life, they argue, is by stopping them unnaturally, is by killing them dead.

The true challenge, they argue, is not in painting some modern object, but in painting it without losing its modern speed, its full noise, its full participation in the "ferment of modern life." Futurism is transfiguration *plus*. They would take no pleasure in the frozen beauty of Sheeler's Precisionist locomotive wheels or Estes's eerily silent Photorealist city streets. In such work (they would say) exactly what is most modern and most wonderful has been lost. The true challenge is painting not only the modern world's wondrous color or shape but also its wondrous speed, all that "reality" which previous painters had despaired of painting as "plastically non-existent and hence invisible."

The futurists are pre-war and share with their fathers that nineteenth-century faith in progress which must underlie any such vast program. "Man," Enrico Prampolini writes in "Chromophony—the Colours of Sounds," "being superior to animals intellectually, must continue to progress. . . . the perfection of our human senses is nothing less than a question of habit and education. . . ."[44]

Such faith gives the Futurists more in common with Whitman than with the Dadaists just a few years later, on the other side of the Great War's divide. The Dadaists use many of the Futurists' techniques—the spectacles, manifestos, demonstrations—to hurl Futurism back in their teeth. Futurism's vaunting optimism and its pride in the artist's role[45] nauseated those postwar ex-artists. Futurism, they knew, had coupled it all with a longing for "our great hygienic war, which should satisfy all of our national aspirations, centupl[ing] the renewing power of the Italian race."

Boccioni and Sant'Elia were killed; Russolo and Marinetti were seriously wounded. Futurism never recovered.

Russolo, Cage, and "Noise"

The Italian Futurists ended so far in advance of the audience's powers that it took half a century for all their predictions to be worked through (often, to be sure, by artists who had never read them). In the 1930s, Cage—who had—was merely one of those artists.

We will only repeat existing work[46] and lose the thread of our own narrative if I try to follow futurism through Cubism and Suprematism, or through Leger's work and Ozenfant's; through the project's American avatars in Joseph Stella's work or William Carlos Williams's; through Precisionism or the sharp focus photographers of the twenties and thirties; in the work of sculptors who started sculpting with steel, like David Smith, or with motors, like Naum Gabo (Standing Wave, 1920); or later with fluorescent lights, cars, television sets—with all of it, in short, until by the 1960s any mere real thing, including technological things, could be interpreted as an art object; and most of them had been.

Even this brief rereading of the Futurists equips us to understand why the 1937 Cage who praised "noise" and the "sound of a truck at fifty miles an hour" was far from radical. One of the reasons Cage later found Eastern thought congenial is that he was by temperament respectful, filial—*xiao*—though the intellectual parents Cage was filial to are not those audiences most quickly recognize. One of his best-known mottoes is, "Find a teacher you trust, and then try trusting him." He was a "gut" conservative, as Wordsworth was a gut radical. Cage's writings become, as I said, a kind of *tai chi* for the unwary critic because Cage tries dutifully to acknowledge the importance of almost everyone who preceded him. This is gracious, also proof of a lifelong desire to believe himself part of a tradition. One thinks of Confucius, claiming for all his most original thoughts that he only followed the Chou, but he followed them well. Reading Cage's discoveries of his own ideas in older artists one remembers the Chinese literary tradition of discovering one's thoughts in the sayings of the earliest sage-kings. "The Master [Confucius] said, 'I have "transmitted what was taught to me without making up anything of my own," I have been faithful to and loved the Ancients.'"[47]

Before the First World War began, Italian Futurism had come through America—had come, and even gone. The musical world's indifference to the young, futuristic Cage was not, as critics now imply, because he was ahead of his time. He was behind it. No matter how he had personally arrived at his beliefs—through Schoenberg and Cowell, most

likely—for Cage to be praising machine noises as *late* as 1937 would have been, to any knowing audience, surprising only in its traditionalism, like writing a manifesto for photorealism in the early nineties. Cage was not even following futurist theory to unexplored conclusions.[48]

The last section introduced the Futurist Luigi Russolo, whose work Cage listed third of the ten books that had most influenced his thought. A quarter of a century before Cage's praise of "noise," Russolo had written, in 1913, that "ancient life was all silence. In the nineteenth century, with the invention of the machine, Noise was born." (Cage respectfully adopted Russolo's term.) Now man lived in the "roaring atmosphere of major cities," and Noise "reigns supreme over the sensibility of man." By contrast with the lively cities, the concert halls were now merely "hospitals for anaemic sounds," and "WE FIND FAR MORE ENJOYMENT IN THE COMBINATION OF THE NOISES OF TRAMS, BACKFIRING MOTORS, CARRIAGES AND BAWLING CROWDS THAN IN REHEARING . . . THE 'EROICA' OR THE 'PASTORAL.'"

Noise, however, was still "reaching" most men "in a confused and irregular way. . . ." The new Futurist music, "selecting, coordinating" the noises very slightly (not to "detract" from their "irregularity") will "enrich men. . . ." "After being conquered by Futurist eyes our multiplied sensibilities will at last hear with Futurist ears." "Let us cross a great modern capital with our ears more alert than our eyes, and we will get enjoyment from distinguishing . . . the palpitation of valves, the coming and going of pistons, the howl of mechanical saws, the jolting of a tram on its rails. . . ." With our ears newly alert we will "enjoy creating mental orchestrations" from "the variety of din, from stations, railways, iron foundries, spinning mills, printing works, electric powers station and underground railways. . . ."

Russolo opens his ears to all the modern industrial sounds but wants "TO ATTUNE AND REGULATE THIS TREMENDOUS VARIETY OF NOISES HARMONICALLY AND RHYTHMICALLY." He may stand for several groups of artists just before Cage and, indeed, the young Cage, too. For Cage to have worked this way in the late 1930s he need not have thought it new, he need only have thought it right. We should lose any assumption that if an artist proposes a way of working he must think it new. At least we must stop trying to understand Cage that way, despite the innovations that his conscience will lead him to, particularly after 1960.

Before magnetic tape was developed during the Second World War, making an Art of Noise fully possible, the most feasible method of including the sounds was designing new instruments. Russolo talks of cre-

ating instruments to staff a "Futurist orchestra" that will play the "six families of noises," including

1	2	3	4
Rumbles	Whistles	Whispers	Screeches
Roars	Hisses	Murmurs	Creaks
Explosions	Snorts	Mumbles	Rustles
Crashes		Grumbles	Buzzes
Splashes		Gurgles	Crackles
Booms			Scrapes

not to mention "Shrieks Howls Laughs Wheezes and Sobs." What instrument could be created to produce "Grumbles" I do not know, nor do I know by what logic "Rumbles" appear in a different family from "Gurgles"; but I am not a professional musician. "The practical difficulties in constructing these instruments," Russolo assures us, "are not serious."[49] (In fact, in 1990, Cage, no longer able to play an instrument, inventoried "the sounds I can make with my mouth" and performed hisses, snorts, grumbles and gurgles through powerful amplifiers.)

Cage, like Varèse, comes out of a more sober side of this way of thinking, winning acclaim in his youth for an altered piano which produced an expanded variety of sounds. Before the perfection of magnetic recording tape procedures, Cage could go little farther than Russolo's Futurist orchestra. Cage's best-known contribution (an inexpensive one) to the neofuturist orchestra was perfecting the "prepared piano," a piano converted halfway to a percussion instrument by nuts, bolts, rubber washers (and so forth) placed strategically along the strings.

In the 1937 "Credo," Cage explained (as he has many times since) that "percussion music" interested him because "any sound" could be considered "percussion music." It was, he said, in 1937, a "contemporary transition" from the sounds of the keyboard to the "all-sound music of the future."[50] Cage announced, two years later, in the 1939 "Goal: New Music, New Dance," "Percussion music is revolution." He meant he had grasped that by accepting a category—"percussion music"—the audience had tacitly accepted, without quite realizing it, that potentially any mere real noise might be interpreted as "music." Notice the familiar "sage" expansion of a word or concept. In this case, also notice Cage's glee that the audience itself had opened the door for this expanded definition. That's the "revolution" against perfected sounds that "percussion music" would usher in. "A healthy lawlessness" has already been sanctioned, Cage proclaims, and now we're free to "experiment" by "hitting anything—tin pans, rice bowls, iron pipes—anything we can lay our

hands on. Not only hitting, but rubbing, smashing, making sound in every possible way." Magnetic tape had not been invented, but in the 1937 "Credo" he proposes we record his beloved noises with the clumsy and expensive optical recording techniques used to record on motion picture film. "Given four film phonographs, we can compose and perform a quartet for.explosive motor, wind, heartbeat, and landslide."[51]

Though his teacher Schoenberg would call him "more of an inventor than a composer," Cage was still, as much as any Futurist, "composing" music, as the statement just quoted indicates.[52] Like Russolo or Varèse, Cage still believed noises needed an "artist's" intervention before they became "music." He had gone no further than to accept a futuristic collage-like redefinition of music as the "organization of sound" and the composer as the "organizer of sound." Later, during the genuinely important part of his career, he will break entirely with composition and let the sounds be themselves. To do that, however, he would have to undergo a spiritual crisis and a religious awakening.

C. On the Buddha's Raft

Cage's Crisis

For all his early futurism, however, by temperament no one was ever more opposite the Futurists than Cage. No filial pietists, no incipient Buddhists they! They loved din, but as an outlet for their bellicosity, their love of change and the vaunting Western self. Cage wanted escape from self; wanted permanence not change, stillness not speed.[53]

After the war, the rationale Cage had subscribed to for making his sort of music began to fail him. He "determined to find another reason" or quit.[54] That was no idle threat. Virgil Thomson wrote in 1945 that Cage had "carried Schoenberg's twelve-tone harmonic maneuvers to their logical conclusion. . . ." That logical conclusion felt to Cage more like a dead end.[55] During this personal crisis, he ended his marriage, doubted his sexual orientation, tried psychiatry, "'and then in the nick of time . . . Gita Sarabhai came like an angel from India.'"

Ms. Sarabhai was Cage's music student. Searching, personally and professionally, for some kind of direction, he asked her what her teacher in India had said music's "purpose" was. "She replied that he had said the function of music was 'to sober and quiet the mind, thus rendering it susceptible to divine influences.' I was tremendously struck by this."[56] He has treasured that moment of saving revelation. Asked in the mid-1970s to review his earlier statement ("Is this a view you still hold?"),

Cage replied, "Certainly." Throughout the 1980s and 1990s he retold the Sarabhai anecdote no less gratefully.

After some rather random aesthetic investigation, and some "window shopping" (Calvin Tomkins quotes Cage) "among the world's philosophies and religions," Cage grew certain that quieting the mind was indeed music's "proper purpose." Musical art was only to be a way "to let the sounds be themselves," to "change the mind" so that it opens to "experience, which inevitably is interesting."

At this critical point in his life, Cage encountered the works of Daisetz Teitaro Suzuki.

Suzuki and "Suffusion"

That Cage studied Zen with Suzuki is well known. Who Suzuki was, and what the philosophy was that he called Zen, is much less well known. So far we have seen the young Cage as a discontented late futurist. To study the vastly more important mature Cage, we must leave that relatively familiar area. Aesthetics, perhaps reluctant to venture too far from home, has for thirty years been content to accept journalistic accounts, particularly Calvin Tomkins's, of Cage's encounter with Suzuki and Zen. Yet no one doubts that the subject is crucial to any understanding of Cage's most admired works. Cage himself assures us Zen study led him directly to his mature aleatory art and his masterwork, 4′33″: "Since the forties and through study with D. T. Suzuki of the philosophy of Zen Buddhism, I've thought of music as a means of changing the mind. . . . an activity of sounds in which the artist found a way to let the sounds be themselves." A bald enough declaration of Suzuki's influence! Cage has even said that his "interest in silence naturally developed" from his interest in Zen—"I mean, it's almost transparent." Aesthetics must stop avoiding this subject. I will consider it at some length.

And the first question will be, who was Suzuki, and what was the nature of his Zen, if Cage, "amazed," could later discover its best ideas in an American transcendentalist, Thoreau? Zen, Arthur Danto wrote in 1972, "by some paradox of history, has become a household word. . . ."[57] It is amazing. It should make us curious. Is it only a paradox?

We become even more curious when we leave the artworld to explore this question and discover that Suzuki's reputation in the small, newly professionalized American Buddhist community has plunged in the last twenty years and is now quite other than the artworld thinks.

When Cage encountered Suzuki, Suzuki was about to be engulfed by hero-worship. Historian Lynn White, Jr., would write of Suzuki's *Essays in Zen Buddhism, First Series,* that their publication in 1927 "may well seem

to future generations as great an intellectual event as William of Moerbeke's Latin translations of Aristotle in the thirteenth century or Marsiglio Ficino of Plato in the fifteenth. But in Suzuki's case the shell of the Occident has been broken through."[58] Carl Jung wrote a foreword to Suzuki's *Introduction to Zen Buddhism,* Erich Fromm organized a workshop with him later published as *Zen Buddhism and Psychoanalysis.*[59] When the University of Hawaii began to publish *Philosophy: East and West,* the first number contained two articles on Suzukian Zen, the second and third, articles by Suzuki. Thomas Merton wrote, in a typical passage, that "though less universally known than Einstein and Gandhi," Suzuki was "no less remarkable," a man who embodied "all the indefinable qualities" of the Asian religious tradition's "'Superior Man' the 'True Man of No Title' . . . and of course this is the man one really wants to meet. Who else is there?" Meeting Suzuki was "like arriving at one's home."[60] Christmas Humphreys, the ubiquitous president of the Buddhist Society, London, summed up the contemporary attitude toward Suzuki in a preface added to each Rider volume of his works: "To those unable to sit at the feet of the Master his writings must be a substitute."[61] Suzuki's prominence in the artworld is unchanged to this day.

Not so in the American Buddhist community. By 1985, when his disciple Masao Abe edited a *festschrift* for Suzuki, Abe had to spend an embarrassing amount of time defending Suzuki against charges he conceded were "to an extent . . . undeniably correct." Many Americans, converted during the Suzuki-inspired "Zen boom" of the late 1950s, had by then managed to study in Japan. They had discovered how different Japanese Zen actually was from what Suzuki had said. (Alan Watts had predicted their disillusionment, in his 1959 essay, "Beat Zen, Square Zen and Zen."[62]) First the Americans discovered, Abe acknowledged, that Suzuki had presented only the Rinzai sect of Zen, "neglecting the important stream of Soto Zen." That's no technicality. Soto disparages the idea of sudden satori, which Suzuki told the West was Zen's very heart. Stanford's Carl Bielefeldt, writing on Soto in 1991, could call Suzuki's references to Soto's founder, "blasphemy."[63] Suzuki's scholarship, the American Buddhists came to realize, was—Masao Abe had to concede— "unscholarly," "subjective," "not based on careful historical and textual studies." Reading Suzuki had converted many of these people. Now they were denouncing him as an inaccurate "popularizer."

Most startling, for those brought up in the "sit at the feet of the Master" adulation that surrounded Suzuki (though no fault of his own) was the realization that "the Master" was, in fact, *not* a Zen Master, a *roshi.* When he was sent to Chicago in 1897 by a genuine Zen master, Soyen Shaku, Suzuki was not even a Zen monk. He was Soyen's translator.

Soyen got him a job in Chicago translating for Dr. Paul Carus's Open Court Publishing. Back in Japan, young Suzuki had been an English teacher. Only in Chicago, far from Japan, did the English teacher, having become not only the first but the sole Zen Buddhist living in America, become Zen's apostle to the gentiles.

None of this should have been such a surprise. In the very preface in which Christmas Humphreys wrote of sitting at "the feet of the Master," he dutifully mentioned that Suzuki had never been "a priest of any Buddhist sect." There had been blunt challenges to Suzuki's authority as far back as 1953 when Dr. Hu Shih, a major twentieth-century Chinese literary and political figure, controverted, in *Philosophy: East and West,* the core of what Suzuki claimed about Zen. Suzuki, it need hardly be said, never misrepresented himself to anyone. Yet the adulation surrounding Suzuki had been uncontrollable and uncontrolled, and the reaction came. Today, the researcher trying to discuss Suzuki with American Buddhist scholars encounters a lot of embarrassed silences, like a sophomore asking his professor what the artworld thinks about Andrew Wyeth.

One can miss the whole point. One can (and many do) mistake for error some brilliantly creative misreadings; may even put oneself in the position of those "certain persons" Acts 15 delicately declines to name, who came out from the mother tradition in Judea and scared Paul's gentile converts, saying "those who were not circumcised in accordance with Mosaic practice could not be saved." This dead literalism rightly brought Paul and Barnabas into "fierce dissension" with them. Suzuki and Cage, by the same token, are religious figures, not minor scholars of Asian religion reconstructing some "authentic reproduction." If one could travel back to the first century A.D., but had to choose only one church to visit—either the moribund Jewish sect presided over by the faithful Peter, or the bastard, compromising, Christian church at Corinth led by the highhanded Paul—archeologists might choose the former but religious personalities would go see Paul.

Suzuki's "satori Zen," the Zen of Cage's 4'33", has been far more important to American spiritual life than the purist, but still microscopic, Zen congregations. In *A Nation of Behavers,* Martin E. Marty introduces the valuable concept of "suffusion," which works much the way I argued the *Weltanschauung* works: any *really* important writer no longer has to be read. One need never have heard of Suzuki or Cage to have been influenced by them. The "new religions," Marty writes, will most affect American society in two ways. First, as an "intrusive presence," a kind of standing judgment on "majority religions."

The second, more important way, is as "suffusive forces; they offer some features that will suffuse, will cast a glow upon, will subtly soften

or open or alter the Jewish and Christian faiths and the secular style."
Marty's example is meditation. "One might remain a Presbyterian *and*
practice Zen, might be a Catholic communicant who is absorbed in
yoga. . . ." But that it is really additive: Presbyterianism *plus* Zen. We
could take this good concept even further. By the 1990s, one might *think*
one was a Presbyterian—but actually be doing something else, right
there in the church. In 1990, for instance, the Episcopal Bishop of San
Francisco led congregations on Earth Day to link hands and chant
"Om!" Indeed, one might even think one was a Baptist who believes in
biblical inerrancy—yet piously celebrate Earth Day, an idea of humani-
ty's relation with nature thoroughly Natural Supernatural. One might
think oneself a Catholic—yet now believe in a sanctity of the body noth-
ing in St. Augustine allows. So the Vatican feared when it issued, in 1989,
a 23-page document approved by John Paul II warning that Zen and
yoga can "degenerate into a cult of the body" and lead to "moral devia-
tion" and "mental schizophrenia."[64]

Suzuki did not lack for disciples. Some, like Alan Watts, wrote many
popular books. I credit Cage with completing this new suffusive transmis-
sion because it reached America not through Zen temples but through
the universities. My evidence is firsthand. In the 1960s, well before there
were any Zen temples to attend, Columbia courses in humanities, music,
and even visual arts immersed us in John Cage. It was through the arts,
as they were professed in the universities, that Zen became, as Danto
said, a "household word."

But now we have a new problem: *was* what reached America "Zen?"
The American Buddhists don't think so. Suzuki, I hope to show, suc-
ceeded because he gave the West a new variant of Natural Supernatural-
ism—this time secularizing East Asian metaphors instead of Western
ones. The temple-going Zen religious sects, which have grown up in the
last twenty years, more faithful to the East Asian tradition, really are Zen,
and so they matter to ten or twenty thousand American devout. On the
other hand, some version of the bastard, compromising spiritual philos-
ophy which Suzuki, Cage, and a few others fused from Zen and Natural
Supernaturalism may already, by suffusion, be the spiritual life of a *major-
ity* of educated Americans. Nevertheless, even perceptive writers on
American Zen like Harvey Cox and Helen Tworkov, and the adherents
of more conservative Zen traditions (like Shunryu Suzuki's) continue to
write as if Daisetz Suzuki had made some kind of error.

Trying to understand Cage's relationship with Suzuki—and Cage tells
us we must to understand his mature art—involves us in a fascinating
drama of creative misreadings, religious improvisations, and cultural
cross-fertilizations. This book has spoken often of creative misreadings,

of sage techniques. What luck to be able to climax with the image of a Japanese Buddhist and a German theologian designing a new World Religion in a small Illinois town; and their impact, through an "anti-artist" on American culture. To understand why Zen became a "household word" we must examine what John Cage thought was Zen, why he quickly found it so congenial, why—partly through his efforts—it swept with equal ease through the artworld, the universities, the educated public; and why, in the end, Cage rediscovered it in the *Journals* of a Western transcendentalist. "I'm amazed that in reading Thoreau I discover just about every idea I've ever had worth its salt," he exclaimed in 1975. "It's what I've been saying in my books all along." How well the young John Cage understood who Suzuki was, and what Suzuki was about is far from clear. (The artworld's understanding has not increased at all.) In later life Cage seemed genuinely surprised to discover what he considered "Eastern" thought in American transcendentalists—what he called "all of those ideas from the Orient there. . . ." Cage's explanation was that Thoreau "actually got them, as I did, from the Orient."[65]

But in Cage's case, the "Orient" he got the ideas from was Dr. Suzuki, primarily. What if Suzuki got them from Emerson and Thoreau? After all, Suzuki once wrote, "I am now beginning to understand the meaning of the deep impressions made upon me while reading Emerson in my college days." Does he mean in Japan or at the University of Chicago? Letters still on file at Open Court, his first employer, show Suzuki, in the late 1890s, investigating University of Chicago courses, considering John Dewey's, studying at the Newberry Library. Reading Emerson, Suzuki said he was actually "digging down into the recesses of my own thought. . . . That was the reason why I had felt so familiar with him—I was indeed, making acquaintance with myself then. The same can be said of Thoreau."[66]

A frank discussion of Daisetz Suzuki's brilliance and audacity will help us understand why his Zen was so accessible to Cage and to the West. If American Buddhists have discovered Suzuki's wasn't "good" Zen, all is not lost; in fact, everything is gained. Here the spirit of Harold Bloom's work is helpful. Rather than write off Suzuki as a "subjective" popularizer, making "unscholarly" mistakes, a contemporary literary critic immediately wonders if he has encountered a "strong" poet creatively misreading some text to breathe new life in it. Suzuki's Zen, "satori Zen," is no "blasphemy" but a splendid religious creation, a strong variant of Western Natural Supernaturalism, rather than a corrupt variant of Eastern Buddhism. Suzuki's first published essay, the year before he began his eleven-year residence in Illinois, was "On Emerson."

Since we've mentioned Emerson, consider, for a start, that Suzuki

writes, "Zen is the religion of *jiyu* (*tsu-yu*)," and translates that as "self-reliance." Zen the religion of self-reliance?—how Emersonian, how accessible. But the usual translation of *tsu-yu* is "freedom." "Freedom" certainly implies self-possession or self-reliance so the translation isn't exactly a fib—but it's a stretch. By translating *tsu-yu* as "self-reliance," Suzuki casts over Zen a friendly Emersonian glow. It's a sage-technique worthy of Emerson himself.

Chicago Zen: Natural Supernaturalism and Eastern Religion

Teitaro Suzuki, later given the honorific name "Daisetz" ("great simplicity") by his teacher Soyen Shaku, was a young man from a good, but impoverished family—his father died when he was six—who had taught himself English from books. Born in 1870, he died in 1966. Though one mentally associates him with Cage's generation, he was ten when Carlyle died, and near thirty when Ruskin and Queen Victoria did. His famous lectures at Columbia (1951–57) concluded when he was eighty-seven years old. Getting that right matters, because Suzuki's life effort was typical of his Japanese generation. He was born only two years after the Meiji Restoration abruptly ended Japan's 250 years of paralyzingly successful seclusion—with effects, Arthur Koestler once commented, "as explosive as if the windows of a pressurized cabin had been broken."[67] In the space of a decade, the Japanese were thrust out of the feudal Middle Ages into the late Industrial Revolution, scrambling to catch up after the centuries they had lost. There was no time to reinvent what the West had done. Much like the Russians in the 1990s, the Meiji effort was to discover what the West knew, capture it, and import it. To become a scholar of American language and culture was to become no pedant but a hunter on Japan's great safari into the West, an exciting expedition which drew many of the most adventurous talents. Suzuki's lifelong mental effort is typical of the Meiji. His generation combed the West's culture for social customs to replace those of the vanished feudal caste system. When Suzuki's religious bent showed itself, he naturally carried on that search in the sphere of religion. His good fortune was to meet, in Chicago, a small group of Western thinkers who, in the wake of Darwin's and Lyell's shock to Western religious culture, were wandering through as new and confusing a mental landscape as the Meiji Japanese were. They had trekked into Eastern spiritual culture hunting for new solutions as eagerly as the Meiji were hunting through Western material culture and political culture.

For a while Suzuki survived as a primary school teacher, taking nondegree courses whenever he could at Tokyo's Imperial University. He never

earned a college degree. His doctorate came *honoris causa* at the age of sixty-three. His family, like most good families of the abolished samurai class, had belonged to the Rinzai Zen sect, as a matter of course. Suzuki, like many laymen, took advantage of Abbot Kosen's reforms to attend Zen lectures, then lived at the monastery as a lay brother. Kosen, Helen Tworkov writes, was a radical Zen protestant, who had made the "heretical move" of opening the bureaucratized Rinzai sect's temples to sincere lay pupils, trying to turn interest away from the letter of the law back to the "spirit of Zen." Suzuki, the young English student, was one of those laymen. When Kosen's successor, Soyen, helped him find a position in Chicago, Suzuki had not even been, as it were, ordained. Suzuki's "lack of pedigree," Tworkov says politely, made him a "perfect first emissary to the United States, itself a product of disrupted lineages."[68]

American Buddhists still look back with gratitude to Chicago's 1893 Columbian Exposition, which hosted the unprecedented World's Parliament of Religions.[69] "People must realize," Suzuki once wrote, "that it was the World's Parliament of Religions which introduced Buddhism to America."[70] In response to the Parliament's letter of invitation, Soyen Shaku, Kosen's successor and Suzuki's unorthodox roshi, decided to become the first Zen-man to visit America. Suzuki was tapped to translate Soyen's brief speech into English.

The speech so impressed Dr. Paul Carus, editor of Open Court Publishing, that he invited Soyen to spend a week at his home in the nearby Illinois town of LaSalle. Their conversations led Dr. Carus to compile *The Gospel of Buddha,* which Suzuki, back in Japan, translated into Japanese. In later years Suzuki remembered coming to America at Carus's request, to be a translator. Unpublished letters, however, show Suzuki, after translating the *Gospel,* asking Carus if he could come to Illinois to learn from him. Soyen writes Dr. Carus on his behalf: "[Suzuki] tells me that he has been so greatly inspired" by Carus's books, "that he earnestly desires to go abroad and to study under your personal guidance" (15 January 1896). Suzuki writes Carus that his new booklet on religion is "your philosophy plus Buddhism plus my own opinions. The amalgamation of the three will become the initial feature of my book" (14 May 1896). What Carus could teach Suzuki wasn't Zen, obviously. What Suzuki wanted to learn, and did learn, was the unusual *methodology* he saw Paul Carus use in *The Gospel of Buddha* (discussed below). Soyen promised Carus that Suzuki was "an honest and diligent Buddhist, though he is not thoroughly versed in Buddhistic literature, yet I hope he will be able to assist you."[71]

So Suzuki, twenty-six years old, despite four years of Zen study, was no master, no monk—indeed he still had not even achieved satori. The

dedicated new Zen practitioners of the 1980s knew it was no mere technicality to learn Suzuki was not a true roshi, had received no "direct dharma transmission" from an established master—particularly once his Zen was discovered to be so odd. For good doctrinal reasons, one can no more ordain oneself a Zen master than one can elect oneself Pope.[72] Zen deals with an experience which can be known, but not through words. Since one cannot "get it" from words, or from books, one must get it through various practices, supervised, logically enough, by a master. He alone—and in Japan it was always "he"—will certify when one has gotten it. But the only way to know that he *himself* has gotten it, and is therefore qualified to tell his student likewise, is if a qualified master told *him* so. Therefore, somewhat the way the special authority of the latest pope depends on the authenticity of the line all the way back to Peter, lineage matters philosophically to Zen. Hands must be laid on. Verses traditionally attributed to the circle of Bodhidharma, the mythic Indian missionary who in the sixth century A.D. became China's first Zen patriarch, underscored transmission's centrality:

> A special transmission outside the scripture
> No dependency on words and letters,
> Pointing directly to the mind of men,
> Seeing into one's nature and attaining Buddhahood.

Helen Tworkov notes that Bodhidharma's dispensing with the scriptures was as presumptuously "heretical" as it sounds. It was instantly attacked. The Roman Catholic Church bases its special claim for the Pope on the special transmission to Peter. Bodhidharma's sect was advancing a parallel claim to a "special transmission" from the historical Buddha himself to the disciple Mahakasyapa. A thousand years before, Mahakasyapa alone had understood Gautama Shakyamuni Buddha's "flower sermon," in which, unwilling to speak the ineffable, the Buddha simply held up a "golden colored lotus flower" for the disciples to contemplate. Only Mahakasyapa did not violate this wordless sermon with feeble words. He simply smiled, and the Buddha noticed.

Suzuki tried to dismiss Bodhidharma as little more historical than most early Christian saints, and this document in particular as a late forgery. "There must have been some necessity to invent a legend for the authorization of Zen Buddhism. . . ."[73] The tradition, however, leaves no doubt the concept of "transmission" was woven into Zen's core; and Suzuki never received it. Huang Po, the ninth-century Chinese founder of Suzuki's own Rinzai (Lin Chi) sect, wrote, "Since the Tathagata [Blessed One, historical Buddha] entrusted Kasyapa [Mahakasyapa] with the Dharma [here, doctrine] until now, Mind has been transmitted with

Mind, and these Minds have been identical." Transmission can't be accomplished "through words," and "few indeed," Huang Po says, "have been able to receive it."[74] "From time immemorial," Hui Neng, the great Sixth Patriarch of China, recalls the Fifth Patriarch saying to him, each Patriarch has transmitted to the next "the esoteric teaching from heart to heart." And so, Hui Neng recalls, "the Dharma was transmitted to me at midnight . . . suddenly. . . ."[75] According to the old stories, in Hui Neng's day (c. 700 A.D.) the contest among disciples for the master's transmission became so fierce they threatened each other's lives. Hui Neng himself had to disarm an assassin sent by a rival. Although those mythic days had long passed, in Suzuki's day wealthy devotees still routinely paid money to have corrupt lineage charges produced. Scandals like that had prompted Abbot Kosen to his experimental reforms.

Suzuki's decision to leave Japan for Chicago caused an emotional and intellectual "crisis," Suzuki later recalled, which pushed him to "extremity" in the final seven-day *sesshin,* meditation retreat, he attended before leaving. On the fifth day he had what he termed the "first glimpse of satori," *kensho,* "Seeing into the Self-nature. . . ."

Suzuki went to America. For the next eleven years he lived with Dr. Carus in La Salle, paying for his room and board by doing everything that needed doing at a small press which published not only books, but two important learned journals: translating, editing, typesetting, taking photographs; and, in his capacity as boarder, even cooking and running errands. Riding his bicycle through the fields, reading in the countryside south of Chicago, Suzuki at last had the transfiguring spiritual experience which had eluded him for years and on which he would found his theology. In Illinois, he records, meditating on the "Zen phrase . . . 'the elbow does not bend outwards'" he finally reached satori.[76]

Suzuki, twenty-seven years old, who had had little college, who was not even "thoroughly versed" in Buddhism, found himself thrown into a den of ferociously erudite nineteenth-century German religious scholars, heirs to the Higher Criticism in general and the famous "Tübingen School" in particular. A Tübingen Ph.D., Carus was eighteen years older than Suzuki and, when they met, had written half of the 1,500 titles his bibliography finally contained. Carus had married the daughter of his friend, philanthropist Edward Hegeler, a German zinc millionaire financing a scholarly publishing house devoted to the reconciliation of religion with modern (Darwinian) science. In their two learned journals, Carus regularly published articles by John Dewey, Bertrand Russell, Charles Peirce. The press, which always lost money, published inexpensive editions of philosophic classics and new work by Boole, Binet, and other scientists. Carus himself produced perhaps seventy-four books.

Tolstoy translated Carus's *Nirvana: Two Buddhist Tales* into Russian and wrote to apologize when reprinters credited him with its authorship.

From age 27 to age 38, Suzuki—literally—ate, slept, and drank Open Court and its unusual mission. Suzuki's generational and personal interest in culling the West found its match in Carus's interest in culling the East. Suzuki's formal education had been slight. Carus's was prodigious, and he and Suzuki together corresponded with and edited the finest minds of the time. Open Court was Suzuki's graduate education. Opening their journal, the *Monist* from the 1890s, just before Suzuki arrives, one is at first puzzled by how familiar it seems—the style, the problems addressed, the topics. Then one realizes the 1890s *Monist* is familiar to us from Suzuki and his student, Cage. For instance, Suzuki's works—and, later, Cage's—abound in references to Meister Eckhart, a rather recondite medieval German mystic. Eckhart, a favorite of the nineteenth-century German liberal religious world, was a pet topic of the German religious philosopher Carus and his friends, years before Suzuki arrived.

Carus's father had been Superintendent-General of the State Church of Eastern Prussia. Carus experienced a familiar, but painful, nineteenth-century unconversion, followed by a period of despair, which led to his eventual relocation in America. He ached for a spiritual vehicle compatible with his scientific rationalism. Reading his biography, it's impossible not to think of *Sartor Resartus* and Carlyle's tormented German philosopher hero, Diogenes Teufelsdrockh.

Hegeler had founded Open Court to reconcile science and religion, but Paul Carus believed Western anthropomorphic religion too damaged by science to reconcile. He had a bolder plan—so bold, that when he died in 1919 he must have seemed almost a crank. Carus's idea was that some distillate of Asian religion, particularly of Buddhism—its tenets only recently distinguished in the West from those of Hinduism—might prove genuinely compatible with science and provide the rationalistic West with an outlet for its spiritual energies. "Buddhism is a religion which knows of no supernatural revelation," Carus argued. "The Buddha bases his religion solely upon man's knowledge of the nature of things, upon provable truth."

Carus's daring attempt at *Weltreligion*, called *The Gospel of Buddhism*, fired his young Japanese translator's imagination and showed him his lifework. *The Gospel* models Suzuki's mature methods. Carus fashions a Buddhism for the West by selecting from the gigantic Buddhist canon only certain accessible texts and arranging them in a format parallel to the familiar Christian gospels. The Buddhist "Gospel" would engage the Christian gospels in a dialectic, leading to a higher synthesis—"a nobler

faith which aspires to be the cosmic religion of universal truth," Carus wrote. That became his young translator's goal.

The new American Zen converts, were they to read Carus, might misunderstand him too as "subjective" and "unscholarly." That would be ignorance. Carus's sophisticated methodology comes, like his doctorate, from the famous "Tübingen School" of Pauline criticism. When the researcher learns that Carus took his doctorate at Tübingen, much of Carus, Suzuki, and even Cage falls into place with a click. Contemporary scholarship on St. Paul begins with the "Tübingen School's" famous founder, Ferdinand Christian Baur (1792–1860). Baur shifted scholarly interest from Jesus to Paul, whose true glory, Baur argued, was his audacious revision of Christianity into "Paulinism," a "religion for the world." Carus too wrote, honestly, that he was revising Buddhism into a "cosmic religion."

Suzuki, translating Carus, saw him willing to go so far as to add his own verses to the *Gospel of Buddha,* and tell you frankly he'd done so! Besides rearranging material, even adorning it with pictures (in the 1915 edition) of a thin, haloed Buddha with a Caucasian face like a Durer Jesus, Carus had made, he admitted, "additions and modifications." No matter: these additions "contain nothing," he calmly assured the reader, "but ideas for which prototypes can be found somewhere among the traditions of Buddhism, and have been introduced as elucidations of its main principles. . . . this book characterizes the spirit of Buddhism correctly."

That's the crucial difference: the spirit. For the Tübingen school, the *spirit* was all that mattered. Baur had argued that "Paulinism's" central "principle" was "For the written code kills, but the Spirit gives life" (2 Cor. 3:6). Great religious figures (strong poets?), to convey the living "spirit" of a religion, are authorized to modernize, revise, or otherwise rewrite traditions. In his new *Gospel,* Carus didn't hesitate to "cut out . . . apocryphal adornments" or "prune away the exuberance of wonder" which would alienate a Western rationalist. He frankly said he translated passages "freely in order to make them intelligible to the present generation."[77] Suzuki, later his translating partner, wouldn't hesitate to translate *tsu-yu* as "self-reliance," or, translating the concept of *wabi,* write, "*wabi* is to be satisfied with a little hut, a room of two or three tatami mats, like the log cabin of Thoreau."

Suzuki, following Carus, was equally frank about his goals. He himself asked us to understand his work as creative misreading, not as error, in the *Essays on Zen Buddhism, First Series.* Readers must find it odd that the start of this, his central work on Zen, should be a long meditation on Pauline, post-Jesus theology, but given his training we see the connec-

tion. Suzuki had identified with the "Tübingen School's" Paul beyond what Carus could. Paul was, unlike the Hebrew Christians back in Jerusalem, a Roman citizen whose outlook made the original sect's willingness to fight only on the Jewish battlefield seem unambitious and parochial. Suzuki, now a master of Western language and literature, looked similarly outward from Asian culture. He had begun to see himself as apostle to the gentiles—as Paul.

The *Essays*, both a manifesto and a statement of methodology, tell us to read Suzuki's work as a continuation of the Tübingen/Open Court way of thinking—the "progressive modern Christians" that Suzuki declares Buddhism must learn from. Paul, Baur wrote, had to free the "moral universal, the unconfined humanity, the divine exaltation" in Jesus, from the "cramping and narrowing influence of the Jewish national Messianic idea." Baur despised all such "particularist" views of Jesus as an obsession with the particular historical role Jesus was merely "obliged to assume." If Jesus were to enter "the stream of history" at all, he was forced to be a particular person walking around at a particular time in a particular country. That particularity was only the means, however, whereby the supremely valuable universal spirit beyond his mere physical manifestation was to enter history, en route to entering the "general consciousness of mankind." Inevitably, Baur lamented, there were those parochial souls who became "attached" to the particular "national side" of Christ's "appearance" and were thus condemned "never to surmount the particularism of Judaism at all."[78]

Like Baur, Suzuki, in his 1927 *Essays*, identifies in all religious systems, a "progressive party" which holds that "religion is a living force." Opposing them, Suzuki finds a party of "static conservatism" which looks back to a "founder" (Baur's diminishing word for Jesus) and erroneously regards his teaching "as sacred heritage—a treasure not to be profaned by the content of their individual spiritual experience." Religious history is the "record of the struggle" between these two parties.

So the Buddha, Suzuki wrote, had been constrained by human limitations to be a particular person in a particular place. If we let the Jerusalem apostles, so to speak, detour us into fixation on those historical circumstances, we might never surmount the particularism of Asian Buddhism and recover the human universal which any Buddha worth the name must represent. The Japanese traditions—Suzuki argued, in volume after volume of historical studies—were what Baur would have called "particularist" versions of Chinese traditions, themselves very much (Suzuki insisted) "practical" Chinese interpretations of Central Asia's more metaphysical mindset. None of these particularist traditions

would help us strip off the decayed clothes hiding the founder's universal significance.[79]

Reading Baur, we know where Carus and Suzuki got the enormous courage of their convictions. Yes, Baur declares, Paul, in his Epistles, "appears so indifferent to the historical facts of the life of Jesus"; yes, he "bear[s] himself little like a disciple. . . ." "This only shows us," Baur rhapsodizes, turning defects into virtues, "how large and how spiritual his conception of Christianity was. The special and particular"—all those inconvenient historical facts—"vanish for him in the contemplation of the whole."

"How much Christianity," Suzuki echoed at the start of his central work, "as we have it today is the teaching of Christ himself? and how much of it is the contribution of Paul, John, Peter, Augustine, and even Aristotle?" Christianity was "not the work of one person, even of Christ." The "great mistake" of the conservatives is "to think that any existent religious system was handed down to posterity by its founder as the fully matured product of his mind. . . ." The central lesson Suzuki had learned from Open Court, the light by which his work must be understood, is the principle Baur enunciated and Carus acted upon. "Historical facts," Suzuki also writes, are not as important as the "religious truth of Christianity: the latter is what ought to be rather than what is or what was. It aims at the establishment of what is universally valid, which is not to be jeopardized by the fact or nonfact of historical elements. . . ." For the conservatives to take the "form" of Christianity at "a particular time as something sacred," and insist we transmit that form forever, "is to suppress our spiritual yearnings after eternal validity." That, Suzuki says, is the viewpoint of "progressive modern Christians," and Buddhists must adopt it to their own religion. "Inasmuch as Buddhism is a living religion and not an historical mummy stuffed with dead and functionless materials, it must be able to absorb and assimilate all that is helpful to its growth." Suzuki spends the next two hundred pages reworking Buddhist history in support of that premise.

Suzuki must have noted one further resemblance between himself and Baur's picture of Paul. Paul, Baur argued, was freed from doing petty historical reconstructions because he had had direct revelation of Christ in the spirit. Baur declared of Paul, "Why should he go to eye-witnesses and ear-witnesses of Christ's life to ask what he was according to the flesh, when he has seen himself in the spirit?" Suzuki had had satori. What did Suzuki need from the confused, corrupt sutra-traditions of the fleshly Buddha's sayings when he had experienced satori himself and knew not what the Buddha said but what the Buddha *meant?* "Why,"

Baur thunders, "should he ask whether what he is teaching agrees with the original teaching of Jesus, and with the discourses and sayings which have been handed down from him, when in the Christ who lives and works in him he hears the voice of the Lord himself?" So Suzuki cavalierly writes that "historical facts" are not as important as "religious truth." Facts are merely "what is or what was." "Truth" is "what ought to be." "Why should he draw from the past," Baur declared, "what the Christ who is present in him has made to be the direct utterance of his own consciousness?"[80] Suzuki's Zen is no simple popularization. It is his application of sophisticated Tübingen methodology to Buddhism; an application Paul Carus had begun in *The Gospel of Buddha*.

Like Baur's Paul, then, Suzuki did not hesitate to revise doctrine so as not to lay "unnecessary burdens" upon his new converts. The letter only kills; the spirit gives life. One could not make any change more radical than the one Paul made at Antioch when he announced to the hostile Jews that, though Jesus's message had had to be offered to them "first," "we turn now to the Gentiles" (Acts 13:46). Suzuki's changing Zen from a variant of Buddhism into a Western Natural Supernaturalism is a parallel audacity. Paul decided not to dishearten his prospective converts with circumcision and was called on the carpet for it by the original sect. Suzuki, Helen Tworkov says gently, did not "dishearten his enthusiastic audience with alien rituals"; his "concern" was to "alleviate cultural impositions for his Western readers." Transmission went the way of circumcision. Suzuki, the Emerson scholar, built on the West's existing cultural disposition—a *Weltanschauung* by then steeped in a hundred years of Natural Supernaturalism. When Western artists discovered that Zen (at least, Suzuki's Chicago Zen) made a good deal of sense to them, they paid unwitting tribute to that great scholar's creative religious genius.[81]

The Pauline gospel which Paul's fellow traveler the Lucan author produced for Roman ears omits the Roman soldiers flogging Jesus in the praetorium; Suzuki's Zen also selects. Cage's Zen is an even more careful selection from that selection. I find it telling that from a complex, indeed a complicated tradition, Cage selected no more than the mainstream Natural Supernatural morals.

What other stumbling blocks did Suzuki and Cage revise? Zen was the samurai's religion—often violent, militaristic. General Tojo himself had been one of Suzuki's university students.[82] (Suzuki had returned with honors from the West, to teach.) During the 1950s, the underrated French concept artist, Yves Klein, a Judo champion, tried to bring this violent side of Zen West. The West shunned it. Cage deletes it. Suzuki, while acknowledging that "people of the West may wonder how Zen came to be so intimately related to the art of killing" tries to neutralize

the topic. He makes an incomprehensible sage-distinction between "the sword that kills and the sword that gives life." The latter swordsman, the Zen-man, "has no desire to do harm to anybody. . . . It is as though the sword performs automatically its function of justice, which is the function of mercy. This is the kind of sword that Christ is said to have brought among us."[83] Wordsworthian poets need not write poetry, Suzukian samurai have swords that "give life."

Suzuki deals similarly with Western stumbling blocks like reincarnation and the transmigration of souls. He describes the doctrine—the possibility of being reborn as a cat, as a "*preta* (hungry ghost)," or an "*asura* (fighting devil)," or even into a hell (*Naraka*)—with the weary politeness of a Unitarian minister discussing the Resurrection. (". . . An inspiring theory and full of poetic suggestions," Suzuki offers.) Then he announces that since transmigration "does not seem to enjoy any scientific support," the popular concept of a bodyless soul is impossible. "What is it that migrates, then?" By the time Suzuki finishes, only *trisna*, a formless principle which "lies at the back of Schopenhauer's Will [to live]."[84]

Nor, as Masao Abe had to admit, though Zen's very name means "the practice of sitting meditation," did Suzuki think that the grueling practice of "zazen" was "absolutely necessary for the attainment of enlightenment."[85] In Japan the monks were sitting seven-day *sesshins*. Suzuki had himself. But in Suzuki's Western Zen, one no longer need sit Zen.

Suzuki moved to his *weltreligion's* heart one value, one experience: satori. Of the three main Zen sects back home, only Suzuki's sect, Rinzai, had been interested in satori. When the Soto sect's leader, Shunryu Suzuki (no relation) arrived in America and published his ideas (*Zen Mind, Beginner's Mind*), his disciples pointed out that the word *satori* never appeared in the book.[86] Even for Rinzai it was only a starting place en route to the kind of utter negation of personality that the *sesshin* was supposed to encourage. In the West, however, an analog to satori had been a major cultural concept for a long time: Suzuki's satori is largely identical to transfiguration of the commonplace. "Satori finds a meaning hither-to hidden in our daily concrete particular experiences," Suzuki explains, regarding the world from the "religious aesthetical angle of observation. . . ." The "artist's world," therefore "coincides" with that of the Zen-man except that the Zen-man, Suzuki was teaching by 1938, has freed himself of art objects. "While the artists have to resort to the canvas or brush or mechanical instruments or some other mediums to express themselves, Zen has no need of things external. . . . The Zen-man is an artist," but he "transforms his own life into a work of creation!"[87]

When Suzuki moved his version of "religious aesthetical" satori to his

Zen's center, he thereby, Helen Tworkov wrote, "provided a powerful—and romantic—attraction" for Westerners. Satori was a "concept of spontaneous liberation" which "triggered an image Americans could grasp." Though Suzuki "captivated" Americans with this promise of spontaneous liberation, his and his followers' work "contains little about the formal discipline of Zen that generates and grounds this experience."[88]

One does not fault Paul, however, for changing Christianity. That's what a Paul does. Suzuki too.

Crossing the Rubicon

It is now, in the "first flush" of his "early contact with Oriental philosophy," Cage has said, that his "interest in silence naturally developed; I mean it's almost transparent." "Sweet fire, the sire of muse," another religious figure, Gerard Manley Hopkins, S. J. had prayed, "I want the one rapture of an inspiration." That Cage had had. He had felt the "strong spur, live and lancing like the blowpipe flame," his career regains direction, and—no longer the tentative, belated futurist of his first period—he works "with aim now known and hand . . . now never wrong." He begins the work which culminates, four years later, in his most famous and radical piece, 4'33". "It stands to reason," Cage later pointed out, that if you've become a Buddhist, "you want the wheel to stop. . . ." All his life he unhesitatingly called 4'33" his "most important" work. "I always think of it before I write the next piece."[89] In all the works of this mature second period, we feel the roll, the rise, the carol, the creation.[90]

The broad road Cage followed he variously termed "silence," or "chance operations," or "indeterminate" art. A word in more widespread use for such art is "aleatory art."[91] The name comes from *alea*, dice. Caesar's "*Alea jacta est*," "the die is cast," seems appropriate to cite, for using these methods Cage crossed the Rubicon out of the artworld. I will follow customary usage in speaking of these pieces as "art," but their whole point is proving to the audience that they no longer need artists or their special objects. The audience is ready to board the raft with Cage and sail across the Rubicon.

Danto exemplified this moment by presenting us with the fable of J, which we have discussed several times. J exhibited his unaltered bed to show that all mere real things now could be interpreted as art objects. Historically, it was not Marcel Duchamp (as many once thought) or Warhol (working later, and indirectly under Cage's influence) but John Cage who played the role of J for the West.[92] However, the process was more complex. A mere real thing proved unexpectedly hard to find. That was what pushed Cage to refine his aleatory methods.

Cage: Beyond Collage

Since the last century, many composers had been proceeding along lines parallel to the visual arts, expanding the term "music" to cover newer and stranger sounds. Cage dated the motion toward this goal as far back as Debussy's statement that "'Any sound in any combination and in any succession is henceforth free to be used in musical continuity.'" Edgard Varèse he honored as the one who "fathered forth noise into twentieth century music." After his awakening, Cage wanted to go the final step. He declared that "ways must be discovered" to let the "noises and tones be just noises and tones" not compositional materials "subservient to Varèse's imagination."[93]

That is to say, Varèse had still "composed" the noises *into* artworks. So had Cage. A helpful visual arts parallel to Cage's early works would be Kurt Schwitters's collages contemporary with them—giant collages which seem mountains of readymades but emphatically are not. Schwitters had reached the point of thinking "a baby carriage wheel, piece of wire netting, string, cotton," as useful as "color"—to *design* a work of art with. Schwitters still believed "an artist's creative power is exercised through selection, distribution, and deformation of materials."

Schwitters might create a plane with a playing card, draw a line with "a piece of string"; to "glaze" he might cover the plane with waxpaper. But he has composed his artwork, however expanded his palette. We even understand the practical advantages of his method when Schwitters remarks how a "piece of cotton" could give a composition an area of "softness" otherwise hard to obtain.[94]

That had been the spirit in which the cubists used bits of reality to compose their collages, which Marjorie Perloff judged "perhaps the central artistic invention of the avant guerre."[95] "You may paint with whatever material you please," Apollinaire had written of his cubists, "with pipes, postage stamps . . . candelabra, pieces of oilcloth."[96] Such pieces had a fascinating precedent in tribal sculpture from Africa, Oceania, and the Americas, as the Cubists and Futurists knew well from the Musée d'Ethnographie du Trocadero (opened, 1882).[97] Boccioni was familiar with the early cubist collages when, in the 1912 "Technical Manifesto of Futurist Sculpture," he declared that "even twenty different materials can compete in a single work to effect plastic emotion . . . glass, wood, cardboard, iron, cement, horsehair, leather, cloth, mirrors, electric lights, [etc.]."

This sounds so much like the 1950s Cage's all-accepting love that we must distinguish carefully. Even such horsehair-and-cloth works are compositions—not only art *objects* but art*works*. Certainly Boccioni's contemporary, Kandinsky, was not ready to accept any splotch, dab, or blob: the

word "composition" recurs pointedly in Kandinsky's titles and writings. No less than the cubists Kandinsky believed the artist must compose the nonobjective colors and forms. We find endless sketches and studies for Kandinsky's nonobjective artworks.[98]

Russolo—like Pratella, his contemporary, and Varèse after him—still talks in 1913 of "selecting" and "coordinating" sounds.[99] To mix a metaphor, he is widening the composer's palette but the composer must still compose. Cage would go beyond. A good analogy to Russolo's would be Boccioni's demand the year before (in the "Technical Manifesto of Futurist Sculpture" 1912) for an end to sculpture from marble and bronze. When Boccioni proposes sculptures made *from* "glass, wood, cardboard, iron, cement, hair, leather, etc.," he does not say that the glass, wood, cardboard, and iron are *already* sculpture.

Even Rauschenberg's 1950s "combines" (done after his close association with Cage) seem a logical step past Schwitters and collage, a further leap of daring—but still compositions. It's interesting to discover how long Rauschenberg wrestled with that goat in the tire, how many combinations he tried and how much paint he applied to it, before it reached its final amazing form. It's a composition, anything but chance art. While Schwitters and the Cubists usually preferred to compose with pieces of things, or things taken so out of context that their formal qualities leapt out at us, Rauschenberg composed with objects unmasked and defiantly whole. Schwitters might have arranged some goat hair next to tire tread so that we noticed, before identifying the objects, pleasing contrasts of black and white, of hard and soft. In Rauschenberg's combine we're given no chance to think of formal elements before we realize we're confronting a goat in a tire.

By contrast, Cage now tried to abandon composition and achieve what have been called art *pieces* but not art *works*. Yet the word "art" on the front is vestigial. Cage worked to persuade us that any sound or object, even those encountered without selection or intervention from a so-called artist, is the equal of art. That was the whole point. Even the educated art audience in the fifties, reading how he had let his notes be chosen by flipping coins, assumed they were being taunted in the old dadaist way. Ironically, Cage had been trying with characteristic humility to efface himself—trying to show that even *this* noise, produced with no artistic intervention, was wonderful.

In words which reveal his original debt to the collage tradition, Cage explains, "All that's needed is a frame, a change of mental attitude. . . ." Collage had added a physical frame which changed one's mental attitude toward the objects within. Cage's music frames both sound and life that way. We awaken to the wonder of mere real sounds, mere real

things. "Waiting for a bus, we're present at a concert. Suddenly we stand on a work of art, the pavement."[100]

Apollinaire had explained that Picasso's collages, "These strange, un-couth and ill-matching materials, become noble because the artist con-fers on them his own strong and sensitive personality. . . ."[101] Cage would have none of that. As long as one kept embellishing mere real things with one's personality, how could they be shown to be marvelous all on their own? The artist must stop standing between real things and the sun, like a bad photographer laying his shadow across his images. Cage (speaking of what little of Varèse's personality remained in his music) even used the word "mannerism" the disapproving way Constable used it: "These mannerisms do not establish sound in their own right. They make it quite difficult to hear the sounds just as they are, for they draw attention to Varèse and his imagination."[102]

At this stage Cage dislikes "imagination" the way Wordsworth disap-proved of "ornament" or Constable of "bravura"—as "the great vice of the present day . . . an attempt to do something beyond the truth,"[103] an attempt to "trick out or elevate nature."[104] Cage seeks a way to finally show that the world out of clothes, unadorned real things and their mere real sounds are enough. "Varèse has defined music as 'organized sound,'" Cage had written disapprovingly the year before. "The presence of his imagination is strong as handwriting in each of his works. . . . In these respects Varèse is an artist of the past."[105]

By 1951, then, Cage had in fact gone beyond Danto's J and his se-lected bed. J's bed became an art object through J's intention, the way some people thought Duchamp's chosen snow shovel had. In the end, the whole argument over Duchamp's intentions almost doesn't matter, since all such readymades, glimpsed through the haze of their selectors' personalities, Cage now purposed to leave behind. By virtue of an artist's choice, readymades were, though not elite—elect. Knighted by a gesture of the artist's hand, they still implied, no matter how humble their ori-gins, a world of serf objects which he, in his discrimination, had passed over in making his selection.

But a mere real thing is hard to find. How to bring an art audience into contemplative contact with those pure objects (or sounds) without, in the process, electing them through selection? Cage's work was de-rided for its apparent easiness, but we can now appreciate that he faced no simple task.

Election, Cage thought, like composition, inevitably tampered with the objects chosen. Apollinaire had argued, defending the cubists, that an artist's choice of a mere real thing would subtly but inevitably express his "sensitive personality" and thereby mix it with the object—or noise—

chosen. Cage feared Apollinaire was right; feared that listeners wouldn't "listen to the sound itself but try to listen *through* the sound" to the composer's intentions. Sounds would become the "mere vehicle for the composer's ideas." Trying to "detect" the ideas, we miss "hearing" the sound. We learn one human's thoughts or emotions and nothing of the whole world around us. We experience a human being but have no experience of "Reality." Cage wanted the composer to "stop creating" and enable audiences to "simply hear what is there, to relish the audial feast we miss because conventional music has ruined it for us."[106]

There is a strong parallel between Cage's difficult journey away from even elect objects, with their trace of the human clinging to them, and John Muir's journey into the wilderness in search of vivifying, holy contact with reality untouched by man. Muir declared "every purely natural object" to be a "conductor of divinity." If we can "expose ourselves in a clean condition to any of these conductors" we will be "fed and nourished by them." So Cage tries for vivifying contact with wildness, with sound no human has touched in any way. "Only in this way," Muir explained, "can we procure our daily spirit bread. Only thus may we be filled with the Holy Ghost." In Cage's Huang Po Zen language, only thus can we be aware of the Universal Mind filling us.

Such reasoning led Muir to declare that "the clearest way into the Universe is through a forest wilderness"; but Cage was getting there quicker through the *I Ching*.[107]

The *I Ching* (circa tenth century B.C.) is one of the Chou dynasty classics Confucius was proud of editing. As Benjamin I. Schwartz and Arthur Waley have explained, early China's *problematique* was discovering what the spirits wanted, and giving it to them. One could resort to a medium, oracle, or shaman, but perhaps he or she was faking; or simply an imperfect transmitter. On the other hand, one could divide all phenomena into what men cause and what men cannot have caused—therefore what was caused by the spirits. No man could interfere with the way cracks form in a heated tortoise shell or cow scapula. If one wrote a question on the shell before heating, and—by observing the right ritual, caught the spirits' attention—might not one interpret the cracks as their reply? A briefer method might be tossing sticks or coins and interpreting the patterns they formed. The book of interpretations was the *I Ching*.[108]

Early China, including Confucius, was deeply interested in music theory and the *I Ching* had nothing to do with it. Cage did not use it to determine how tomorrow's deer hunt would go, but his creative misuse in one sense paralleled the original use. He wanted direct contact with something as pristine as Muir's glaciers, and he found a mystical sensa-

tion in his contact with this pure, inhuman reality. Above all: he avoided electing an object.

"Imaginary Landscape No. IV," for instance, was written for twelve radios by, Cage explained, using the *I Ching* method of random coin tosses, which were then read "in reference" to a fantastically complicated "chart of the numbers 1 to 64" arranged in geometric patterns. Twelve radios were played simultaneously, the dials being continually tuned according to the chance pattern's dictates.

The static, interference, music, talk—all of it became the sound one heard: a sound no one had ever created or elected, a sound impossible to reduce to an expression of anyone's sensitive personality. "It is thus possible to make a musical composition the continuity of which is free of individual taste and memory (psychology) and also of the literature and 'traditions' of the art."[109] This sound had been *invited* but not *elected:* the artist's shadow was removed from real things.

And the philosophic implications of the audience's acceptance of this wild sound were great. They had been brought into contact with a mere real thing far purer than J's elected bed. If they could experience even *this* as if it were an art object, didn't it prove they no longer needed art objects? And then—away with your nonsense of oil and easels?

Anticipating the audience's uneasiness with this demonstration of their power to abandon art and artists, Cage wrote,

QUESTION: "I mean—but is this *music?*"
ANSWER: . . ."Do you need me or someone else to hold you up? . . ."
QUESTION: "But seriously, if this is what music is, I could write it as well as you."
ANSWER: "Have I said anything that would lead you to think I thought you were stupid?"

How, then, if such were his ideas, were there still artists? "There are people who say, 'If music's that easy to write, I could do it. Of course they could, but they don't.'" Cage, then, by this time, did not create music; he was, most nakedly, the Natural Supernaturalist artist/aesthetician, creating not music but new *definitions* which would enable people to turn from artworks and hear mere real sounds as "music."[110]

In "How to Pass, Kick, Fall and Run," which, after 1965, Cage read as the "irrelevant accompaniment" to Merce Cunningham's dance by that name, Cage explained that his pieces were "not objects, but processes," through which "everyone . . . becomes a listener." The "purpose of this purposeless music would be achieved if people learned to listen," for if they "listened they might discover that they preferred the sounds of

everyday life" to those Cage himself had produced that evening. "That . . . was all right as far as I was concerned." Enough of Science and of Art! In 1990, in the massive *I–VI* issued by Harvard University Press containing his 1988–89 Charles Eliot Norton lectures, he assured readers, "My composing is actually unnecessary. Music never stops. It is we who turn away."[111]

The Blissful Hour: 4′33″

In his 1990 *Encounters and Reflections: Art in the Historical Present,* Arthur Danto wrote (with some amusement) of encountering Warhol's 1964 *Brillo Boxes* again, a quarter century after they sparked his original inspiration. Danto reaffirmed his belief that with those works Warhol, "the nearest thing to a philosophical genius the history of art had produced" brought "art history" to a close. Though many still dismiss Warhol as a "shallow opportunist and glamour fiend," when the last *"Popular History of Art* is published, ours will be the Age of Warhol."[112]

To which, many of Arthur Danto's greatest admirers can only murmur, "God forbid!" I agree that something special happened at Warhol's 1964 Stable Gallery exhibitions. When one rereads Danto's original article, he isn't looking at the *Brillo Boxes,* but at their *reception:* it was the audience that fascinated Danto. The art audience, he reported, "instantly" accepted the *Brillo Boxes* as art. That was the miracle—but it wasn't Warhol's doing. That savvy audience had been brought to ripeness by one whom, like Carlyle, had been the teacher of their teachers. That distinction, which F. R. Leavis, George Eliot, and John Ruskin knew had been Carlyle's a hundred years before, was now, in the twentieth century, John Cage's. Little evidence supports Danto's model of Warhol as "philosophical genius." A truly embarrassing pile points the other way. There was another figure, however—though not in the visual arts— whose "philosophical genius" no one has ever doubted.

In the 1950s and 1960s, Warhol, and many other distant planets, moved within the gravitational pull of a larger mind.[113] In place of Warhol's 1964 *Brillo Boxes* I would submit as the moment of transfiguration John Cage's 4′33″ twelve years earlier. Cage considered it his "best" piece, his most "radical," and "most important piece." Critics and audiences have long agreed.

With the 29 August 1952 premiere of 4′33″ at Woodstock, New York, we have arrived at last at the moment Wordsworth prayed for in the "Prospectus." Years later, frustrated by how little progress toward it he had made, Wordsworth concluded that generations of *vates* figures (he calls them poets) would have to "lend" their "divine spirit to aid

the transfiguration" of the commonplace. At the end of his life work he recorded his continued faith that "what we have loved, others will love. . . ." Always he knew himself writing "long before the blissful hour arrives," singing "in lonely peace" his prophecies of that "great consummation."

In the long meditated 4'33" Cage finally worked out a way to show the audience that, as Wordsworth put it, "Beauty—a living presence of the Earth / Surpassing the most fair Ideal Forms" that any artist had ever with his "craft . . . composed" waited all around us, the "simple produce of the common day." Or, as Cage put his ambition, "I have felt and hoped to have led other people to feel that the sounds of their environments constitute a music which is more interesting than the music which they would hear if they went into a concert hall." That, he said, was the reason for 4'33", "the piece I like most."

The piece is so elegantly, deceptively simple that one can miss how, even better than the *I Ching* pieces, it dodges the problem of the elect object—which even J did not avoid in his "Bed" and which Warhol tumbled into with the *Brillo Boxes*. Cage uses no specifying title like that. He avoids electing anything. He only specifies the length of an experience, and that length chance selected, not he. Several times Cage has recalled how he worked on 4'33" probably "longer" than he worked on "any other. I worked four years. . . ."

It took a lot of daring, and thirty years later Cage still remembered the "friends whose friendship I valued and whose friendship I lost" because of 4'33". What "pushed" Cage into it was his friend Robert Rauschenberg's daring "white paintings," which Cage, thirteen years older, already celebrated, had given Rauschenberg the courage to try.[114] Though neither as extreme nor as ingenious as 4'33", the empty white canvasses elude the elected object peril as well as any art materials can, displaying every chance light and shadow as the viewer approaches. In his essay on them, Cage quoted Rauschenberg: *"A canvas is never empty."* The white paintings, Cage explains, "were airports for the lights, shadows. . . . Hallelujah! The blind can see again." The viewers, that is, who had been "blind" to what they saw, "so that seeing this time is as though first seeing. . . ." Cage concluded, "Beauty is now underfoot wherever we take the trouble to look."[115]

When he saw the White Paintings, Cage told himself, "I must; otherwise I'm lagging, otherwise music is lagging." Must go the final step, although he knew the derision the 1952 audience would heap on the work. By the time of the *Brillo Boxes,* Cage's lesson had had years to sink in. In later interviews Cage corrected the too cheerful account he originally gave Calvin Tomkins of the first performance. Though it was not

as bad as later situations in which the audience stormed the stage and smashed the light he was reading his poetry by (Milan), or the time when the musicians tore the microphones off their instruments and stamped them "in fury" (New York Philharmonic), or the time when—amazingly—fifteen hundred Buddhists went into so "violent" an uproar that people had to come on stage to protect Cage (Naropa Institute), plainly it was bad enough. The Dadaists reveled in causing such reactions. Cage, who had been trying as earnestly as Wordsworth to bring people to the "blissful hour," was left shaken and grieving, even when recalling it during an interview decades later. Danto is quite correct to date transfiguration, as a cultural phenomenon, from the audience's *acceptance,* twelve years later, of the Warhol *Brillo Boxes.*

In 4'33", Natural Supernaturalism removes the last garments masking its activity in the artworld. 4'33" uses no art; performs no music. It uses only the Western audience's habit of obeying the conventions of art appreciation. It is a paradigm of Natural Supernaturalist sage tactics. Cage manipulated the audience's desire to contemplate an elite object, so as to force the audience to contemplate mere real things.

In the premiere, the pianist David Tudor walked out to a piano in a Woodstock, New York, auditorium which opened onto some woods. At a signal, he opened the keyboard as any pianist would who was about to play. A hush fell; and then he sat for 4'33", though he did close the keyboard cover three times to signify the work's three "movements."

Stanley Cavell has commented that such pieces, though "performed as music" could as easily be called "parareligious exercise." Cavell is right. Cage had finally denuded Natural Supernaturalism of what little remained of art's clothes, baring the thing itself: not art, but a religious exercise (why "para"?) which had long worn the clothing of art because it coveted art's conventions, above all the way art could make the audience stop their daily concerns and pay attention, contemplate, meditate. In 4'33" Cage now retained, from all the musical artworld, no instruments, no sounds, not even noises, only that precious convention of sitting and awakening to the sounds around one.

The first audience, Cage recalled, obeying the open keyboard's summons to contemplation, finally awakened and heard. Cage was incredibly lucky, as anyone who has tried to perform 4'33" for a class knows. A rainstorm was about to strike, and in the first movement the audience heard the wind "stirring" the trees. "During the second, raindrops began pattering the roof" and after that there were the sounds of people walking out.[116] No matter. 4'33" would go on to become Cage's most famous work, even a beloved work.

It is only an accident, for Cage's work usually takes place in cities or

celebrates their sounds, but there is a beautiful symmetry in this last moment of Natural Supernaturalism taking place in a wooded setting. In its first moment (in English, at least) the two poems which began *Lyrical Ballads,* Wordsworth told Matthew, "Enough . . . of art," come hear the "sweet . . . music" of the woods. "Come forth into the light of things." By "last moment" we mean, of course, only the last moment of Natural Supernaturalism's primary dependence on the artworld.

During the following years, the "blissful hour" rolled outward. Everyone who experienced it has his or her own memory. "Pop redeemed the world in an intoxicating way," Arthur Danto recalls. Some time after his encounter with Warhol and the *Brillo Boxes,* he realized his experience of everyday life had changed:

I have the most vivid recollection of standing at an intersection in some American city, waiting to be picked up. There were used-car lots on two corners, with swags of plastic pennants fluttering in the breeze and brash signs proclaiming unbeatable deals, crazy prices, insane bargains. There was a huge self-service gas station on a third corner, and a supermarket on the fourth, with signs in the window announcing sales of Del Monte, Cheerios, Land o Lakes butter, Long Island ducklings, Velveeta, Sealtest, Chicken of the Sea . . . Heavy trucks roared past, with logos on their sides. Lights were flashing. The sound of raucous music flashed out of the windows of automobiles. I was educated to hate all this. I would have found it intolerably crass and tacky when I was growing up an aesthete. . . . But I thought, Good heavens. This is just remarkable![117]

Warhol himself, writing with Pat Hackett, has left us his memory of a similar moment. On the verge of his first celebrity in 1963, invited to Los Angeles for a show, he chose to drive there in a station wagon with three friends. "It was just that I wanted to see the United States; I'd never been west of Pennsylvania on the ground." They drove, listening to "Leslie Gore, the Ronettes, the Miracles, Bobby Vinton," eating in truck stops, admiring the "beautiful blond kids, girls in ponytails and ironed blouses, boys in crew cuts or long slicked-back farmer cuts. . . ." The farther west they drove, the more the small crew of Pop artists was "dazzled" by America—"Pop was everywhere"—an America that no one yet saw the way they saw. They believed in their "new art," Warhol writes earnestly, speaking for once without his protective mask. "Once you 'got' Pop, you could never see a sign the same way again. And once you thought Pop, you could never see America the same way again." At night he lay on a mattress in the back of the station wagon, like Huck Finn on the raft, "looking up at the lights and wires and telephone poles zipping by, and the stars and the blue-black sky. . . ." He would think of Hope Cooke, who had just gone off to marry the ruler of Sikkim, and wonder,

"How could she do it! America was the place where everything was happening. . . . I didn't ever want to live anyplace where you couldn't drive down the road and see drive-ins and giant ice cream cones and walk-in hot dogs and motel signs flashing!"[118]

"But Danto and Warhol, that's the elite," David Antin and Allan Kaprow objected at this point in the manuscript. "Those who picked up on Cage's attitude," Kaprow said, "could be counted on one hand." "The hand that was clapping," Antin added. "Yeah!" Kaprow laughed. "There was myself and about a hundred others, that's all, going out into the world because—because it's just the most perfect world it could ever be. Only a very small group was reaching that vision." Much larger than they knew, and since I was in a position to observe it, I'll record here what I saw. In 1964, the year after Kennedy was shot and the Beatles arrived, I returned to college for my sophomore year and found New York celebrating Pop, the Happenings, and Cage. We had endured Levittown childhoods, Ike and Dick, H-Bomb drills, Catholic schools. We scented something new in the air. No artist myself, still a government major from a second-rate public high school, I joined with other ordinary, non-artworld types—engineers, pre-meds—nailing egg cartons to the walls of our rooms as sculptures, watching the static between TV stations, reading three poems aloud simultaneously. We hung each other backwards out the window over Broadway, eyes closed, listening to the subway roar as music. Warhol and the Pop artists were soon counterculture heroes like the Beatles and Muhammad Ali. Kaprow's Happenings spread so quickly there was a hit Motown single called "The Happening" from Diana Ross and the Supremes. So widespread did student Happenings become that by 1966, *Esquire* magazine, in its annual feature deciding In and Out, decreed, "Where Not to Be Seen: At a Happening."[119] Our professors were all Cage devotees. I first heard his name, when, entering a humanities class late, I was stopped and ordered to walk in again, so everyone could concentrate on the rhythm of my walk. When the Beatles (guided by their engineer George Martin) began cutting up tape, throwing it in the air, splicing it together in random order, playing it fast or slow or even backward, we knew who they'd been studying and we knew how to enjoy the noises. Even the popular press eagerly followed the latest styles in art. When the "Op Art" show opened at the Museum of Modern Art, the Eyewitness News went the night before, filmed the paintings being lifted from their crates, and showed it as a scoop—like a preview of the latest Paris hemline. Channel Seven's viewers had now seen the latest style a day ahead of anyone else.

Countless educated nonartistic people were having the experiences that Danto and Warhol record above. I looked up from a meal in a New

York luncheonette one day and saw beauty so overwhelming that I, like Danto, can never forget the moment. The late afternoon summer sun was pouring through the plate glass window onto the candy counter's tiered display igniting hundreds of rolls of Lifesavers into bars of living color. "Anything I say, do, or think, is art," Allan Kaprow was proclaiming in those days. Even those of us not in the artworld savored that new power.[120]

But in that same 1966 manifesto, Kaprow was also saying, "Once, the task of the artist was to make good art; now it is to avoid making art of any kind." During those climactic years, many artists said, "Enough of art"; formally and ceremoniously divested themselves of the art object. Newton Harrison sickened of his award-winning sculptures, smashed them, and began the journey that would end with him and partner Helen Harrison reclaiming rivers as an act of art. At the important *Software* art show organized by the conceptual artist/theoretician Jack Burnham (opened 16 September 1970 at the New York Jewish Museum, then moved to the Smithsonian), the artist John Baldessari ceremoniously burned his life work, "to rid my life of accumulated art. . . . The container of ashes will be interred inside a wall of the Jewish Museum."[121] At that show David Antin created not a new poem, but a Conversation Room to persuade the audience its speech was poetry. Entering, one heard a tape-recorded word, and was asked to speak into a microphone a brief story using that word. When one put the microphone down one heard one's story played back, together with other people's on that same word: a "stochastic" poem in the real language of real men; unexpectedly moving, like a bit of tribal myth.[122] "Obviously it is no longer important who is or is not a good artist," Burnham (echoing Cage) was writing two years later, "the only sensible question is—as is already grasped by some young people—why isn't everybody an artist?"[123]

There were many decisions to abandon the art object in those years. In California, Robert Irwin temporarily retired. "I cut the knot. I got rid of the studio, sold all the things I owned, all the equipment, all my stuff; and without knowing what I was going to do with myself or how I was going to spend my time, I simply stopped being an artist in those senses. I just quit."[124]

But Cage never quit. A few years later, Natural Supernaturalism, whose roots had been planted in the artworld's soil, flowered into ecology, and Natural Supernaturalists scattered like seeds across the whole culture.

Once again, Cage went before them. It is a part of his life very little studied, but it is where he had been heading all along. Like the raft the Buddha told his bhikkus about, art was not something to carry about on

your back once you had reached the opposite shore. Rather, the Buddha taught, he would beach the raft for others to use but then, "went on my way. . . ."

Cage did not abandon his music, but beached it for others' crossings. He went on his way. Since his way was no longer inside the artworld and Cage is usually written about by people interested in art, the entire culmination of his life, the thirty years he has spent as an ecologist, goes virtually unrecorded. We write of the journey but not of its goal; we write of Cage's raft but not of the opposite shore and what he found when he arrived. Cage's journey, moreover, was prophetic of the journey the entire culture would take, as people who shared it poured out of the confines of the artworld (and its suburb, the university) into ecology and environmentalism. Cage enacted the journey as a whole, and only the last part of Natural Supernaturalism's journey, now taking place outside the artworld, makes the first part of its journey, which took place within it, fully intelligible.

D. *The Ultimate Object*

The Two Cages

In 1956, when the Merce Cunningham company had to dance before some midwestern college audiences, Cage warmed up the audience with some elementary "remarks," as he later called them. They were reprinted in *Dance Observer* magazine and in Cage's first anthology, *Silence*. Many have felt that one "remark" in particular lay near the heart of Cage's philosophy:

Our intention is to affirm this life, not to bring order out of chaos nor to suggest improvements in creation, but simply to wake up to the very life we're living, which is so excellent once one gets one's mind and one's desires out of its way and lets it act on its own accord.[125]

Calvin Tomkins's subsequent *New Yorker* piece on Cage, reprinted in Tomkins's excellent and influential books, pulled that remark forward to explain how Cage had united music and Zen. Tomkins, a distinguished art critic and journalist, was, of course, no authority on Zen. He merely connected what Cage had told him about Zen with what he knew of Cage's music. Tomkins pictures Cage deciding that music should try to do "*externally*" what Zen "attempted *internally*," quiet your mind so it could reach a kind of *satori*, "the Zen idea of 'waking up to the very life we are living'" (emphasis his).[126] What Cage himself had described as "remarks" written for a presumably unsophisticated audience in Prin-

cipia College, St. Louis, gradually inflated, in *The New Yorker*'s pages, then in both of Tomkins's often-reprinted books, to the status of a manifesto; ironic, considering the dozens of manifestolike statements Cage has obliged us with since the 1937 "The Future of Music: Credo."

Yet, all that being said, Tomkins's journalistic instincts were correct. The pressure of explaining himself to midwestern undergraduates had forced Cage to succinctness. Though the remarks were actually intended to illuminate a Cunningham dance (and probably don't—Cunningham has complained that if he did allow dancers to race around the stage by chance they would collide and hurt themselves), the remarks do epitomize what Cage in 1956 had long been writing in more considered works (like the 1952 "Juilliard Lecture" discussed below). For that reason, no doubt, the influential critic Ihab Hassan—who knows Cage well—also chose to bring the St. Louis remarks forward in his seminal 1967 work, *The Literature of Silence: Henry Miller and Samuel Beckett.*[127]

During the 1960s, when Danto saw Warhol's *Brillo Boxes* and the most influential galleries and journals in New York became dedicated to Pop art and "the transfiguration of the commonplace," Cage's remarks about art awakening us to life's excellence seemed prophetic. Rauschenberg and Warhol are but two of the many who acknowledged his inspiration, and many were inspired by them in turn.[128]

The first significant negative study of Cage's idea came in 1969 from Harvard theologian Harvey Cox. Cage's spiritual influence on American intellectual culture had by then become so marked that Cox gave Cage his first serious religious evaluation. Cox was not impressed. Cage's stance was more familiar in religion than it had been in music, and it had had its critics. Cage preached, Cox decided, a kind of "incarnational immolation": "the past is immolated in the name of the present." If overdone, this position can "deteriorate very easily into perversions." Though Cage's theology had brought to the youth culture a "needed emphasis on *incarnation,* the presence of the spirit in the flesh," such a stance could lead into "presentism," by which Cox meant, "a total absorption in the here and now." Indeed, such an absorption had been one of Cage's stated goals.

But such a stance, Cox warned, could degenerate into a "supine acceptance of the world as it is." Presentism "assumes a creation that is not only good but perfect." Cox was concerned that "radical theology," evolving to meet the challenges of the "secular city" would "fall prey to Cage's presentism," which he saw not as a "solution" to modern dilemmas but as a flight from them, "a symptom of our sickness." Ironic as it may have seemed in 1969, Cox worried that the avant-garde Cage's theology could easily become "socially conservative," lead to a quest for

"sensate euphoria" that "overlooks the gross injustices of the present and the need for a disciplined quest for social change."[129]

By the 1980s, many shared such worries about what they took to be Cage's position. The well-known lines about life's excellence were becoming unpopular, particularly among the growing ranks of feminist artists. The performance artist Yvonne Rainer acidly protested, in 1981, that "only a man born with a sunny disposition" could have said anything so fatuous. (She quotes one of Cage's unguarded comments about himself.) Rainer must own her debt to his aleatory methods, but claims that artists will now use them "not . . . so that we may awaken to this excellent life" but for a "contrary" goal: so that we can "awaken to the ways in which we have been led to believe that this life is so excellent, just and right." Contrary, indeed! The perceptive performance art critic Henry Sayre quotes Rainer in his 1989 book, *The Object of Performance*, himself pausing to lament Cage's dictum as "so vastly apolitical, so vastly unconscious of social and political reality."[130]

Such criticism will certainly increase. In a time of worldwide Earth Day observances, of Green political parties and general consciousness-raising about a possible "end of nature" and an endangered planet, Cage's sunny 1956 beliefs that art's only task is to wake us up to the excellence of life look at best naive. At worst, Cage, whose works were designed to, as he says, "awaken" us, may seem himself, as Henry Sayre says, oddly "unconscious."

But Tomkins, in choosing that quotation to represent Cage, then enshrining it in his influential book, stopped the clock on Cage in 1956. To this day, Cage criticism follows essentially the path Tomkins mapped out. (Tomkins himself repeats it in his 1980 sequel, *Off the Wall.*) In 1990, when American's Public Broadcasting System honored Cage with an "American Master" profile, the hour ended with the 33-year-old lines.

There is another Cage. In the PBS special, Cage was asked if he had "learned anything in the great debate" over 4′33″? Cage startled the audience by saying that in the years since he did the piece, he had been "changing" his mind. Haltingly, earnestly, Cage explained that "All of us have changed since 4′33″ was first made in the early fifties. We have less . . . less confidence now in time as it goes into the future. We wonder, for instance," Cage said gravely, "how long the future will be. We don't take for granted that it will be forever." He paused, and concluded, "You might say we wonder whether we have ruined the silence."[131]

Asked about the incident later that year, he laughed out loud. "Wasn't that terrible of me? The darker side! But perhaps we have. And imagine," he said ruefully, "then they went right on to me collecting mush-

rooms. . . ." They had cut back to his brighter side: while they played a recording of the inevitable quotation, "waking up to this very life we're living, which is so perfect. . . ."

The "blissful hour" Natural Supernaturalists had aimed at turned out to be less blissful than Wordsworth, in his too-long-ago "Prospectus" had dreamed. The hour took a century and a half to arrive. The industrial revolution arrived first. In the 1960s, when the Matthews of the world did finally begin *en masse* to rise with Wordsworth and seek enlightenment in the woods, they found the trees corroded by acid rain and the green linnet dead.

Cage himself was the first to recognize the paradox in his giving people new ears, new eyes, then sending them out to experience global pollution. Certainly one could understand if Cage, already in his fifties, after a life of struggle, had been content to watch people reach the shore he long had rowed them toward and to relish his catapulting fame. His place in cultural history was assured. Though criticism still knows only the transfigurationist Cage, it is satisfied with *his* greatness. Cage's true greatness, I think, lies in his refusal to be similarly satisfied. He could not convince himself that this place he had labored so to bring us to was Nirvana. Even as the lessons of 4'33" spread, he experienced a second mental crisis, parallel to the one which brought him to Zen and chance, and he himself took the lead in questioning his life's effort. In a 1990 meeting Cage acknowledged the foregoing with some relief, read or heard the pages which follow and contributed corrections and ideas.

Eliot once remarked that what was interesting about the Victorians was not the quality of their belief, but the quality of their doubt. In the 1960s Cage's work acquires a Tennysonian, even an Arnoldian quality of doubt, self-questioning. There lies its great interest. In the 1860s Tennyson and Arnold fought, despite onslaughts, to retain their sophisticated personal versions of Christianity; but the sea of Christian faith, once at its full, inexorably withdrew. In the 1960s Cage fights to retain his sophisticated personal version of Natural Supernaturalism. Yet even while his 1960s music/pieces continue (almost helplessly) to affirm what 4'33" had affirmed, in Cage's contemporaneous poems the sea of his Natural Supernatural faith continues to ebb. By the 1970s, we only hear its long, melancholy retreating roar. One thinks of a line often cited in connection with the great Victorians: Lord, I believe; help thou my unbelief.

Success in life, Walter Pater once wrote, was never to "acquiesce" in a "facile orthodoxy" of another or "of our own." That hard success has been Cage's. His hard-earned solution to his second crisis helped speed the American ecology movement and colored its methods and assump-

tions. By 1965 his poem "Diary: How to Improve the World (You Will Only Make Matters Worse)" was calling for "global planning" of the environment. He recalls that in 1968, reading Thoreau's *Journal*, he rediscovered his Western roots, deciding that Thoreau's work contained "any idea I've ever had worth its salt."[132] The 1975 "Empty Words" was a sixty-five page homage to that environmentalist classic. The 1990 Harvard lectures continued that homage, as Cage identified ever more closely with that other quirky, surprisingly influential American original. Studying Cage's mature dissatisfaction with both Natural Supernaturalism and the quietist parts of the Eastern religious outlook, we will get a better sense of what the "intellectual tendency" was finally worth and which Eastern ideas are less likely and more likely to form a lasting synthesis with Western ones. Cage's own synthesis is a possible guide. This chapter will only sketch some of the rich fields that await future study. There are two Cages, and the second one is the best critic of the first.

Improving the World

In the revolutionary year of 1968, a different John Cage from the one Tomkins wrote about sat down to write an introduction to a collection of his recent essays. That book, *A Year from Monday,* he had dedicated "To us and all those who hate us, that the U.S.A. may become just another part of the world, no more, no less." "Is my thought changing?" Cage asked himself in the preface. Marshall McLuhan had excited him, Buckminster Fuller had been "of prime importance." He is, he says, "less and less interested in music," though his "ideas certainly started in the field of music. And that field," he adds, ambiguously, "is child's play." He is "now concerned with improving the world." (When I became a man, I put away childish things?) Lest anyone mistake his seriousness, Cage writes, "Our proper work now if we love mankind and the world we live in is revolution."

"Improving the world." With those words, Cage himself has, as long ago as the 1960s, already repudiated his famous statement that his "intention" was "*not to . . . suggest improvements* in creation, but simply to wake up to the very life we're living, which is so excellent" (emphasis mine). The second Cage, now concerned with "improving the world" commits heresy against the first with that phrase. The first Cage had premised aleatory methods on the belief that life did not *need* to be improved, that the artist's improvements on mere real sounds were egotistical and could be dispensed with. Now, however, this second Cage starts

the new book with the long poem entitled "Diary: How to Improve the World (You Will Only Make Matters Worse)."

> FULLER: AS LONG AS ONE HUMAN BEING IS
> HUNGRY, THE ENTIRE HUMAN RACE IS
> HUNGRY. City planning's obsolete. What's
> needed is global planning. . . .

He will publish installments of "How to Improve" for years. The work—a montage of notes chosen by chance from his diary—at first angers and frustrates the reader, as Cage's earlier sound collages did. The reader would prefer to follow the thoughts to logical conclusions, much as he or she would probably prefer to follow a melody. "How to Improve the World" is less like an Emerson essay, however, than like an early Eliot poem. As Cage writes, London Bridge is falling down, falling down, and he has shored these fragments against his ruins. The clashing typefaces, bold letters, frantic intercutting all too effectively give the frightening, probably unwelcome sensation, of a mind in crisis, a career in chaos:

> **ELECTRONICS.** Day comes, the day we
> die. *There's less and less to do:*
> *circumstances do it for us.* *Earth.*
> Old reasons for doing things no
> longer exist. (Sleep whenever. Your
> work goes on being done. You and it no
> longer have a means of separation.)

"People still ask for definitions," he writes with irritation at one point, "but it's quite clear now that nothing can be defined. Let alone art, its purpose etc." Which is tantamount to saying, his purpose. He had long argued, in the first Cage's playful way, that music was child's play, but when he says it now, just before saying our "proper work" is "revolution," he seems to mean it in a sad new way. "How to Improve the World"— its despairing, self-mocking parenthesis ("You Will Only Make Matters Worse") embedded in the very title like a knife in a back—hits pitches of personal urgency, almost frenzy:

> **I'll**
> **write to the President (of the U.S.), to**
> **the Secretary (of State of the U.S.).**
> **Time passing[. . .]**
> **I'll write to Fuller. Should have done**
> **that in the first place (Pope Paul,**
> **Lindsay: Take note.)**

A Taoist would say Cage has turned completely from *wu wei*, quietism, wise inaction, to *yu wei*, activism. This seems a complete reversal of the younger Cage's Eastern contemplative, aestheticized quietism. How can he espouse such activism without repudiating the younger man and all his works? "How to Improve the World (You Will Only Make Matters Worse)" is part of a recognizable Natural Supernatural genre, the visionary artist's crisis-poem: Wordsworth's "Ode: Intimations of Immortality" is the classic example:

> There was a time when meadow, grove and stream,
>> The earth, and every common sight
>>> To me did seem
>>> Apparelled in celestial light
>>> ***
>> Whither is fled the visionary gleam?
>> Where is it now, the glory and the dream?

Ruskin's *Fors Clavigera*, written after his conversion from art to social activism, is a prose analog, a poetic diary which, in its urgency, fragmentation, and allusiveness, sometimes bears strong resemblance to Cage's long work. Reading *Fors*, someone said, was like listening to the beat of one's heart during a nightmare, and that could be said of Cage's poem, with its self-destroying title. At the end of the 1965 installment the second Cage awakens to the daily life we're living, and it's a bitter epiphany:

> We've
> poisoned our food, polluted our air
> and water, killed birds and cattle,
> eliminated forests, impoverished,
> eroded the earth[...]
>
>> What would you call it?
> Nirvana?

A few lines later comes the judgment, "Fuller's *life* is art" (emphasis mine). After all the soul-searching about the artist and his lost visionary purpose, it seems a self-critical moment. "World needs arranging," Cage rebukes himself again. The whole point of aleatory art was that it didn't.

"How to Improve" intercuts three times with the book's older material from the first John Cage, bracketing it, finally ending the book, so that the book as a whole resembles the poem. By giving them a new context, the poem questions the older works it encloses. The book itself comes to illustrate the divisions in Cage's thought which have produced the conflict we experience when we read the poem. To pass from "How to Improve" back to the 1952 "Juilliard Lecture" is to experience culture shock, and then to realize that these two cultures exist within the

thought of one man. The second Cage never wholly replaced the first one; if he had fully converted, Cage might have been happier, but he would be less interesting. Many transfigurationist artists endured this division during the Vietnam era, but I know no work which dramatizes the inner conflict of those years as well as *A Year from Monday,* read as a whole. What's very interesting is to notice that while 1952's "Juilliard Lecture" is filled with the names of Eastern quietists, 1965's "How to Improve" is filled with the names of Western activists. "How to Improve the World"'s very title illustrates the split in Cage's mind, for the second half, "you will only make matters worse," Cage identifies elsewhere as a quotation from Chuang-tse. The title exemplifies the conflicting impulses in his mind: the American, Bucky Fuller-ish, activist, how-to, can-do spirit, instantly mocked by the Chinese Taoist. The book similarly exemplifies the split: the Western, committed crisis-poem clashing with the interludes of Eastern quietism.

For, as the Juilliard Lecture shows, a sophisticated kind of quietism is what Cage associated with the East. The first thing which had caught his attention about Eastern art was Gita Sarabhai's teacher's dictum that music's purpose was to "sober and quiet the mind." The very typography of "How to Improve"—blaring, jarring, discordant, inharmonious—contrasts with Cage's 1952 Juilliard Lecture. There, silent and tranquil voids slow and calm the sentences:

				To accept	
whatever comes	,	re-gardless of the		consequences	
, is to be	unafraid		or		to be
full of that	love which comes	from a	sense of at-		
oneness with whatever.					

With "*whatever*"? "Accept whatever comes"? Surely the second Cage cannot accept that "we've poisoned our food, polluted our air and water, killed birds and cattle, eliminated forests, impoverished, eroded the earth." For Cage to print this old lecture after his new and eloquent refusal to accept, after his preface calling for "revolution," is to undercut it, perhaps demolish it. And yet its quiet peace is so appealing, we feel the attraction this way of thinking has for him even as he casts doubt on its merit in the present crisis. The 1952 lecture speaks of his "Music for Changes," which he based on the *I Ching,* the Chou dynasty *Book of Changes,*

Now for a	little about	accepting	naturally,
finally	. It is a	discipline, which,	accepted
in return	accepts	whatever.	

But in "How to Improve" he quotes a Western philosopher, Bertrand Russell, attacking America for using napalm in Vietnam, and Cage himself reflects, "Napalm and phosphorus burn until the victim is reduced to a bubbling mass." Would it really be a valuable "discipline," the reader thinks, to "accept whatever," when "whatever" includes that? We must recognize that we have this thought because Cage, for long the master of collage, has invited it by his selection of materials and his intercutting.

The first signs of a synthesis come in his 1967 installment of "How to Improve." "We open our eyes and ears seeing life each day excellent as it is," Cage writes, deliberately echoing his famous lines. He connects that realization with yoga, "zazen," and "art." But now, in 1967, he immediately adds

<div style="text-align:center">

**Having this realization, we gather

energies, ours and the ones of

nature, in order to make this intolerable

world endurable.**[133]

</div>

This is a new, profitable division: though "life" is excellent, the "world" has grown "intolerable." Life and the present state of the world are not the same thing. Is it still art's purpose to awaken us to *life*, for there we recharge ourselves, gain the natural energies to improve the intolerable *world*? Cage goes no further with this interesting line of thought, for now.

Before he does there will be a detour. A book should be written about contemporary Western misreadings of the *Wen Hau Da Ge Ming*, the Great Cultural Revolution. Cage's *M* (the M stands in part for Mao) would figure into it. Was our misunderstanding a form of what Edward Said calls "Orientalism," the Western projection of appealing exoticism onto the East? Was it simply that during what the Chinese have now explained to us was a reign of terror, something closer to the Hitler Youth than to the Children's Crusade, the Chinese intellectuals were brutalized into silence and little accurate information seeped out?

Both, no doubt. In 1971 even so sharp a critic as Norman O. Brown wrote to Cage that "What's happening in China is really important. China maybe has stepped into the future." Cage, a great admirer of Asian thought, radicalized and saddened by the Vietnamese war (*M* also carried *Monday*'s dedication, "to us and all those who hate us") dutifully followed Brown's advice to read Mao and his apologists, "corroborated" them by speaking with a Chinese-American dancer who'd asked a Chinese factory worker she'd met if he were happy. (He said it didn't matter, he was working for China.) Cage, like many Westerners, looked at such minimal evidence, and in their despair over Vietnam, chose to find hope

in the thought that China might be passing beyond the capitalist "war of all against all," as Hobbes and Carlyle had expressed it. Cage never visited China. By his own account he was no more mistaken than his teachers, some of the best minds in the country. (As for now, we must "learn from facts," as Deng Xiao Ping used to say before he stopped.) Freud calls such an error born of hope, such a miragelike mistake, an "illusion." God, he says, in *The Future of an Illusion* is the mirage man most frequently sees; during the later years of Vietnam War, Western liberals saw in China an antimaterialistic, noncompetitive society. In "How to Improve," which again brackets the book, Mao takes his place next to the Western activists. "Mao: Our point of departure is to serve the people wholeheartedly . . . not [to act] from one's self-interest or from the interest of a small group."[134]

Cage couldn't have known that Mao was popularly associated in China with *fa jia*, the ancient school of thought which emphasized force, "might makes right," and more recently power growing from the barrel of a gun.[135] He thought he'd found in Mao someone who balanced the Chinese culture he admired with the social activism he now believed necessary to save the planet. Fuller, Cage writes, had said in 1972 that by the year 2000 the second half of mankind would have everything they needed for survival. If this does happen, Cage tells us, it won't be "we Americans" who will have done it. "We will have the Chinese to thank, and Mao Tse-Tung in particular." "Give us the Chinese sense of nature, the Chinese sense of society," Cage pleads in the 1971 "How to Improve" at the book's end.[136]

(Re)Turning West

Both "How to Improve" and Mao vanish from the 1979 collection, *Empty Words*. In their place rises Thoreau: Cage declares, "No greater American has lived than Thoreau." In the intervening book, *X*, references to Mao had dwindled, references to Thoreau increased.[137] *Empty Words* ends with Cage making a radical identification between Thoreau and Chuang-tse, a Taoist sage, and probably with himself; finding what is certainly his most convincing *apologia* for the entire body of his work. Cage builds a bridge for himself between Chuang-tse and Thoreau, between the active and the quiet, between the Eastern and Western poles of his mature thought; between bamboo and oak, so to speak. If his Zen had always been somewhat American transcendentalist, his vision of Thoreau is taoist.

The final piece, "The Future of Music," was written roughly forty years after his 1937 "The Future of Music: Credo," the earliest manifesto he

has provided us with. His first book, *Silence,* began with it; his fourth book ends with this counter-credo, a synthesis of the early one and the activist thought of *How to Improve.* The earlier credo is the work of a Western formalist, a technical discussion of attractive new means to incorporate new sounds into musical compositions. The later meditation on the "future of music" includes environmental ethics, Chinese philosophers, and a moral evaluation of the formalism that earlier credo exemplified. It begins, "For many years I've noticed that music—doesn't enter into my mind. Strictly musical questions are no longer serious questions."[138]

Discussing Chuang-tse he has returned to the taoist roots: Chuang-tse's text, one of the three central taoist collections, was written perhaps a millennium before taoist and Buddhist elements began evolving, in India and China, into the philosophy whose name the Japanese later pronounced "Zen." There's a further link to Cage: Chuang-tse himself is unique among Chinese philosophers for the Cagean light-heartedness of his expression.[139]

Cage begins by mentioning Norman O. Brown's irritation with some "complacent, though religious" young people he had met in a California commune. Perhaps they were spending their time complacently awakening to how excellent the world was, a stage Cage had long ago passed. Brown reacted to their complacency by talking about the need for action, for work. "In our polluted air," Cage says, as he has since 1965, "there is the idea that we must get to work." And, he says tersely, "Work has begun." People are still asking him what his "definition of music" is. "This is it. It is work. That is my conclusion." Cage will not retreat from the social vision of "How to Improve." Thoreau and taoism will help him reconcile, finally, the two Cages of the Vietnam era.

The synthesis involves one of Chuang-tse's fables, the one about the tree whose wood was so gnarled, whose leaves were so bitter—that no one ever bothered to cut it down. Cage cites it in the new manifesto. As a result of its very uselessness it grew so huge that forty teams of horses could take shelter in its shade. Chuang-tse concluded, "'Everybody knows that the useful is useful, but nobody knows that the useless is useful too.'"

Cage then recalls Emerson complaining that Thoreau could have been a "great leader of men" but that he'd ended up leading parties of children out to pick huckleberries. Yet, Cage points out, this seemingly inactive man's writings "determined the actions" of those great activist leaders of men, Martin Luther King, Jr., and Ghandi. "The useless tree that gave so much shade," Cage comments, uniting Thoreau and Chuang-Tse's fable. "The usefulness of the useless is good news for art-

ists. For art serves no material purpose. It has to do with changing minds and spirits."[140]

Thoreau embodies for Cage the balance of both worlds. Cage understands Thoreau through taoism, through the concept of *wu-wei*, actionless activity. "The Sage relies on the actionless activity," the *Tao te Ching* says, "but the myriad creatures are worked on by him." Though he "controls them" the *Tao* says he does not "lean on them." Though he is "chief among them," he does not seem to be. The *Tao* concludes, "This is called the Mysterious Power."

Thoreau is the quietist who led huckleberry-picking parties for children as Cage led mushroom-picking parties for adults, and who, like Cage, wrote essays. Yet Thoreau shows, through his powerful active disciples like King and Ghandi (whose acts Cage virtually awards to Thoreau) that the *Tao* is right: such quietism can, as the *Tao* claims, be the highest activism. Thoreau gained the mysterious power. So did Cage. Cage's defense of art as the tree to shelter under, picks up the idea of it he'd had in 1967: art—at least, his kind—as a place to recharge your energies through contemplation of life, before going out to reform the "intolerable" world.

In Cage's taoist vision of Thoreau's life, Cage at last finds an acceptable vision of his own, and he kept it to the end of his life. In *Empty Words* the clashing typography of "How to Improve" is gone. The prose runs smoothly. The work is filled with playful, friendly poems constructed around friends' names. There is no napalm. "Steam from the hot water produces the slow disappearance of one's image. Pleasure of having a body."[141] Writing, it is twenty years since the simplicities of his 1956 remarks about awakening to life's excellence—simplicities he is wrongly taxed with even today. The regained tranquillity at the end of *Empty Words*, the reintegrated self and the new sense of purpose to his art, has been hard-earned.

There is a paradoxical statement in the *Tao te Ching* which sums up Cage's career:

> Hold fast enough to the silence
> And of the ten thousand things all can be worked on by you.

E. *Ecology: 24'00"*

Cage's journey forecast the journey of Natural Supernaturalism as a whole, and of many artists in particular. In the late sixties concept art began the final motion into ecology by championing the cause of large

objects, but soon swelled to a planetary scale.[142] The ultimate art object was the planet.

In London, Jonathan Benthall may represent many who followed Buckminster Fuller from art into ecology. In "The Relevance of Ecology," after a Wordsworthian expansion of "the word artist" ("simply . . . someone of superior imagination or clairvoyance"), Benthall writes that the "artist" is now "likely to become the 'minister' of a higher ecology of his own making." In America, two of the most uncompromising ecological artists are the pair Cage himself directly encouraged, Helen and Newton Harrison. The Harrisons report they were originally bewildered by Cage's active support for their work. He insisted that if they weren't doing it, he would be himself. That's amazing when you consider that the Harrisons reclaim rivers and waterways, raising community consciousness and support through interviews, Happenings, and above all, magnificent and frequently visionary landscape photographs, which they publish together with their poetic dialogs on the projects. But what they really do is reclaim waterways. All else is a manipulation of artworld conventions and genres in that cause. Newton Harrison had been a prize-winning sculptor once, but he destroyed his sculptures. Asked in 1990 if he were interested in the photos, catalogs, and so forth for themselves, apart from their use to clean up the environment, he was offended: "I haven't time to care about that crap." John Muir did not regard Yosemite as something he could get another book out of. The Harrisons have no more interest in visual arts for their own sake than Muir had in writing for *its* own sake. The Natural Supernatural orientation now pervades a much greater world than just the artworld, though it retains souvenirs.[143]

In the West, among countless ecological projects one could name since the late sixties, Robert Irwin and James Turrell joined with the psychologist Edward Wortz on a 1969 project for the Los Angeles County Museum, which led to the First National Symposium on Habitability. Its topic was "the quality of life," a phrase and a concept that entered the popular value-systems. To acknowledge the highly individual and different contributions of Smithson, Christo, de Maria, or Holt would require separate volumes as long as this one.

On the East Coast, Cage's old friend Rauschenberg sponsored EAT (Experiments in Art and Technology), a program helping some six thousand artist and engineer members locate each other for projects, many of them ecological.[144] Jack Burnham was arguing in *The Structure of Art,* "Art is disappearing because the old separations between nature and culture no longer have any classification value. Biology tells us that what is cultural is ultimately natural or it does not survive. Ecologists insist

that what is natural must become an integral and valued part of our culture."[145] As Natural Supernaturalism passed into being part of the orthodox Western *weltanschauung*, people who had been educated into it in college art and literature courses flowed outward into ecology, Earth Days, environmentalism, "appropriate technology" and the Zenlike side of the handicrafts movement, itself directly descended from William Morris and Ruskin's essay, "The Nature of Gothic." Concept art, as it evolved in the sixties, led swiftly into world ecology and "habitability."

In truth, Natural Supernaturalism had been flowing out of the artworld all along. A valuable study could be done of those activists who were the bridges over which it passed into the Western worldview. For example, one may trace a direct line from Carlyle and Emerson to the American National Parks. We spoke earlier of Emerson's worshipful disciple, the naturalist John Muir, who had explored all through the High Sierras carrying with him only some tea, dried bread, and Volume I of *The Prose Works of Ralph Waldo Emerson*. Muir, first president of the Sierra Club, had helped father the modern National Park system. Appropriately, as one drives up to the Grand Canyon today, quotations from Emerson are broadcast to you on a special channel on your car radio (together with instructions on which parking lots are filled and how to take the mini-tram to the overlooks); selections from Muir and Thoreau are on sale at the National Park bookstores. The West has come all the way around, as a culture, from Bellori's nature, *"tanto inferiore all' arte,"* and Alberti and Zeuxis, *prestantissimo*, selecting from earth's tainted beauties (or Phidias and Raphael not even deigning to do that), and even from Reynolds, who wrote, "All the objects which are exhibited to our view, upon close examination will be found to have their blemishes and defects." And that was the 1780s—yesterday.

The figure who served as Cage's Muir, bridging the gap between the spiritual leader who created 4'33" and the ecological activists who created Earth Day was Allan Kaprow.[146] As I described in the last section, his Happenings succeeded so completely it now seems they have always been with us. They are part of the American artistic vernacular; many of the artists just cited above make use of them. Kaprow's work has a misleading surface resemblance to the Futurist, Dadaist, or Surrealist manifestations (each as different from the others as from him). Much the way we now interpret cynical Dadaist provocations as Pop celebrations of the everyday, so those earlier performance arts have been influenced retroactively by Kaprow's transfigurations. Futurism was more political, Dadaism more nihilistic, Surrealism more Gallic and cerebral than America

generally likes. One reason the Happenings became part of the American artistic arsenal so quickly was their good fit with our spiritual tradition.

Kaprow had been a graduate student at Columbia, studying art history with Meyer Schapiro, aesthetics with Albert Hofstadter. Impressed by Jackson Pollock, he left Columbia to paint. He tried extending Pollock's "action painting into action collage, then action assemblage," but it wasn't all-embracing enough. He considered adding sounds to create "environments." He had, through his friend George Brecht, begun attending Cage's weekend mushroom hunts, and one weekend he asked Cage for help with "this sound thing." Cage detailed for him which tape recorders to buy, how to attach "masters" to "slaves" to do "voices on voices" and even how to cut up tapes and combine them through chance operations. "It's just collage," Cage said.

Kaprow, grateful, began driving in from Rutgers every week in his Model A Ford to attend Cage's New School classes in composition. He stayed two years. His early Happenings, Kaprow reports, were actually homework assignments from Cage. "John would say, 'Do a two and a half minute piece determined by three accidental moves.... '" Cage had experimented in this line at Black Mountain College. The two men became lifelong associates and friends. Like Cage, Kaprow became interested in Zen and to this day sits several times a week (with the noted roshi Charlotte Joko Beck).

When Kaprow took the class, he had been unconsciously preparing to receive Cage's message for years. Four years before, still a philosophy student, he had attended the second performance of 4'33" at the Carnegie Recital Hall in New York. Since I've never seen an account of this second performance, I'll transcribe Kaprow's recollection in full:

It was a hall that you could hire, quickly, and it would seat a modest number of people—seventy-five at the most. A small, beautiful little hall. It was in the summertime, and the windows were open, either in the hall or in the hallway outside. We heard the traffic sounds. David Tudor, then very young, came out and sat at the piano, and I believe he had a somewhat formal outfit on, as befitting a performer. He adjusted, in the usual manner, his seat—I remember this very vividly—because he made a pointed activity out of it. He kept pushing it up, and pushing it down. He had a stopwatch, which was the usual way of John's things—being timed. And he opened up the piano lid and put his hands on the keys as if he was going to play some music. What we expected. We were waiting. And nothing happened. Pretty soon you began to hear chairs creaking, people coughing, rustling of clothes, then giggles. And then a police car came by with its siren running, down below. Then I began to hear the elevator in the building.

Then the air conditioning going through the ducts. Until one by one all of us, every one of that audience there—and I think they must have been all of our kind [artists], began to say, "Oh. We get it. Ain't no such *thing* as silence. If you just listen, you'll hear a lot." I was very struck by 4'33". I intuited that it was his most philosophically and radically *instrumental* piece. "Instrumental" in the sense that it made available to a number of us not just the sounds in the world but all phenomena. Then the question is, now that everything's available, what do you do?

At Columbia Kaprow had been excited (Jeff Kelley has shown) by John Dewey's *Art and Experience,* by Dewey's refusal to let art be separated from life. As a painter Kaprow had been intrigued by the implications of Jackson Pollack's art: it seemed to want to go splashing past the borders of the canvas and out into the living world. Kaprow found in 4'33" his parole from art's objects, from paint and from canvas, his permission to stage a transforming *experience* rather than to manufacture a *thing.* 4'33" was an *experience* which transformed everything in its vicinity. So would the Happenings be.

The great enthusiasm for the Happenings in the early 1960s was, in retrospect, a very American kind of dionysiac religious revivalism. Cage and Kaprow shared a similar religious orientation; but if Cage in a former life was Thoreau, Kaprow was Billy Sunday. Cage's 4'33" was austere, High Church Natural Supernaturalism. The Happenings were an outbreak of Enthusiasm, albeit from the same faith. The joyous movement, unstoppable as America's earlier Great Awakenings, picked up the solemn political sit-in and transfigured it into the ecstatic Be-In. Allen Ginsburg led one Happening-protest against the Vietnam War in which tens of thousands of enthusiasts tried to hum and chant the Pentagon building into the air.

Most lastingly, and fittingly, on 22 April 1970, ten million Americans, most of them college students, staged a nationwide series of Happenings that they called Earth Day. 4'33" had swelled into 24'00", a whole day of planetary consciousness. The West's new religious orientation had finally created a spiritual holiday all its own. Out of the artworld, onto the calendar! There were readings of Wordsworth, Emerson and Thoreau, ceremonies of tranquil Cagean awareness and Zen contemplation. There were also mock funerals for the internal combustion engine, teach-ins against polluters, offshore oil drillers, DDT manufacturers. Earth Day 1970 is considered the start of the mature environmental movement. Six weeks later two very senior U.S. senators—hitherto thought unbeatable, but whom the students had targeted as anti-environment—were defeated; renewing, as John Stuart Mill contended,

"a lesson given to mankind by every age, and always disregarded. . . . That speculative philosophy, which to the superficial appears a thing so remote from the business of life and the outward interests of men, is in reality the thing on earth which most influences them, and in the long run overbears every other influence."[147] Congress hastily converted, passing "The Clean Air Act of 1970, [then] massive appropriations for waste treatment plants, the attack on hazardous waste dumps, the Endangered Species Act, the banning of DDT. . . . the Marine Mammal Protection Act, the Clean Water Act," and more.[148]

As Earth Day's twentieth anniversary approached, there was a great stirring. The year before, *Time* magazine had passed up its "man of the year" feature to name Earth "Planet of the Year." There were new "Green" political parties, like planets condensing out of the solar wind, and old political parties trying desperately to sound "Green." Even so, the unexpected public enthusiasm for Earth Day was startling. Television programming was pre-empted for most of the week before.

On Earth Day, in Walnut Creek, California, twenty thousand school children each built an animal and brought it to the Lindsay Museum. The 16 April *San Francisco Chronicle* lists approximately 220 other Earth *Week* events, including children releasing "masses of ladybugs," numerous John Muir Birthday Celebrations, riparian nature walks, Monterey Pine plantings, a totem pole dedication, an "endangered species parade," many outdoor sunrise and sunset services, and the "Catholic/Presbyterian creation theology group" celebrating the "Environmental Sabbath," as accurate a name for Earth Day as any. On the twentieth anniversary of Earth Day itself, an estimated 100 million people in 134 countries took part, and it seemed as if every major corporation in America was nervously trying to sponsor a celebrity telethon in honor of mere real things, which had become transfigured—sacred.[149]

For 170 years Natural Supernaturalists, from their staging point in the artworld, extolled the perfectness of those despised everyday objects. Its lessons learned, Natural Supernaturalism left the raft behind to live in the daily life of the times. And the artworld wakes up, like a person exorcised of a wonderful dybbuk—trying to remember what it did before it was possessed.

Epilogue

Once art had ended, you could be an abstractionist, a realist, an allegorist. . . .
Everything was permitted, since nothing any longer was historically mandated.
I call this the Post-Historical Period of Art, and there is no reason for it ever to
come to an end. Art can be externally dictated to, in terms either of fashion or
of politics, but internal dictation by the pulse of its own history is now a thing
of the past.—Arthur Danto, *Beyond the Brillo Box*, 1992

When I was writing a draft of this book, living in the California High
Desert, I used to see a "dust devil" go twisting over a mesa, picking up a
column of dust as it went. It looked like the dust was the devil. Then the
devil hit the blacktop highway, dropped the dust and went on by itself.
The artworld created by Natural Supernaturalism's intrusion into the
arts was (Carlyle would have liked this oxymoron) a sort of dust angel.
For over a century and a half, that breath, that spirit, moving across art,
embodied itself in material things like paint and stone. But the dust was
not the angel. At last the angel was able to drop the dust and live as it
had always wanted to in the life of the times, a general Western cul-
tural assumption.

But now what happens to the arts? What follows is only an epilogue,
as much a hope as a conviction. The book's arguments do not inevitably
lead here.

Since Natural Supernaturalism's primary dependence on the art ob-
ject has ended, and the process has at last risen to Hegelian self-
consciousness, we have a new opportunity to look at art, aware that trans-
figurationist art has been only what one religious orientation needed
from the many possibilities art offers. Natural Supernaturalism has been
about awakening to the world; now we awaken to what Natural Supernat-
uralism did to the artworld. We know ourselves, and thereby, free our-
selves. Arthur Danto's work dramatically accelerated that process for us.
There's every chance we may decide that one of the experiences we want
to continue having from art is what transfigurationist art has given us:
the awakening, the wonder. Many educated people live in the religious
world that Wordsworth or Emerson lived in and need an art which will
transfigure the always changing commonplace, an art that turns our ev-
eryday life into, as Jack Miles says, "sacral acts." Now, however, if we adopt

191

a Natural Supernatural aesthetic, it will be by choice. Nor will we be as doctrinaire as we were. We will be in the position of civilized Western people who, after the anthropologists like Mead and Boas had done their work, continued to live in their original culture *but* with a new sense that their ways were not engraved in the starry heavens. Like those people, I think we will be tempted to at least sample some of our freedom; and, like them, we will be more likely to respect other ways than ours.

For the artist, that can only be a good thing. The artworld which Natural Supernaturalism slowly created, became, during the twentieth century, as punishing a place for artists who would not conform, as the one before it had been. "As in *Ecclesiastes*," Harold Rosenberg lamented, "there is a time for Impressionism, a time for neo-Plasticism, a time for Action Painting. As a corollary, 'All things grow foul in their season' and must be put aside . . . the validity of a work depends on its timing . . ."[1] The idea of the single timely art movement meant, in practice, that a painter could be good, even great, yet still be historically incorrect; if he was, for instance, like Leon Golub, a representationalist or figurationist in 1965. Since, as Kasimir Malevich once tried to prove, what an artist excels at is often outside his or her control, the new aesthetic created a terrible new way for good artists to be deprived of an audience, encouragement, training, money, materials, time to work.

The contemporary artworld's mood of "end" and exhaustion is unnecessary. Art isn't over. On the contrary, there has been no moment this fresh since the late 1790s when Wordsworth wrote *Lyrical Ballads*. The artworld dominated by Natural Supernaturalism has indeed completed itself. Nor can we return to the one before it. The second artworld has expanded our eyes irrevocably: we can never again see the world or art the way Sir Joshua Reynolds saw them. If we are confused, it is because the task that has been forced upon us is no less than the creation of a third artworld. This moment has not occurred since the time of Wordsworth and Constable. I accept Danto's radical and daring idea that we have actually entered a new artworld—perhaps a final, permanent artworld.

Goethe, at the beginning of the last artworld, wrote that the people born after such a time are like those who walk in the reaped field picking up the gleanings. After living so long in the gleaning-time of the second aesthetic, the fresh time has come around to us again.

Notes

RWE Ralph Waldo Emerson, *Emerson: Selected Writings*, edited by Donald McQuade
SC Samuel T. Coleridge, *Biographia Literaria*
SCM Stanley Cavell, *Must We Mean What We Say?*
SHM Samuel Holt Monk, *The Sublime: A Study of Critical Theories in XVIII-Century England*
SR Thomas Carlyle, H. D. Traill, ed., *Sartor Resartus*
TC Arthur Danto, *The Transfiguration of the Commonplace*
TK Thomas Kuhn, *The Structure of Scientific Revolutions*
TT Tony Tanner, *The Reign of Wonder*
UM Ursula Meyer, ed., *Conceptual Art*
UPP Rensselaer W. Lee, *Ut Pictura Poesis: The Humanistic Theory of Painting*
WT Walt Whitman, *Leaves of Grass*, edited by Sculley Bradley and Harold W. Blodgett
WW William Wordsworth, *The Poetical Works of William Wordsworth*, rev. ed., edited by Thomas Hutchinson and Ernest de Selincourt

Chapter I

1. Arthur Danto, *The Transfiguration of the Commonplace* (Cambridge, MA: Harvard University Press, 1981), pp. vi–vii; hereafter cited as TC. Actually, Danto had the luck to see an unusually appreciative audience. In 1991 he reported learning, much later, from Emile de Antonio, that most of the 1964 audiences "hated the boxes," and the show failed. Eleanor Ward, the Stable Gallery's owner, was "offended" by the boxes too but had told Warhol, "Do a picture of my lucky two-dollar bill and I'll give you a show." Warhol was, however, soon widely popular. "One of the minor miseries of my life," Danto adds, "is that, although I actually wrote the article, for some reason I didn't buy a Brillo Box" (Personal communication, 11 July 1991).

My understanding of Danto's work is principally indebted to years of letters and conversations with Danto himself and with Richard Kuhns, my teacher and Danto's long-time colleague, to whom *Transfiguration* is dedicated. I thank Danto and Kuhns for graciously reading and improving drafts of this book as I revised it. *Transfiguration* is, Danto informs me, part of that "main philosophical work" he undertook after *The Analytic Philosophy of History.* The most succinct introduction to Danto's philosophy as a whole is his new preface to *Narration and Knowledge:* Danto describes how he has moved, in the last twenty years, "beyond analytic philosophy to a kind of rapprochement with phenomenology," examining "the structures of philosophical consciousness as such." He believes his works suggest "certain categories of thought that might be said to compose the metaphysics of everyday life—a spontaneous and perhaps unrevisable philosophy that incorporates the philosophies of knowledge, action, psychology and art. . . ." (*Narration and Knowledge*, [New York: Columbia University Press, 1985, pp. xiii–xiv]). Danto's 1989 *Connections to the World* (New York: Harper and Row) is much more than a revision of his 1968 *What Philosophy Is.* When he characterizes twentieth-century philosophy as an attempt to bring philosophy to "an end

so conspicuous" that no one need do philosophy anymore, we see the similarity in his approach to art (p. 5). In *Falling in Love with Wisdom: American Philosophers Talk about Their Calling* (Oxford, U.K.: Oxford University Press, 1993) Danto describes how, in 1948, he enrolled as a probationary graduate student in philosophy solely to draw his benefits from the G.I. Bill and finance his "real ambition," to become a painter. Much like Ruskin, he was a good painter who turned out to be a gifted writer. Even so, it was fourteen years before Danto could give up his first art.

Danto continues to publish, in several languages, on topics less related to aesthetics. Meanwhile his practical art criticism has appeared every other week in *The Nation* since 1984 and is collected in the 1987 *The State of the Art*. A new conclusion once more affirms that art itself has come to "a certain natural end" (New York: Prentice Hall, p. 209). Danto genially condescends to contemporary art as "posthistorical." A similar volume, which included his important essays for *Grand Street*, was *Encounters and Reflections: Art in the Historical Present* (New York: Farrar Straus Giroux, 1990); hereafter cited as ADE. It received the National Book Critics' Circle Award. The final essays, particularly "Bad Aesthetic Times" and "Narratives of the End of Art" reprise and augment *Transfiguration's* main theme. Despite the title, "Description and the Phenomenology of Perception," in *Visual Theory*, edited by Norman Bryson, Michael Ann Holly, and Keith Moxey (New York: Harper Collins, 1991), contains Danto's most adventurous aesthetic theories since *Transfiguration*. Revised into "Animals as Art Historians: Reflections on the Innocent Eye," it itself reflects Danto's recent interest in John Ruskin. The essay appears in *Beyond the Brillo Box: The Visual Arts in Post-Historical Perspective* (New York: Farrar Straus Giroux, 1992); hereafter cited as BBB. It has been cross-pollinated with passages from *Mark Tansey: Visions and Revisions* (New York: Abrams, 1992). The *Nation* pieces (and other occasional works) have flowered into longer meditations, collected with some revisions by Columbia University Press as *The Philosophical Disenfranchisement of Art* (New York, 1986). The final essay, "Art, Evolution, and History," shows Danto holding fast to his essential message: "Having reached this point, where art can be anything at all, art has exhausted its conceptual mission" (p. 209). The recent *Beyond the Brillo Box*, mentioned above, is, I think, Danto's best book since *Transfiguration*, an attempt to grapple with the *consequences* of living in a posthistorical artworld.

The best criticism of Danto's early work in aesthetics is still George Dickie's *Art and the Aesthetic: An Institutional Analysis* (Ithaca, NY: Cornell University Press, 1974). Danto, George Dickie, and the "institutional theory of art" are in turn discussed throughout Howard S. Becker's incisive *Art Worlds* (Berkeley: University of California Press, 1982). See pp. 145–62 in particular. Daniel Herwitz's superb *Making Theory/Constructing Art: On the Authority of the Avant-Garde* (Chicago: University of Chicago Press, 1993) arrived while my book was in proofs. It devotes many chapters to Danto, arguing his work's centrality to the twentieth-century Western "avant-garde." The writing is vigorous, even ebullient: Herwitz laments, for instance, the way critics try to "squeeze musical orange juice" out of Cage's 4′33″. More important, he has the nerve, and the prose, to suggest the human dimensions to sectarian aesthetic questions:

The need for theory is urgently felt, for in the absence of utopian revolutions looming on the horizon of culture, in the absence of any clear picture of what current diffuse times are like . . . we search, or yearn, for an explanatory key to the age. . . . We seek a voice with which to speak the world, as if merely to find the right words to explain the world is already an act of resistance to the attentuation of language, art, education, and conversation one feels too acutely nowadays. (p. 158)

I find it confirmatory of both Professor Herwitz's book and my own that we worked independently, yet arrived at conclusions often complementary (see also chapter 4, note 112). Danto himself admires the writing of David Carrier, whose work often springs off from his former teacher's. See Carrier's *Principles of Art History* (University Park, PA: Pennsylvania State University Press, 1991). In Berel Lang's illuminating anthology, *The Death of Art*, a spectrum of contemporary aestheticians respond both to a new Danto essay on "The End of Art" and to *Transfiguration's* bolder claims in general. In a recent letter, Danto seemed excited about how well a forthcoming Basil Blackwell essay collection about him was turning out. Thirteen essays, all by philosophers, will be published as *Danto and His Critics.* "I spent much of November [1992] responding to them, seeking to weave my responses into a kind of narrative, rather than emitting them dotwise, and what was nice is that the pieces fitted themselves to that sort of pattern, not repeating points, even though a good many of them stressed the philosophy of art" (22 January 1993).

The best biographical essay on Danto as art critic is surely Elizabeth Frank's long *New York Sunday Times Magazine* article, "Art's Off-the-Wall Critic," deeply respectful, despite the title. She is the one who equates his present influence with Harold Rosenberg's or Clement Greenberg's in their prime (19 November 1989, pp. 47–78 passim). For a more scholarly interview, see my own "Dancing with Danto" in the *San Francisco State Humanities Magazine* (Spring 1992). Stephen Davies' philosophic overview of the problem, *Definitions of Art* (Ithaca, NY: Cornell University Press, 1991) offers interesting insights, but his Danto is not exactly the Danto I'm familiar with. ("His Silvers isn't the Silvers you know, either," Anita Silvers adds.) Danto himself has reservations about the book. Nonetheless, *Definitions* treats this important topic at length and makes a real contribution.

For a less friendly, sustained critique of Danto's book and its terms, see B. R. Tilghman, *But Is It Art?* (Oxford, England: Basil Blackwell, 1986), particularly pp. 58–64, 93–102, 105–18. Other pertinent articles are Richard Sclafani, "Art as Social Institution: Dickie's New Definition," *Journal of Aesthetics and Art Criticism* 32 (1973): 111–14, and his "Art Works, Art Theory and the Artworld," *Theoria* 34 (1973): 18–34.

Also pertinent to Danto's work, among the many books on the general subject (but particularly on Wittgenstein's meaning for contemporary aesthetics) is Richard Wollheim, *Art and Its Objects*, 2d ed. (Cambridge, England: Cambridge University Press, 1980) and *Painting as an Art* (Princeton, NJ: Princeton University Press, 1987). See also, Anita Silvers, "Once upon a Time in the Artworld," in

Aesthetics, 2d ed., edited by George Dickie, Richard Sclafani, and Ronald Roblin (New York: St. Martin's Press, 1989).

The most provocative challenge to any idea that the avant-garde has "ended" is Henry M. Sayre's *The Object of Performance* (Chicago: University of Chicago Press, 1989), which Danto himself, in a blurb, calls "consistently illuminating." Gianni Vattimo's *The End of Modernity: Nihilism and Hermeneutics in Postmodern Culture* (translated by Jon R. Snyder [Baltimore, MD: Johns Hopkins University Press, 1988]) contains a chapter, "The Death or Decline of Art," which is too perfectly of its time and place, Italy in the early 1980s. One finds Nietzsche, Benjamin, Adorno, but not one artist's name; references to some monolith called "avant-garde art" which includes "earth works, body art, street theatre, and so on. . . ." (And so on? All the same?) Though Vattimo, like Danto, addresses Hegel, even Heidegger, he seems completely ignorant of, or uninterested in, the long American discourse on the topic. "The last prominent figure to preach the death of art was Herbert Marcuse. . . ." Within its world, the book is competently argued, but reading it is claustrophobic, like sitting through the meeting of a small, convinced midwestern Protestant sect.

Mark C. Taylor's *Disfiguring: Art, Architecture, Religion* (Chicago: University of Chicago Press, 1992) uncovers—much as I do—a "theoesthetic" which "implicitly and explicitly informs aesthetic theory as well as artistic and architectural practices" from the romantics to the present. I admire the book and regret that it arrived too late to consult.

Finally, Gunther Stent, a molecular biologist, proposed in 1969 that if the scientific disciplines may plausibly be thought of as "bounded," why not art? Once the "deep problems" of a discipline are solved (like the mechanics of DNA) what remains is but an infinity of increasingly trivial detail. Stent's essay, "The End of the Arts and Sciences," appears in *Paradoxes of Progress* (San Francisco, CA: W. W. Freeman, 1978).

2. TC, p. vii.

3. ADE, p. 335.

4. Arthur Danto, "The Artworld," *Journal of Philosophy* 61 (1964):571–84. "Artworld" is a slippery term. By 1991 Danto had refined it to mean "the historically ordered world of artworks enfranchised by theories." He called George Dickie's use (the "experts who confer the status of art") a "wonderfully creative misreading" of his term but vulnerable to attacks such as Richard Wollheim's in *Painting as an Art.* I follow Danto's usage. Art history shows clearly that no critical establishment has ever been strong enough to permanently christen anything "art" by simple fiat. I follow also—when context will make it clear—the common English usage which equates "artworld" with "academic world" or "advertising world": those who keep up with the discourse on those topics, and who form little worlds unto themselves in doing so. A useful distinction: the *artworld* of Reynolds's time was neoclassical, even though Reynolds himself makes it clear that *most* Englishmen still naively thought whichever picture was the best "likeness" was the best art (personal communications, July 1991; in 1992 Danto published a clarification, "The Artworld Revisited: Comedies of Similarity," in BBB, pp. 33–53).

5. *The Visionary Company* (Ithaca, NY: Cornell University Press, 1971 rev. of 1961), p. xvii. For Harold Rosenberg's reaction to Poggioli's book, see "D. M. Z. Vanguardism" in *The De-Definition of Art* (Chicago: University of Chicago Press, 1985), pp. 212–22. For a sustained critique of Poggioli and a "radically opposed" theory of the avant-garde as the result of art becoming "commerce" in bourgeois society, see Peter Burger, *Theory of the Avant-Garde,* translated by Michael Shaw (Minneapolis: University of Minnesota Press, 1986).

6. Irving Sandler, *Art Journal 40,* "*Modernism, Revisionism, Pluralism, and Post-Modernism*" (Fall/Winter 1980): 345–47; hereafter cited as AJ.

7. AJ, p. 346.

8. He himself had written, in 1969, "Frontiers may remain, but the artists who discover them cannot be considered avant-garde, since the impulse to press to the limits has become established as a tradition" (AJ, p. 346). Among other critics, Harold Rosenberg considered the topic for many years, in essays now collected by the University of Chicago Press. See particularly "Inquest into Modernism," pp. 44–51, and "Art as a Special Way of Thinking," pp. 318–23, in *Art and Other Serious Matters* (Chicago, 1985); "On the De- Definition of Art," pp. 11–14, and "Set Out for Clayton!" pp. 244–50, in *The De-Definition of Art* (Chicago, 1985); "Art and Its Double," pp. 11–23, in *Artworks and Packages* (Chicago, 1985); and "What Is Art?" an interview of Rosenberg by Melvin Tumin which concludes *The Case of the Baffled Radical* (Chicago, 1985), pp. 233–85.

9. Jacques Barzun, *The Use and Abuse of Art* (Princeton, NJ: Princeton University Press, Bollingen Series XXXV, 1973), p. 48; hereafter cited as JB.

10. AJ, p. 346.

11. TC, p. 2.

12. TC, pp. 12–13.

13. "As for the thesis that art (so far as possible) 'imitates' nature—or better, nature's *modus operandi*—it was understood, as it had been by Aristotle, only as a parallelism, not as a cause-and-effect relationship" (Erwin Panofsky, *Idea: A Concept in Art Theory,* translated by Joseph J. J. Peake [Columbia, SC: University of South Carolina Press, 1968], p. 42; hereafter cited as IDEA).

14. AJ, p. 346.

15. Murray Krieger, *Arts on the Level: The Fall of the Elite Object* (Knoxville, TN: University of Tennessee Press, 1981), p. 56.

16. Ursula Meyer, ed., *Conceptual Art* (New York: Dutton, 1972), p. 19; hereafter cited as UM.

17. The precedent for such actions had been set not only by Duchamp but by such artists as the much underappreciated Yves Klein ("Theater of the Void," November 1960).

18. Joseph Kosuth, "Art After Philosophy, I, II," in *Idea Art: A Critical Anthology,* edited by Gregory Battcock (New York: Dutton, 1973), pp. 94, 87; hereafter cited as GB.

19. John Cage, *M: Writings '67–'72* (Middletown, CT: Wesleyan University Press, 1972), p. 146; hereafter cited as JCM.

20. Stanley Cavell, a philosopher who is also a musician, has written an interesting and corroborative article about music since the Second World War, study-

ing particularly the periodicals *Die Reihe* and *Perspectives of New Music:* "Music Discomposed," in *Must We Mean What We Say?* (New York: Cambridge University Press, 1976); hereafter cited as SCM. This essay raises an entire set of problems I find extremely suggestive. Charles Newman's book-length *Salmagundi* essay has been reprinted as *The Post-Modern Aura: The Act of Fiction in an Age of Inflation* (Evanston, IL: Northwestern University Press, 1985). See also Hal Foster's "Postmodernism: A Preface" in his anthology, *The Anti-Aesthetic: Essays on Postmodern Criticism* (Port Townsend, WA: Bay Press, 1986). Also relevant to the topic in general is Timothy J. Reiss, *The Discourse of Modernism* (Ithaca, NY: Cornell University Press, 1985, 1986).

21. GB, pp. 185–86. Jacques Barzun must feel some satisfaction at having lived to see art wind up where he long predicted it would and the art audience in the end, unwillingly, sharing many of his opinions.

22. Duchamp, in his interview with Pierre Cabanne, reminisces about the cubist era, "There was also an amazing fellow, Martin Barzun.... His son, Jacques, who is completely American, is an official at Columbia University...." (Pierre Cabanne, *Dialogues with Marcel Duchamp* [New York: Viking, 1971, trans. of 1967 French], p. 24).

23. JB_2 p. 134.

24. JB, p. 139.

25. Amédée Ozenfant, *Foundations of Modern Art* (New York: Dover, 1952), p. 11.

26. Ibid., p. 12.

27. JB, p. 141.

28. Gunther Stent, *Paradoxes of Progress* (San Francisco: W. H. Freeman, 1978), pp. 46–47.

29. "The End of Art," in *The Death of Art*, edited by Berel Lang (New York: Haven Publications, 1984), pp. 34–35; hereafter cited as BL.

30. Hal Foster, "The Problem of Pluralism," *Art in America* (January 1982): 9–10. Foster's essay appears as "Against Pluralism" in Hal Foster, *Recordings: Art, Spectacle, Cultural Politics* (Port Townsend, WA: Bay Press, 1985). See also Rosalind Krauss's essay "Sculpture in the Expanded Field" on pp. 31–43 of *The Anti-Aesthetic: Essays on Postmodern Criticism*, edited by Hal Foster (Port Townsend, WA: Bay Press, 1986). Herbert Marcuse's well-known attempts to interpret concept art as a revolt against capitalism (in such works as *The Future of Art* [New York: Viking, 1970]) were possibly more important to critics suspicious of concept art than to those who supported it.

31. AJ, p. 366.

32. AJ, p. 367.

33. AJ, p. 379.

34. Italics his; TC, p. vii.

35. JB, p. 141.

36. BL, p. 9.

37. BL, p. 21.

38. BL, p. 24.

39. BL, p. vii; ADE, pp. 331–45. In this essay Danto discusses, for the first

time, a parallel, independent 1984 theory by the German art historian Hans Belting, *Das Ende der Kunstgeschichte?*

One odd story. There is a second class of object capable of including all mere real things. At the end of the sixties the Museum of Modern Art held a mammoth dada retrospective. I had been making sculptures from found styrofoam objects. I wondered by what principle of exclusion my mere real things could be ruled out of such an exhibition and resolved to experiment. I had recently framed an extravagant abstract shape, sleek as a Brancusi, that came packed around a record player's turntable and arm. I signed it "Mr. Mutt's Stereo," to parallel Duchamp's urinal (signed R. Mutt) and took it to MOMA with a friend, the pioneer comic book writer Claire Feldstein (*Tales of the Crypt, Mad*), to hang the piece. Unfortunately, an unphilosophic guard stopped us at the door. All objects, even aspiring art objects, had to be left at the checkroom. Claire Feldstein then took the styrofoam and, fitting her head in the hole where the turntable had been, demanded entrance—not on the grounds that the styrofoam was art, but that it was now *her hat*. I remember the look on the guard's face as he realized she had him: for not only could any mere real thing be interpreted as an art object in 1969, any mere real thing could also be interpreted as a woman's hat. Inside the museum, people trailed Claire Feldstein, admiring the sculpture (or perhaps hat), but at last we were alone in a room and we hung the object. When people drifted in, we hoped for some debate, but it was neither better or worse than its neighbors, and no one noticed it at all. At last we grew bored waiting for it to be discovered and left it there.

40. BL, pp. 161, 165.

41. BL, p. 141.

42. BL, p. 43; ADE, p. 35. For a fuller exposition, see Kuhns's *Psychoanalytic Theory of Art: A Philosophy of Art on Developmental Principles* (New York: Columbia University Press, 1983) and *Tragedy: Contradiction and Repression* (Chicago: Chicago University Press, 1991).

43. Danto, himself, inspired by Heinrich Wölfflin, has always been intensely aware that, "Not everything can be an artwork at every time; the artworld must be ready for it" ("Artworks and Real Things," in *Aesthetics Today*, rev. ed., edited by Morris Philipson and Paul J. Gudel [New York: New American Library, 1980], p. 329). In Danto's exact language, there was a time when the number of mere real things interpreted as artworks was much smaller than now. The artworld "evolved," to admit more mere real things. It only remained for Danto, if he had cared to do it, to look over the art historical record and find the time when the number of things began to increase. He would have found that the number of objects interpreted as artworks remained amazingly constant from Plato right up to Sir Joshua Reynolds. About Constable's time the number begins to increase and is soon increasing so wildly that finally there's nothing left to add in: art has expanded to include all mere real things.

After twenty-four hundred years of stability, why would something like that happen? What was the impetus? What hit art? That was one of the problems Danto's colleague and friend, Richard Kuhns, proposed to his graduate aesthetics class in 1969. *Transfiguration* is dedicated to Kuhns, and Kuhns's 1970 *Struc-*

tures of Experience contains a chapter titled, significantly, "Philosophy as a Form of Art." It is less than an accident Danto's work and mine intersect.

44. *Emerson: Selected Writings*, edited by Donald McQuade (New York: Random, 1981), p. 293; hereafter cited as RWE. Tony Tanner, *The Reign of Wonder: Naivety and Reality in American Literature* (Cambridge, England: Cambridge at the University Press, 1965), p. 155; hereafter cited as TT.

45. William Wordsworth, "Prospectus," in *The Poetical Works of William Wordsworth*, rev. ed. with Introduction and Notes, edited by Thomas Hutchinson and Ernest de Selincourt (Oxford, U.K.: Oxford University Press, 1969), p. 590; hereafter cited as WW.

46. Catherine L. Albanese, *Nature Religion in America: From the Algonkian Indians to the New Age* (Chicago: University of Chicago Press, 1990), p. 81; hereafter cited as NRA.

47. "Self Reliance," in RWE, pp. 136, 150.

48. Not that Shakespeare wouldn't have understood their assertion that all that is spoke is marr'd. Here, as often, Emerson uses Platonic ideas for his novel ends.

49. "Circles," in RWE, p. 103.

50. "Art," in RWE, p. 291. For instance, Gay Wilson Allen calls "Emerson's theory of artistic creation . . . completely Platonic. . . ." *Waldo Emerson* (New York: Penguin, 1981), p. 290.

The essay dramatically records Emerson's break with the neoclassical tradition that he, like all educated people, had read in Joshua Reynolds's famous *Discourses* and heard of in school. The unpublished manuscript of a Concord lecture on "Genius" two years before the 1841 "Art" shows Emerson vainly trying to reconcile Reynoldsian dogma (about art being superior to mere real things) with his own emerging philosophy. In "Art," Emerson stops trying to accept neoclassicism: he quotes a sentence of praise from the early lecture, then unveils a new and most un-Reynoldsian aesthetic. Painting and sculpture, no matter how expert, are "merely initial," a step on the road to recognizing life's "masteries of eternal art." In time, art will be discarded. I discuss Reynolds in the next chapter. The unpublished Emerson lecture appears in *The Early Lectures of Ralph Waldo Emerson*, vol. 3, edited by Robert E. Spiller and Wallace E. Williams (Cambridge, MA: Harvard University Press, 1972), p. 73.

51. *The Prelude*, Book XIV, ll. 446–47, in WW, p. 588. Wordsworth, who opened his first book of poems with a poem suggesting we close the book, is germane to this discussion, but may be separated from it till a later chapter.

52. "Art," in RWE, p. 291.

53. "Nature," in RWE, p. 5.

54. "Art," in RWE, p. 291.

55. Ibid., p. 292.

56. Ibid.

57. Ibid., p. 293.

58. Hegel's contemporary, H. G. Hotho, constructed the text we call *Aesthetics*. For comments on its accuracy and a bibliography, see *Art and Logic in Hegel's Philosophy*, edited by W. E. Steinkraus and Kenneth L. Schmitz (New Jersey and

Sussex: Hegel Society of America, 1982); for its influence, see Michael Podro, *The Critical Historians of Art* (New Haven, CT: Yale University Press, 1982), pp. 17–31.

59. Georg Hegel, *Aesthetics: Lectures on Fine Art*, translated by T. M. Knox (Oxford, U.K.: Oxford University Press, 1975), p. 11; hereafter cited as GHI. I'm carefully choosing mild terms like "prompt" and "stimulus" to describe Hegel's contribution to Emerson's aesthetic.

60. GHI, pp. 10–11.

61. GHI, p. 13.

62. GHI, p. 89.

63. GHI, p. 43.

64. In 1965, Tony Tanner, an extremely sensitive critic, could still only conjecture that "Emerson . . . works against his own intention" when he makes every ordinary thing a "miracle": he leaves himself no "criterion of exclusion," and without one art "cannot start to be art for it cannot leave off being nature" (TT, p. 155).

65. "Art," in RWE, p. 296.

66. GB, p. 23.

67. "Art," in RWE, pp. 296–97.

68. "Art," in RWE, p. 297.

69. "Nature," *Essays, Second Series,* in RWE, p. 392.

70. "Song of Myself," Section 31, l. 688. *Leaves of Grass,* edited by Sculley Bradley and Harold W. Blodgett (New York: Norton, 1973; reprint of 1965); hereafter cited as WT.

71. Susan Sontag, "The Aesthetics of Silence," in *Styles of Radical Will* (New York: Delta, 1970), p. 6.

72. Susan Sontag, *Against Interpretation* (New York: Dell, 1969), p. 296.

73. UM, p. 217.

74. Sontag, "Aesthetics of Silence," p. 5. To be sure, there was certainly a political edge to some sixties conceptual artists' hostility to objects. Compare Les Levine in GB, particularly p. 196.

75. WT, sec. 2, ll.31–37.

76. TT, 155. On the subject of modern American artists unwittingly borrowing from the French what the French owed American Transcendentalists, see Betsy Erkkila's *Whitman Among the French* (Princeton, NJ: Princeton University Press, 1980), particularly pp. 171–74 on Whitman's Cubist Decade cult there.

77. "Art," in RWE, p. 298. How well did Emerson and Whitman live up to their high-principled disdain for art's "rubbish"? Not very, but that's not unusual. Danto declared art over and immediately took a job as an art critic, Cage achieved "silence" in 4′33″ and went right on creating, Newton Harrison smashed his statues, John Baldessari burned his paintings and entombed the ashes in the Brooklyn Museum's wall as if it were a crematorium, Robert Irwin quit art as if he were quitting smoking—but all, in one way or another, eventually came back. See Ann Hostetler, "Emerson and the Visual Arts: Private Response and Public Posture," *ESQ: Journal of the American Renaissance* 33 (3): 121–36. Whitman in particular consorted enthusiastically with artists. See Miles Tanenbaum's

doctoral dissertation, "Walt Whitman and American Art," University of Tennessee, 1988.

78. "Art," in RWE, p. 292.

79. For an overview of the complex international artworld just before the 1800 changes, see Robert Rosenblum's chapter, "Neoclassicism: Some Problems of Definition," in his *Transformations in Late Eighteenth Century Art* (Princeton, NJ: Princeton University Press, 1967). The very complexity of the situation requires a broad, complex approach: "Beginning around 1760, Western art becomes so hydra-headed that the historian who attacks it from a single approach is sure to be defeated. . . . What are we to call those strange new emotions . . . if not Romanticism? What are we to call that abundance of works newly inspired by Greco-Roman Art . . . if not Neoclassicism?" (pp. vii–viii). For historic changes in status among the arts themselves, see Paul Oskar Kristeller's two long and classic essays, "The Modern System of the Arts: A Study in the History of Aesthetics," which, despite the title, are about the rise, since Greek times, of the five "'major arts'" as the arts' core: painting, sculpture, architecture, music, and poetry. Parts I, II, *Journal of the History of Ideas* 12 (October 1951), 13 (June 1952); hereafter cited as POK. There is an extensive bibliography, particularly for continental sources.

80. Jean-Jacques Rousseau, *Emile,* translated by Barbara Foxley (New York: Dutton, 1966), p. 276.

81. J. Hillis Miller, *The Disappearance of God: Five Nineteenth-Century Writers* (Cambridge, MA: Harvard University Press, 1963).

82. Rousseau, *Emile,* p. 227.

83. JB, p. 26.

84. The best recent, long (500 pages) detailed study of this phenomenon is Martha Vogeler's *Frederic Harrison: The Vocations of a Postivist* (Oxford, U.K.: Oxford University Press, 1984). Professor Vogeler very kindly read two drafts of this manuscript. Another standard work is Noel Annan's revised *Leslie Stephen: The Godless Victorian* (New York: Random, 1984).

85. Clive Bell, *Art* (New York: G. P. Putnam, 1958), p. 181.

86. Harold Bloom, *The Visionary Company* (Ithaca, NY: Cornell University Press, 1971 rev. of 1961 ed.), p. xvii.

87. M. H. Abrams, *Natural Supernaturalism: Tradition and Revolution in Romantic Literature* (New York: W. W. Norton, 1971), p. 13; hereafter cited as NS. In the last thirty years Abrams's seminal work has acquired a literature of its own. Much of Harold Bloom's "visionary" work is itself the best indirect comment on it (my own ideas about Abrams's work were largely formed through Abrams's student, Bloom). For an entire book assessing Abrams's import, see *High Romantic Argument: Essays for M. H. Abrams,* edited by Lawrence Lipking (Ithaca, NY: Cornell University Press, 1981). Most interesting is Jonathan Culler's argument that "*The Mirror and the Lamp* teaches us to explore systems of metaphor" and that Jacques Derrida is continuing Abrams's "project of deconstructing the theological system of our critical thinking. . . ." Abrams, replying, said (after reservations), "I am compelled to agree that I can indeed be plausibly represented as a precursor of the disseminating strategies of Jacques Derrida. . . ." ("The Mirror Stage" and

"A Reply," pp. 163 and 167). Abrams had, indeed, written in *The Mirror and the Lamp: Romantic Theory and the Critical Tradition* (New York: W. W. Norton & Co., 1958; hereafter cited as ML) that "a particular aim" of his would be to "emphasize the role in the history of criticism of certain more or less submerged conceptual models—what we may call 'archetypal analogies' in helping to select, interpret, systematize and evaluate the facts of arts" (p. 31).

Culler was attempting what Barzun used to call "rehabilitation." In the 1970s, during the extraordinary boom for those theories popularly called "deconstructionism," the learned Abrams somehow was maneuvered (by J. Hillis Miller, among others) into entering the lists as champion of the critical *ancien régime*. For Abrams's often caustic comments on Derrida and company, in articles with titles like "The Deconstructive Angel," see M. H. Abrams, *Doing Things with Texts: Essays in Criticism and Critical Theory*, edited by Michael Fischer (New York: W. W. Norton, 1989). Jon Klancher reviews the debate from a New Historian's perspective in "English Romanticism and Cultural Production," in *The New Historicism*, edited by H. Aram Veeser (New York: Routledge, 1989). Two decades after the controversy unreasoning boom threatens to give way to unreasoning backlash as some of Abrams's complaints can be heard even from the likes of Umberto Eco. In any event, lines of inquiry radiating from Carlyle's old concept "Natural Supernaturalism" can be confidently pursued. I underscore that the term is Carlyle's. Abrams spun the term out into something much more complex. Plainly I respect Abrams, but my use of Thomas Carlyle's term does not mean I'm signing up for everything Professor Abrams later meant by it.

88. Barbara Novak, *Nature and Culture: American Landscape and Painting 1825–75* (New York: Oxford University Press, 1980), pp. 3–17, in particular.

89. T. E. Hulme, "Romanticism and Classicism," in *Speculations: Essays on Humanisms and the Philosophy of Art* (New York: Harcourt, Brace, 1924), p. 118.

90. *English Romantic Poets: Modern Essays in Criticism*, edited by M. H. Abrams (New York: Oxford University Press, 1960), pp. 3–22, passim.

91. Arthur O. Lovejoy, quoted in *English Romantic Poets*, p. 8.

92. Chapter 14 of vol. II of *Biographia Literaria, or Biographical Sketches of My Literary Life and Opinions*, edited by James Engell and W. Jackson Bate (Princeton, NJ: Princeton University Press, Bollingen Series LXXV, 1983), p. 7; hereafter cited as SC.

93. SC, p. 7.

94. WW, p. 590.

95. Bloom, *The Visionary Company*, pp. xxiv–xxv.

96. NS, p. 28.

97. NS, pp. 26–27.

98. Marjorie Hope Nicolson, *Mountain Gloom and Mountain Glory: The Development of the Aesthetics of the Infinite* (New York: Norton, 1963), particularly pp. 207–12. Basil Willey, *The Eighteenth Century Background: Studies on the Idea of Nature in the Thought of the Period* (Boston: Beacon Press, 1961). I think we must call it a *religious* orientation or risk the parochial Western mistake of thinking religions which lack anthropomorphic dieties somehow less religious than those that don't. By that ethnocentric standard, perhaps most East Asian high religion is

"secular." There's nothing secular about Wordsworth or Carlyle. They aren't involved in secularization, but in de-anthropomorphization.

99. Thomas Kuhn, *The Structure of Scientific Revolutions* (Chicago: University of Chicago Press, 1962, 1970), p. 16.

100. Fernand Leger, "The Machine Aesthetic: The Manufactured Object, the Artisan and the Artist," in Leger's *Functions of Painting* (New York: Viking, 1973), pp. 52–53; hereafter cited as FL.

101. WW, p. 590.

102. Sir Joshua Reynolds, *Discourses on Art*, edited by Robert R. Wark (New York: Collier [1966 reprint of Huntington Library, 1959], Dis. 13), p. 207; hereafter cited as JRD, with Discourse abbreviated as "Dis." Professor Wark has also annotated an edition of the *Discourses* and appended relevant texts at the end (New Haven, CT: Yale University Press, 1975). I thank Professor Wark for guidance on Reynolds research during my long-ago grant at the Huntington Library.

103. JRD, Dis. 3, p. 46; Dis. 13, p. 207.

Chapter II

1. Erwin Panofsky, *Idea: A Concept in Art Theory,* Joseph J. S. Peake 1960 translation of 1924 German original (New York: Harper Icon, 1968), p. 5; transliteration from the Greek mine; hereafter cited as IDEA. As well as being a critical work, *Idea* collects the major texts and prints them facing their originals so one may judge the translations for oneself. In the text, Panofsky, himself inspired by a Cassirer lecture, traces the permutations in the Ideal from classical times to Kant. While he corrects Sir Joshua's generalization (above) about critical uniformity, he testifies to the Ideal's persistence. For Panofsky's relation to earlier art historians see Michael Podro, *The Critical Historians of Art* (New Haven, CT: Yale University Press, 1982), particularly pp. 178–208. Panofsky, "challenging" Wolflin and Weber, "revived the Hegelian project of constructing an absolute viewpoint from which to regard the art of the past . . . from which the inner structure of all works of art could be made clear" (pp. 178–79).

2. Jean Hagstrum, *The Sister Arts: The Tradition of Literary Pictorialism from Dryden to Gray* (Chicago: University of Chicago Press, 1958), p. 53; hereafter cited as JH.

3. JH, p. 21; *Iliad* xviii, pp. 548–49. Richmond Lattimore translation.

4. Compiled from three older anthologies dating back to the first century B.C., Hagstrum calls these epigrams "iconic epigrams." For his fuller discussion, see JH, pp. 22–24, 47–51, 74–75. For a recent collection of essays by notable scholars following Hagstrum's lead, see *Articulate Images: The Sister Arts from Hogarth to Tennyson*, edited by Richard Wendorf (Minneapolis: University of Minnesota Press, 1983). Note the extensive "A Checklist of Modern Scholarship on the Sister Arts," pp. 251–62.

5. JH, p. 24. For the similar Daidalos legends, see J. J. Pollitt's *The Art of Ancient Greece: Sources and Documents* (Cambridge: Cambridge University Press, 1990), pp. 13–14; Greek text in *Select Passages from Ancient Writers Illustrative of the*

History of Greek Sculpture, edited by H. S. Jones (Chicago: Argonaut, 1966), pp. 3–4. Daidalos is less Stephen Daedalus's ancestor than Baron Frankenstein's.

6. JH, p. 38.

7. Dis. 3, JRD, p. 50.

8. Cennini's nearly contemporary *Libro dell'arte* is more in the tradition of the medieval craftsman's handbook. For Alberti's anxiety about painting's status, see Larry Silver, "Step-Sister of the Muses: Painting as Liberal Art and Sister Art" in Richard Wendorf, ed., *Articulate Images,* pp. 36–69 (particularly 37–45). Though we now call this tradition "humanistic," the word itself probably "grew out of late fifteenth-century university slang," Michael Baxandall tells us in *Giotto and the Orators: Humanist Observers of Painting in Italy and the Discovery of Pictorial Composition, 1350–1450* (Oxford, U.K.: Oxford University Press, 1971); hereafter cited as BX. The men we call early "humanists" generally described themselves as "orator" or "rhetoricus" (BX, p. 2). For some differences between Alberti's Latin version, *De Pictura,* and his Italian version, *Delle Pittura,* see BX, pp. 29–30. On translation from Latin to the era's vernacular in general, see pp. 7–20.

9. *On Painting,* translated by John R. Spencer (New Haven, CT: Yale University Press, 1956, 1970), p. 65; hereafter cited as AI.

10. An important date is 1563, when, Kristeller tells us, "under the personal influence of Vasari, the painters, sculptors and architects cut their previous connections with the craftsmen's guilds and formed an Academy of Art (Accademia del Disegno)." This was the first arts Academy, an imitation of the literary ones, the "model for later similar institutions." The Academy replaced the old "workshop tradition with a regular kind of instruction" that even included geometry and anatomy (POK, p. 514).

11. AI, p. 43.

12. Alberti's book is so straightforward, one understands *Della pittura's* great and immediate popularity: "A point is a figure which cannot be divided into parts. . . . These points, if they are joined one to the other in a row, will form a line" (AI, p. 43). "This dispute is very difficult and is quite useless for us. It will not be considered" (AI, p. 46). Alberti labors in hope that his work will be "useful and helpful to painters," and even asks that "if it is, and they are grateful, I ask only that as a reward for my pains they paint my face in their *istoria* in such a way that it seems pleasant and I may be seen a student of the art" (AI, p. 98). He has some characteristically candid words on the motives behind criticism: "There is no one who does not think it an honour to pass judgment on the labours of others" (AI, p. 98).

13. AI, p. 72.

14. AI, p. 75.

15. AI, p. 76.

16. AI, p. 76.

17. AI, p. 77.

18. AI, pp. 77–78.

19. By the 1980s a postmodern painter like Leon Golub, no less concerned

with the *istoria* than Alberti or Sir Joshua, would be keeping a huge file of magazine photos filled with expressive poses (Personal communication, 1986).

20. Dis. 4, JRD, p. 41.

21. Dis. 3, JRD, p. 51.

22. Dis. 13, JRD, p. 204.

23. Ibid.

24. Rensselaer W. Lee, *Ut Pictura Poesis: The Humanistic Theory of Painting* (New York: Norton, 1967), p. 69; hereafter cited as UPP.

25. Dis. 4, JRD, p. 64.

26. Dis. 9, JRD, pp. 150–51.

27. Dis. 3, JRD, p. 44.

28. In the "Timaeus." Not to be confused with the fifth-century A.D. aesthetician and follower of Plotinus.

29. Dis. 3, JRD, p. 44.

30. Plato's *Republic,* translated by F. Cornford (New York: Oxford University Press, 1945), pp. 209–10; Ch. VI.501.

31. IDEA, p. 15: Aristotle, *Politics,* III.6.5/1281b.

32. IDEA, p. 30: Plotinus, *Ennead* V.8.1.

33. IDEA, p. 37.

34. IDEA, p. 47. Alberti's is one of those frank Renaissance bids to equal the ancients: "The first great care of one who seeks to obtain eminence in painting is to acquire the fame and renown of the ancients. It is useful to remember that avarice is always the enemy of virtue. Rarely can anyone given to acquisition of wealth acquire renown. I have seen many in the first flower of learning suddenly sink to money-making" (AI, p. 67).

35. IDEA, p. 48.

36. AL, p. 92.

37. AI, p. 95.

38. AI, p. 93.

39. BX, p. 38.

40. UPP, p. 3.

41. For more on Dryden's "Parallel," *De Arte Graphica* and a history of that poem's significant changes during several translations, see pp. 38–65 in Lawrence Lipking's *The Ordering of the Arts in Eighteenth-Century England* (Princeton: Princeton University Press, 1970); hereafter cited as LL. "The pervasive if variable authority which Horace wielded over the poets of Europe from 1670–1790, Du Fresnoy wielded over her painters" (LL, p. 38). See also JH, p. 174.

42. Panofsky and Lee both have shown that Bellori sacrificed some of Ficino's ideas (about, for instance, *a priori* knowledge) in the course of building, in 1664–65, the first "definite formulation of" an aesthetic "that had already existed without such formulation in Renaissance criticism" (UPP, p. 14, note 52). And Panofsky tells us that Bellori's 1672 work has itself "turned out to be the summary and codification of trains of thought that were already current" among the Carracci painters' circle and "formulated previously in the manuscript papers" of their friend, G. B. Agucchi about 1610 (IDEA, p. vii).

43. "Dryden . . . salvaged Du Fresnoy for an English audience [and] modified and expanded his precepts according to the best respected opinion of his day" (LL, p. 52). For more on Zeuxis in the Renaissance, see BX, pp. 35–39.

44. Rome, 1672.

45. JH, p. 175.

46. IDEA, p. 12: Orator. The humanistic critics "who fashioned the doctrine *ut pictura poesis*" respected painting as "a serious interpreter of human life, and the humanistic critic who is deeply concerned with art as a repository of enduring human values [like the refugee Panofsky, during the Nazi era] will always believe that human life is as supremely the painter's province as it is the poet's, and that some subjects are of more universal interest and importance than others . . . (Dis. 3, JRD, p. 43–44).

47. IDEA, p. 26: Plotinus, *Ennead V.*8.1.

48. IDEA, p. 60.

49. IDEA, pp. 160–63.

50. IDEA, p. 161.

51. Dis. 3, JRD, p. 44.

52. Aesthetics has usually been a branch of larger philosophies and has often produced exceptionally pure statements of those philosophies. Aesthetics, for many complex reasons, often seems to bring the soul of a philosophy to the surface. Ruskin said, "Tell me what you like and I'll tell you who you are." When a philosophy begins talking aesthetics it begins talking about what it likes. To give us an aesthetics it must finally bare its soul—and sometimes that soul is unexpectedly repellant. Many a seemingly attractive philosophy turns out to have an aesthetic which is little more than mind control. Others reveal themselves naively materialistic or embarrassingly limited in their concepts of what humans enjoy—which is as much to say, their concepts of what humans are. Speaking personally, the test of a philosophy is its aesthetic, its clearest statement of what it thinks humans like.

53. JRD, pp. vi–vii. Reynolds was not without English predecessors. For his debts to Jonathan Richardson's pioneering essays on art (1715–22), see Lipking (LL). Northcote pointed out that Richardson taught Reynolds to venerate Raphael's paintings before Reynolds had ever seen one.

54. See Hazard Adam's "The Blakean Aesthetic," *Journal of Aesthetics and Art Criticism* 13 (1954): 233–48. See also Hazlitt's brief essays on Reynolds. Hazlitt painted seriously, and the essays should be better, but they lose the thread (as often happens with Hazlitt) and wander off into painterly quarrels over specific painters' merits—almost useless to us. When writers of that era discuss "Rembrandt" or "Titian" they reference a body of work which barely overlaps what we link with those names. In 1969 I took some Ruskin volumes through Italy, trying to read him on site, comparing the passages with their subjects. Half of his Giottos were now Barnas and Orcagnas, details he praised were erased as corrupt additions, and the colors he lauded likewise.

55. Here Reynolds follows in the steps of Leonardo, Raphael, and Michelangelo, who were the first painters ready, Jean H. Hagstrum explains, to challenge poetry as a sister art, a liberal art. "'Painting' enjoyed a prestige that it had

perhaps never before been accorded." The challenge, issued in the form of several Renaissance *paragoni* (critical contests) was more "explainable . . . sociologically" than "philosophically."

> Painters and sculptors were now successful enough to reject the inferior social and educational position they had occupied since antiquity and to strive for recognition of their pursuits as liberal disciplines. In a tract on painting published in 1609 the personified Pittura says: "You know that what displeased me above all else was that I was not placed among the seven liberal arts and that I was born in ignorance." Sculpture and painting had been considered mechanical, not liberal art, and hence worthy neither of a freeborn citizen's practice nor of a place in the trivium or quadrivium. (JH, p. 66)

. . ."In proportion to the mental labour employed in it," Reynolds wrote in Discourse 4, "or the mental pleasure produced by it . . . our profession becomes either a liberal art, or a mechanical trade" (JRD, p. 55). "Mechanical trade" had, of course a social stigma. A gentleman did not work with his hands, and painters obviously did. "Exertion of mind . . . is the only circumstance that truly ennobles our Art" (Dis. 4, JRD, p. 55). See Iain Pears's *The Discovery of Painting: The Growth of Interest in the Arts in England, 1680–1768* (New Haven, CT: Yale University Press, 1988) for a mine of suggestive statistics about that artworld's economics.

56. Frederick Whiley Hilles, *The Literary Career of Sir Joshua Reynolds* (New York and Cambridge, 1936), p. 16; hereafter cited as LCJR.

57. Reynolds began his writing career with three letters written for Johnson's *Idler* in 1759, which Johnson "required . . . from him on a sudden emergency" (LCJR, p. 16). Analyzing a page which has survived, showing Johnson's "small hand" correcting a page of the Eleventh Discourse, Hilles concludes, "As has long been pointed out, [Johnson] knew little about the fine arts and cared less. What he could and did do was to make the Discourses more resounding, more melodious" (LCJR, pp. 135–36). Johnson's changes were, Morris Brownell once advised me, only "editorial." But misconceptions about Johnson's authorship were widespread. "Since his closest friends were Johnson and Burke, the *Discourses* were generally considered to be the work of the one or the other" (LCJR, p. xviii). In Sir Joshua's day and ours, the educated public considered a painter's literary zeal something of a quirk. Even now it is not usually observed that Reynolds's literary interests follow logically from his beliefs. The humanistic painter was bitterly aware that his art was misunderstood to be a merely sensual enterprise.

58. A show of Reynolds's manuscripts at Yale's Beinecke Library in 1973 made this point clearly: one could see Johnson's handwriting on Reynolds's text, making widely scattered minor corrections and improvements. I thank Robert Wark for two conversations on this point while I was on fellowship at the Huntington in 1974–5.

59. John Ruskin, *Works*, Library Edition, edited by E. T. Cook and Alexander Wedderburn, 39 vols. (London: George Allen, 1903–12); hereafter cited as CW, followed by volume and page numbers; as in CW, 5:21. The greatest assistance we know of (on four late discourses) may have come, Hilles decides, from Edmond

Malone, who had also "spent hours with Boswell moulding the *Life of Johnson*" (LCJR, p. 142). That Sir Joshua's drafts did benefit from editing is clear, I think, from an early version of the sixth discourse in which he recommends "enriching and manuring the mind with other men's thoughts. . . ." (LCJR, p. 142).

60. Walter Jackson Bate, *From Classic to Romantic: Premises of Taste in Eighteenth-Century England* (New York: Harper, 1961), p. 179.

61. Dis. 4, JRD, p. 55.

62. LCJR, p. 233.

63. SCM, p. 104.

64. CW, 5:46.

65. WW, p. 590.

66. "The Excursion," in WW, p. 18.

67. "For example, once 'Debussy' referred to music of a certain ethereal mood, satisfying a taste for refined sweetness or poignance; today it refers to solutions for avoiding tonality: I find I waver between thinking of that as a word altering its meaning and thinking of it as referring to an altered object" (SCM, p. 104).

68. Dis. 3, JRD, p. 46.

69. Ibid., p. 45.

70. CW, 5:98.

71. Dis. 3, JRD, p. 46.

72. Ibid.

73. Dis. 13, JRD, p. 207. Even beyond the results of applying the method of Zeuxis, the older aesthetic's admirable humanism could slide into contempt for the nonhuman world. Bate cites a statement by Socrates to Phaedras: "'I am a lover of knowledge; and the men who dwell in the city are my teachers, and not the trees or the country,'" then tells us "such statements would have elicited at least some agreement from any classicist. 'The absence or the deprecation of the landscape in Greek and Roman art is no historical accident: whether the classical artist sought to portray physical or moral beauty, his attention was directed to its existence and its ideal potentiality in the human being" (Bate, *From Classic to Romantic*, p. 2).

74. Dis. 13, JRD, p. 214. Reynolds was, in fact, by no means in the conservative wing of his aesthetic. David Irwin, considering the effect of the antique upon Sir Joshua (*English Neo-Classical Arts: Studies in Inspiration and Taste* [Winchester, MA: Faber & Faber, 1966]) decides Reynolds had only the "very deep respect" for antique art that "any gentleman in the eighteenth century" had; and by the thirteenth discourse (by 1786, that is, the thirteenth of fifteen discourses) he was far from his earlier admiration for it. Irwin will even argue that by taking a stand against Batoni and Mengs in the fourteenth discourse, Reynolds was actually taking "a stand against neoclassicism," since they were "two of its leading exponents in Italy" (p. 76). Surely we should at least excuse Reynolds from becoming some sort of romantic.

75. Ruskin's emphasis. CW, 5:173. Reynolds is willing to allow the Dutch pictures are a beauty "of a lower order," but insists that attention to the lower beauties can only be had at the cost of the higher beauty, "since one cannot be ob-

tained but by departing from the other" (Sir Joshua Reynolds, *Literary Works,* vol. II [London: Cadell, 1835], p. 128; hereafter cited as JRW). The highest beauty, highest study, can be reached only by leaving behind this petty beauty.

> Other kinds [of painting] may admit of this naturalness, which of the lowest kind [of painting] is the chief merit; but in Painting, as in Poetry the highest style has the least of common nature. (JRW, II:129) . . . As Sir Joshua says in his notes to Du Fresnoy's poem, "To paint particulars is not to paint nature, it is only to paint circumstances." (JRW, II:300)

76. Dis. 4, JRD, p. 57. Emphasis his.
77. Dis. 4, JRD, p. 58.
78. JRW, II:144–45.
79. Dis. 3, JRD, pp. 45–46.
80. Dis. 13, JRD, p. 207.

Chapter III

1. WW, p. 590.
2. NS, p. 20. Neither Abrams nor Bloom, however, realize how many of Wordsworth's allusions here are to visual art theory.
3. WT, p. 415, ll. 176–79. Punctuation his.
4. SC, p. 7.
5. Like Abrams and Bloom I agree—cautiously. There are as many Wordsworths as there are Picassos. Albert O. Wlecke once said that Wordsworth, more than any other poet, embodied the manifold possibilities of human experience, and Michael Cooke has suggested that the romantics were "inclusiveness" itself. Again, I write not to reduce the authors in this chapter (or any chapter) to one theme, but to trace one theme in the authors' works.
6. SC, p. 7.
7. WW, p. 588. James Engell cites Shelley's agreement with this passage in an equally influential one from the 1821 "Defence of Poetry," "Poetry . . . purges from our inward sight the film of familiarity which obscures from us the wonder of our being" (*The Complete Works of Shelley,* 10 vols., edited by R. Ingpen and W. E. Peck, vol. VII [New York: Gordian, 1965], p. 137).
8. "Prospectus," ll. 815–24, WW, p. 590.
9. Jack Stillinger, ed., *Wordsworth's Selected Poems and Prefaces* (New York: Riverside, 1965), p. xvii.
10. ML, pp. 157–58.
11. "Preface to Lyrical Ballads," WW, p. 738.
12. "Song of Myself," sec. 46, WT, p. 84.
13. René Wellek, *Kant in England* (Princeton, NJ: Princeton University Press, 1931).
14. Ibid., pp. 159, 72.
15. Samuel Holt Monk, *The Sublime: A Study of Critical Theories in XVIII-Century England* (Ann Arbor: University of Michigan Press, 1960), p. 154; hereafter cited as SHM. Even Engell's excellent book only spares him a few pages. Alison's phi-

losophy ran afoul of Ruskin. Associationism had led Alison to say that the "pleasing Associations" of "Grecian" structures would always make them our favorite architecture (Archibald Alison, *Essays on the Nature and Principles of Taste* [Hildesheim: G. Olms, 1968], p. 367; hereafter cited as AL). This would not do; Ruskin denigrated Alison and his work gradually vanished. On Alison's reception and influence see P. Funnell, "Visible Appearances," in *The Arrogant Connoisseur,* edited by M. Clark and N. Penny (Manchester, England: Manchester University Press, 1982), pp. 82–97. For another view of Ruskin's differences with Alison, see Gary Wihl's *Ruskin and the Rhetoric of Infallibility* (New Haven, CT: Yale University Press, 1985), pp. 50–58. Modern critics who have gone into Alison's book at length have been excited, but surprisingly unable to excite others. Monk (following Arthur Beatty) interrupted *The Sublime* to write a chapter ("A Glance Ahead") largely about Alison and the romantics. Louis Hawes, in his doctoral dissertation on Constable pointed out how Constable "lavishly praised" Alison, calling the *Essay's* closing chapter, "by far the most beautiful thing I ever read" ("John Constable's Writings on Art," Princeton University, 1963, p. 90). George Dickie praised him. Yet one can look through most books about the romantics without finding so much as a footnote on him.

A 1980 doctoral dissertation at the University of Florida, "Archibald Alison and the Spiritual Aesthetics of William Wordsworth," by Marsha Kent Savage provided evidence that Wordsworth and Coleridge knew Alison personally. Alison's wife was raised by Mrs. Montagu in an intellectual circle which Sir George Beaumont, Wordsworth's patron, undoubtedly knew. Alison subscribed to Coleridge's tiny 1809–10 periodical, *The Friend* (where he would have read Wordsworth's poetry) and the record of a casual call Alison paid Wordsworth in 1820 has been accidentally preserved.

In 1983 Michael Rosenthal expanded on Hawes's point: "It is vital to recognise the significance of Constable's preferring Alison to Burke." ("I am delighted with Alison's book . . ." Constable wrote, "I prefer it much to Mr. Burke's. . . .") "For Burke, 'aesthetic emotions' were aroused by particular characters—size, shape, colour," while Alison, by contrast, wrote that "the qualities of matter are in themselves incapable of producing emotion" (AL, p. 10). Michael Rosenthal, *Constable: The Painter and His Landscape* (New Haven, CT: Yale University Press, 1983), p. 74.

16. AL, p. 1.
17. AL, p. 2.
18. AL, p. 6.
19. AL, p. 5.
20. AL, p. 7.
21. AL, p. 6.
22. AL, p. 411.
23. TT, pp. 2–5.
24. AL, pp. 7–14.
25. But not as they grew older. In another book I will show at length which would here distract, how the first part of the *Immortality Ode* is Wordsworth's sad

acceptance of Alison's pessimism—followed by Wordsworth's triumphant overcoming of that pessimism by his new solution written two years later.

26. AL, pp. 66–71.

27. SHM, p. 148. In *Art and the Aesthetic: An Institutional Analysis* (Ithaca, NY: Cornell University Press, 1974) however, George Dickie quarrels with Jerome Stolnitz's contention that Archibald Alison is "a clear case of an aesthetic-attitude theorist with a fully developed conception of disinterested perception or attention." Dickie replies that Alison has "all the usual five elements" of a theory of taste in the eighteenth-century manner.

Stolnitz is right. Alison has many interests; but his book, as large and rambling as an eighteenth-century British estate, does include, as a main sitting room, the aesthetic experience. Dickie wants Alison to be a more systematic thinker than Alison was. Alison "is not claiming that there are two kinds of attention or perception but only that there is attention to aspects of the external world and *in*attention to such aspects." Professor Dickie would have to concede, however, that Wordsworth (and Constable) were reading a theory whose differences from later Kant-inspired explanations of the aesthetic experience are so slight that even Jerome Stolnitz can't tell Alison apart from the later aesthetic-attitude theorists. Nor can I, even after reading Dickie's exceptions. (And in fact, in his *Aesthetics* [Indianapolis, IN: Pegasus, 1971] even Dickie had written that Alison has "a fully developed conception of disinterestedness.")

28. AL, p. 6.

29. AL, pp. 90–91.

30. AL, p. 321.

31. AL, p. 411.

32. Wordsworth in concert with Coleridge, of course. Since this part of their poetic program is much closer to Wordsworth's practice, I'll continue to write "Wordsworth" alone, but the reader is again alerted. Much as Picasso and Braque couldn't tell later which of them painted certain early paintings, Wordsworth's earliest critical work was the sum of "conversations" with Coleridge carried on "so frequently" that neither later knew who "first started any particular Thought" (Coleridge, in *Literary Criticism of William Wordsworth*, edited by Paul M. Zall [Lincoln: University of Nebraska Press, 1966], p. 15; hereafter cited as PZ). Though Coleridge and Wordsworth had differences by 1802, important phrases even in Wordsworth's 1815 Preface are quotes from an 1807 letter in which Wordsworth implies they're Coleridge's.

33. Dis. 13, JRD, pp. 205–6. PZ, p. 10.

34. PZ, p. 10.

35. *Prelude*, "Book I," ll. 80–85, WW, p. 496.

36. Wordsworth quotes Gray's lines in the preface to *Lyrical Ballads*, WW, p. 736. Pronounce "join" to rhyme with "shine."

37. Harold Rosenberg, *Artworks and Packages* (Chicago: University of Chicago Press, 1969), p. 31.

38. One wonders where the eighteenth-century aestheticians regularly found this sort of information, since it has become so hard for us to obtain (AL, p. 314).

39. See James Engell's authoritative *The Creative Imagination: Enlightenment to Romanticism* (Cambridge, MA: Harvard University Press, 1981). Engell summarizes some of his points in his long introduction to *Biographia Literaria* (SC, vol. 1, pp. lxvii–cxxxvi). For an argument that Wordsworth and Coleridge's new definition of imagination was influenced by John Wesley's "spiritual sense" (through which, to the newly converted man, "all things around him are becoming new. . . . He sees, so far as his newly-opened eyes can bear the sight. . . ."), see Richard E. Brantley's *Locke, Wesley, and the Method of English Romanticism* (Gainesville, FL: University of Florida Press, 1984), particularly p. 100, pp. 103–28, 152, 158.

40. John Holloway, *The Victorian Sage* (New York: Norton, 1953), p. 41.

41. Harold Rosenberg, *Artworks and Packages* (Chicago: University of Chicago Press, 1985 [New York: Horizon, 1969]), p. 90.

42. Rosalind Krauss, "Sculpture in the Expanded Field," *October*, no. 8 (Spring 1979). Later published in *The Originality of the Avant-Garde and Other Modernist Myths* (Cambridge, MA: MIT Press, 1985), pp. 226–90.

43. Richard Kostelanetz, *Conversing with Cage* (New York: Limelight Editions, 1988), p. 181; hereafter cited as RKZ. Morris Weitz's work, "The Role of Theory in Aesthetics," *Journal of Aesthetics and Art Criticism* 15 (1956), became, George Dickie tells us, "the best-known denial that art can be defined." "Until [1962–63] this argument had persuaded so many philosophers"—backed, as it was, by Wittgenstein's philosophy's prestige—"of the futility of trying to define art that the flow of definitions had all but ceased." Now Weitz's work looks more like a sane way to weather the storm of Natural Supernaturalism's final years in the artworld, by getting off the beach and refusing to mark that rising tide. Weitz saw that the attempt to define had been futile. Cage, Yves Klein, Kaprow, and other fathers of conceptual art were already active. Relying on an analogy with the novel (by 1956 Joyce and Beckett had joined anyone's canon, and novels could not be said to share any essential or defining characteristics), Weitz tried to explain Natural Supernaturalism's omniverousness by saying "art," *in general,* like the novel, must be an "open concept," like "game," which Wittgenstein had said could not be defined. Weitz confuses all of "art" with one current, and that a fairly recent one. By the mid-sixties the transfigurationist process was clear enough for perceptive observers like Danto and Dickie to produce good accounts of it, though they too hoped they had produced general definitions of art. In any event, Danto and Dickie wrote two subtle accounts of Natural Supernaturalism as a systematic transfiguration. "The institutional theory of art," Dickie confessed "may sound like saying, 'a work of art is an object of which someone has said, "I christen this object a work of art."' And it is rather like that, although this does not mean that the conferring of the status of art is a simple matter." Dickie's institutional theory is not a theory of art but, right down to the secularized religious ceremony ("I christen this object a work of art"), an excellent description of Natural Supernaturalism's work *in* the arts.

44. Holloway, *The Victorian Sage*, pp. 42–49, *passim.*

45. SC, vol. I, chapter 4, p. 80.

46. John Milton, "L'Allegro," l. 133, in *Oxford Anthology of English Literature,* vol. 1, p. 1213.

47. Addison, *Spectator,* no. 411, 418.

48. For the views of those contemporaries, particularly the German aesthetician Tetens, see Engell, *The Creative Imagination,* pp. 118ff. "On the nature of the imagination, Kant stands largely on the shoulders of Tetens (1736–1807)." Tetens's fifteen hundred page work, one hundred and fifty pages on the imagination, "directly influenced Coleridge" (Engell, pp. 118–19). Richard E. Brantley's *Locke, Wesley, and the Method of English Romanticism,* proposes that "Locke's theory of knowledge grounds the intellectual method of Wesley's Methodism. And second, Wesley's Lockean thought . . . provides a ready means of understanding the 'religious' empiricism and the English 'transcendentalism' of British Romantic poetry" (p. 2). Brantley contends that "Coleridge's youthful Unitarianism" was closer to dissenting Evangelicalism, "of which Wesley's influence formed the trunk" (p. 163).

49. NS, p. 414.

50. SC, vol. I, chapter 4, p. 81.

51. SC, chapter 14.

52. "Tam o'Shanter," ll.59–62. I thank Katherine Morsberger for calling this significant misquotation to my attention.

53. SHM, pp. 158–59. Morton D. Paley is more respectful of what he calls Burke's "new, psychological sense of the word" than Monk is, or than I am. Paley documents a subgenre within the Sublime, a growing British obsession, as the French Revolution nears, with images of "the crack of doom." See *The Apocalyptic Sublime* (New Haven, CT: Yale University Press, 1986); for my review of it, *Los Angeles Times Book Review,* 23 November 1986.

54. Richard Payne Knight, *An Analytical Inquiry into the Principles of Taste,* 4th ed. (London, 1808), p. 384.

55. Cited in Albert O. Wlecke, *Wordsworth and the Sublime* (Berkeley: University of California Press, 1973), p. 11.

56. George Gordon Lord Byron, "English Bards and Scotch Reviewers," ll. 237–46, in *Poetical Works* (London: Oxford University Press, 1967), p. 116.

57. Book 1, WW, p. 592.

58. For a detailed examination of these many acts of apperception, see Albert O. Wlecke, *Wordsworth and the Sublime,* and Geoffrey Hartman, *Wordsworth's Poetry, 1787–1814* (New Haven, CT: Yale University Press, 1964, 1971), p. 11.

59. *The Excursion,* Book I, WW, p. 592.

60. Preface, 1855, *Leaves of Grass,* WT, p. 715.

61. PZ, p. 53.

62. "Essay upon Epitaphs III," PZ, pp. 120, 124.

63. "Essay upon Epitaphs II," PZ, p. 119.

64. Unlike Emerson's work or Leger's, for these poems there can be no question of inspiration by Hegel's 1820s art lectures.

65. Stillinger, ed., *Wordsworth's Selected Poems and Prefaces,* pp. 514–15.

66. Hartman, *Wordsworth's Poetry,* p. 155. Professor Hartman probably re-

members a comment Wordsworth made about Hazlitt and the poems' inspiration, but the finished texts deal specifically with "books" and "Art." Paul M. Zall, by contrast, considers the poems, and their position at the front of the volumes, "seriously meant" (Personal communication, December 1984).

67. SC, vol. I, chapter 4, p. 81.

68. WW, p. 377.

69. Even metaphorically, hearts don't watch. Wordsworth falls back on the hoary English metaphor of the "heart" to denominate here, an organ which receives the Powers' impress; elsewhere he says, "the Mind." No one as interested in scientific psychology as Wordsworth is said to be (by Stillinger, for one) would casually interchange the mind with a heart—that "watches." The truth is that Wordsworth's current, from its start to its completion in the 1960s, often considered itself first parallel to, then identical to scientific contemplation of this world (Cage embracing Buckminster Fuller; Robert Irwin, Newton Harrison and other Concept Artists taking up ecology and world "Habitability"). Ruskin was an enthusiastic naturalist as were Constable and Goethe (Kurt Badt has shown). Constable through his son John, Faraday's student, even followed Faraday's experiments. Invited by Faraday to lecture at the Royal Institution, Constable said, "I hope to show that [landscape painting] is *scientific* as well as *poetic;* that imagination alone never did, and never can, produce works that are to stand by a comparison with *realities....*" (John Constable, *John Constable's Discourses,* edited by R. B. Beckett [Ipswich: Suffolk Records Society Publications, 1962–68], p. 39). So it's worth this pause to note that, from the current's start, Wordsworth also admired science:

> The knowledge both of the poet and the Man of Science is pleasure.... Poetry is the breath and finer spirit of all knowledge; it is the impassioned expression which is in the countenance of all Science. (WW, p. 738)

70. NS, pp. 67–68. The still-unknown Emerson wrote the little-known Carlyle, on 2 November 1837, that when a friend remarked they could have made Carlyle more money by publishing *Sartor* in America themselves, "Instantly I wondered why I had never such a thought before, and went straight to Boston" where Emerson made a "bargain with a bookseller to print the *French Revolution...*I shall sustain with great glee the new relation of being your banker and attorney" (Joseph Slater, ed., *The Correspondence of Emerson and Carlyle* [New York: Columbia University Press 1964], p. 170). Carlyle was also *un*lucky with his disciples. See H. J. C. Grierson's 1933 *Carlyle and Hitler* (Cambridge, England: Cambridge University Press) and Eric Bentley's once well-known *A Century of Hero-worship: Carlyle and Nietzsche* (Boston: Beacon Press, 1957). For a relatively recent long biography, see Fred Kaplan, *Thomas Carlyle: A Biography* (Ithaca, NY: Cornell University Press, 1986).

71. John Stuart Mill, *On Bentham and Coleridge* (New York: Harper, 1962 [London: Chatto, 1950], p. 102). My ideas about Carlyle are indebted to my teacher, John D. Rosenberg. I thank John for sharing with me an early version of his definitive *Carlyle and the Burden of History* (Cambridge, MA: Harvard University Press, 1985); hereafter cited as JRC), which explores the impact of Carlyle's his-

tories—both content and narrative form—on Mill, Emerson, Whitman, Dickens, George Eliot, Thackeray.

72. Mill, *On Bentham and Coleridge,* pp. 102, 39–40.

73. Harold Bloom, *The Anxiety of Influence* (New York: Oxford University Press, 1973), pp. 94–95; hereafter cited as HBA.

74. HBA, p. 19.

75. *Paradise Lost,* Book IV, ll. 49–52.

76. HBA, p. 126.

77. For a recent instance, see Lawrence Kramer's attempt to describe the unity we feel between Wordsworth's poetry and Beethoven's music, *Music and Poetry: The Nineteenth Century and After* (Berkeley: University of California Press, 1984).

78. Karl Mannheim, *Essays on the Sociology of Knowledge,* edited by Paul Kecskemeti (London: Routledge and Kegan Paul, 1959), p. 81.

79. HBA, p. 88.

80. David Antin, *Talking at the Boundaries* (New York: New Directions, 1976), pp. 22–23.

81. HBA, p. 14.

82. Antin, *Talking at the Boundaries,* p. 22.

83. Though Bloom seems embarrassingly unaware that people do anything but read. Poets have life-experiences too; why must their poetry only be influenced by their reading? Did Elie Weisel read about the Holocaust? Why must poets only be influenced by, moreover, their grapples with their "ghostly fathers" but never with their real fathers?

84. See Kuhns's full discussion, in *Structures of Experience* (New York: Harper, 1974 [Basic, 1970]), pp. 82–131 specifically. In "Art as a Phenomenology of the Imagination," Richard Kuhns interprets Mannheim's explanation of the *Weltanschauung* as it applies to artobjects (my method and this discussion are indebted to Kuhns). Mannheim is "bringing into our awareness distinctions" implicit in Hegel's thought but which "Hegel did not clearly formulate."

85. Natural Supernaturalism's progress in America, through Carlyle's ally Emerson, and Thoreau and Whitman in literature, through the Luminists, Washington Allston and Frederick Church among others in painting, has been traced so fully by Tony Tanner *(The Reign of Wonder)* and Barbara Novak *(Nature and Culture)* it needs no addition from me. "Perhaps the most avid reader of Carlyle's work was Emerson. . . . When he drew up a list of 'My men' in his journal, the very first entry was—Thomas Carlyle." Carlyle's famous effect on his contemporaries is traced most fully in *Carlyle and His Contemporaries: Essays in Honor of Charles Richard Sanders,* edited by John Clubbe (Durham, NC: Duke University Press, 1976), and in Charles Richard Sanders, *Carlyle's Friendships and Other Studies* (Durham, NC: Duke University Press, 1977).

86. See John Rewald's *Post-Impressionism: From van Gogh to Gaugin,* 3d ed., rev. (New York City: Museum of Modern Art, 1978), p. 271.

87. John Ruskin, *Modern Painters,* vol. III, Part 4, Appendix 3, "Plagarism."

88. See G. B. Tennyson's chapter "Structure" in *Sartor Called Resartus* (Princeton, NJ: Princeton University Press, 1965), pp. 157–93.

89. *Sartor Resartus*, Book II, chapter 6; hereafter cited on this model: SR, II:7. My text follows the standard "Centenary" edition, edited by H. D. Traill, 30 vols. (London: Chapman and Hall, 1896–1901). See Noel Annan, "The Strands of Unbelief," in *Ideas and Beliefs of the Victorians*, edited by Harman Grisewood (New York: Dutton, 1966, [1949]), pp. 153–54.

90. G. B. Tennyson wrote (in 1965) that Book Two of *Sartor*, "with Teufels-drockh as representative man and as the artist in society, stands as Carlyle's *Portrait of the Artist* and calls to mind some substantial points of kinship between Carlyle and Joyce. The subject has remained largely unexplored. . . ." (*Sartor Called Resartus*, p. 302). Amazingly, that's still true. I'll publish elsewhere a long discussion which proved too digressive for the topics at hand.

91. SR, II:8, 9, 10. This moment would recur over and over in Natural Supernaturalist art and literature. Fernand Leger puts it,

> The collapse of religions has created a void that spectacle and sensualism cannot fill. Our eyes, closed for centuries to the true, realistic Beauty, to the objective phenomena that surround us, are beginning to open up. ("The Spectacle," in FL, p. 45)

The Surrealists, for instance, look familiar after one has been reading Carlyle. "Perhaps the most constant sources of wonder for (Roux) were the objects that surrounded him every day—what some years later Aragon was to call 'the daily miracle'" (Anna Balakian, *Surrealism: The Road to the Absolute* [New York: Dutton, 1959, 1970], pp. 76, 77). It didn't take Aragon to come up with "the daily miracle." Ms. Balakian, interviewed in 1973, conceded something familiar about "Saint"-Pol-Roux's dictum, which she herself translates, "The spectacle of the meanest flower emancipates my eyes" (*Surrealism*, p. 77). For a consideration of Carlyle's theory of symbolism, see Avrom Fleishman, *Figures of Autobiography: The Language of Self-writing in Victorian and Modern England* (Berkeley: University of California Press, 1983), pp. 121–37. Shelley, in "The Defence of Poetry," had alluded to the double meaning of the Latin *vates:* "Poets, according to the circumstances of the age and nation in which they appeared, were called, in the earlier epochs of the world, legislators, or prophets: a poet essentially comprises and unites both those characters." For an essay which, though on Wordsworth, illuminates this side of Carlyle, see Geoffrey Hartman's "The Poetics of Prophecy," in *High Romantic Argument: Essays for M. H. Abrams*, edited by Lawrence Lipking (Ithaca, NY: Cornell University Press, 1981), pp. 15–40.

92. Thomas Carlyle, *On Heroes, Hero-Worship and the Heroic in History;* hereafter cited on this model: HHW, Lec. [Lecture] 1.

93. HHW, Lec. 3.

94. HHW, Lec. 1. To understand why "silence" must cover that topic would require a digression on Victorian "reticence," as Carlyle calls it, and his fears that only what's left of Christianity holds back a revolution like the French one. "If, even on common things, we require that a man keep his doubts *silent...*how much more in regard to the highest things. . . ." (HHW, Lec. 5).

95. HHW, Lec. 4.

96. SR, II:8.

97. SR, II:8.

98. James Froude, *Thomas Carlyle: A History of the First Forty Years of His Life, 1795–1835* (New York: Charles Scribner's Sons, 1882), vol. 2, p. 359, entry 26, July 1834. Cited by John Rosenberg in *Carlyle and the Burden of History*. Rosenberg notes several times Carlyle's contempt for art but only ascribes it to his "Puritan soul." "For Carlyle, '*Kunst,* so called,' was cant" (p. 151). My section on Carlyle has its origin in conversations with John Rosenberg while he was writing *Burden,*—I had just dedicated a book to Carlyle—in which we shared our dismay over what seemed to be Carlyle's puritanism or philistinism. David J. DeLaura, in a typically brilliant essay, "The Future of Poetry," examines the youthful Carlyle's interest in poetry, while he was still under Goethe's and Schiller's spell. Nonetheless, DeLaura reports that (after 1833, surely) Carlyle "shared" the Benthamite conviction of "the irrevocable extinction of poetry. . . ." "All Art is but a reminiscence now," Carlyle was writing in 1833, "Prophecy . . . not Poetry is the thing wanted. . . ." DeLaura does not separately address Carlyle's expressed disgust with art objects (Clubbe, *Carlyle and His Contemporaries,* pp. 148–80).

99. *The Oxford Anthology of English Literature: Victorian Prose and Poetry,* edited by Lionel Trilling and Harold Bloom (New York and London: Oxford University Press, 1973), p. 155.

100. Thomas Carlyle, *Past and Present,* Book II, chapter 10. Carlyle had, his friend Froude uncomfortably recalls, "a true Teutonic aversion for that unfortunate race. They had no *humour,* and showed no trace of it any period of their history—a fatal defect in Carlyle's eyes. . . ." After that amazing comment Froude remembers Carlyle joking about taking "the pincers" to Jews like the Rothschilds, and getting back the money they had presumably stolen from the Nation. For the Ruskin letters, starting 20 April 1874, see George Allan Cate's *The Correspondence of Thomas Carlyle and John Ruskin* (Stanford, CA: Stanford University Press, 1982). Ruskin usually closes, "Ever your loving."

101. James Froude, *Thomas Carlyle: A History of His Life in London, 1834–1881* (New York: Charles Scribner's Sons, 1895), vol. 2, chapter 18, p. 22.

102. 19 July 1850, in Slater, ed., *Correspondence of Emerson and Carlyle,* p. 459.

103. Michael Goldberg, *Carlyle and Dickens* (Athens: University of Georgia Press, 1972), p. 78.

104. See *Carlyle and the Burden of History.* John D. Rosenberg's ten years of patient research into Carlyle's sources has established even the fanciful-seeming passages' essential veracity, though augmented by imagination and not so much written as told, in that unique voice. SR, III:7. By his own account, Carlyle is here particularly inspired by Fichte. I don't take Carlyle as a historian in our sense of the word, but for an evaluation of Carlyle's heroic conception of history, see John Rosenberg's *Burden of History,* cited above, and Hayden White's *Metahistory: The Historical Imagination in Nineteenth-Century Europe* (Baltimore, MD: Johns Hopkins University Press, 1973), pp. 146–49.

105. Goldberg, *Carlyle and Dickens,* pp. 142–43.

106. Carlyle, "The Opera." My text for this short work follows the "Boston Edition" (New York: John W. Lovell).

107. My text follows the "Boston Edition." For a more detailed study of Car-

lyle's portrait theory, see Charles Richard Sanders's "The Victorian Rembrandt: Carlyle's Portraits of his Contemporaries," in *Carlyle's Friendships and Other Studies,* pp. 3–36.

108. *The Genius of John Ruskin,* edited by John D. Rosenberg (Boston: Riverside, 1963), p. 18. Also see CW, 3:499.

109. CW, 3:22. Praise—of the Christian God. Ruskin is a believing Christian. Constable, Ruskin, and later, Hopkins expressed many reservations about unbelieving colleagues like Wordsworth and Carlyle. They fought side by side with them, however, against the blasphemous aesthetic that exalted man's creations above mere real things—God's mere real things, to them.

110. CW, 15:351.

111. CW, 22:222.

112. CW, 22:152, 485.

113. CW, 22:152–53.

114. CW, 15:13, 22:153.

115. TK, pp. 116–17.

116. CW, 3:142.

117. Solomon Fishman, *The Interpretation of Art* (Berkeley: University of California Press, 1963), p. 19.

118. *The Oxford Anthology of English Literature: Victorian Prose and Poetry,* pp. 154–55.

119. TK, p. 24.

120. Compare CW, 22:491, 16:187, 18:515n. For some valiant attempts to reconcile Ruskin's self-contradictions, see *The Ruskin Polygon: Essays on the Imagination of John Ruskin,* edited by John Dixon Hunt and Faith N. Holland (Manchester, England: Manchester University Press, 1982). Gary Wihl's revision of his doctoral dissertation, *Ruskin and the Rhetoric of Infallibility* usefully reviews much recent criticism, but contains the (to me) dumbfounding statement, "religion in Ruskin is usually a rhetorical mask for a difficult epistemological problem" (p. 43).

121. "The Athenaeum," in *Ruskin: The Critical Heritage,* edited by J. L. Bradley (London: Routledge, 1984), pp. 74–75.

122. Compare CW, 3:628.

123. CW, 5:111.

124. Rev. John Eagles, "Blackwood's Magazine," October 1843 in Bradley, ed., *Ruskin: The Critical Heritage,* pp. 34–35.

125. CW, 22:491.

126. Dis. 15, JRD, p. 248.

127. CW, 22:83.

128. CW, 22:85–86.

129. CW, 5:22.

130. CW, 22:493.

131. Tim Hilton, *John Ruskin: The Early Years* (New Haven, CT: Yale University Press, 1985), p. 50. Hilton took Ruskin's scientific ambition seriously. I'm indebted to his book. I owe lesser debts to work by other Rosenberg students, such as Elizabeth Helsinger and Paul Sawyer. See also Dinah Birch's "Ruskin and the

Science of Proserpina," in *New Approaches to Ruskin*, edited by Robert Hewison (London: Routledge and Kegan Paul, 1981), pp. 142–56.

132. CW, 26:98.
133. CW, 9:409.
134. CW, 3:188.
135. CW, 3:167, CW, 3:499. On this topic, see George P. Landow's "Ruskin, Holman Hunt, and Going to Nature to See for Oneself," in *Studies in Ruskin: Essays in Honor of Van Akin Burd*, edited by Robert E. Rhodes and Del Ivan Janik (Athens, OH: Ohio University Press, 1982).
136. CW, 3:499.
137. CW, 3:616, 617.
138. CW, 3:141, 142.
139. GB, p. 168.
140. CW, 3:329.
141. CW, 3:227; CW, 5:291; CW, 35:314. Nor is Ruskin's technique as unprecedented as all that. For all our interest in Ruskin, we tend to shy away from his own lifelong interest in the classical languages; but we should not overlook his knowing the tradition of "ekphrasis," coming down from the *Imagines* of Philostratus, a part of rhetorical training for fourteen hundred years. "The special virtues of ekphrasis are clarity and visibility," a second century A.D. rhetorician wrote, "the style must contrive to bring about seeing through hearing" (Baxandall *Giotto and the Orators*, BX, p. 85). This exercise's challenge was to make the hearer (or reader) seem to "see" a scene or artwork in question, often in highly charged, evocative language. "If the subject is florid, let the style be florid too, and if the subject is dry, let the style be the same" (see BX, pp. 85–96, and JH, passim). Ruskin took the classical ekphrastic tradition and honed it into a weapon for transfiguration.

Taken as a whole, Ruskin's education of the eye is plainly the reverse of the education prescribed in Reynolds' *Discourses*, that long comparison which would teach the imperfection of the world. Ruskin had given her a "new sense," Charlotte Brontë wrote after reading *Modern Painters;* "sight" (Rosenberg, *Genius of John Ruskin*, p. 12). Constable, for whom Ruskin always had a blind spot (possibly due less to Constable's rivalry with Turner than to Constable's outspoken contempt for Gothic architecture), had already experimented with the concept art form. *English Landscape Scenery* is only partly to promote Constable's art: often it is an attempt, using the conventions of such works as Claude's *Liber Veritatis*, to expand the eye to see, as his title plainly says, the *scenery* that inspired his landscapes. A chapter on the subject proved too digressive for the book at hand and will be published as an article.
142. CW, 3:366.
143. Environmental ethics feels its youth, and there has been an effort to orient itself, find forebears, learn its own tradition. I found helpful the 77-page annotated bibliography to Thomas J. Lyon's *This Incomparable Land: A Book of American Nature Writing* (New York: Houghton Mifflin, 1989). North Point Press's 1987 *On Nature: Nature, Landscape and Natural History*, contained a 34-page annotated bibliography by a distinguished group of six advisory editors (including

Annie Dillard, John Hay, and Edward Hoagland). Though everyone from Pliny to Turgenev appears, Ruskin does not. Catherine Albanese's twenty-page "Suggestions for Further Reading" (NRA, pp. 239–59) must now be any serious scholar's starting place.

144. *The Wilderness World of John Muir,* edited by Edwin Way Teale (Boston: Houghton, Mifflin, 1954), pp. 162–65; hereafter cited as JMO.

145. JMO, pp. xix–xx.

146. CW, 3:553, 554.

147. JMO, pp. 162–65.

148. CW, 3:570.

149. JMO, pp. 162–65.

150. CW, 5:172.

151. CW, 5:172.

152. CW, 10:197.

153. CW, 17:114.

Chapter IV

1. D. T. Suzuki, *Essays in Zen Buddhism: First Series,* (New York: Grove, 1961), pp. 149–51; hereafter cited as EZB. For another translation see Walpola Rahula, *What the Buddha Taught* (New York: Grove, 1974, rev. of 1959), pp. 11–12.

2. Irving Sandler acknowledges specifically (as do most artists and critics) that art "now" (which he calls "post modernism") seems, in important ways, a return to art before "modernism," "filled with extra-aesthetic reference" that modernism had "purged." He quotes Kim Levin: "All the words that had been hurled as insults for as long as we could remember—illusionistic, theatrical, decorative, literary—were resurrected" (AJ, p. 345).

3. Jean Stein, *Edie: An American Biography,* edited by George Plimpton (New York: Alfred A. Knopf, 1982), p. 184.

4. *American Masters: John Cage,* directed by Allan Miller, written by Vivian Perlis, 1990; hereafter cited as AMJC, 1990.

5. Interviews with John Cage by the author, 5–6 October 1990. A partial transcript appears in the *San Francisco Review of Books* 25:3 (Winter 1990): 17–18.

6. Marjorie Perloff, *The Futurist Moment: Avant-Garde, Avant Guerre and the Language of Rupture* (Chicago: University of Chicago Press, 1986), p. xvii.

7. Sir Kenneth Clark, *Landscape into Art* (Boston: Beacon Press, 1969), p. 79.

8. Arthur Elton and F. D. Klingender, *Art and the Industrial Revolution* (New York: Shocken, 1968), pp. 10, 16.

9. John D. Rosenberg, "Varieties of Infernal Experience: The City in Nineteenth-Century English Literature," *The Hudson Review* 23 (1970): 464. The literature of the everyday scenes the new industrial world presented is as vast as the topic. Classic accounts are Alexis de Tocqueville, *Journeys to England and France,* edited by J. P. Mayer, translated by George Lawrence and K. P. Mayer (New Haven, CT: Yale University Press, 1958); Friedrich Engels, *The Condition of the Working Class in England,* translated by W. O. Henderson and W. H. Chaloner (Stanford, CA: Stanford University Press, 1958), particularly, pp. 108–49 on the

towns and 274–94 on the miners; Henry Mayhew, *London Labour and the London Poor* (New York: Dover, 1968 facs. of London: Griffin, Bogn, 1861–62), vols. I–IV, particularly vol. II, pp. 142–45, "Of the 'pure'-finders," and 155–58, "Of the Mud-larks." ("They may be seen of all ages, from mere childhood to positive decrepitude, crawling among the barges . . . grimed with the foul soil of the river . . . , many, old women . . . during the winter, bent nearly double with age and infirmity, paddling and groping among the wet mud for small pieces of coal, chips of wood, or any sort of refuse washed up by the tide" (p. 155).

See also, T. S. Ashton, *The Industrial Revolution, 1760–1830* (New York: Oxford University Press, 1948, 1969); Asa Briggs, *Victorian Cities* (New York: Harper, 1963). On the ubiquity of street prostitution, see Steven Marcus, *The Other Victorians* (New York: Basic, 1966).

10. "The Gothic and Greek revivals," Robert Herbert writes, "like Barbizon art, were a way of pulling the mantle of the past over the ugly present" (*Barbizon Revisited* [Boston: Museum of Fine Arts, 1962], pp. 64–65). "In [the modern city] the romantic love of nature passed into a new phase. It became the nostalgia for a lost world of peace and companionship, of healthy bodies and quiet minds. . . . This is the background against which we should read the nature poetry of the Victorians and understand the popularity of Wordsworth. . . . (Walter E. Houghton, *The Victorian Frame of Mind* [New Haven, CT: Yale University Press, 1973], pp. 79–80).

11. WW, "Lines Left Upon a Seat in a Yew Tree," pp. 17–18.

12. J. D. Chambers, *The Workshop of the World: British Economic History 1820–80* (London: Oxford University Press, 1961), p. 119.

13. SC, vol. II, p. 7.

14. WW, p. 738.

15. Friedrich von Schiller, *Naive and Sentimental Poetry,* translated by Julias A. Elias (New York: Ungar, 1966), pp. 84–85, 105.

16. Elton and Klingender, *Art and the Industrial Revolution,* pp. 35, 36, 39. Spelling his.

17. WW, pp. 682–83.

18. "For [Rousseau, Diaz, Corot, Millet, Daubigny] the countryside was not just different from the city, it was the past still surviving in the present." In their letters, Robert L. Herbert tells us, the country's "solitude, silence and peace . . . are constantly opposed to the city they had left behind. . . . Until the latter 19th century, it was still possible to believe that modern industry could be spurned, and that man could cling to the soil" (*Barbizon Revisited,* pp. 64–65). For recent work on American artists' reaction to the industrialization of landscape, see John R. Stilgoe, *Common Landscape of America, 1580–1845* (New Haven, CT: Yale University Press, 1982); then Marianne Doezema, *American Realism and the Industrial Age* (Bloomington, IN: Indiana University Press, 1981).

19. Herbert, *Barbizon Revisited,* p. 64.

20. See "The Environs of Paris," in T. J. Clark, *The Painting of Modern Life: Paris in the Art of Manet and His Followers* (Princeton, NJ: Princeton University Press, 1984), pp. 147–204. Also John Rewald, *The History of Impressionism* (New

York: Museum of Modern Art, 1973, 4th rev. ed. of 1946), p. 38. Rewald's book contains extensive annotated bibliographies, as does his history of the post-impressionists. For a history and critique of modernism and modernolatry in Goethe, Marx, Baudelaire, the St. Petersburg writers, and 1950–80 New York, see Marshall Berman's *All That Is Solid Melts Into Air* (New York: Simon and Schuster, 1982).

The artworld at any time is a rope of many strands, and Natural Supernatural-ism is but one of them. That religious orientation has been active so long, how-ever, that it has provoked important responses. By the mid-nineteenth century we already find a backlash, in England and France, against the cult of the com-monplace, and the too-high, even millennial hopes Wordsworth, Ruskin, and their followers had raised for fifty years. The first great reaction against the trans-figuration of the commonplace emerged in the second generation after the ap-pearance of *Lyrical Ballads.* Two generations of artists and critics proclaiming the superiority over artworks of mere real things finally sparked a great rebellion among artists. "That Nature is always right, is an assertion, artistically, as untrue, as it is one whose truth is universally taken for granted," Whistler protests. Na-ture is "very rarely right. . . . it might almost be said that Nature is usually wrong" ("Ten o Clock," in *The Gentle Art of Making Enemies* [New York: Dover, 1967 repr. of 1892], p. 143). This backlash in defense of the object deserves a longer study, now in preparation, which complements this book's themes.

Jacques Barzun and Murray Krieger follow established usage by referring to this reaction as the "religion of art," but it's possible to be more specific and point out that it's actually a religion of the art *object*—a cult of art's perfected objects, a worship of the "masterpiece." The "perfect object cult," as I'll term it, sprang up among apostate ex-disciples like Pater, Wilde, and Whistler. The first two had studied with Ruskin himself; the third attacked him symbolically in the famous lawsuit. "That damned Realism," Whistler once wrote, ". . . cried aloud to me with the assurance of ignorance: 'Long live Nature'. . . . The regret I feel and the rage and even hatred that I have for that now would perhaps astonish you. . . ." (Rewald, *History of Impressionism*, p. 160). Contemporary criticism un-derestimates how philosophically sophisticated this rebellion was. These former disciples understood earlier than anyone else the anti-artobject implications of their masters' thought and tried to save the object from them. The artificiality, the un-naturalness of their prose and public personae seem to undermine their seriousness, but are in keeping with their aesthetic.

The perfect object cult can look superficially like a return to pre-1800 aesthet-ics. Once again it is the artist's job to select, as Whistler typically puts it, from "all that is dainty and lovable" and create "that wondrous thing called the master-piece." Once again the perfected object "surpasses in perfection" everything in nature. Reading Whistler, we recall Zeuxis and his maidens with fatigue: "And the Gods stand by and marvel, and perceive how far away more beautiful is the Venus of Melos than was their own Eve." Despite that Bellori-like respect for a statue over a woman, however, Whistler is only superficially classical. Whistler despises all literary reference and, consequently, all humanism, which is classi-cism's heart. Although in one breath he disparages nature, in the next he vilifies

as "claptrap" all the humanistic *istorie* classicists thought art's highest goal. Whistler scorns the critic who "degrades art, by supposing it a method of bringing about a literary climax." Art should "stand alone" (Whistler, *The Gentle Art of Making Enemies*, pp. 127, 146). The perfect object cult is something new. Reynolds would have been horrified by its ultimate statement, J. K. Huysmans's 1884 novel, *A Rebours*. In its pages, Flaubertian disgust for the bourgeoisie has deepened into a "horror of the human face." The hero, Des Esseintes, creates a jewelled womb into which he crawls, sealing the world out and himself inside. The late nineteenth century's recoil from everyday life to, and even *into*, the perfect object can go no further (New York: Dover, 1969 reprint of New York: Three Sirens, 1931, pp. 6–18).

It will take a second book to do this justice. The post-1800 artworld is a rope woven of innumerable strands, but I hope eventually to disentangle three: the Natural Supernaturalist orientation; the perfect object cult, a reaction; and the twentieth-century disillusion and exhaustion with both positions, Duchampian "indifference." For a long note on the last, see note 92.

21. See "Art," in RWE, pp. 298–99; FL, p. 57. Leger and Emerson both disdain those who approach art and its problems only aesthetically, preferring those who (Leger writes) can "see the whole spectrum of human drama without blinders."

22. "The Machine Aesthetic: The Manufactured Object, the Artisan, and the Artist," in FL, pp. 52–53. Leger (at least in this essay) stops short of the mechanical Darwinism which had some of the artists of his day protesting, in an unwitting revival of Hogarth's aesthetic, that the more an object is fitted to its use—for instance, the more streamlined the automobile gets—the more beautiful it becomes. Alison had replied to "Fitness is beauty" by observing that the pig's snout was perfectly fitted to rooting, but that hadn't made it beautiful. Leger, in the companion essay to the one just quoted, protests that the factories are aesthetic shambles which must be reorganized, for,"It is necessary to distract man from his enormous and often disagreeable labors, to surround him with a pervasive new plastic order in which to live." Leger's mix of socialism and transfiguration may remind Victorianists of an earlier praiser of artisans and fighter of hierarchies: "Everything made by man's hands has a form, which must be either be beautiful or ugly . . . Time was when the mystery and wonder of handicrafts were well acknowledged by the world. . . ." (William Morris, "Innate Socialism," in *William Morris: Selected Writings*, edited by Asa Briggs [Baltimore, MD: Penguin, 1962], pp. 85, 89).

Morris's handicrafts movement, growing from Ruskin's essay, "The Nature of Gothic," for all its differences from Leger, is still a step toward full respect as art for the "familiar" objects of "everyday life." "I cannot in my own mind quite sever . . . the great arts commonly called Sculpture and Painting . . . from those so-called Decorative Arts" of the objects which surround us (*William Morris: Selected Writings*, pp. 84–85). Leger will *not* sever them: "We should deeply admire this worthy craftsman," he says of a haberdasher decorating his shop-window; some of "these artisans" create "the equivalent of existing artistic manifestations, whatever they may be. We find ourselves in the presence of a thoroughly admirable

rebirth of a world of creative artisans . . . In the face of these artisans' achieve-
ments, what is the situation of the so-called professional artist?" (FL, pp. 56–57).

When Leger praises "the beautiful pharmacies on the Boulevard Sebastopol,
the horsemeat shops on the Rue de la Roquette . . . a hundred equine hind legs
lined up like soldiers, according to size, as if they were on parade" (FL, pp.
79–80), we get a preview of Pop art. Rauschenberg, Johns, and Warhol all
designed store windows early in their careers—a better training for their later
aesthetics than generally supposed.

But Leger and Emerson both disdain those who approach art and its prob-
lems only aesthetically, preferring those who (Leger writes) can "see the whole
spectrum of human drama without blinders."

23. RWE, pp. 312, 322, 324.

24. *Propos d'artistes,* in FL, p. 66.

25. WT, p. 412.

26. See Karen Tsujimoto's *Images of America: Precisionist Painting and Modern
Photograph* (Seattle, WA: published for the San Francisco Museum of Modern Art
by the University of Washington Press, 1982).

27. WT, p. 328.

28. RWE, pp. 298.

29. Preface 1855, in WT, p. 421.

30. Anthologized in *Silence* (Middletown, CT: Wesleyan University Press,
1961), p. 3; *Silence* hereafter cited as JCS.

31. RKZ, p. 44.

32. The best and surely most authoritative evaluation of Cage's earlier years
(to 1952) is still his former teacher Henry Cowell's piece for *Music Chronicle*
(January 1952), reprinted in *John Cage: An Anthology,* edited by Richard Kostela-
netz (New York: Da Capo, 1991 rev. of 1970). A full-length biography has ap-
peared, David Revill's *The Roaring Silence. John Cage: A Life* (New York: Arcade,
1992). I've heard the book criticized as too dependent on Kostelanetz's *Convers-
ing with Cage,* but it would be folly to overlook that invaluable montage of inter-
views. Revill's book—which Cage supported—is witty and never too reverential.
(Cage, he observes, had "cultivated a native simplicity" [p. 12].) Yet, unless the
feeling of reverence is itself a sin, and always to be avoided, it is hard to exclude
reverence from any biography of Cage. After all, we're hardly dealing with Mi-
chael Milken here. Reviewing sixty years of well-documented public life, the em-
barrassed researcher can discover little not to Cage's credit. Cage lived a life of
courage, principle, near-poverty, even monogamy; he was kind, generous, demo-
cratic and indifferent to material success. Gradually the cynical researcher per-
mits himself to believe that Cage really was as admirable as he seemed. Perhaps
we should revel in this rare chance to feel some reverence.

33. Ibid., p. 138.

34. Milton Hindus, "Apollinaire's April Fool's Day Whitman Hoax," in 1980:
Leaves of Grass at 125, edited by William White; a special issue of *Walt Whitman
Review,* Detroit, Wayne State University, pp. 38–39.

35. Betsy Erkkilla, *Walt Whitman among the French: Poet and Myth* (Princeton,
NJ: Princeton University Press, 1980), p. 142.

36. Ibid., p. 176. Erkkilla's persuasive thesis is that American and English

writers who went to France for inspiration from the time of the First World War on were unknowingly borrowing back Whitman's poetics and futurism.

37. Daniel J. Robbins, "Sources of Cubism and Futurism," *The Art Journal* 41, no. 4 (Winter 1981): 324. The best brief introduction to Marinetti is now Pellegrino d'Acierno's poetic "Filippo Tommaso Marinetti" in *European Writers: The 20th Century*, vol. 12, edited by George Stade (New York: Charles Scribner's Sons, 1992), pp. 747–832.

38. If anyone is wondering why we're connecting the poet Whitman, and not, for instance, the painter Eakins, with these Continental circles, see Joshua C. Taylor, *Futurism* (New York: Museum of Modern Art, 1961), p. 7. See also Christiana J. Taylor, *Futurism: Politics, Painting and Performance* (Ann Arbor, MI: UMI Research Press, 1979).

39. "The Founding and Manifesto of Futurism 1909," in *Futurist Manifestos*, edited by Umbro Apollonio (New York: Viking, 1973); hereafter cited as FM.

40. Futurism began as just one of the contemporary literary movements that looked to Whitman as a predecessor "in the attempt to give a literary voice to the urban and industrial landscape," Betsy Erkkila reports in *Whitman among the French* (p. 176).

41. RWE, p. 150.

42. Quoted by Pellegrino d'Acierno, "Marinetti," in *European Writers*, p. 802; Taylor, *Futurism*, p. 35.

43. FM, pp. 21, 65, 69–70, 75, 86, 87, 64.

44. FM, pp. 199, 177, 173, 176–77, 180–81.

45. Duchamp, no matter what he said later, had painted some extremely Futurist-looking works when they were at the height of their influence. His Nude Descending the Staircase looked so much like Futurism that the Cubists privately convened and—to the idealistic young man's shock—refused to allow him to continue exhibiting with them. That blow disillusioned Duchamp with the artworld even before World War I.

46. "The decades between 1910 and 1930," Douglas Davis sums up in *Art and the Future: A History/Prophecy of the Collaboration Between Science, Technology and Art*, "were characterized by a flood of new movements, groups, and schools," addressing the question "whether art should ignore, oppose, or exploit the technology implicit in rising industrialism" ([New York: Praeger, 1973], p. 15. Davis calls that the "key issue of the new century"; we have traced the concern over that question back to its roots in the old century. See Jack Burnham's *Beyond Modern Sculpture: The Effects of Science and Technology on the Sculpture of This Century* (New York: Braziller, 1968); George Rickey's *Constructivism: Origins and Evolution* (New York: Braziller, 1967); Gyorgy Kepes's *The New Landscape in Art and Science* (Chicago: Paul Theobald, 1944); J. L. Martin, Ben Nicholson, and Naum Gabo's *Circle: International Survey of Constructive Art* (New York: Praeger, 1971). See also "Past Machines, Future Art," in Harold Rosenberg's *The De-Definition of Art* (Chicago: University of Chicago Press, 1985), pp. 156–66. Rickey's book, in particular, contains a long descriptive bibliography of works in all major languages to 1966. Of course, the literature on this subject is enormous and new works appear constantly.

For a classic defense of the formal values of what the machine makes—a

defense of even the commonest mass-produced objects—see Herbert Read's *Art and Industry: The Principles of Industrial Design* (Bloomington, IN: Indiana University Press, 1961 [1953 rev. ed. of 1934]).

Perhaps a majority of the best-known American technological artists (Nam June Paik, James Seawright, SITE) are presently affiliated with a remarkable figure, Dave Bermant, who instead of building for them yet another museum places their often-enormous pieces in shopping centers. Bermant has commissioned over a hundred adventurous works for places like Pittsfield, Massachusetts; Berwyn and Mt. Prospect, Illinois; West Erie, Pennsylvania. Over the past twenty years the Long Ridge Mall in Greece, New York, has acquired dozens of gigantic kinetic pieces. Since 1980 the most philosophically radical have been the interactive computer pieces by "Flash Light." See note 124.

47. *Analects* 7.1, 7.2, translated by Arthur Waley (London: George Allen and Unwin, 1938), p. 123.

48. Cage himself, with characteristic generosity, has labored to acknowledge predecessors. For his authoritative "Forerunners of Modern Music" and other essays, see JCS, pp. 62–84, and pp. 36–50 in *A Year From Monday: New Lectures and Writings by John Cage* (Middletown, CT: Wesleyan University Press, 1967). For a more critical estimate of the Schoenberg-Cage direction in modern music, see George Rochberg's collected essays from 1955–1982, *The Aesthetics of Survival: A Composer's View of Twentieth-Century Music* (Ann Arbor, MI: University of Michigan Press, 1985). For Futurist and Dadaist interest in aleatory art, see Harriett Ann Watts, *Chance: A Perspective on Dada* (Ann Arbor, MI: UMI Research Press, 1979).

49. FM, pp. 76, 85–87.

50. JCS, p. 5. For Cage's prewar methods see also, in RKZ, the section "Autobiography," "His Own Music," and "Radio and Audiotape."

51. "Credo," in JCS, p. 3.

52. Peter Hansen, *Introduction to Twentieth Century Music* (New York: Allyn Bacon, 1967), p. 391.

53. JCS, pp. 3–6, 115–17.

54. Richard Kostelanetz, *John Cage* (New York: Praeger, 1970), p. 76.

55. Calvin Tomkins, *The Bride and the Bachelors: Five Masters of the Avant-Garde* (New York: Viking, 1968), p. 100.

56. RKZ, pp. 42, 166.

57. Arthur Danto, *Mysticism and Morality: Oriental Thought and Moral Philosophy* (New York: Columbia University Press, 1987; repr. of 1972), pp. 16–19. One valuable attempt, by the great pianist Margaret Leng Tan, unfortunately equates Suzuki with Zen. "'Taking a Nap, I Pound the Rice': Eastern Influences on John Cage," *Bucknell Review* 32, no. 2 (1989): 35.

58. "The Changing Canons of Our Culture," quoted in Masao Abe, *Zen and Western Thought*, edited by W. R. LaFleur (Honolulu, HI: University of Hawaii Press, 1985), p. xi; hereafter cited as MA.

59. Erich Fromm, D. T. Suzuki, Richard de Martino, *Zen Buddhism and Psychoanalysis* (New York: Harper, 1960).

60. Thomas Merton, *Zen and the Birds of Appetite* (New York: New Directions, 1968), pp. 59–61.

61. "Preface" to D. T. Suzuki, *The Zen Doctrine of No-Mind* (London: Rider, 1949, 1969), p. 5.

62. Alan Watts, "Beat Zen, Square Zen and Zen," in *The World of Zen*, edited by Nancy Wilson Ross (New York: Random, 1960), pp. 331–41. RKZ, p. 66. The most scholarly and forgiving book on the subject is still Van Meter Ames, *Zen and American Thought* (Honolulu, HI: University of Hawaii Press, 1962).

63. Carl Bielefeldt, *Dogen's Manauls of Zen Meditation* (Berkeley, CA: University of California Press, 1988), p. 3.

64. Martin Marty, *A Nation of Behavers* (Chicago: University of Chicago Press, 1976), pp. 143–57. *San Francisco Examiner*, p. 1, A26, 14 December 1989.

65. RKZ, p. 42.

66. Daisetz T. Suzuki, *Zen and Japanese Culture* (Princeton, NJ: Princeton University Press, 1970), pp. 343–44. Cage, in his restless pilgrimage through the avant-garde artworld, had encountered Eastern ideas for many years. In his youth, he briefly joined a California church which attempted to fuse East and West; he knew Ananda Coomaswarmy's work, and Alan Watts's. Yet his conversion to Zen (and it amounted to no less than that) came about, he has always insisted, through Daisetz Suzuki.

67. Arthur Koestler, *The Lotus and the Robot* (New York: Macmillan, 1961), p. 174.

68. Helen Tworkov, *Zen Buddhism in America: Profiles of Five Teachers* (San Francisco, CA: North Point, 1989), pp. 3–8.

69. Rick Fields gives an excellent brief account in *How the Swans Came to the Lake: A Narrative History of Buddhism in America*, rev. ed. (Boston: Shambhala, 1986), pp. 119–29.

70. MA, p. 20.

71. I thank Open Court's Mr. Blouke Carus for generously making D. T. Suzuki's unpublished letters available to me.

72. Suzuki himself acknowledges this (see EZB, p. 169).

73. EZB, p. 176. For a more recent, trustworthy discussion of the lineage issue, the historicity of the early Ch'an patriarchs, etc., see Philip Yampolsky's *The Platform Sutra of the Sixth Patriarch* (New York: Columbia Univ. Press, 1967).

74. *The Zen Teaching of Huang Po on the Transmission of Mind*, translated by John Blofeld (New York: Grove, 1958), p. 50.

75. *The Diamond Sutra and the Sutra of Hui Neng*, translated by A. F. Price and Wong Mou-Lam (Boulder, CO: Shambhala, 1969), p. 20.

76. MA, pp. 11–12, 226.

77. Paul Carus, *The Gospel of Buddha* (Chicago: Open Court, 1915), pp. v–xv.

78. Ferdinand Christian Baur, "Hebraists, Hellenists, and Catholics," in *The Writings of St. Paul*, edited by Wayne A. Meeks (New York: Norton, 1972), pp. 279–81.

79. EZB, pp. 42–47.

80. Baur, "Hebraists, Hellenists, and Catholics," pp. 279–81.

81. Helen Tworkov, *Zen in America: Profiles of Five Teachers* (San Francisco: North Point Press, 1989), p. 6.

82. MA, p. 205.

83. Suzuki, *Zen and Japanese Culture*, pp. 160, 145.

84. "Transmigration," in D. T. Suzuki, *Mysticism Christian and Buddhist* (London: Unwin, 1970; repr. of 1957), pp. 84–93.

85. MA, p. 116.

86. Shunryu Suzuki, *Zen Mind, Beginner's Mind* (New York: Weatherhill, 1970), pp. 9–13.

87. Suzuki, *Zen and Japanese Culture*, pp. 16, 17, 376.

88. Tworkov, *Zen in America*, pp. 3–8.

89. RKZ, pp. 53, 66.

90. Here is documentation of Bloom's rarest form of influence, "apophrades," when a later figure becomes so strong he "influences" an earlier one. See note 92.

91. See Peter Manning, *Electronic and Computer Music* (New York: Oxford University Press, 1985). For Cage against the background of postmodernism, see the revised second edition of Ihab Hassan's *The Dismemberment of Orpheus: Toward a Postmodern Literature* (Madison, WI: University of Wisconsin Press, 1982). I thank my graduate student, Julie Sundell, formerly Hassan's student, for sharing with me her monograph written after Cage's lectures to Hassan's class. For extensive interviews and eyewitness accounts relating to Cage's artworld and Cage's associates in New York, see Calvin Tomkins's superb *The Bride and the Bachelors;* and *Off the Wall: Robert Rauschenberg and the Art World of Our Time* (New York: Penguin, 1981 [Doubleday, 1980]). Tomkins was usually on assignment for *The New Yorker,* whose fact-checking department is well recognized. Since Tomkins was often present at the various performances and events, his books are invaluable primary sources. My own account, however, depends ultimately on my own first-hand observations and interviews.

92. Their number has declined, but some critics, conditioned by Cage and Pop, can't believe Duchamp's readymades could ever have been seen as anything but transfigurations—that intricate bottle rack, that gleaming urinal? Nothing more clearly displays Natural Supernaturalism's success than the way it finally transfigured even dadaist protests against it. Here is documentation of Harold Bloom's rarest form of influence, "apophrades," when a later figure becomes so strong he "influences" an earlier one. In other terms, the later figure so changes our *Weltanschauung* that the earlier figure is seen through the later. Duchamp's readymades, "which were meant not only to be non-art, but anti-art," Irving Sandler exclaimed, "have been elevated into art" (AJ, p. 346). There's abundant documentation. "I threw the bottle rack and urinal into their faces as a challenge," Duchamp complained to Hans Richter in 1962, "and now they admire them for their aesthetic beauty."

What's fascinating is that Duchamp's staunchest defender is John Cage, who has made Duchamp the object of his filial reverence since the 1940s. In 1990, when told point-blank, "Duchamp didn't do it first. You did it. The readymades were dada. They're not 4'33"." Cage loyally protested, "Marcel did it all before me!"

"These new Pop-people have chosen Marcel Duchamp as their patron saint,"

Hans Richter, one of the original dadaists, records. Shortly after the first important Pop show, Duchamp protested to Richter,

> This Neo-Dada, which they call New Realism, Pop Art, Assemblage, etc., is an easy way out, and lives on what Dada did. When I discovered ready-mades I thought to discourage aesthetics. In Neo-Dada they have taken my ready-mades and found aesthetic beauty in them. (Letter of 10 November 1962, quoted in Hans Richter, *Dada: Art and Anti-Art* [New York: Oxford University Press, 1965], p. 207)

"The critical misunderstanding of his intentions," Ursula Meyer writes, after quoting the letter to Richter, "still abounds today . . ." (UM, p. ix).

Both Meyer and Richter evidence Duchamp's 1961 anti-pop speech, "Apropos Readymades." Since it's an important speech and Meyer's version differs slightly from Hans Richter's version (Meyer's is more accurate), I'll transcribe a selection here from a photograph of the original text both typed in English and signed by Duchamp.

> A point which I want very much to establish is that the choice of these "readymades" was never dictated by an aesthetic delectation.

> This choice was based on a reaction of *visual* indifference with at the same time a total absence of good or bad taste. . . . in fact a complete anesthesia.

[Further on:]

> At another time wanting to expose the basic antinomy between art and readymades I imagined a "reciprocal readymade": use a Rembrandt as an ironing board.

> I realized very soon the danger of repeating indiscriminately this form of expression and decided to limit the production of "readymades" to a small number yearly. I was aware at that time, that for the spectator even more than for the artist, *art is a habit forming drug* and I wanted to protect my "readymades" against such a contamination. (*Dialogues with Marcel Duchamp*, edited by Pierre Cabanne [New York: Viking, 1971], p. 106; cited hereafter in this note as PC)

Duchamp is at pains to tell us his "choice was based" on "Indifference . . . in fact a complete anesthesia." When even "violent" actions become exhausted, annihilated by the Satanic insistence of a continuous and progressive 'what for?' what remains, what dominates," Tristan Tzara wrote in his 1924 "Lecture on Dada," "is *indifference*."

In short, nothing—not even art—is as big a deal as we pretend it is. That's what unites, in Duchamp's mind, an exhibited urinal, using a Rembrandt as an ironing board, drawing a mustache on the Mona Lisa. Who cares? And if we should all be blown up tomorrow—so what? It's dangerous to let dadaists speak for each other, but Tzara, in 1924, perfectly catches a mood—he calls it "indifference." Don't expect me to explain dada to you, Tzara says.

You explain to me why you exist. You haven't the faintest idea. You will say: I

exist to make my children happy. But in your hearts you know that isn't so. You will say: I exist to guard my country against barbarian invasions. That's a fine reason. You will say: I exist because God wills. That's a fairy tale for children. You will never be able to tell me why you exist but you will always be ready to maintain a serious attitude about life.

You will never understand that life is a pun, for you will never be alone enough to reject hatred, judgments, all these things that require such an effort, in favor of a calm and level state of mind that makes everything equal and without importance. (In *Theories on Modern Art: A Sourcebook by Artists and Critics*, edited by Herschel B. Chipp [Berkeley: University of California Press, 1968], p. 386)

By the 1920s, Duchamp had come to this "indifference" to art, and turned his back on it for chess. That's the famous Duchamp "myth"—which I think by and large correct. Octavio Paz suggests that the readymades aren't even "anti-art," but "an-artistic." "While I'm writing these notes, he's playing chess." They possess "what Duchamp calls the *beauty of indifference*" (emphasis his; *Marcel Duchamp in Perspective*, edited by Joseph Masheck [Englewood Cliffs, NJ: Prentice Hall, 1975], pp. 84–89).

"No!" John Cage protested, reading this. "Marcel's indifference" was like taoist equanimity, and Cage "knew for a fact" that Duchamp had been studying Eastern thought at the end of his life. Cage explained how he knew and why he considered the revelation a mark of special favor to him. "But you can't write that!" he said—the only time he put anything off the record. I withhold specifics to honor his request. However, Cage, in 1973, had answered Moira and William Roth differently:

ROTH: [Duchamp] taught like a Zen master?
CAGE: I asked him once or twice, "Haven't you had some direct connection with Oriental thought?" And he always said no. ("John Cage on Marcel Duchamp," *Art in America* 61, no. 6: 72–79)

Duchamp's final angry letter protesting that the readymades were not attempts to transfigure the world reminds us that people who thought they were such attempts have always had to pick their readymades carefully. The snow-shovel is now lovely curves and a cylinder, but where is the transfiguration in drawing a mustache on the Mona Lisa and affixing a filthy pun below her, "LHOOQ": "*elle a chaud au cul*"—"she's hot in the cunt." (Meant to be, as Duchamp said, a "very risque joke on the Gioconda," that is, a deliberately harsh explanation of the smile Walter Pater and his followers had too long debated.)

And what of the "ordinary metal dogcomb," as Duchamp later described it, "on which I inscribed a nonsensical phrase . . . 'Three or four drops of height have nothing to do with savagery.' During the 48 years since it was chosen as a readymade," Duchamp recounts with pleasure, "this little iron comb has kept the characteristics of a true readymade: no beauty, no ugliness, nothing particularly esthetic about it . . ." unlike the readymades he accused the Pop artists of co-opting for art. "It was not even stolen in all these forty eight years!" (*Marcel*

Duchamp, edited by Anne d' Harnoncourt and Kynaston McShine [New York: Museum of Modern Art, 1973], pp. 289, 279).

What New York took (and sometimes still takes) as Duchampian revelations were comments on ideas which had been trumpeted about Paris until he was sick of them. Hanging a snowshovel on a wall as late as 1915 was probably a sarcasm about the sort of dated futurist talk one still heard in New York, provincial echoes of the old Italian Futurist stuff about racing cars being more beautiful than the Victory of Samothrace, and the opening and closing of a valve being as beautiful as the opening and closing of an eyelid and infinitely newer. Years before the snowshovel (Leger has reported), he and Duchamp left an art show to go to the mechanic's show next door, and they gloried over the propellers and machines. Leger's love for all that only increased; Duchamp sickened of everything he had loved.

Yet, Duchamp had specifically told Cage (Cage argued) that his work anticipated Pop. "They call it neo-Dada," Cage wrote in 1965. "When I talked with M. D. two years ago he said he had been fifty years ahead of his time." So he told Cage, that is, the very year after he wrote that furious statement, which we just read, separating himself from "neo-Dada."

Some conclusions. First, to think the readymades were meant as art would be as much a mistake as confusing Beckett's silence with Cage's silence. Duchamp's often repeated "indifference," like Schopenhauer's, is a serious philosophical position:

> CABANNE: "During the three months you've just spent in Paris, what shows did you like particularly?"
> DUCHAMP: "I didn't see any."
> CABANNE: "You didn't go to the Salon du Mai?"
> DUCHAMP: "No, not even that. My wife went. I didn't want to. I don't want to see shows."
> CABANNE: "Aren't you curious?"
> DUCHAMP: "No. . . . Note, this is not taking sides, it's not desire or need— it's an indifference in the simplest sense of the word." (PC, p. 98)

This is much more like Schopenhauer than John Cage. In fact, Duchamp, speaking with Cabanne, either perfectly misses the point of Allan Kaprow's Happenings and the faithful Cage's music—unlikely—or facetiously misunderstands:

> I like happenings very much. . . . Happenings have introduced into art an element no-one had put there: boredom. To do a thing in order to bore people is something I never imagined! And that's too bad, because it's a beautiful idea. Fundamentally, it's the same idea as John Cage's silence in music; no-one had thought of that. (PC, p. 99)

Duchamp knew perfectly well that Cage was no dadaist. Compare Cage on "boredom": "In Zen they say: If something is boring after two minutes, try it for four. If still boring, try it for eight, sixteen, thirty-two, and so on. Eventually one discovers that it's not boring at all but very interesting (JCS, p. 93). When David Tudor came out to the piano and sat without playing for four minutes and thirty-

three seconds, in Cage's 4'33", you were to start hearing the world around you. It's to awaken you, not to bore you: you're to start listening, expecting an artwork, perfected sounds, but hearing, for the first time, the breathing and shuffling, the creaking of the chairs, the percussion of the coughing and the laughing and the voices.

A second conclusion: a restrained awareness of the "intentional fallacy" is as useful in art history as it has been in literary criticism. Though Duchamp did not mean the readymades as art, they certainly are art now.

To enlarge on the illustration with which we began this book: just as Danto's narrator was helpless to prevent J from pointing to his bed and saying "art object," so, at Natural Supernaturalism's climax, J is helpless to stop Danto's narrator from pointing to some parodic readymade J selected and saying, "Also an art object." It won't do for J to startle and say, "No, no, I meant *that* as visual indifference." That's tough. The bed factory didn't mean J's bed to be an art object either. Few of the mundane objects transfigured into art during the 1960s *were* originally meant as art. Campbell's Soup was furious with Warhol. The way Duchamp's objects, intended as anti-art, were inexorably transfigured anyway (so thoroughly that the eyes which could not see them as art are all but unimaginable to us now) testifies to the current's power. Natural Supernaturalism, as Irving Sandler implied, finally transfigured not only neutral work-a-day objects, but specific protests against itself.

Yet Cage knew Duchamp better than any of the critics cited above, and Cage insists Duchamp *enjoyed* his connection with "neo-dada." Duchamp's proud remark to Cage about being fifty years ahead of his time came a year after he swore loudly he'd never been Pop. There's no reason both statements can't be true. Duchamp had never been Pop, but a year after being so angry at seeing the readymades misunderstood, he had started to enjoy the situation.

Consider a last analogy: Duchamp the dadist was like some ancient pirate, who set off to "burn and pill" the artworld's coast. Instead, the offshore current he steered against turned out to be a mighty oceanic thing that swept him and his readymades away and landed them on the shores of a new continent. Ever after, he is hailed as a Columbus—who after all, had no more been looking for America than Duchamp was for Pop. Columbus missed India but found better, and Duchamp, whatever his intentions, landed on this new place too.

He spends the rest of his life honest about his intentions but proud of his new continent. The real intentional fallacy is reducing work to the intention of the worker; a strong current can carry an artist, like a sailor, to other shores than he set out for.

To bring our conclusions together, Duchamp was a dadist whose most influential work is no longer dada: carried off by the postwar Natural Supernaturalist floodtide, it landed on a new world. To add to the irony, it was Cage, the would-be disciple, who led the movement which turned his master's work into an imitation of his own.

93. "History of Experimental Music in the United States," in JCS, pp. 68–69.

94. Werner Hoffman, *Turning Points in Twentieth-Century Art: 1890–1917*, translated by Charles Kessler (New York: Braziller, n.d.), pp. 139–40.

95. Perloff, *The Futurist Moment*, p. xviii. See Marjorie Perloff's long chapter, "The Invention of Collage," pp. 45–79.

96. *Les Peintres Cubistes, 1913, Cubism*, edited by Edward Fry (New York: McGraw-Hill, 1966), p. 118.

97. Folk art, like Simon Rodia's famous Watts Towers in Los Angeles, often shares this taste for compositional inclusiveness. Picasso: "Primitive sculpture has never been surpassed." William Rubin writes in *Primitivism in 20th Century Art: Affinity of the Tribal and the Modern*, "Just before World War I Picasso began adding oilcloth, rope, tassel, tin, string, nails, and other commonplace materials to his works to form combines and assemblages." Though such work was new to the "Western Fine Arts tradition," Picasso had admired mixtures of "cloth, raffia, bark, metal and found objects" in "tribal sculptures" (Exhibition catalog, New York: Museum of Modern Art, pp. 1, 13).

98. The thrust of recent scholarship, in fact, has been to reveal representations hidden almost subliminally in the works.

99. FM, p. 86.

100. Cage, John, *I–VI: MethodStructureIntentionDisciplineNotationIndeterminacy InterpenetrationDevotionCircumstancesVariableStructureNonunderstandingContingency InconsistencyPerformance* (Cambridge, MA: Harvard University Press, 1990), p. 431. The work contains extensive quotations (like this one) from the text of the 1982 *John Cage: Composition in Retrospect*. I cite the now-standard Harvard text.

101. *"Die Moderne Malerei,"* 1913, in Fry, ed., *Les Peintres Cubistes*, p. 113. I'm not claiming Picasso authorized Apollinaire's remarks, only showing how long such ideas had been discussed.

102. JCS, p. 69.

103. C. R. Leslie, *Memoirs of the Life of John Constable: Composed Chiefly of His Letters* (Ithaca, NY: Cornell University Press, 1980), p. 15.

104. WW, p. 735.

105. "Edgard Varèse," in JCS, pp. 83–84.

106. Harvey Cox, *Feast of Fools: A Theological Essay on Feast and Fantasy* (Cambridge, MA: Harvard University Press, 1969), pp. 37, 39.

107. NRA, p. 100. I'm indebted to Catherine Albanese's discussion of Muir's passage.

108. CW, 3:499.

109. "Composition," in JCS, p. 57.

110. "Experimental Music: Doctrine," in JCS, pp. 17, 72. For two important essays on "composition, improvisation and chance," by a philosopher who is himself a musician, see Stanley Cavell's *Must We Mean What We Say?* (SCM).

111. RKZ, pp. 66–67.

112. ADE, pp. 287, 344. Daniel Herwitz, in his excellent *Making Theory/Constructing Art: On the Authority of the Avant-Garde* considers at length how well Warhol actually illustrates Danto's theories and decides, not very. Professor Herwitz fails, I think, to distinguish between art criticism of Warhol and, as Danto once put it, "philosophy pivoting around Warhol." He also tends to confuse Danto's ceaseless growth with inconsistency. (Certainly my ideas have changed, Ruskin once remarked, but the change was "that of a tree, not of a cloud.") Danto, in

conversation, is so undoctrinaire one realizes that, like Sartre, whom he admires greatly, he must be understood as "a person of dialog." His works are "essays" in the original, provisional sense. Though an unapologetic admirer of Warhol's, he cheerfully accepts Cage's 4'33" as the "end" of "historical art," "if that does it for *you*." Like satori, perhaps, the "end" is an individual experience. Warhol's *Brillo Boxes* did it for *him*—gave him his epiphany of art's coming "end"—and Danto has recorded the fact. But he expects that each of us will have our own moment.

113. Cage's connection with Warhol's work was indirect but real. See Andy Warhol and Pat Hackett, *Popism: The Warhol 60s* (New York: Harper and Row, 1980). Warhol himself declares flatly that the "first person" he knew to have the Pop vision, to be able to see "commercial art as art" was Emile de Antonio, "and he made the whole New York art world see it that way, too." (Warhol glides over Roy Lichtenstein's contribution.) Warhol records in passing that de Antonio was then acting informally as Jasper Johns' and Robert Rauschenberg's agent and was closer to them and Cage than he was to Warhol. Knowing de Antonio's role matters because Pop isn't an art of execution: it took no skill to draw the Coke bottle or Brillo Box (and later Warhol would often delegate that chore to helpers). The skill lay in knowing that, by 1960, merely presenting a gallery audience with the Coke bottle would be enough. Critics usually credit Warhol with that decision; Warhol himself credits de Antonio. In *Close Encounters* and *Beyond the Brillo Box* Arthur Danto—who corresponded with de Antonio—goodnaturedly acknowledges de Antonio's influence on Warhol but finds much less significance in it than I do (see BBB, 131–45). As I remarked in the previous note, Danto's philosophy does not stand or fall on this issue.

Since Warhol's "philosophic genius" has become a minor issue, though, I asked David Antin and Allan Kaprow, two central figures in the sixties Pop art-world to comment briefly. Both are respected aestheticians and both knew Warhol. "Andy," Kaprow offered, "was not a philosophical genius . . . but very interesting. And he raised philosophical *issues* about the value of the artist, his stance, the function of the work . . . the whole business of commercialism. What Andy did, the most 'genial' thing he ever did, was shift his commercial art from one consumer to another. That is, the general consumers of his art as a shoe designer, ad maker, were an uncritical, generally unreflective group—not a very rewarding audience. He decided to hang his hat in the artworld. But he was still a commercial artist: money and the market situation were being manipulated just as before. Only now Andy had a much hipper, more critically sophisticated audience which would be able to address the ideas that were implicit in his moves."

"He *was* very intelligent," David Antin added, "but also very naive. Warhol's brilliance was that he could act out certain paradoxes that were inherent in art at the time, *with his own body.* Thus bringing to a head the entire tendency of the sixties to embrace the vernacular—with *all* of its problems. He embraced the desires for success which were lurking within the artworld, in its attempt to marry the culture. And once he put this on the table by walking into a space and treating it naively—it brought it to a kind of feverish pitch, raising it to a height

of infection that was amazing. That's what his brilliance was: a certain brilliant naivete. Other people would have been embarrassed to walk into that space."

"That's it," Kaprow said.

"Warhol's ability depended on a brilliance of naivete that sometimes shows up in Cage," Antin continued. "There's a certain brilliance of naivete in the *period*—which is very important! Because some of the most interesting acts depended on *suspending* critical judgement . . . and walking into the trap! So that as you experience the trap, you *become* a kind of exemplary act. Warhol became an exemplary act: the exemplary act of, like, marrying the culture, becoming equivalent to the sellout. Warhol didn't then back out of the sellout—"

Kaprow: "No."

Antin laughed. "He decided, 'Of course! *That's* what I'm going to do! Better marketing!' It became a *funny* sort of spin into the system of values—devastating in its implications, but it's not so much truly calculated by him (Kaprow: "No,") but a *con*sequence of his behavior."

114. |For Cage and Rauschenberg, see Calvin Tomkins, *Off the Wall: Robert Rauschenberg and the Art World of Our Time* (New York: Penguin, 1980), pp. 65–75; RKZ, p. 67.

115. "On Robert Rauschenberg, artist, and his work," in JCS, pp. 98–102.

116. RKZ, pp. 65–67.

117. BBB, p. 141.

118. *Popism: The Warhol 60's* (New York: Harper and Row, 1980), pp. 39–40.

119. Allan Kaprow, "Pinpointing Happenings," in *Essays on the Blurring of Art and Life,* edited by Jeff Kelley (Berkeley, CA: University of California Press, forthcoming). I thank Jeff Kelley and Allan Kaprow for sharing these documents in advance.

120. Kaprow, "Manifesto 1966," in *Essays.*

121. *Software Information Technology: Its New Meanings for Art,* edited by Jack Burnham (New York: Jewish Museum, 1970), p. 31.

122. David Antin, Helen and Newton Harrison, personal communications, and *Software,* p. 43. I will treat the Harrisons' pioneering conversion to ecological art in a separate article. See their catalogs *The Lagoon Cycle* (Ithaca, NY: Cornell University Press, 1985) and *Atempause for den Save-Fluss* [Breathing Space] (Berlin, 1989).

123. GB, p. 69.

124. Lawrence Weschler, *Seeing Is Forgetting the Name of the Thing One Sees: A Life of Contemporary Artist Robert Irwin* (Berkeley: University of California Press, 1982), p. 156. About 1969, the cinematographer Robert Dannenmann (who shared an Academy Award for *Woodstock*), abandoned the film and began attaching computerized keyboards to technological devices to prove to everyone that, as Cage claimed, they could stop being the audience and become the artists. Dannenmann took Kaprow-like steps to transform his audience into artists, renting a room above a bar in Greenwich Village, installing his computers and charging the public a dollar to use them. It was an amazing sight—a true Happening—in the early seventies, to come into his "Photon Factory" on a Friday

evening and see the sort of street kids who thronged the Village on such nights sitting contentedly, creating computer art and paying a dollar to do it. In the eighties, as a member (with Nam June Paik) of Dave Bermant's kinetic artists' stable, Dannenmann no longer merely created instruments, but the "Flash Light" computer programs, which fully ceded to his audience the artist's role.

125. "Four Statements on the Dance," in JCS, p. 95.

126. Tomkins, *The Bride and the Bachelors*, p. 100.

127. Ihab Hassan, *The Literature of Silence: Henry Miller and Samuel Beckett* (New York: Alfred A. Knopf, 1967), p. 14. Through a mutual graduate student, I know Cage actually gave classes for Hassan's students in Wisconsin at the end of the 1960s. When Hassan directed the Wesleyan Center of the Humanities in 1969–70, Cage was a Fellow, and Hassan included Cage's poetry in *Liberations: New Essays on the Humanities in Revolution* (Middletown, CT: Wesleyan University Press, 1970). Accordingly, in *The Dismemberment of Orpheus* (New York, Oxford University Press, 1971) Hassan sees clearly that Cage "is really an inheritor of American Transcendentalism, to which he brings the humor of Zen. . . ." (p. 15). Yet the book is almost entirely about European modernists, and Cage's name appears on only five or six pages.

128. See Calvin Tomkins, *Off the Wall* (New York: Doubleday, 1980), and Barbara Rose, *Rauschenberg* (New York: Random House, 1987).

129. Cox, *The Feast of Fools*, pp. 37–41, 126, 130.

130. Yvonne Rainer, "Looking Myself in the Mouth," *October* 17 (Summer 1981): 67–68. Cited in Henry Sayre, *The Object of Performance* (Chicago: University of Chicago Press, 1989), p. 88. I am indebted to Cage's longtime friends and associates, David Antin and Allan Kaprow, for discussions of Cage's work and their own. Both read the section on Cage and gave me line by line improvements. Antin informs me discontent had been quietly brewing for some time. He remembers a mid-sixties meeting at "Dick Higgins' house, when there was a small group of artists—Phil Corner and Alyson Knowles—organized to have a conversation with Cage about his political context. Everybody there had felt there was something inadequate about . . . you know, that 'It is all good, all wonderful, all things are well and all manner of things shall be well,' kind of quality about Cage that people found disturbing in the framework of the Vietnamese war." Antin had already sent Cage a copy of his book of poems, *Definitions*, dealing largely with the thematics of violence central to the times, many about Vietnam or racial issues, "with only one line written on it, 'Is it *exactly* the right amount, John?' And he dropped me a note saying, 'Let's talk.' (Laughs.) He knew *exactly* what line I was talking about—the moment in *Silence* when he's asked, 'Isn't there too much suffering in the world?' And he answers, 'No, there's exactly the right amount.'" Recognition of Cage's literary achievement grows slowly but steadily. Two journal issues largely devoted to Cage pay more attention than usual to his poetry: "A John Cage Reader," *TriQuarterly* 54 (Spring 1982): 68–232. Also, "John Cage at Seventy Five," *Bucknell Review* 32, no. 2 (1989). Marjorie Perloff's work on oral poetry is important, particularly her essays, "Between Verse and Prose: Beckett and the New Poetry," *Critical Inquiry* 9 (December 1982): 415–33 and "'Unimpededness and Interpenetration': The Poetic of John

Cage," *TriQuarterly* 54 (Spring 1982): 76–109. Richard Kostelanetz's book *Conversing with Cage* (RKZ) is endlessly valuable. Cage himself proofread the book three times and supervised Kostelanetz's *John Cage: Writer. Previously Uncollected Pieces* (New York: Limelight, 1993).

131. AMJC, 1990.

132. John Cage, *Empty Words* (Middletown, CT: Wesleyan University Press, 1979), p. 4.

133. Cage, *A Year from Monday,* pp. 3, 13, 23, 105, 111, 146.

134. JCM, preface and p. 198.

135. My understanding of late Maoist China is indebted to my brother-in-law, Professor Ya-Feng Du, of Beijing; my former colleagues at Beijing Advanced Teacher's College; and Mr. Xian-Rong Shi, Head of American Studies at China's Institute of Social Sciences, and now Deputy Director of the Institute.

136. JCM, pp. xi, 213.

137. John Cage, *X, Writings '79–'82* (Middletown, CT: Wesleyan University Press, 1983), pp. 68–69, 140–41.

138. Cage, *Empty Words,* p. 177.

139. My understanding of taoism is primarily indebted to Benjamin Schwartz, *The World of Thought in Ancient China* (Cambridge, MA: Belknap/Harvard University Press, 1985). Also, Arthur Waley, *The Way and Its Power: A Study of the Tao Te Ching and Its Place in Chinese Thought* (New York: Grove, 1958).

140. Cage, *Empty Words,* p. 187. The tree story appears in *Chuang-tse: Basic Writings,* edited by and translated by Burton Watson (New York: Columbia University Press, 1964), p. 61. Cage quotes a friend's translation. Cage's taoism is not the debased popular religion, *tao jiao,* one encounters at the Baiyunguan in Beijing, but the classical *tao jia,* taoist school (literally, family or household) of Chuang-tse and Lao-tse primarily.

141. Waley, *The Way and Its Power,* pp. 143, 153, 162, 109.

142. GB, pp. 34, 37.

143. Interviews, August 1990.

144. See Douglas Davis's detailed history in *Art and the Future,* particularly pp. 161–87.

145. Jack Burnham, *The Structure of Art,* rev. ed. (New York: Doubleday, 1973).

146. JMO, pp. xix–xx. Jeff Kelley graciously shared manuscript sections of his forthcoming book on Allan Kaprow for the University of California Press. For a skeptical countervoice, see Harold Rosenberg's 1968 essay on Kaprow, Cage et. al., "Museum of the New," in *Artworks and Packages* (Chicago: University of Chicago Press, 1969), pp. 144–56.

147. Mill, *Bentham and Coleridge,* p. 39.

148. *Los Angeles Times,* Part V, Thursday, 23 May 1985, pp. 1, 30, 32. Even at the height of Ronald Reagan's popularity, when his administration reversed much social legislation, the "environment" had become so sacrosanct—sacred, in fact—that his environmental administrators James Watt and Anne Burford had to be removed (and their underling Rita LaVelle was even jailed). Nowhere else did Mr. Reagan receive so furious a check: contemporary Natural Supernaturalism transcends politics. Watt's politics were considered sacrilege.

149. As a typical instance, a magazine for young women, *Self,* announced on its cover a 24-page section,

Commitment and you
 *to love
 *to the earth
 *to your self

in that order. Big business scrambled to get on the right side of the issue. The *New Yorker* ran a 13-page "Special Advertising Supplement" paid for in part by Honda and ATT, printed on "one-hundred-per-cent recycled Georgia-Pacific paper." It featured quotes by John Muir and Thoreau and even a shot at "anthropocentric religion." Any magazine or newspaper published in Spring 1990 will carry extensive accounts of Earth Day. For scholarly accounts, see the April 1990 *Smithsonian* (vol. 21, no. 1), which also contains an annotated bibliography (pp. 206–13).

Fervor waxes and wanes, there are conversions, backslidings, reconversions. But there has been a change.

Epilogue

1. Harold Rosenberg, "After Next, What?" in *The Anxious Object: Art Today and Its Audience* (New York: Horizon, 1964). This chapter no longer appears in later editions.

Index

Abe, Masao, 148, 161
Abrams, M. H., 21, 23, 38, 53, 73, 79, 122–24; literature on his work, 203; *The Mirror and the Lamp*, 55; *Natural Supernaturalism*, xi, 19, 12, 22
Abstract Expressionism, 10
Academy of Art (*Accademia del Disegno*), first arts academy, 206
aesthetic, new, 74, 105, 120; composed of idealist and *istoria* families of defenses, 54; older, 45, 55, 66, 67, 69, 210
aesthetics, 208
Albanese, Catherine, 13
Alberti, Leon Battista, *Della Pittura* (1435), 32, 33, 207; *De Statua*, 38, 40
aleatory art, 162, 168, 176, 180
Alison, Archibald, 56–63, 65, 66, 72, 212, 225; *Essays on the Nature and Principles of Taste* (1790), 58
Allen, Gay Wilson, 201
Annan, Noel, 203
anti-art, 26, 98
Antin, David, 67, 122, 173, 236, 237, 238; culture as a sacred discourse, 82
Antonio, Emile de, 120, 194, 236
Apollinaire, 163, 165
apophrades, 230
Arnold, Matthew, "Lines Written in Kensington Gardens," 126–27
Aristotle, 36
art, 191, 200, 222, 225, 232
—attitudes toward: Cage, 69; Carlyle, 89; Duchamp, 231; Emerson, 12–13, 113, (as education) 14; Kaprow, 173; Reynolds, 44, (nature judged by), 47; Ruskin, 99, 102–3
—definition of, 6
—definition expanded (1950–70), 68
—hard to define after 1800, 67
—history, 11
—history of, ended, 4
—problem of defining, 214

—redefinition of, 42
—theories of, 6
—topics: and anti-art (Sontag), 18; audience, 168; disappearing (Burnham), 186; and concept art, 119; end of, 3; feminist, 9; institutional theory of, 214; and nature, 39, 44, 47, 99; political, 9; postliterate story, 9; religion of, 224; and religious feeling, 20; and technology, 10
Art and the Industrial Revolution (Elton and Klingender), 125
art object, xii, 7, 19, 24–26, 31–33, 35, 37, 39, 42, 68, 69, 75, 113, 162, 167
—attacks on, 12
—Carlyle: hostile to, 89; as "icon" tolerated by, 96; regarded as hypocrisy by, 92
—decisions to abandon, 173
—defended by aestheticians at expense of real things, 40
—defense of, 11
—distracting to art, 18
—Emerson's views of, 13, 16, 17
—Hegel's view of, 15
—ideal, 36
—new religious tendency's attitude toward, 119
—ready-made art accepted as, 6
—Wordsworth: his "first shot" against, 54; status of, when Wordsworth entered artworld, 48
Art of Noise (Russolo), 144
artwork, xiii, 26, 200; case against (Carlyle), 93
artworld, xiii, 9, 17, 39, 110, 162, 186, 192, 224–25; before 1800, 41; dominated by Natural Supernaturalism, 192; hostile toward Natural Supernaturalism, 49; loathed by Carlyle, 94; meaning of, 197; Suzuki still prominent in, 148
Atkinson, Terry, 6
avant-garde, 5, 8, 120, 197, 198; end of, 4, 9